MW00791235

Inventing the Louvre

Containing the finest collection of Old Master paintings and antique sculpture ever assembled under one roof, the Louvre, founded in the final years of the Enlightenment, became the model for all state art museums subsequently established. This book chronicles the formation of this great museum, from its origins in the French royal picture collections to its apotheosis during the Revolution and Napoleonic Empire. More than a narrative history, Andrew McClellan's account explores the ideological underpinnings, pedagogic aims, and aesthetic criteria of the Louvre, as well as its contemporary, the Museum of French Monuments, which in complementary ways laid the foundation for the modern museum age. Here, the central and abiding questions of museum practice – arrangement of art works, lighting, restoration and conservation, public education, and service to the state – were first defined and given visual expression.

Drawing on much new archival material, this book also casts new light on the art world of eighteenth-century Paris and its most colorful characters, from Roger de Piles and La Font de Saint-Yenne to Jacques-Louis David and Alexandre Lenoir.

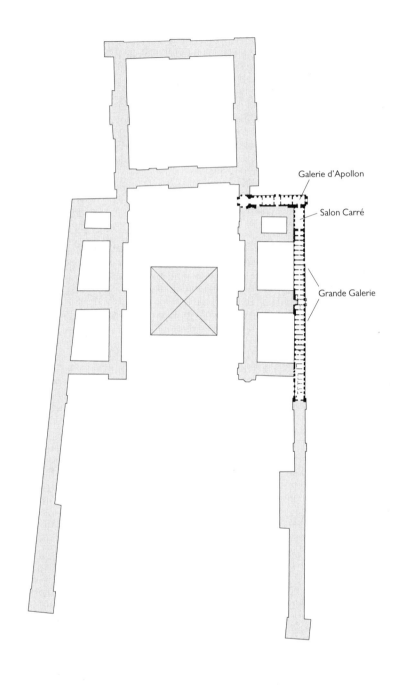

Galerie d'Apollon

Salon Carré

Grande Galerie

Inventing the Louvre

Art, Politics, and the Origins of the Modern Museum in Eighteenth-Century Paris

Andrew McClellan

Tufts University

UNIVERSITY OF CALIFORNIA PRESS
Berkeley · Los Angeles · London

University of California Press
Berkeley and Los Angeles, California

University of California Press, Ltd.
London, England

First Paperback Printing 1999

Library of Congress Cataloging-in-Publication Data

McClellan, Andrew.
 Inventing the Louvre : art, politics, and the origins of the modern museum in eighteenth-century Paris / Andrew McClellan.
 p. cm.
 Originally published: Cambridge, England ; New York : Cambridge University Press, 1994.
 Includes bibliographical references and index.
 ISBN 0-520-22176-1 (alk. paper)
 1. Musée du Louvre. 2. Art and state—France—History—18th century.
I. Title.
[N2030.M34 1999]
708.4'361—dc21 99-14254
 CIP

Printed in the United States of America
1 2 3 4 5 6 7 8 9

The paper used in this publication meets the minimum requirements of American National Standard for Information Sciences—Permanence of Paper for Printed Library Materials, ANSI Z39.48-1984. ∞

For my parents and for Connie

CONTENTS

LIST OF ILLUSTRATIONS

ACKNOWLEDGMENTS

For their help in various ways over the many years it has taken me to write this book, I would like to thank Colin Bailey, Frank Brady, Anita Brookner, Philippa Dickin, Francis Dowley, Peter Funnell, Sura Levine, Yvonne Luke, Ourida Mostefai, Jane Van Nimmen, Marcia Pointon, Edouard Pommier, Alex Potts, Dominique Poulot, Maxime Préaud, Daniel Sherman, Paul Smith, Genevieve Warwick, and Richard Wrigley. I am especially grateful to Michael Fried, who read early drafts of the first chapters and made many valuable suggestions; and to Katie Scott, whose friendship and advice as a fellow *dix-huitièmiste* has been important to me.

My thanks also to my colleagues at Tufts University and to the History of Art Department of The Johns Hopkins University, and especially Elizabeth Cropper, Charles Dempsey, and Herbert Kessler, in whose company I spent a pleasant and productive year as a J. Paul Getty Fellow in 1988–9. I am grateful for the financial support of the British and French governments and the J. Paul Getty Foundation. My thanks to Jeongmin Chu and Pam Krupanski for their help with the bibliography and photographs. Portions of Chapter 3 originally appeared in the *Art Bulletin* and are reprinted by permission of the College Art Association, Inc.

Finally, I would like to thank my parents and my wife, Connie, for their constant encouragement and support.

Medford, Massachusetts
September 1993

INTRODUCTION

In the final decades of the *ancien régime* a succession of ministers under two kings dreamed of creating a public art museum in Paris that would be the envy of Europe. Those dreams were realized when the Louvre opened in 1793 at the height of the French Revolution. This book recounts the key moments in the movement to create that most celebrated of museums. Chapters 1 and 2 consider two forerunners of the Revolutionary Louvre, the exhibition of royal paintings at the Luxembourg Gallery between 1750 and 1779 and the unrealized museum project of Comte d'Angiviller under Louis XVI. Chapters 3 and 4 concern the formation of the Louvre museum from 1793 to its apotheosis a decade later as the Musée Napoléon. A final chapter on Alexandre Lenoir's Museum of French Monuments represents a case apart, but an essential one. A museum born of the Revolution and containing only French sculpture, Lenoir's museum offers a valuable museological foil to the Louvre, in addition to being a fascinating institution in its own right. No account of the dawn of the museum age in France would be complete without it.

At a time of heightened interest in the history and ideological underpinnings of museums and exhibitions, an account of these two famous institutions needs no justification. But what lends the French case particular interest and importance is that it was in Paris in the latter half of the eighteenth century that the central and abiding issues of museum practice – the classification and display of objects, lighting, the aims of conservation – were first discussed and articulated. The fifty years covered in this book witness the emergence of criteria for the display of art in what was essentially a new building type: the public museum of art. It is the process that resulted in the elaboration of modern museum discourse that interests me. Whereas that discourse might seem to be aesthetic in nature, limited to questions of how

works of art are presented and seen, I will argue that it is also deeply political, and that on various levels art museums carry a heavy symbolic load on behalf of the governments and factions that sponsor them.

The Louvre as it came to be under Napoleon is usually and correctly identified as the archetypal state museum and model for subsequent national art museums the world over. But it should equally be seen as the end product and culmination of earlier initiatives.[1] Because these initiatives are my main concern, little will be said about the Musée Napoléon's glorious but museologically unadventurous years after 1803. No doubt a history of those years would be worth writing – especially one that focused on the museum's director, Dominique Vivant-Denon, the prototype of the modern museum man – but it would be an account different in character from the case studies that make up this book. The same can be said for the Museum of French Monuments. Though Lenoir's museum remained popular until it was dissolved at the start of the Bourbon Restoration in 1816, it was essentially complete by 1802. My interest is in the museum's formation and purpose, and I will argue that it is best understood as a product of Revolutionary events and strategies to control memory of the past and of the Revolution itself. Apart from its novel structure and ideology, the Musée des monuments is of interest as the focus of the first sustained critique of the museum's power to transform and alienate works of art not originally intended for its walls. This will be considered at the end of Chapter 5 and in the Conclusion.

The search for criteria of display in late-eighteenth-century Paris was predicated on the assumption that the purpose or "mission" of the museum was, as it still is, to educate and conserve. Therein lies the "modernity" of the museums I discuss, and it is that which distinguishes them from other prominent art collections in Europe. All royal and princely collections in the eighteenth century manifested the wealth and taste of their owners; throughout Europe collecting became a major form of princely patronage. Modeled on the late Renaissance *kunstkammer*, early eighteenth-century cabinets (the term often used to describe rooms set aside for the presentation of valued objects) signified princely rule through an abundant and harmonious arrangement of paintings. At Mannheim (Fig. 1), for example, we find pictures densely and symmetrically arranged around a central vertical axis like pieces of a puzzle. The effect is dazzling, indeed overwhelming; discriminating viewing of individual works is out of the question. Exhibitions such as this closely resembled and were often contiguous with porcelain and curiosity cabinets (Fig. 2), further suggesting that the visual effect of the whole counted for more than scrutiny of its component parts. But in France at the Luxembourg Gallery from 1750 a new set of priorities came into play. Though the protocols of magnificent display were hardly ignored

(damask wall hangings, gilt tables and frames, and porcelain vases were all in evidence), they were supplemented by an arrangement of pictures aimed at instructing artists and would-be amateurs in the art of painting. Working in conjunction with mainstream art theory, particularly the writings of Roger de Piles, the Luxembourg encouraged a comparative mode of viewing that revealed the strengths and weaknesses of chosen artists and the schools to which they belonged through calculated juxtaposition of different paintings. Highly formal in character, this way of seeing was indifferent to chronological sequence, to the "history of art" as we understand it today. It concentrated on the pictorial qualities – what we would now call the "style" – of individual paintings rather than the place of those works within a larger diachronic structure.

In the latter half of the century both the comparative, "mixed-school" arrangement effected at the Luxembourg and the unsystematic, decorative mode of display prevalent in other princely galleries were superseded by a hanging system that served to demonstrate historical evolution within national schools.[2] Propelled by the advent of new taxonomies in the study

Figure 1. Anonymous, *Electoral Gallery, Mannheim.* Drawing, 1731, Bibliothèque d'art et d'archéologie, Université de Paris.

of natural history (especially the binomial genus/species classifications of Linnaeus and Buffon) and the rise of historicism, the ordering of past art according to school and chronology became the norm in leading European art collections by the end of the century. As the prominent dealer and connoisseur Jean-Baptiste-Pierre Lebrun remarked in 1793, a collection not arranged in that fashion was "as ridiculous as a natural history cabinet arranged without regard to genus, class, or family."[3] Just as the baroque picture gallery shared much with the *wunderkammer* in terms of display, so there were important parallels between the rationalization of early modern natural history collections and the reordering of the first art museums. Lebrun's linking of the two is particularly noteworthy because it was dealers and professional connoisseurs such as he who in the late eighteenth century took over from court artists as custodians of royal and princely collections. Men like Count Francesco Algarotti, Louis Petit de Bachaumont, Chrétien de Mechel, Nicolas de Pigage, J. J. Winckelmann, and others formed an international network of advisers who ushered in the new taxonomy and set a standard no enlightened collector could ignore. The mark of the progressive collection after 1750 was its adherence to that standard. The "taxonomic, aesthetic structure" of the collection, to borrow James Clifford's phrase, came to matter as much as the collection itself.[4] "It wasn't enough," Nicolas de Pigage wrote in 1778 of the Elector Palatine, Karl Theodor,

to assemble a magnificent picture gallery at Mannheim and to build a second gallery for plaster casts of the most beautiful antique statues alongside the newly built academy. . . . He wanted at the same time to give a new luster to the Dusseldorf gallery by reorganizing the collection in a more favorable manner.[5]

The new order at Dusseldorf (Fig. 3) involved segregating the different schools and then within a given school hanging works by a celebrated artist together. So, for example, the paintings of Rubens were hung side by side to give the viewer a sense of his *oeuvre*, his manner and range as a painter; and an effort was made to define the Flemish and Italian schools by displaying them in separate galleries. This ubiquitous and largely contemporaneous shift in the organization of European collections defined the art museum as a site of public instruction in the history of art, which was constructed as the succession of great masters and their pupils within national schools. At Vienna in the early 1780s Chrétien de Mechel transformed the ornate baroque gallery (Fig. 2) into what was arguably the first art historical survey museum (Fig. 4). He described the new museum as "a showroom for the visual demonstration of the history of art."[6] A decade later Lenoir aimed to do much the same for French sculpture in his own strictly chronological exhibition.

The second half of the century also witnessed a gradual loosening of the

Figure 2. Frans van Stampart and Anton Joseph von Prenner, *Prodomus.* Vienna, 1735. View of the Imperial Galleries.

Figure 3. Nicolas de Pigage, *La Galerie Electorale de Dusseldorf.* Basel, 1778. The Rubens Room.

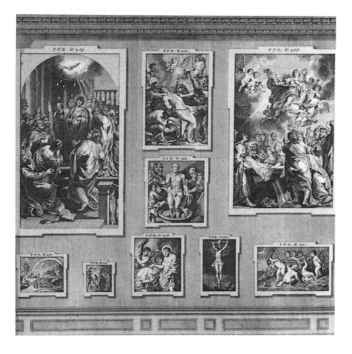

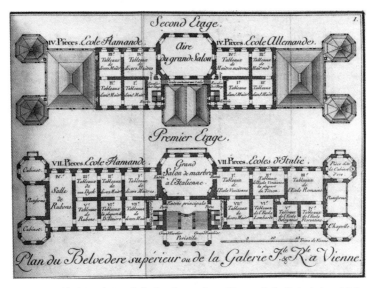

Figure 4. Chrétien de Mechel, *Catalogue des tableaux de la Galerie Impériale et Royale de Vienne*. Basel, 1784. Plan of the Imperial Gallery.

saturated mosaic-like hang as connoisseurs increasingly expected to be able to view paintings at an appropriate distance, up close in the case of cabinet pictures and further away for larger canvases (Fig. 6). The connoisseurial desire to apprehend the surface of a work and traces of the artist's hand heightened interest in conservation and the lighting of picture galleries, the subjects of much discussion during the period. Questions of conservation and lighting concerned the creation of optimum conditions in which to examine art objects and may be linked to the larger eighteenth-century quest for what Michel Foucault and Barbara Stafford have called "transparency": immediate and unmediated contact with the material world.[7] Late-eighteenth-century museums initiated the now commonplace practice of isolating works of art, both from each other, through hanging and frames, and from the social roles and physical contexts that they originally enjoyed, in the service of direct or transparent viewing. The desire for transparency entailed erasure of the life of a picture, its purpose and critical fortunes, between leaving the artist's studio and entering the museum, at the same time that newly developed restoration techniques sought to insulate it from the ravages of time. In order for the viewer to better apprehend the artist's hand and genius, museums aspired to simulate the conditions of the studio in which the object was created.[8] Transparency in the museum encouraged (and still encourages) the illusory sensation of direct contact with the act of creation, the fiction of a canvas as fresh and as *present* as the day it was painted.

The increased public accessibility and didactic emphasis of princely art collections throughout Europe in the second half of the century is a clear mark of the spread of Enlightenment culture. We might add to what Pigage said of the Elector Palatine that it was not enough to own a magnificent and well-ordered collection, one had further to open that collection to the public.[9] In France, moreover, the royal collection came to be seen as national property, part of the nation's cultural patrimony that had to be preserved for posterity. The French case thus anticipated modern national museums in which the rhetoric of collective ownership and the fostering of national pride remain crucial. The Crown became the guardian of transcendant cultural values embodied in works of art that belonged in the public sphere and to the public as much as to the king. Against this background, the question of restoration and conservation assumed great political weight. Accepting responsibility on behalf of the nation, the Crown turned the maintenance of the royal collection to its advantage by forging an equation in the public eye between careful conservation of valued art treasures and good government. As we shall see, this equation grew in importance after its invention at midcentury to the point where, during the Revolution, the museum was used to counteract perceptions at home and abroad of social and political turmoil. In the late 1790s French commitment to conservation was stretched to justify the appropriation of art confiscated as the booty of war in conquered lands. Portraying itself as a politically and culturally superior nation, France claimed to be uniquely qualified to safeguard the world's treasures for the benefit of mankind.[10]

The political possibilities of the museum space expanded under Louis XVI as Comte d'Angiviller, superintendent of royal buildings and minister of art, set out to make the arts "an emanation of the throne."[11] Both in his patronage of living artists and acquisitions for the royal collection, d'Angiviller planned the Louvre as a showcase for French artistic ascendance and a platform for royalist politics.[12] The museum's involvement in the political life of the nation was taken a step further during the Revolution, when, as I argue in Chapter 3, the Louvre museum became a sign of popular sovereignty and the triumph over despotism. The communal enjoyment of nationalized property in a palace that had once belonged to the king contributed to what the Abbé Henri Grégoire, the priest turned revolutionary, called the "republican mold." In a manner similar to popular Revolutionary festivals, the museum shaped the Republican identity. In the late 1790s under the Directory and the Consulate, the integration of museum and state was pursued and manipulated to somewhat different ends. As a result of French territorial expansion after 1794, the Louvre swelled with confiscated art, and the museum became a monument to military might. Military emblems replaced the new national flag, the *tricolore,* as decora-

tion, and visitors were encouraged to regard captured paintings and sculptures as trophies of war.

The transition from Luxembourg to Louvre, from an institution serving the Paris art world to one fully embedded in the nation's body politic, transformed the museum-going public. Entry to the Luxembourg from 1750 was open to all and free of charge, but it is clear that the educated classes – consumers of high culture and potential patrons of Academy artists – constituted the primary or ideal viewing community. When Etienne La Font de Saint-Yenne spoke of the public's desire to see an art gallery in Paris in his important *Réflexions sur quelques causes de l'état de peinture en France* of 1747, he had just such a constituency in mind. Other texts spawned by the gallery are more specific. Bachaumont, for example, addressed his *Essai sur la peinture* of 1751 to "men of good sense . . . and good faith" possessed of "sensibility and quality of mind."[13] An important guide to the exhibition took the form of a letter from a *chevalier* to a *marquise* in the provinces, suggesting that well-bred women as well as men were welcome. Aristocrats and foreign dignitaries of both sexes could view the gallery privately on request.[14] Similarly, the leading artists of the day painted mainly for what Charles-Antoine Coypel, director of the Royal Academy and first painter of the king, described as the "enlightened, delicate public."[15]

The Louvre planned by Comte d'Angiviller in the 1770s and 1780s envisaged a public considerably wider than the circle of refined art lovers served by the Luxembourg. Aware of the museum's political potential and influenced by Enlightenment ideas about the importance of public instruction, d'Angiviller intended to use the museum to address those segments of society whose voice made up "public opinion" on issues of private morality, public service, and devotion to king and country.[16] Eager generally to demonstrate Louis XVI's enlightenment and magnanimity, d'Angiviller promised the public a perfect museum, a "monument unique in Europe." His ambitions fueled the utopian museum designs of Etienne-Louis Boullée (Fig. 5) and his colleagues at the Royal Academy of Architecture, which in their turn raised public expectations still further and put pressure on the government to deliver.[17] D'Angiviller's failure to complete his museum before the outbreak of the French Revolution owed as much to a fear of falling short of those expectations as to the demise of the monarchy. Indeed, so important was the perceived relationship between museum project and public that Jacques-Henri Meister, Baron Grimm's successor at the *Correspondence Littéraire*, wondered if the opening of the Louvre might even have prevented the Revolution! "Who knows if this museum, completed to perfection, might not have saved the monarchy, by providing a more imposing idea of its power and vision, by calming anxious spirits, and by dramatizing the benefits of the Old Regime."[18]

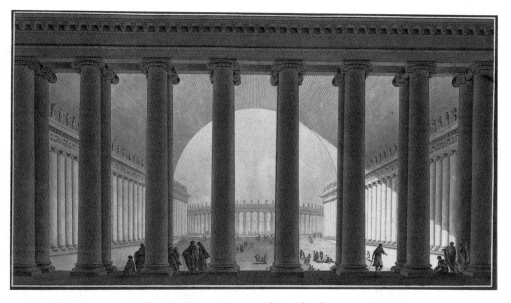

Figure 5. Etienne-Louis Boullée, *Imaginary Museum and Temple of Fame.* Drawing, c. 1783, Bibliothèque Nationale, Paris.

While the passage from royal collection to public museum occurred without fanfare elsewhere in Europe, in France the opening of the Louvre in 1793 was sensational because it was tied to the birth of a new nation. The investiture of the Louvre with the power of a Revolutionary sign radically transformed the ideal museum public. To the extent that the Louvre embodied the Republican principles of Liberty, Equality, and Fraternity, all citizens were encouraged to participate in the experience of communal ownership, and clearly many did (Fig. 6). The introduction of regulations concerning behavior in and around the museum as well as safeguards against theft point to a socially diversified public in need of surveillance.[19] Foreign visitors were struck by the presence of "the lowest classes of the community."[20] But enjoyment of the fruits of revolution required no aesthetic sophistication, any more than access in and of itself supplied the theoretical and historical grounding necessary to *see* the art and decipher its systematic presentation. If people came away from the museum confirmed in their devotion to the state, only some could fathom the art historical lessons inscribed on the walls. Theoretically one, the museum public was divided by degrees of visual competence. The lack of cultural and art historical sophistication in certain viewers led to the type of faux pas that Honoré Daumier was later to make the subject of caricature (Fig. 7). In 1795, for example, in order to underline the act of appropriation, the museum used wall labels to indicate the provenance of works of art seized from émigrés. But, according to one

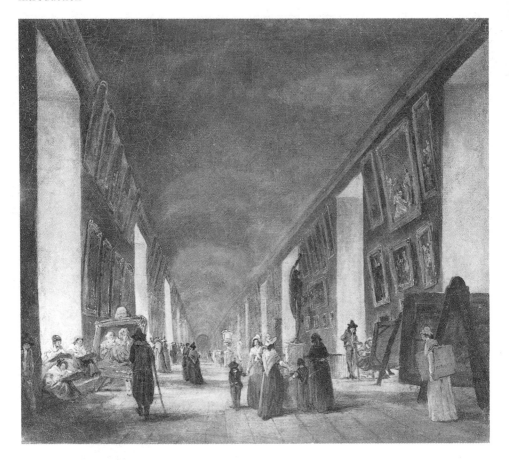

Figure 6. Hubert Robert, *The Grand Gallery of the Louvre between 1794 and 1796.* Oil on canvas, Musée du Louvre, Paris.

account, some visitors completely missed the point: confused by the labels, they mistook busts of Plato and Alexander the Great for the Duc de Brissac and the Prince de Condé.[21] The idea backfired because it had been assumed that anyone could tell the bust of an ancient Greek from one of a French aristocrat simply by the look of it.

Insofar as the museum provided instruction in the history of art, its pedagogic strategies continued to privilege the bourgeois amateur. The debates of the 1790s about how to hang the Grand Gallery meant nothing to and were not intended for the *sans-culotte*. There were no "popular arts" at the Louvre, and even the types of painting that had proven popular with the person in the street at the regular art exhibitions in the Salon – genre scenes and landscape – were condemned during the Terror. The success of the Louvre as outward symbol of Republican culture required the adoption of display con-

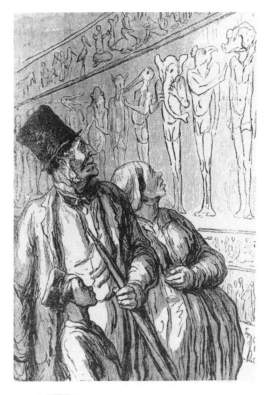

Figure 7. Honoré Daumier, *"The Egyptians weren't good looking!"* Wood engraving, 1867.

ventions and value hierarchies recognized by connoisseurs throughout Europe. There was no education department or written guides to explain to the uninitiated how to look at art or marvel at the "progress" made by Raphael over his teacher Perugino, the purpose of arguably the most important installation in the museum (Fig. 54). Nevertheless, those unable to read the installations were still invited to behold their new-found artistic wealth. Many who came to the Louvre in the late 1790s to admire the paintings and sculptures acquired as the spoils of war were evidently unaware that Bonaparte's booty represented the greatest art ever brought together under one roof. In May 1799, a writer for the Republican journal *La Décade philosophique* described what he had seen on a recent visit to the Grand Gallery. In addition to young artists copying the Old Masters and finely dressed women whose beauties rivaled those of the paintings, he encountered

a young soldier escorting his father, his mother, and his sister, good village people who had never before left their community, and who apparently had never seen paintings other than the sign of the local inn or the smoke-covered daub above the altar. These good people could never tell the difference between a Poussin and a Watteau, but they were all proud to be there; and the son, all the more proud to be leading them, seemed to be saying "it is I that conquered many of these pictures.[22]

Whatever this good family was actually thinking, the author saw in them an illustration of the power of the museum – initially, to draw them to Paris for the first time in their lives, and then to instill in them a sense of national pride. Yet in order to insist on that power he had to deny them the only other reason one could have for visiting the museum: to appreciate the difference between a Poussin and a Watteau. The museum spectacle impressed upon them the difference between local works and the framed canvases in the Grand Gallery, but within the museum the paintings of one artist were indistinguishable from those of another. What separated his humble compatriots from the author was their mode of viewing, their inability to see the museum's contents except as prized trophies.

Elegant men and women of the world rubbed shoulders with artists and simple countryfolk, some proud to be there, others hoping to learn, and some content to be seen. Little has changed in 200 years. Not least of the Louvre's legacies to the modern museum is this diverse yet fractured public. We are still expected to view our great museums with national and civic pride, but only some of us are schooled in the mysteries of art and the museum's strategies of display. The museum bequeathed to us by the Revolution continues to operate on the paradoxical principle of an institution ostensibly open and populist but infused by the exclusive tastes of an Old World elite and full of art fit for kings. Whose museum? Whose art? Of all the questions facing the museum today, none are more pressing.

One thing that the early history of French museums demonstrates is the contingent, constructed nature of the art museum and its public. There is nothing natural or necessary about the way museums are organized or works of art displayed within them. Nor are museums neutral spaces: they "frame" their contents as certainly as a picture frame circumscribes a canvas. I hope the striking parallels between museum practices in the early modern era and now will help readers better understand how museums think and work today. But at heart this book is an eighteenth-century history in which I try to capture the excitement (and intrigue) generated by the movement to create a new kind of public institution, an institution at once noble in design and rich in political possibilities.

THE LUXEMBOURG GALLERY, 1750–79

> *True understanding of painting consists in knowing if a picture is good or bad; in being able to distinguish what is well done from what is not in the same work and to justify one's conclusions.*

Roger de Piles,
*Conversations sur la connoissance
de la peinture,* 1677

*Contemplate the marvels of the Old Masters;
Take care to profit from their wise counsel;
May you respect their diverse talents
But avoid their faults when seeking out their charms.*

Antoine Coypel, *Epître à mon fils,* 1721

In October 1750 the first public art gallery in France opened in the Luxembourg Palace. The exhibition was divided between the east and west wings of the palace (Fig. 8). In the east wing, an initial selection of ninety-nine paintings and twenty drawings from the royal collection was put on display in four adjoining rooms known collectively as the apartments of the Queen of Spain (Fig. 8a). The first two galleries contained paintings of the three principal schools, the Italian, the French, and the Northern (i.e., Flemish and Dutch); the third, called the Throne Room, featured only French paintings; and the fourth room was devoted primarily to the Italian masters of the sixteenth and seventeenth centuries. Throughout the pictures and drawings were adorned with gilt frames (the drawings were also under glass) and hung against a background of green cloth, in imitation of the Salon exhibition after 1746. Further decoration came in the form of marble tables and vases of porphyry and agate, creating an air of opulence befitting a royal spectacle.[1] In the west wing of the palace, equally accessible to public view

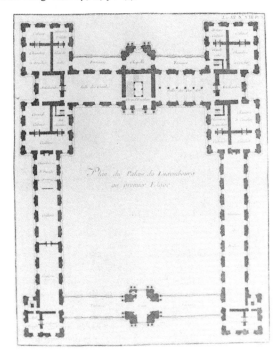
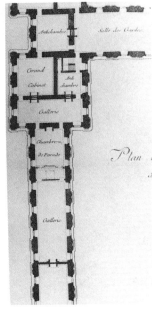

Figure 8. (left) Jean-François Blondel, *Architecture françoise*. Paris, 1752–6. Plan of the Luxembourg Palace.
Figure 8a. (right) Detail of Figure 8. Plan of the Luxembourg Gallery.

and in its original setting, was the great Rubens cycle celebrating the life of Marie de Medici, for whom the palace had been built (Fig. 9). Both wings were open to the public on Wednesdays and Saturdays for three hours at a stretch, in winter during the morning and in summer during the afternoon. They remained accessible at these times until the gallery closed in 1779.

Only the finishing touches remained to be added to the gallery in January 1750 when the project was submitted to King Louis XV for his formal approval, the *bon du roi:*

The King's paintings are so uncomfortably housed in picture cabinets at Versailles that they must be stacked one on top of another, thwarting the curiosity of foreigners and others who desire to see them.

Until such time that His Majesty wishes to build a place where they might be shown to advantage, it is proposed to exhibit them in Paris in the apartment of the Queen of Spain at the Luxembourg.

There are four large rooms where they could be arranged without greater expense than the cost of about a hundred lengths of green cloth to cover the walls on which they will hang.

They will be shown to the public on two days a week.

And as they will be on display attention will be given to those in need of restora-

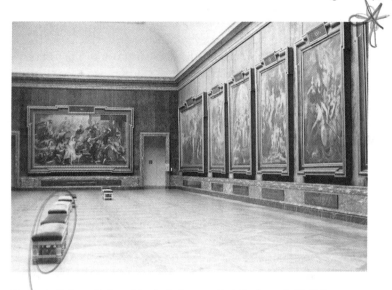

Figure 9. Rubens Gallery, Musée du Louvre, Paris (prior to I. M. Pei's renovations).

tion. Appropriate restorations will be carried out under the supervision of the First Painter of the King.

All paintings intended for the Apartments at Versailles will remain in place; and the cabinets will be sufficiently decorated in order to satisfy the curiosity of foreigners and others who come to Versailles, so that there will be pictures on view in Paris and at Versailles.[2]

As we shall see, the document is a model of discretion that reveals nothing of the complicated and politically embroiled discussion that had set the project in motion three years earlier and entailed an expenditure considerably exceeding the cost of some green cloth.

We cannot say with certainty who first proposed a public exhibition of the king's pictures (one commentator at the time described the project as "so simple that everyone imagined they had thought of it and so fortunate that several people let it be known that the original idea was theirs")[3] but circumstantial evidence points in the direction of Louis Petit de Bachaumont, the influential amateur and pioneer of historical preservation of national artistic treasures. In the correspondence of the Department of Royal Buildings, or Bâtiments du roi (in effect, the ministry of arts during the Old Regime), is an anonymous proposal dating from 1747, a copy of which is filed among Bachaumont's personal papers of the same date, to decorate the Ambassadors' Gallery in the Tuileries Palace with a selection of the king's pictures and to open it to the public.[4] Why not put those pictures to good use, the author argues, instead of allowing them to languish unseen in palaces and storerooms that no one visits? The gallery could be further

embellished with elegant tables sporting porcelain and sculptures of marble and bronze, gilt torchères and crystal chandeliers, and walls hung in crimson damask. This proposal recalls in a general way the princely galleries of Italy, but a more specific and important inspiration was clearly André Félibien's description of the Tuileries Palace from his famous *Entretiens sur les Vies et sur les Ouvrages des plus excellens Peintres* (1666–85), to which I will return. This link with the past is the first of many signs of the Luxembourg's historical and theoretical underpinnings. But why did Bachaumont put forward a gallery proposal of any sort when he did? And what motivated the government to respond so favorably and so quickly to the idea? To answer these questions we must consider the politics of the art world at midcentury and the ambitions of its leading figures.

We should begin with the appointment of Charles-François Lenormand de Tournehem to the post of director general of the Bâtiments du roi in 1745. As we shall see, the Luxembourg was to form an important part of Lenormand's ambitious program of reforms aimed at revitalizing the Royal Academy of Painting and Sculpture and restoring government control over the fine arts. Lenormand owed his appointment to the sudden rise to power of his twenty-three-year-old niece, Jeanne-Antoinette Lenormand d'Etoiles (née Poisson), who in June 1745 was made Marquise de Pompadour and shortly thereafter recognized officially as mistress to Louis XV.[5] Pompadour had the current director general of buildings, Philibert Orry, dismissed and her uncle promoted in his place. At the start of 1746 it was announced that Pompadour's brother, Abel-François Poisson, later Marquis de Vandière and then de Marigny, would inherit the office upon Lenormand's death. Thus were the dynastic fortunes of the Lenormand clan pinned to the fate of the arts in France.

The department of buildings had been treated largely as a sinecure, and the arts ignored, by Lenormand's predeccessors, Orry (director general, 1736–46) and the Duc d'Antin (1709–36). As Thomas Crow has argued, the origins of the Lenormand family in the parvenu world of finance (Lenormand was himself a *fermier général,* or tax farmer, and a director of the Indies company) determined the direction of arts policy during the Lenormand-Marigny years.[6] The family's success in office and in overcoming the taint of finance and what many of the nobility of sword and robe regarded as humble birth depended on the revival of state-sponsored art and in particular the promotion and appropriation of serious history painting in the grand manner. History painting was the highest, most respectable of genres in the academic hierarchy, the raison d'être of the Royal Academy in its heyday under Jean-Baptiste Colbert and Charles Lebrun during the reign of Louis XIV, but one that had been progressively abandoned since the turn of the century.[7] Neglected by its "natural" constituency – the monarchy and nobility – by midcentury history painting had become, in the

words of Crow, "a free-floating symbol of all that was elevated and morally commanding."[8] Through renewed state intervention and, to quote Crow once more, the rebuilding of "the Academy's capacity to generate publicly oriented narrative pictures" Lenormand aimed to appropriate history painting for the Crown and his family.[9]

Over and above the appeal of art as a vehicle of upward social mobility, Lenormand must have recognized in the Bâtiments post an opportunity to make his mark as a civil servant by effecting improvements in an area of government perceived as in need of reform. For evidence that reforms were needed one had to look no further than the dismal results of the recent Prix de Rome competitions. Established by Colbert in 1664, the annual contest involving a set historical subject gave the winners three years (often longer) of study at the French Academy in Rome and represented the climax of the academic process. Given its importance, there was cause for concern when by the 1740s the caliber of up and coming artists had fallen so low that the Academy found itself unable to award prizes on a regular basis. In 1740, 1742, 1744, 1745, 1746, and 1747 the field in painting was so poor that no prizes were given; in the same period Prix de Rome were awarded to sculptors only twice, in 1740 and 1745.[10] In 1743 there were first and second prizewinners in both painting and sculpture, but only four artists were deemed qualified to compete. The paucity of talent would have been all the more apparent as the brilliant generation of François Boucher, Edme Bouchardon, and Carle Van Loo was just now reaching maturity. Successful reform of history painting depended on visible government commitment to the genre and to the rejuvenation of the academic system.

A new start in the form of a return to the principles of Colbert and Lebrun was felt to be in order, which is essentially what Lenormand's initiatives aimed at doing. The most important of those initiatives were the creation of the Ecole des élèves protégés, a school within the Academy to better train Prix de Rome winners with respect to artistic technique as well as history, geography, and literature in preparation for their stay in Rome; the history painting competition of 1747, designed to stimulate the genre; the revaluing of royal commissions to make history painting the most highly rewarded; the revival of academic lectures, or *conférences,* on the seventeenth-century model; the creation of eight new positions in the Academy's "associate" class, intended to broaden support for the institution in high society; and the opening of the Luxembourg Gallery, designed as a school for both artists and amateurs.

<p style="text-align:center">* * *</p>

Lenormand arrived at the Bâtiments as a proven administrator and leader, but he was unfamiliar with its history, bureaucracy, and institutions. He required the advice and support of insiders in order to articulate and imple-

ment his program. (It was precisely to reduce such dependence that Marigny was sent to Italy in 1749 to learn about the arts in the company of artistic advisers.)[11] Lenormand's chief adviser was the painter Charles-Antoine Coypel, who in 1747 was made director of the Academy and first painter of the king, the first to receive the honor since the death of François Le Moyne ten years earlier.[12] He was the last of a distinguished line of academicians, including two Academy directors, and easily the best-connected artist of his generation. The grand tradition of history painting was in his blood (even though he was himself a mediocre artist). Through Coypel the director general was able to draw on the wisdom of influential amateurs like Bachaumont and the Comte de Caylus, who, as Crow has pointed out, had unofficially guided the art world for close to half a century. The fact that all of these men were born close together during the reign of the Sun King inevitably meant that their ideas of reform would be backward looking, rooted in traditional art theory and a collective nostalgia for a glorious past.[13]

Bachaumont's gallery proposal was most probably presented to Lenormand by Coypel; they were close friends (Bachaumont once described the latter as "my good and old friend") and no doubt discussed the project beforehand.[14] As Crow has shown, Bachaumont and Lenormand came from different and mutually antagonistic backgrounds. The former descended from the robe nobility and was raised in the shadow of Versailles (his father had been physician to the dauphin under Louis XIV).[15] He devoted himself early in life to a leisured cultivation of arts and letters and by midcentury had built a reputation as one of the most knowledgeable amateurs in Paris.[16] His class allegiances predisposed him to look askance at the rise of the financier class and the appointment of Lenormand to an important government post. Yet as much as Lenormand needed Bachaumont, Bachaumont saw in the director general's inexperience and social vulnerability an opportunity to direct official arts policy toward issues that he felt were important and that had been woefully ignored under previous administrations. At the top of the list was the conservation of art treasures, which Bachaumont was among the first to declare crucial to the nation's patrimony. As early as 1724, he called attention to the imperiled state of the château of Fontainebleau, suffering from years of neglect.[17] Though a royal palace, he argued that its preservation was a matter of national importance. His range of concerns widened significantly after 1745 and embraced the condition of the royal picture collection. In a letter of 1746 addressed to the director general, Bachaumont, after complimenting him on the success of the previous year's Salon exhibition, turned to the disgraceful state of the two galleries on either side of the Salon carré: the Galerie d'Apollon and the Grand Gallery. He also pointed out that many of the king's pictures were in

need of restoration.[18] It was this concern for the royal collection, mentioned here in passing, that led a year later to the suggestion to establish a public gallery.

A similar opportunism inspired the publication in 1747 of La Font de Saint-Yenne's notorious *Réflexions sur quelques causes de l'état présent de la peinture en France*. Though first and foremost a biting review of the previous year's Salon, the *Réflexions* contained the first publicized appeal for a public art gallery in France. La Font's text is not the origin of the idea, but we may be sure that it did much to press Lenormand into action.

In his *Réflexions*, La Font called on the government to create a royal gallery, ideally in the Louvre, in which the king's pictures might be displayed for the benefit of artists and public alike. Demonstrating an intimate knowledge of the palace at Versailles, La Font criticized the sad state of neglect and disrepair into which the royal collection had fallen, "hidden away in small, darkly lighted rooms . . . unknown to or ignored by foreigners owing to their inaccessibility."[19] Playing heavily on the contrast between public and private, and echoing an observation made earlier in a guidebook to Paris, La Font compared the upkeep of the royal collection unfavorably with the collection of the Duc d'Orleans at the Palais Royal (on view from 1727) and went on to suggest that the duke's pictures might even surpass in quantity and quality those of the Crown:

If His Majesty's paintings surpass in number and in quality those [of the duke], a claim often made but difficult to prove as there has never been a published catalogue, what a loss their imprisonment is for the talented artists of our Nation![20]

La Font concluded his harangue with a blunt attack on the "criminal negligence" of the concierges at the Luxembourg Palace, who did nothing to protect the Rubens paintings from the scorching rays of the midday sun.

The purpose of these critical remarks on the royal collection, situated in a review of contemporary painting, was twofold. First, La Font was concerned about the condition of those works of art that he regarded, together with Bachaumont, as national treasures. Second, he suggests that the plight of the royal pictures was intimately bound up with the underlying theme of his text, namely, the steady decline in artistic standards since the days of Louis XIV. Neglect of those paintings and other great monuments of the past, in particular the Louvre palace, not only deprived young artists of inspirational models but was symptomatic of the steady erosion of that "unchanging beauty, founded on reason and impervious to the passing of time and the follies of fashion" and its gradual replacement by a "decadent" style of art and decoration.[21] La Font had in mind, of course, the contrast between what would later be labeled the classical and the rococo. By committing itself to maintaining important national monuments such as the

Louvre and the royal picture collection, the government would symbolically resurrect and revalorize the grand tradition of seventeenth-century classicism and halt the slide into what La Font called the "empire of novelty."[22] The state should become involved once again in dictating taste.

Though La Font is today rightly considered a precursor to Diderot and later critics who was instrumental in ushering in a new seriousness of subject and style in French art, he was at heart a traditionalist, a reactionary even, whose inspiration was a vision of a strong and confident France under Louis XIV and Colbert. As he said himself in a printed defense of his second book, *L'Ombre du grand Colbert:* "My intention, in the imaginary resurrection of this immortal minister, has been to revive with him the grandeur and former rigor of the nation's genius, not only in the fine arts, but in everything that might contribute to the strength and splendor of the kingdom."[23]

The timing of the *Réflexions*'s appearance was no coincidence. La Font must have known in advance of Lenormand's plans to revitalize state support for history painting – indeed it was surely in light of those plans that he wrote his book.[24] We know that the *Réflexions* began circulating in Paris in the summer, it seems toward the end of July, of 1747, a time calculated to cause maximum embarrassment to the government.[25] Though ostensibly a review of the previous year's Salon, its scope was considerably more ambitious, as we have seen, and La Font's disparaging summary of recent trends in French painting can only have been intended to preempt the celebratory debut on August 25 of the eleven history paintings commissioned by the director general from leading Academy artists at the end of 1746. At the very least his criticisms would provide terms of reference for a public discussion of the new Salon, and more generally state policy and the direction of the arts. For our purposes it is equally probable that La Font knew of plans to establish an art gallery similar to the one he described.

La Font's purpose was clear: by broadly publicizing issues and proposals that were already in the air he was hoping to enhance the likelihood of their implementation. Stimulating public discussion and increasing public expectations could only make it more difficult for the government not to follow through.[26] His authorial stance was that of a disinterested citizen who spoke not in his own interest (anonymity protected him from that charge) but in that of the "public," and of the nation as a whole. La Font was also responding to Lenormand's declaration of intent to enact meaningful state intervention in the arts, his commitment to treating the office of director general of buildings as more than a sinecure. La Font evidently shared the prevailing view in Bachaumont's circle that the triumph of the rococo style and the taste for luxury goods that went with it – which, in La Font's view, had literally banished serious painting from the fashionable interior – could be identified with the ascendance of the financier class. The private artistic

tastes of the Lenormand family, epitomized by Pompadour's patronage of François Boucher, served only to confirm that opinion.[27] It was thus out of character, not to say ironic, that a tax farmer should espouse the cause of history painting and academic reform. Thus *Réflexions* may be read as a challenge to the new director general to rise above the tastes and instincts of his class. He would have to prove he deserved the comparisons he did little to discourage between himself and his predecessor, "the great Colbert."[28]

La Font's strategy was as novel as it was shrewd. He comes across in his texts as a man of principle, unafraid of controversy, who wrote as if he had nothing to lose. Born in 1688, midway through the reign of Louis XIV, into a solid bourgeois family involved in the Lyons silk trade, we know little about La Font's life until his appointment in 1729 as gentleman to the queen (Marie Leczinska).[29] He remained at Versailles until 1737, and it was during this period he became acquainted with the court and the royal picture collection. During that period, too, he befriended the first painter of the king, François Le Moyne, an exact contemporary through whom he must have learned much about painting. It is tempting to see more than a coincidence in the timing of La Font's departure from Versailles and Le Moyne's tragic suicide in 1737 at the age of forty-nine. Be that as it may, we lose track of his movements until 1747 when he showed up on the doorstep of the well-connected engraver and amateur, Pierre-Jean Mariette, with a manuscript written by a friend, or so he claimed, which was none other than the *Réflexions*. La Font read parts of it to Mariette, who, given his close Academy ties, predictably advised against publication. As he was leaving he assured Mariette that "the work would never see the light of day." "Apparently," the latter continued, "someone changed his mind, for a short while later I learned that the book had appeared and just so I couldn't doubt it the author sent me a copy."[30] Mariette had been duped; he had reacted just as La Font had hoped he would, and if he was offended by the *Réflexions*, others in high places were sure to be as well.

It has been suggested that La Font had Bachaumont as an ally in this and later ventures. Certainly they had mutual interests, and we know they were acquainted.[31] Quite possibly it was through Bachaumont that La Font kept in touch with plans at the department of buildings. Furthermore, given their mutual interest in seeing the Louvre completed, it is not implausible that La Font's second book, *l'Ombre du grand Colbert*, was to some extent a collaborative effort (though Bachaumont flatly denied it). The two men were not close friends, however, and the differences between them are significant. Clearly they shared a concern for the nation's artistic heritage, and they appear to have been united in their condescension toward Lenormand and his family. On those matters they could make common cause. Perhaps, as Crow suggests, Bachaumont found in La Font's caustic style and indiffer-

La Font
Bachaumont response

ence to controversy a useful vehicle for the promotion of his own interests. Where they differed was in their stake in the art world. Bachaumont numbered many artists, including Charles-Antoine Coypel, among his good friends. His reputation as the leading Parisian amateur depended on a cultivated intimacy with living painters. His grievance was with the government and its stewardship of the nation's artistic patrimony, not with practicing artists, and he objected to La Font's public art criticism on the grounds that it could serve no useful purpose. To advise artists privately was one thing; to criticize them in public was another. It is significant, for example, that Bachaumont could be critical of J.-B.-M. Pierre's paintings in person but had only good to say about the artist in his public capacity as adviser to potential patrons, a role he played in good faith for many years.[32] It was not his style – at least initially – to make public his recommendations to the director general in the form of criticism; he preferred to lobby for his causes through Coypel and by means of discreet memoranda. Only after he witnessed the success of La Font's books and articles did he venture into print himself, and then he limited commentary to matters concerning historical preservation.

Bachaumont's immensely successful *Essai sur la peinture, la sculpture, et l'architecture* of 1751 is a case in point.[33] Whereas the essays on architecture and sculpture deal with the deterioration of the Louvre and the statues in the park at Versailles, respectively, the essay on painting is an unambiguous defense of the French school – past *and* present. Bachaumont held up paintings by Antoine and Charles-Antoine Coypel as evidence of the continuing strength of the grand manner in France, implicitly countering La Font's claim that painting had gone into decline after the death of Louis XIV. The bulk of the text is devoted to a discussion of the relative merits of the two most famous pictures on display in the state apartments at Versailles: Charles Lebrun's *Tent of Darius* and Paolo Veronese's *Pilgrims of Emmaus* (Figs. 10 and 11). The choice was highly significant. Ever since Charles Perrault had paired the two in his *Parallèle des anciens et des modernes* of 1688 in order to defend French art against an already pronounced prejudice in favor of the Italians, the pictures had come to symbolize the struggle of native artists to gain equal recognition alongside their Italian and Northern rivals.[34] By the middle of the eighteenth century it would have been impossible to read a comparison between these pictures in any other way. Nothing could be more indicative, therefore, of Bachaumont's patriotic, pro-Academy sentiments. Having been accused of collaboration with La Font, it is as if Bachaumont wanted to distance himself publicly from his criticisms of contemporary art and to make his own position perfectly clear.

The artists of the Academy were outraged by the *Réflexions*. Rebuttals were soon forthcoming, and La Font became the subject of caricature.[35]

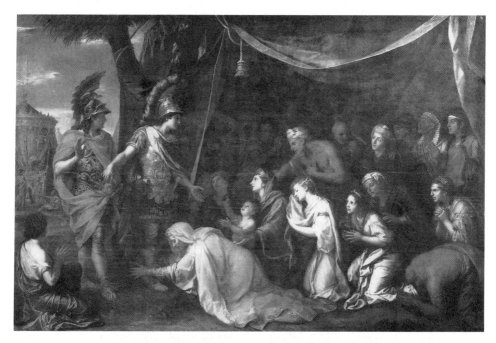

Figure 10. Charles Lebrun, *Tent of Darius.* Oil on canvas, c. 1660, Musée de Versailles.

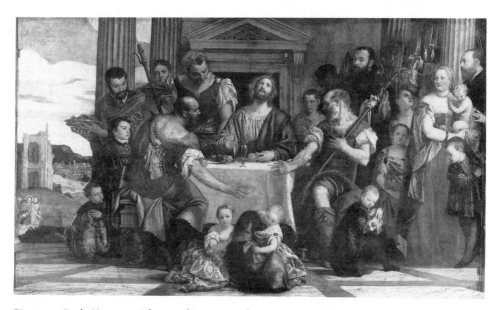

Figure 11. Paolo Veronese, *Pilgrims of Emmaus.* Oil on canvas, c. 1560, Musée du Louvre, Paris.

Nevertheless, and no doubt much to the chagrin of Lenormand and the Academy, the response to the *Réflexions* in other quarters was far from unfavorable. "It would offend the truth," wrote Mariette, "to deny that this book wasn't perfectly well received by the public."[36] In Bachaumont's opinion it contained "more good than bad"; the Abbé G.-T.-F. Raynal was much taken with it; and, for our purposes most important, a glowing review appeared in the influential *Journal de Trévoux,* in which La Font's passage calling for a public gallery was quoted and enthusiastically endorsed.[37] The journal's only reservation was whether such a project would ever be realized.

<p style="text-align:center">✶ ✶ ✶</p>

La Font's insinuations of government irresponsibility prompted a swift response. By the winter of 1747, wood stoves were installed in the Rubens gallery at the Luxembourg to prevent humidity,[38] and in January 1748 the director general of buildings issued the following ordinance:

> His Majesty has ordered the lighting of fires in the gallery stoves during winter and the drawing of curtains at the height of summer in order to preserve the beautiful paintings by Rubens; and desiring that foreigners and amateurs may enjoy these precious works at convenient times, the concierge is directed to guide curious visitors through the gallery, either personally or by arrangement, on Tuesdays and Fridays of each week, in winter from ten in the morning till midday and in summer from four till six.[39]

Unintentionally, one imagines, Lenormand recalled La Font's description of the concierges who did nothing to protect the paintings from the damaging rays of the summer sun. The timely opening of the Rubens gallery would demonstrate that La Font's claims were exaggerated. Evidently, little in the way of preparation was needed before the general public was allowed in (it seems the gallery had never been inaccessible to the privileged visitor).[40] A public exhibition of royal pictures was entirely another matter, however.

The first priority was to find a suitable exhibition space for the collection. The obvious location, at least to critics, was the Louvre or the adjoining Tuileries. For some reason the latter was never considered. As for the Louvre, although it was both the premier royal residence in Paris (it was still hoped that the king would one day move back to the capital from Versailles) and home of the Royal Academy of Painting and Sculpture, it could not have accommodated a picture gallery at that time. No one as yet was thinking in terms of the Grand Gallery along the Seine, occupied from the late seventeenth century by the strategically important scale-relief models of the fortified towns of France; and evidently there was no room in the old palace block for a formal display of objects. When, for example, L.-L. Pajot d'Onsenbray bequeathed his important natural history collection to the Royal Academy of Science in 1754 with the expressed desire that it be

(margin annotation) 1st act of conservation

housed near the Academy in the Louvre, no place could be found for it.[41] The Luxembourg Palace on the far side of the Seine was chosen instead.

The Luxembourg, as it happened, had much to recommend it as a site for the royal gallery. The rooms on the first floor of the east wing were vacant and easily accessible to the public; and, of course, the Rubens gallery was across the courtyard. In addition, at a time of heightened awareness of the topography of Paris, generated in large part by the project to build a new *place royale* dedicated to Louis XV (now the Place de la Concorde), its location on the Left Bank away from the dominant axis of royal landmarks linking the Bastille and the Tuileries may have been a distinct advantage.[42] Certainly the choice of the palace would have pleased Bachaumont's friend, J.-B. de La Curne de Sainte-Palaye, who in 1748 published a proposal in the *Mercure de France* to open the city and link the Right and Left Banks by means of two new thoroughfares, one running east-west from the Louvre to the Tuileries, the other running north-south from the Porte Saint-Gervais to the Luxembourg.[43]

Once a space had been found the business of selecting the pictures from the 1,800-strong royal collection could begin. The choice fell to those closest to the project and most familiar with the collection: Charles Coypel, in charge of the gallery; J.-A. Portail, keeper of the king's pictures at Versailles; and Portail's counterpart at the other royal châteaux, Jacques Bailly. Coypel ordered a new and comprehensive catalogue of the royal collection from the Academy's secretary, F.-B. Lépicié, in order to accelerate the gallery (also to answer La Font's complaints); it proved slow work, however, and Nicolas Bailly's 1709 inventory was probably used instead.[44]

Many of the best royal pictures were unavailable for display in the new gallery because they formed part of the permanent decoration at Versailles. Since the 1680s the state apartments had been treated as semipublic galleries in which the paintings served the politically important function of impressing visiting dignitaries. Removing those pictures merely to enhance the Luxembourg was out of the question.[45] The commitment to Versailles affected a number of significant masterpieces – for example, Veronese's *Pilgrims of Emmaus* and Lebrun's *Tent of Darius*, and Raphael's *Saint John in the Desert* and Domenichino's *King David Playing the Harp*, which hung on either side of the king's bed. And, as the Luxembourg catalogue was forced to admit, the royal collection was short on movable works by "Messrs. Boulogne, Jouvenet, de Troy the elder, and other excellent artists."[46] Under Louis XVI a concerted effort would be made to acquire cabinet pictures by the recognized French masters.

Once chosen the pictures had to be restored and framed for exhibition.[47] Many if not most of the paintings destined for the Luxembourg had not

been carefully stored or seriously looked at, let alone cleaned, in years.[48] This was precisely Bachaumont's complaint in his 1746 memorandum to Lenormand, and it formed the basis of La Font's remarks a year later. The *Réflexions* made conservation a controversial public issue and, as a consequence, the practice of picture restoration in connection with the Luxembourg became a matter of extraordinary government concern.

The work of cleaning, retouching, relining, and varnishing the gallery's pictures fell to the two resident restorers at the Bâtiments: François-Louis Colins and Marie-Jacob Godefroid, better known as Madame or *veuve* Godefroid.[49] Both entered the royal service with considerable experience in private collections behind them. Colins, originally from Brussels, was well known as an art dealer and restorer (the two often went hand in hand) and came highly recommended by Edme Gersaint, himself an important dealer.[50] Godefroid's reputation was established through her husband, J.-F. Godefroid, another respected dealer-restorer who was employed to maintain the outstanding collections of the Prince de Carignan and the Comtesse de Verrue. She took over her husband's business after he was killed in a duel in 1741. Gersaint also thought highly of her abilities.[51]

It seems Colins and Godefroid were the first restorers to be formally employed by the Crown. Previously the responsibility for maintaining the king's pictures – easel paintings as well as inset decorative works – belonged to the *gardes des tableaux* at the various châteaux.[52] From 1743 Colins and Godefroid were given a royal pension of 200 *livres* between them. Henceforth a significant distinction was made between highly valued Old Master paintings that became the responsibility of qualified restorers and lesser works – ceilings, overdoors, portraits, and so on – which were left to the *gardes des tableaux*.

We know little about the practice of restoration in France before the Luxembourg era, but it is clear that the emergence of restoration as a distinct profession was linked to the development of picture collecting and the growth of the art market in the early decades of the century. Hence the dealer Gersaint was an authority on the matter. It would seem that engaging the services of a reliable restorer became part of owning a sigificant collection (witness the Prince de Carignan and the Comtesse de Verrue). To an equal degree, restoration became an integral part of the picture trade. By the third quarter of the century, if not before, it was standard practice to restore a collection before it was put up for auction. As we have seen, dealers often doubled as restorers. As conservation standards rose in private collections, the royal collection deteriorated – such at least must have been the perception of Bachaumont, La Font, and others in the know. But this situation changed abruptly in the wake of La Font's *Réflexions* and the Luxembourg Gallery project. Once Lenormand was persuaded of the importance

of maintaining the royal collection, or rather the risks in terms of public opinion of not doing so, the initiative in restoration transferred to the Crown. During the next fifty years, restorers on the Bâtiments payroll were responsible for a number of technical innovations and more generally for setting a higher standard of practice than could be found in any other European city (with the possible exception of Venice). Though, as we shall see, the political motives that sustained official interest in restoration between 1750 and 1800 differed from one government and museum project to the next, one goal remained central: the forging of an equation in the public eye between good government and the conservation of the national art treasures. This equation continues to inform government policy on museums throughout the world to this day.

The granting of a royal pension to Colins and Godefroid in 1743, while significant in itself, did not entail a tangible increase in the amount of restoration ordered by the Crown: that had to wait for the Luxembourg. In 1748 Lenormand changed the basis on which the restorers were to be employed, raising their status to a new level of importance and giving the government greater control over their activities.[53] From 1749, individual records of paintings restored and an account of the work done in each case were kept for the first time.[54] Thanks to those records, we know that roughly half of the ninety-nine paintings exhibited at the gallery when it opened underwent some form of restoration in the years 1749–50.

The most convincing refutation of La Font's accusations of indifference and neglect, however, lay not so much in the systematic cleaning and retouching of a great many pictures at the Luxembourg (and other palaces), but in the dramatic proof that under the auspices of the Crown one Robert Picault had perfected the seemingly miraculous art of transferring a painting's layers of color from an original support to a new one, thus conferring on the picture apparent immortality. Greeting the visitor to the Luxembourg Gallery in 1750 was Andrea del Sarto's *Charity* (Fig. 12), and displayed next to it, on a second easel, was the wooden support from which the painting had been transferred. What better testimony to the government's concern than the time-worn, worm-eaten panel juxtaposed with the revived masterpiece, brought back from the brink of ruin. The Crown possessed the "secret" that could guarantee to posterity paintings that until then had seemed doomed to disintegration. Picault's feat, described at length in the gallery catalogue and the press, fired the public's imagination. Lépicié, in his *Catalogue raisonné*, gives us an official version of events:

The painting was on the verge of disintegrating; the panel on which it was painted was entirely worm-eaten and it would soon have turned to dust. M. the director general of buildings, always attentive to the glory of the arts and the interests of the king, thought the painting could be saved by making use of the secret of monsieur

Picault, who discovered a way to remove the layers of color from panel to canvas. The painting was given to monsieur Picault; he duly performed the restoration and it proved a great success, for the painting is now on canvas and there remains no trace of the operation; it has not suffered the slightest alteration in its design or color.[55]

Picault's transferral of the *Charity* was not his first work for the Crown. By his own account he was first employed in 1745 on the architect Ange-Jacques Gabriel's recommendation to try to save a number of frescoes at Fontainebleau that were to be lost in the course of structural alterations ordered by the king.[56] Later in the same year Gabriel used him again to salvage a set of decorative paintings by Antoine Coypel from a pavilion at Choisy, demolished in 1746. One of the paintings was exhibited at the Salon of 1745, though it seems to have gone largely unnoticed.[57] It is this connection with Gabriel that explains the otherwise curious fact that Picault's skills were first endorsed in March 1747 by the Academy of Architecture and not the Academy of Painting.[58] That his "secret" could be used to safeguard easel pictures in the royal collection seems not to have occurred to anyone up to that point. Had it not been for the Luxembourg and the need to discredit La Font, one wonders how long it would have been before that possibility was explored.

Early in 1748, under the watchful eye of the Academy and the director general, Picault transferred his first easel picture from the royal collection – an unidentified work attributed to Parmigianino measuring two feet square. This success was followed by others, and in May he was given a royal pension of 600 *livres*, securing for the king first call on his services and in effect possession of his "secret."[59] Over the next year Picault worked on paintings by Guido Reni, Correggio, and Palma Vecchio, in the build-up to the *Charity*.[60] The latter was, in turn, a trial run for his most celebrated transferral, Raphael's *Saint Michael* (Fig. 13). Painted by Raphael for King Francis I and eulogized by Charles Lebrun in the first lecture delivered at the Royal Academy in 1667, the *Saint Michael* was among the most famous works of art in the royal collection. In Lebrun's day it hung above the king's throne at the Tuileries. Concern over its deteriorated state was first raised in 1748 by Lépicié in connection with his inventory;[61] a subsequent examination by Charles-Antoine Coypel and others revealed that, like the del Sarto, the picture had "greatly deteriorated and was threatened with imminent ruin."[62] The preciousness of the Raphael urged caution, and Picault's treatment of it was contingent upon the outcome of the *Charity*. In June 1750 Lenormand wrote to Coypel:

Following the presentation to the king of the painting by Andrea del Sarto which M. Picault transferred from wood . . . there was widespread admiration at Ver-

Figure 12. Andrea del Sarto, *Charity*. Oil on canvas (transferred from panel), 1518–19, Musée du Louvre, Paris.

Figure 13. Raphael, *Saint Michael*. Oil on canvas (transferred from panel), 1518, Musée du Louvre, Paris.

sailles, where it was exhibited for a day. Everyone agreed that the same technique should be used to prevent the loss of the *Saint Michael* which deteriorates daily.[63]

The Academy deliberated one more time before the picture was finally given to Picault in December.[64] A full eighteen months later, midway through 1752, Picault emerged from behind closed doors and, following a minute examination of the picture's surface and its new support, the Academy hailed the restoration a success. For his effort Picault received the astounding sum of 7,000 *livres*.[65] The king expressed his personal satisfaction by raising his pension from 600 to 2,000 *livres* a year, making it double that of first painter of the king, Charles-Antoine Coypel. Picault was given an apartment next to the royal picture depot at Versailles, and he and his son were granted a royal *brevet,* entitling them to practice their trade without interference from the guilds.[66] Significantly, the revived *Saint Michael* was temporarily displayed at the Luxembourg before it was returned to its customary setting in the Salle de Mercure at Versailles.[67]

Picault's meteoric rise to fame and the excitement generated by his "secret" were intimately bound up with the politics of display at the Lux-

embourg Gallery. Picault was not, in fact, the inventor of the transferral technique, and others soon came forward to prove that they could perform the same restorations for a fraction of the cost and in less time.[68] Though Picault continued to receive his generous royal pension until his death in the 1780s, he was employed by the Bâtiments only twice after 1753. In a sense the *Saint Michael* also represented the high point of the art of transferral itself. At midcentury transferral was regarded as a miracle cure for paintings facing irreversible decline, but once Picault's secret had been demystified and knowledge of the procedure spread it came to be taken for granted.[69] By the 1770s, Picault's successor at the Department of Buildings, Jean-Louis Hacquin, was paid at a fixed rate of eighteen *livres* per square foot, a rate comparable to the eighteen *livres* per day paid to the resident picture cleaners.[70] Hacquin worked much faster and without the secret and noxious potions used by his rival. Picault insisted on the superiority of his technique, but to no avail. After frequent appeals for recognition, Comte d'Angiviller, director general of buildings under Louis XVI and a man of noted scientific interests, was forced to confess: "I see neither the necessity nor the importance of preserving the old support which seems to be the one feature distinguishing your method from that of the others who practice the art of transferral."[71] But we should not forget that in 1750 half the value of Picault's secret consisted precisely in being able to preserve and display the original support. By the Revolution, transferral, though still highly valued, was viewed as a purely mechanical process, demanding patience and careful training, but little "art." Cleaning and repainting, which themselves had been taken for granted in 1750, had become the crucial aspects of restoration. Interest had shifted from a picture's support to its painted surface.

Once the gallery had opened and the Picault sensation became old news, official interest in restoration declined. Marigny suspended virtually all such work during the Seven Years' War (1756–63) and commissioned little thereafter.[72]

<p style="text-align:center">*　　*　　*</p>

Returning to the gallery, we need to explain its place within Lenormand's program of academic reforms. How would the gallery best serve the needs of those aspiring artists mentioned by La Font? Or the public for art targeted by his *Réflexions*? Customarily dismissed in the literature on museums as an elegant picture cabinet of the Old Regime, I believe that the Luxembourg had a pedagogic and theoretical coherence grounded in mainstream art theory of the late seventeenth and early eighteenth centuries. My argument hinges on being able to demonstrate that what appears at first glance as a conventional princely display governed by size and symmetry of object (Fig. 18 and Appendix I) represents instead – or in addition to – a

deliberate attempt to encourage what I would call a comparative viewing of pictures. The goal was to reveal the pictorial qualities of a given work by means of contrast and comparison with pictures of a different type. Predisposed by the writings of André Félibien, Roger de Piles, and their disciples to judge performance in painting in terms of the handling of constituent "parts" (drawing, color, expression, etc.), the initiated viewer would experience the Luxembourg as a sequence of illuminating formal comparisons: the strong coloring of a Titian, say, contrasting with the measured *disegno* of a mature Poussin; or perhaps the treatment of landscape in pictures by a variety of Italian, French, and Northern masters.

All museum displays construct ideal "paths" through a collection and anticipate or construct certain ways of seeing.[73] In the late twentieth century the museum goer expects to scrutinize isolated paintings hung by national school and in rough chronological order, leading simultaneously to an intimate knowledge of the object and a sense of its place in the history of art. Because this mode of display has become so naturalized in the world's survey museums, we have difficulty recognizing, much less crediting, alternative display strategies. As Pierre Bourdieu has remarked, "Individuals have difficulty in imagining other differences [between works of art] than those which the system of classification available to them allows them to imagine."[74] Thus if we are to see a meaningful order in the Luxembourg we must try to reconstruct eighteenth-century viewing habits and expectations, and read the collection through eighteenth-century eyes.

To that end, let us begin where French art history does, with André Félibien's *Entretiens sur les vies et sur les ouvrages des plus excellens peintres,* published in installments from 1666.[75] *Entretiens* 1 through 6 have as their subjects the origins and progress of painting from the ancients and the different parts of painting: invention, drawing and proportion, color and light, perspective, and expression. These parts are considered in relation to the works of the Old Masters; color is discussed in connection with Titian and the Venetians, drawing with reference to Michelangelo, and so on. Félibien thus fused history and theory and thereby avoided the dry prescriptive nature of earlier theoretical texts at the same time that he freed himself to write about historical figures only in proportion to their merit. He was not interested in replicating the comprehensive historical survey pioneered by Giorgio Vasari. His concern was to demonstrate excellence in painting and to explain what made the great masters worthy of eternal fame.

Félibien's synthesis of history and theory stemmed from his belief in the efficacy of teaching by example rather than precept. Knowledge derives from doing and seeing, not from textbook abstractions. As he tells us in the Preface, Félibien's own understanding of art had come directly from watching Nicolas Poussin paint and from listening to him discuss both his own

work and that of others, past and present.[76] Félibien's method also echoed the form and purpose of the Academy's program of *conférences,* or lectures, begun in 1665, which involved the detailed explication by one of its members of works of art in the royal collection. Each month a painting was brought to the Academy where its strengths and weaknesses were analyzed by a senior academician. (Félibien edited the first *conférences* for publication in 1668.[77])

Unable to illustrate his text, and in order to work from examples, Félibien describes a visit to the Tuileries Palace where paintings from the royal collection were on display in the Ambassadors' Gallery.[78] At the start of the sixth *entretien,* the author conducts his friend and would-be amateur, Pymandre, to the palace in order to confirm by sight all that had been said in previous conversations about individual artists and excellence in the respective parts of painting:

Enter the Gallery, I said, and you will see excellent works by the great masters. It is there that each of them displays his strengths, and taken together their works form a marvelous concert. Their different beauties manifest the grandeur and excellence of painting. That which is peculiar to one, and which is not to be found in others, testifies to the vast extent of this art, which no one man can master in all its parts, as I have told you often enough.[79]

Dazzled by the variety of pictures on view and unsure how to proceed, Pymandre asks the author to explain how one discerns excellence and faults in a picture and the criteria according to which paintings should be distinguished. By way of example, Félibien stops in front of a famous (unidentified) Titian and proposes that they compare it in terms of its treatment of color and light to Caravaggio's *Death of the Virgin,* hung a short distance away. A formal analysis of the latter prompts a recollection of Poussin's belief that Caravaggio had been sent to destroy painting through his slavish imitation of nature. Happily a painting by Guido Reni is at hand to illuminate further the crucial difference between "noble" and "vulgar" nature in art.

Félibien chose not to identify two of the three paintings he discussed, as if specificity would have bound the text too closely to a particular reading of a particular collection. His goal was not to provide an itinerary for the Ambassadors' Gallery but to show how such a collection should be used by the beholder to yield insights into the art of painting. Comparison of different types was established as the route to correct judgment, and difference was determined primarily by performance in the fixed categories, or parts, of painting. Defining the parts and determining a hierarchy among them fueled much debate within the Royal Academy in the late seventeenth century.[80] The essential triad of drawing, color, and composition inherited from

Renaissance theory was variously qualified and expanded before stabilizing in the four parts set forth in Roger de Piles's *Balance of Painters* (Fig. 14), published in 1708: composition, drawing, color, and expression.[81] Though dismissed by modern commentators as an aberration, in the eighteenth century the *Balance* was widely respected.[82] Notwithstanding occasional criticism of individual scores (Algarotti thought it scandalous that Rubens should outscore Raphael!) and even the mathematics, there was fundamental agreement about its underlying principles: that is, the belief in the possibility of objective analysis of painting and the idea that achievement should be measured separately in each of the parts.[83] As we might expect, de Piles was a great proponent of comparison as the basis of judgment: "It is only

BALANCE des Peintres de M. de Piles, telle qu'on la trouve à la fin de son Cours de Peinture, & à laquelle on a seulement ajoûté la colonne des sommes.

NOMS des PEINTRES LES PLUS CONNUS	Composition	Deſſein	Coloris	Expreſſion	SOMMES des quatre PARTIES
Albane	14	14	10	6	44.
Albert Dure	8	10	10	8	36.
André del Sarte	12	16	9	8	45.
Baroche	14	15	6	10	45.
Baſſan, Jacques	6	8	17	0	31.
Baſt. del Piombo	8	13	16	7	44.
Belin, Jean	4	6	14	0	24.
Bourdon	10	8	8	4	30.
Le Brun	16	16	8	16	56.
Calliari P. Ver.	15	10	16	3	44.
Les Caraches	15	17	13	13	58.
Corrège	13	13	15	12	53.
Dan. de Volterre	12	15	5	8	40.
Diepembek	11	10	14	6	41.
Le Dominiquin	15	17	9	17	58.
Giorgion	8	9	18	4	41.
le Guerchin	18	10	10	4	42.
le Guide	...	13	9	12	34.
Holben	9	10	16	13	48.
Jean de Udiné	10	8	16	3	37.
Jaq. Jourdans	10	8	16	6	40.
Luc Jourdans	13	12	9	6	40.
Joſépin	10	10	6	2	28.
Jules Romain	15	16	4	14	49.
Lanfranc	14	13	10	5	42.
Léonard de Vinci	15	16	4	14	47.
Lucas de Leide	8	6	6	4	24.

NOMS des PEINTRES LES PLUS CONNUS	Composition	Deſſein	Coloris	Expreſſion	SOMMES des quatre PARTIES
Michel-Ange Bonarotti	8	17	4	8	37.
Michel-Ange Caravage	6	6	16	0	28.
Mutien	6	8	15	4	33.
Otho Venius	13	14	10	10	47.
Palme le vieux	5	6	16	0	27.
Palme le jeune	12	9	14	6	41.
le Parmeſan	10	15	6	6	37.
Paul Véronèſe	15	10	16	3	44.
Fr. Penni il fattoré	0	15	8	0	23.
Perrin del Vague	15	16	7	6	44.
Pietre de Cortone	16	14	12	6	48.
Pietre Perugin	4	12	10	4	30.
Polidore de Caravage	10	17	...	15	42.
Pordenon	8	14	17	5	44.
Pourbus	4	15	6	6	31.
Pouſſin	15	17	6	15	53.
Primatice	15	14	7	10	46.
Raphaël Santio	17	18	12	18	65.
Rembrant	15	6	17	12	50.
Rubens	18	13	17	17	65.
Fr. Salviati	13	15	8	8	44.
le Sueur	15	15	4	15	49.
Teniers	15	12	13	6	46.
Teſte, Pietre	11	15	0	6	32.
Tintoret	15	14	16	4	49.
Titien	12	15	18	6	51.
Vandeik	15	10	17	3	53.
Vanius	13	15	12	13	53.
Thadeé Zuccre	13	14	10	9	46.
Fréderic Zuccre	10	13	8	8	39.

Figure 14. Roger de Piles, *Balance of Painters*, 1708. From *Histoire de l'Académie royale des sciences avec les mémoires de mathématiques (1755)*, Paris, 1761.

Score out of 18? / 20?

33

through comparison," he wrote, "that things may be determined good or bad."[84]

One imagines Pymandre would have found the *Balance* useful on his tour of the Ambassadors' Gallery. It would have told him to go to Guido Reni rather than to Caravaggio to learn about good drawing and expression (Caravaggio scored zero in the latter). More to the point, it would have helped him make sense of a juxtaposition of works by the two. In fact, as Elizabeth Holt suggested, the *Balance* did prove useful to exhibition goers through the eighteenth century.[85] However, both Félibien and de Piles insisted that in order to know painting one had to articulate that knowledge, to be able to explain why, or in what ways, a given work of art was good or bad. De Piles put it succinctly: "True understanding of painting consists in knowing if a picture is good or bad; in being able to distinguish what is well done from what is not in the same work and to justify one's conclusions."[86] To qualify as a connoisseur one had to be able to defend one's judgments, and to have those judgments recognized by others. Connoisseurship was therefore performative and required social skills and the right vocabulary. De Piles would have been the first to admit that the *Balance* was of little help here.

In order to address this performative aspect of connoisseurship, Félibien asserts his authorial presence in the *Entretiens*: not only does he show Pymandre what to look at and how to establish theoretical grounds on which to compare different paintings, he also provides a model of discourse. His verbal performance in reported dialogue with his friend is offered for consideration as much as the content of his speech. Félibien's use of a dialogue format served two purposes. First, it recalled and attempted to recapture the flavor of conversation he himself had enjoyed with Poussin in Rome as a young man, at once memorializing his friendship with the great master and making Poussin an indirect authority for what was said. Second, the dialogue introduced art and art history into the realm of subjects worthy of polite conversation.

Polished conversation was an essential attribute of the aristocrat and *honnête homme*.[87] In late-seventeenth-century literature, the dialogue format was frequently employed as a vehicle for conveying specialized material to a nonspecialist but elite public.[88] Treatises on courtly deportment stressed the importance of introducing new topics for conversation, and that is precisely what Félibien's *Entretiens* aimed to do for painting.[89] At the outset he states openly that his text is aimed at instilling in "all learned and *honnêtes* people" an idea of excellence in painting.[90] By its nature conversation was intimate; its locus was the salon or the cabinet. Félibien extended the geography of conversation to include the picture gallery. A mute dialogue between different pictures juxtaposed on a wall prompted active dialogue – visual and verbal – between beholder(s) and canvas.

The *Entretiens* coincided with the Academy's campaign to build a public for art. As Crow has pointed out, Félibien's task as the Academy's first "honorary amateur" was to produce a legitimizing discourse, primarily by publishing the *conférences* but also through his conversations with Pymandre.[91] De Piles continued Félibien's efforts to expand the public for art through texts in dialogue form, most notably his *Conversations sur la connoissance de la peinture* of 1677. His interest in doing so became directly tied to the lives of contemporary artists when he in turn was named "honorary amateur" in 1699. More emphatically than Félibien, de Piles insisted on the primacy of quality judgment and the virtues of comparative viewing. When he reached out to would-be amateurs in his *Conversations* and later texts it was to persuade them of the relative superiority of determining excellence in painting, of "knowing if a painting is good or bad," over the connoisseurial pursuits of attribution and authenticity. Assessing the strengths and weaknesses of a given work of art requires rational judgment, he argued, whereas deciding its authorship and originality is but an exercise of memory.[92] De Piles insisted on the distinction because he feared a privileging of the latter would lead to – or, indeed, had already created – a hierarchy of values unduly influenced by critical reputation and prejudicial to living artists, in particular those of the nascent French school. To define knowledge of art primarily in terms of attribution and originality was to define the amateur's domain as the art of the past. Judgments of quality, on the other hand, based on systematic and objective analysis of performance in the parts of painting, were indifferent to names, dates, national origin, and the presence (or absence) of signatures. Modern painting and the works of the Old Masters, French pictures as well as Italian, merited equal scrutiny and deserved to be judged by the same absolute standards. Fearing that prejudice interfered with clear perception, de Piles called for hard looking and critical thinking as the basis for true knowledge of art as opposed to name recognition and the sufficiency of identifying different hands.

One final point about the *Balance*. Though it guided the judgment of amateurs, it also served young artists in pursuit of worthy models of imitation. (The same is, of course, true of Félibien's *Entretiens* and most other theoretical-historical texts of the period.) Artistic education within the Academy system consisted of instruction in each of the four parts defined by de Piles: invention (grounded in knowledge of history, literature, and mythology); drawing (taught at the Academy); expression (the speciality of Charles Lebrun and eventually recognized in the prize competition sponsored by the Comte de Caylus in 1759); and color (acquired in the studio and through copying at the French Academy in Rome). And to the extent that aspiring artists were expected to look to the past for inspiration, they were taught to do so selectively, confining their study of the Old Masters to those parts in which they were perceived to have excelled.[93] The amateur

was supposed to evaluate the past just as the artist was to exploit it, prizing what was good and disregarding the rest. De Piles and Félibien were aiming to unify the art world by virtue of a shared critical vocabulary and set of aesthetic values.

We do not know if the Ambassadors' Gallery at the Tuileries was arranged intentionally to facilitate comparative viewing. What matters is that Félibien shows us that the Gallery was used in this way by the enlightened art lover. His reading of that collection, and more generally the model of comparative viewing established by him and de Piles in their various texts, directly influenced the display of important early-eighteenth-century collections in Paris, notably those of Pierre Crozat and the Duc d'Orléans, and eventually the Luxembourg Gallery itself.

Turning first to the Crozat collection, we see that a reconstruction of the elevation of one wall (Fig. 15) reveals an arrangement both elegant in its configuration and provocative in its juxtaposition of different artists and genres.[94] A similar eclecticism is evident in the arrangement of the Orléans collection, recorded in a midcentury Paris guidebook (Fig. 16).[95] Both collections were large enough to permit a modern classification by school and in which works by the same artist are grouped together, but precisely the opposite effect was sought. In each case the aim was to emphasize the stylistic identity and pictorial qualities of individual works through juxtaposition with paintings of a different type.

Significantly, both of these outstanding Parisian collections were formed by men committed to perpetuating the legacy of Félibien and de Piles. From about 1700, in the wake of the removal of the royal collection from Paris to Versailles, Crozat's hôtel on the rue de Richelieu became the place for artists and amateurs to view Old Master paintings. Crozat's interest in art as well as his collection of paintings was guided by the leading artists and theorists of the day: de Piles, the Comte de Caylus, Charles La Fosse, Antoine and Charles-Antoine Coypel, Antoine Watteau, Nicolas Vleughels, and others. Crozat's library contained de Piles's works, and de Piles himself received a pension from Crozat during the last year of his life.[96] As Thomas Crow has argued, Crozat's house became a kind of "shadow academy," a staging point for the theorizing and social activities vital to the public life of the Royal Academy but which most Academy artists had little taste for.[97] De Piles and his circle used Crozat and his collection to promote their ideal of the cultivated amateur, who bought paintings new and old and who used his collection in an enlightened and socially productive way. Crow is right to state that "much of the most influential eighteenth-century theory and connoisseurship have their origins there." I would add that the composition of the collection and its arrangement constituted an important element in the theoretical program.

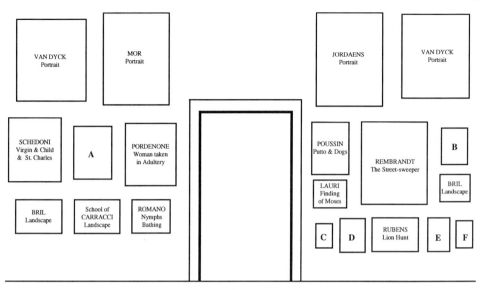

A LANFRANCO - Virgin with Rosary
B GUERCINO - Virgin & Child & St. Clair
C RUBENS - Medici Sketch
D MASTELLETTA - Resurrection
E CARRACCI - Portrait
F RUBENS - Medici Sketch

Figure 15. Crozat collection, arrangement of paintings in the second room on the rez-de-chaussée. Paris, 1755.

Figure 16. Annibale Antonini, *Mémorial de Paris et de ses environs.* Paris, 1749.

Not surprisingly, the rhetorical discussions in the texts of Félibien and de Piles became a reality in the Hôtel Crozat. The weekly reunions there became famous, and Mariette, for one, recalled that he owed his knowledge of art "to the works of the great masters we examined there and equally to the conversation of the noble persons who made up the company."[98] Much in the way that Crozat played out the life of the seventeenth-century *honnête homme* through the *fêtes galantes* of Watteau, as Crow has shown, so he fashioned himself in the image of the ideal amateur represented in the dialogues of the founding fathers of French art history and theory.

The Orléans collection at the Palais Royal, which from the 1720s became the premier collection in Paris, had close ties to the Crozat circle. Crozat himself went to Rome in 1714 on behalf of the regent, Philippe, Duc d'Orléans, to negotiate the purchase of Queen Christina's collection, which had passed into the hands of the Odescalchi family.[99] The duke had been taught to paint and to appreciate art by Antoine Coypel, de Piles's close friend and follower.[100] At the very time that Coypel was shaping the regent's collection he was also inculcating a new generation of artists and amateurs with de Pilesian theory through a series of lectures at the Royal Academy, published in 1721 as the *Discourses* and dedicated to the duke. "Is it not true," he asked rhetorically in one lecture, "that a painter who wants to perfect his art must adopt as models the greatest of the Old Masters, studying and imitating them in the parts for which they are best known?"[101] And at the outset he reaffirmed the superiority of quality judgments over attribution, concluding: "What pleasure it will give [the *homme d'esprit*] comparing the different talents of the great masters and the parts in which they distinguished themselves."[102] Charles-Antoine Coypel's frontispiece to the *Discourses* (Fig. 17), showing the figure of Painting exhorting the artist/reader to contemplate the marvels of the great masters, was at once an allegory of selective imitation and a recommendation for comparative viewing. It might well have illustrated Dubois de Saint-Gelais's 1727 catalogue of the duke's pictures. Widely accessible until the Revolution to artists and amateurs, the Palais Royal was, as Dubois described it, "a learned school of painting."[103]

The same desiderata informed the choice of paintings and their arrangement at the Luxembourg Gallery in 1750. A consideration of adjoining walls in the first room of the Gallery and the corresponding pages from the official catalogue (Figs. 18 and 19) reveals a hang analogous to those we have seen before. Like those earlier displays, the arrangement here was designed to instruct both amateur and artist in the "excellencies" of painting by means of contrast and comparison. Unlike the earlier collections we have seen, however, the Luxembourg was accompanied by a catalogue that

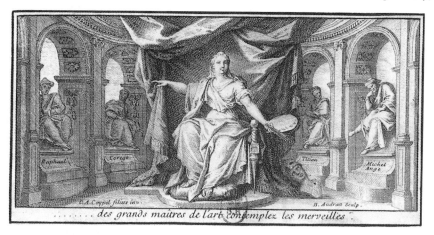

Figure 17. Charles-Antoine Coypel, . . . *des grands maîtres de l'art contemplez les merveilles.* Engraving, 1721, Bibliothèque Nationale, Paris.

guided the visitor through the gallery. Since the paintings were without labels, the itinerary mapped by the catalogue was especially important. Matching catalogue with configuration of pictures, the numerical sequence leads the eye in a zigzag path across the wall, entailing comparison of works by different artists. One was not bound to follow the established route, of course, but no matter what order one chose, contrast and comparison were unavoidable.

Interestingly, the two published descriptions we have of the Gallery frequently departed from the planned route as they moved through the space, yet they did so in order to rehearse, and thus to propose to the reader, new, unexpected comparisons. In one account, entitled *Lettre sur les tableaux . . . au Luxembourg,* the author at one point moved back and forth across the Gallery in order to compare ten paintings of the Virgin and Child by different Italian, Northern, and French artists (Appendix I: nos. 96, 82, 60, 81, 85, 78, 61, 38, 45, and 56). The author later did the same for paintings of Christ's Passion, the lives of saints, historical and mythological subjects, landscapes, and still lifes.[104] The second account, in the form of a letter from one Chevalier de Tincourt to a marquise in the provinces, opened by praising the agreeable and startling contrasts of style and subject the visitor encountered at every turn.[105] Entering the first room, Tincourt remarked that the marquise would be pleasantly surprised to find "thirteen paintings and four drawings, whose variety offers the curious a sampling of the five different schools. The ingenious and agreable contrasts! The variety of subjects is no less fortunate."[106] After discussing each of the pictures, he further noted: "How rare it is to find in one place such a happy mixture of the Lombard, Florentine, Venetian, Flemish, and French schools! The masters

| LANFRANCO Coronation of the Virgin 2 | VAN DYCK Portrait of Rubens & his Wife 3 | TITIAN Jupiter & Antiope 5 | VAN DYCK Portrait of Rubens & his Son 8 | VERONESE Martyrdom of St. Mark 9 |
| CLAUDE Embarkation of Cleopatra 1 | POUSSIN Plaugue of Ashdod 4 | POUSSIN Rape of the Sabines 6 | POUSSIN Israelites Gathering Manna 7 | CLAUDE Sunset 10 |

Two Drawings each by Bassano & Rubens

NOT SHOWN:
RAPHAEL - Portrait of Adrian VI (above entrance door)
DEL SARTO - Charity (on easel, next to entrance)
TITIAN - Portrait of Cardinal Medici (above door to Small Gallery)

South Wall West Wall North Wall

First Room

Figure 18. Luxembourg Gallery, arrangement of paintings on the west wall on the first gallery. Paris, 1750.

8 TABLEAUX DU ROY
Face vis-à-vis les fenêtres.
VAN DEIK.
Ecole Flamande.
3. Un Tableau repréſentant le Portrait de la femme de Rubens & de ſa fille, hauteur 6 pieds 1 pouce, ſur 4 pieds 1 pouce & demi.
Né à Anvers en 1599, mort à Londres en 1641, âgé de 42 ans.

POUSSIN.
Ecole Françoiſe.
4. Un Tableau repréſentant les Philiſtins attaqués de la peſte, hauteur 4 pieds 7 pouces ſur 6 pieds.
Né dans la ville d'Andely en 1594. Louis XIII. le fit venir de Rome en 1640, pour peindre la Gallerie du Louvre, & le nomma ſon premier Peintre ; mais la mort du Cardinal de Richelieu & la jalouſie de Vouet, dont la réputation floriſſoit alors, lui cauſa des chagrins, qui le déterminerent à retourner à Rome, où il mourut en 1665, âgé de 71 ans.

TITIEN.
Ecole Vénitienne.
5. Un Tableau repréſentant Antiope couchée, Jupiter ſous la figure d'un Satyre,

AU LUXEMBOURG. 9
& Payſage, hauteur 6 pieds 1 pouce, ſur 12 pieds 3 pouces.
Né à Cador, dans le Frioul en 1477, mort à Veniſe en 1576, âgé de 99 ans.

POUSSIN.
6. Un Tableau repréſentant l'enleve- ment des Sabines, hauteur 4 pieds 10 pou- ces, ſur 6 pieds 3 pouces.
Par le même.
7. Un Tableau repréſentant les Iſraëlites qui reçoivent la Manne dans le déſert, hau- 4 pieds 5 pouces, ſur 6 pieds.

VAN DEIK.
8. Un Tableau repréſentant le Portrait de Rubens & de ſon fils, hauteur 6 pieds 1 pouce, ſur 4 pieds 1 pouce & demi.

PAUL VERONESE.
9. Un Tableau repréſentant le Martyre de S. Marc, hauteur 6 pieds 1 pouce, ſur 4 pieds.
Né à Veniſe en 1532, mort dans la même ville en 1588, âgé de 58 ans.

Figure 19. Jacques Bailly, *Catalogue des tableaux . . . au Luxem- bourg.* Paris, 1750.

whose works sparkle there are the most celebrated of each of those schools."[107]

Entering the second room, larger than the first but equally varied, Tincourt reported: "The variety in this room was no less striking; the pious, the profane, the poetic, and the pastoral serve as pendants to each other, and the different schools demonstrate their respective strengths."[108] In each of the last two rooms, Tincourt proposed particular comparisons that involved different artists, schools, and genres, on one wall a telling juxtaposition of history paintings by Le Moyne (*The Continence of Scipio*, no. 39), Lebrun (*Conquest of the Franche-Comté*, no. 37), and Poussin (*Ecstasy of Saint Paul*, no. 40);[109] on another, two *Village Fêtes* by Rubens (no. 69) and Annibale Carracci (no. 59).[110] Like the author of the first account, Tincourt more than once traversed a room to make still other fruitful comparisons.[111]

Both descriptions took the form of letters, the literary sister of the conversation. They identified the ideal audience as literate and aristocratic. Both took advantage of the spontaneity of the letter to suggest possible topographies of the gallery; the serendipitous nature of the recorded stroll through the collection masked a calculated interpretation of the hang while leaving open to the visitor the possibility, and indeed the challenge, of constructing new paths through the collection. Both letters provided an example of how the gallery could be read.[112]

Continuity with past models was to be expected given that Lenormand's reform program was backward looking and his intention was to return the Academy to its "former luster," to quote Charles Coypel. It will be recalled, moreover, that the director general and his advisers all belonged to a generation that came of age in the Crozat circle in the shadow of de Piles. The younger Coypel had fond childhood memories of de Piles, and in Academy lectures of the 1720s and 1730s (all in dialogue form) he carried on the fight against the prejudiced *demi-connoisseur* who knew names but understood nothing of quality.[113] There was Bachaumont whose original proposal for a public gallery evoked Félibien's *Entretiens* in suggesting the Ambassadors' Gallery at the Tuileries as an ideal location.[114] Also prominent was the Comte de Caylus. He was responsible for reviving the academic *conférence* in its original Colbertian form, the purpose of which he explained in an address to the Academy in 1746:

What a striking spectacle the revival of that practice would be! The sublimity of Raphael, the grandeur of Michelangelo, the learned grace of Correggio would be explicated by our masters, and with that truth and enlightened understanding which alone will reveal the secret springs of art. It would demonstrate both the general and particular paths the great masters have pursued to immortality. The description of a painting's specific beauties and faults will enable one to praise or criticize the manner of its author; all the schools will become familiar and our

understanding will grow deeper; the good and bad equally balanced will yield sound judgment and open the eyes of these students whom you love.[115]

Most probably for reasons of conservation, paintings were not brought to the Academy as they had been in the days of Lebrun, but it was assumed that students would apply lessons learned from the *conférences* to paintings at the Luxembourg. It was surely no coincidence that Caylus's first lecture after the gallery opened, "On Composition," featured Poussin's *Deluge*, then on display in the second room.[116]

The next incarnation of what I have called the comparative mode of pictorial display was to be its last. When the Louvre museum opened in 1793, under the guidance of Academy artists, a hang reminiscent of the Luxembourg greeted the visitor (Fig. 20). For reasons both political and aesthetic, which will be fully explored in Chapter 3, the decision was attacked as regressive and inappropriate for the forward-looking Republic. A new, scientific classification according to chronology and national school was called for instead. The museum administration responded that this new system might well satisfy a "handful of scholars," but theirs would prove more useful by allowing the beholder "to compare the styles of the old masters, their perfections as well as their faults, which only become apparent upon a close and immediate inspection."[117] Artists, still indebted to de Pilesian theory, clung to the idea that a painting's value must be judged by its pictorial qualities. Progressive connoisseurs, however, while by no means blind to issues of quality, insisted that a formal display of art must make manifest the characteristics of national school and the historical sequence of great masters. In 1794 the latter won out, and the Louvre collection was rearranged by school and chronology.

(6)

bras; près d'elle est le génie de l'abondance.
H. 5 pi. 4 po. , L. 3 pi. 10 po.

L'ESPAGNOLET.

3. Saint Paul.
H. 4 pi. 3 po. , L. 2 pi. 2 po.

LÉONARD DE VINCI.

4. La Sainte Famille avec Saint Michel.
H. 3 pi., L. 2 pi.

LE BERNIN.

5. Saint Jean-Baptiste prêchant dans le désert.
H. 2 pi., L. 1 pi. 8 po.

VAN-HUYSUM.

6. Fleurs et fruits.
H. 2 pi. 4 po., L. 1 pi. 11 po.

SOLIMENE.

7. Héliodore chassé du temple.
H. 5 pi. 2 po. , L. 6 pi. 3 po.

N. POUSSIN.

8. La Vierge à la colonne.
H. 9 pl., L. 7 pi. 4 po.

7

L'ESPAGNOLET.

9. Saint Pierre.
H. 4 pi. 3 po., L. 2 pi. 2 po.

FRANÇOIS MOLE.

10. Saint-Bruno en extase.
H. 3 pi. L. 2 pi.

PIERRE MIGNARD.

11. Sainte-Cécile.
H. 2 pi. L. 1 pi. 6 po.

VAN-HUYSUM.

12. Corbeille de fleurs.
H. 2 p. 4 po. L. 1 pi. 11 po.

N. POUSSIN.

13. Les Philistins attaqués de la peste.
H. 4 pi. 7 po. L. 6 pi.

LANFRANC.

14. Jesus-Christ couronnant la Vierge.
H. 6 pi. 9 po. L. 4 pi. 4 po.

A 4

Figure 20. Catalogue des objets contenus dans la galerie du Muséum Français. Paris, 1793.

* * *

The primary beneficiaries of the Luxembourg were supposed to be French artists, especially the pupils of the Ecole royale des élèves protégés, the school within the Royal Academy created in 1749 to give advanced training to the most promising young students in preparation for their customary three-year stay at the French Academy in Rome.[118] Entry to the school was reserved for winners of the Prix de Rome, and the idea was that three years of additional study would help the chosen few make better use of their time in Italy. In light of dismal recent prize competitions, it was hoped that the Ecole royale would raise standards and have a tonic effect on the entire academic system.

For most historians of eighteenth-century French art, who, following Locquin, have been concerned with the evolution of history painting culminating in Jacques-Louis David, the Ecole royale was important for the emphasis it gave to training in ancient history, literature, and geography. But study of ancient texts constituted only a part of the curriculum, and historians have too quickly overlooked the equally serious measures introduced to improve the level of artistic practice.[119] Lenormand's reforms were aimed not simply at generating history painting but history painting in the grand manner, in a style worthy of comparison with the Old Masters.

After early morning lessons in history, the students spent the rest of the day in their studio at the Galerie d'Apollon, next to the Salon carré in the Louvre, "either copying the king's pictures or others borrowed from private collections, or working on their own compositions."[120] As the painter J.-B.-M. Pierre tells us in a letter of 1775, the paintings copied by the élèves protégés were to come from the Luxembourg:

It was thought a good idea . . . to familiarize students, whose path is uncertain, with the manners of the different masters in order to prevent the kind of infatuation that is so common among the young following their arrival in Rome. The exhibition of the king's pictures at the Luxembourg was to have provided those students with a means of comparison through the copies they made there.[121]

From at least the seventeenth century copying in oils after the Old Masters had formed an important part of learning how to paint, and in particular learning how to color. It was a cornerstone of the curriculum at the Academy in Rome. Through the Luxembourg it was to have become standard practice in Paris as well. Traditionally instruction in painting came in the studio and was the responsibility of one's master. Exposure to alternative models of handling and color through copying had to wait until Rome. As Pierre's letter makes clear, the Ecole royale was designed to institutionalize copying at an earlier stage in the artist's development and thus give the Academy greater control over the one aspect of artistic practice, the one

part of painting that had escaped its jurisdiction.[122] The artist brought in to supervise the "protected students," Carle Van Loo, was an obvious choice since not only did he have an outstanding reputation as a teacher but he was also regarded (at least in France) as the finest technician and colorist in Europe.[123]

In practice, though, it is far from clear how useful the Luxembourg proved as a didactic aid. Lenormand's successor, Marigny, discouraged copying in the Gallery, and references to Van Loo borrowing pictures for the purpose are rare.[124] In 1760 the architect Jacques-Germain Soufflot drew up plans for an elaborate "city of the arts" in the Luxembourg Palace, housing studios and apartments for Academy artists, but nothing came of the project.[125] Artists had to wait until the Revolution before the king's pictures were made available for copying.

At the Ecole royale and generally at the Academy, competition was the lifeblood of the system. Every sort of promotion and prize depended on it. Though no prizes were given in connection with the biennial Salon exhibition, artists naturally competed for the public's attention. All the while, as Norman Bryson has argued, artists of the eighteenth century, "latecomers" in the modern tradition, equally competed with the past.[126] Contemplating the marvels of the Old Masters, the aspiring artist dreamed of one day taking his place beside them. As La Font insisted (perhaps too strongly), the artist's most powerful incentive and reward were not instant financial success but the prospect of having his work displayed in the king's gallery "alongside the illustrious men of all countries and especially Italy."[127] The gallery's final purpose was to provide a public space in which those dreams might be realized and in which a French school of painting might be defined and celebrated.

Notwithstanding the extraordinary international success of French art and taste within Europe – by midcentury virtually every court from St. Petersburg to Madrid had come under its sway – there was still a defensiveness about French achievement, a need to demonstrate that French art constituted a school and a tradition on a par with those of Italy and the Low Countries. Numerous texts, beginning with Charles Perrault's *Parallèle des anciens et des modernes* of 1688, had set out to make this point. The gallery aimed to substantiate the argument visually. The first public art gallery in France, the Luxembourg was also the first museum in Europe intended to represent (indeed to invent) and promote a national artistic tradition.

The eclectic mix of artists in the first two rooms embodied a competitive historical field in which French artists took on their Italian and Northern rivals. The juxtaposition proved flattering to the French to judge by the

response of patriotic amateurs. One Sireul, engaging a sporting metaphor, remarked:

Our modern painters will certainly be encouraged by the strong showing of the French school among the works of the greatest masters. Vouet, Poussin, Le Sueur, Lebrun, Antoine Coypel, Noel Coypel, La Fosse, Mignard, Le Moine are every bit the match for those athletes.[128]

A second commentator went further to discern a French advantage: "[In the gallery] the masters of the different schools vie for superiority, and the French, too often looked down upon, have performed honorably and perhaps may even claim victory."[129]

The third room, the so-called Throne Room, was devoted exclusively to French artists of the seventeenth and eighteenth centuries (up to Le Moine). The range of subjects and artists represented pointed to a rich and sustained tradition, a tradition that, in time, would embrace living artists. Continuity between past and present was further implied by the timing of the gallery opening just days after the 1750 Salon closed – a coincidence noted by contemporaries.[130]

Although a clear effort was made to include all genres of painting in the gallery, in keeping with the ideal of a varied cabinet recommended by de Piles and others and satisfying all constituencies of the Academy, in the Throne Room a strong tradition of history painting was particularly in evidence.[131] Indeed, every conceivable type of history painting was on view, from ancient history (Le Moine's *Continence of Scipio*, no. 39) to modern history (Lebrun's *Conquest of the Franche-Comté*, no. 37), mythology (Noel Coypel's *Apotheosis of Hercules*, no. 41), Old Testament narrative (Antoine Coypel's *Esther and Assuerus*, no. 42), New Testament icon (Jean-Baptiste Santerre's *Magdalen*, no. 55), Christian Virtue (Pierre Mignard's *Faith*, no.54), and secular allegory (Simon Vouet's *Victory Crowning Louis XIII*, no. 51). To the extent that the Throne Room *defined* French painting, it defined it primarily as history painting. A clear message was sent to living artists that posterity heavily favored the most exalted of genres. Just as the two prize-winning pictures of the Duc d'Antin's history painting competition of 1727 were displayed at the Luxembourg (Le Moine's *Scipio* and Jean-François de Troy's *Bath of Diana*, added sometime between 1754 and 1759),[132] so it was to be expected that the winner of Lenormand's recent 1747 contest, and others to follow, would eventually be honored in like fashion.

Though, as it happened, the 1747 competition did not give rise to sustained royal support for history painting, the most important commission of the Lenormand–Marigny years – Claude-Joseph Vernet's fifteen views

Figure 21. Claude-Joseph Vernet, *The Port of Bordeaux.* Oil on canvas, 1759, Musée de la Marine, Paris.

of French ports, executed between 1753 and 1762 (Fig. 21) – was put on display at the Luxembourg. Combining a topographical record of the ports and their trade with landscape painting of the highest order, the purpose of the series was to celebrate the commercial success and territorial unification of France under the Bourbons. Its logical destination was a significant public space. Following their debut at the Salon, the paintings were given uniform frames and transported to the Luxembourg Palace. Exactly where they were displayed remains a mystery, but a number of important visitors to Paris went to the gallery to see them, including Emperor Joseph II in 1777.[133] The public display of the views of French ports signaled the government's desire to have its patronage of serious and patriotic painting recognized in a forum more permanent than the Salon and anticipated the more ambitious project of d'Angiviller to commission history paintings and statues expressly for the Louvre museum, to which I will return in Chapter 2.

Though itself a product of a lengthy campaign to promote the French school of painting, the Luxembourg Gallery was connected with other mid-century "patriotic" texts that deserve to be mentioned. Together, these related initiatives succeeded at long last in making the collecting of contemporary French art desirable and prestigious in a way that would have gratified Félibien and de Piles.[134]

There was François-Bernard Lépicié's *Vies des premiers peintres, depuis Lebrun jusqu'à présent* of 1752, based on lectures originally given at the

Academy. Pictures by each of the first painters of the king from Lebrun to Le Moyne could be seen at the Luxembourg.[135] A second contribution to the cause was the Marquis d'Argens's eccentric *Réflexions critiques sur les différentes écoles de peinture* also of 1752, whose stated purpose was to "compare our French painters with the Italians and the Flemish in order that their equality, and perhaps even their superiority in certain respects, might be recognized at a glance."[136] Many of d'Argens's parallels are far-fetched (Palma Vecchio and Hyacinthe Rigaud? Noel Coypel and Parmigianino?) but what is of interest to us is that some of the comparisons – and conceivably the book itself – were inspired by visits to the Luxembourg. Witness the comparison between Mignard and Correggio:

You will be easily convinced of the similarities between these two artists by studying the pictures by them in the rooms of the Luxembourg. There are four by Mignard which exhibit a precious finish as well as fresh and vigorous colors, admirably blended. If among his paintings you carefully examine the largest of them, a Virgin and Child [no. 56], and if you next consider a large painting by Correggio of a satyr eyeing a sleeping woman with a cupid by her side [no. 74], you will see that Mignard, having at times colored, blended, and built up his paints like Correggio, also drew more correctly than he; for though this Italian artist drew with taste, his contours are not correct.[137]

Lastly, we should include Bachaumont's *Essai sur la peinture* of 1751, which took the form of a dialogue, worthy of Félibien or de Piles, between two amateurs on a day trip to Versailles. As mentioned above, conversation turned to a comparison of the relative strengths and weaknesses of Lebrun's *Tent of Darius* (Fig. 10) and Veronese's *Pilgrims of Emmaus* (Fig. 11) – a comparison that would have been read as an unambiguous defense of French painting. When Perrault first used the comparison to that effect in his *Parallèle,* the two pictures were displayed as a pendant pair in the Grand Apartement du Roy at Versailles, where, he wrote, "It seems they were placed side by side to force a comparison."[138] By the turn of the century, they had been moved to the Salle de Mars, where they remained (and may again be seen today) figuratively in battle until the Revolution.[139] They were two of only six pictures taken to Paris by Louis XVI in 1791, and so firmly were they identified as a pair that when the Louvre museum opened two years later they were displayed in adjoining bays.[140] The comparison had become famous enough by midcentury to figure prominently in the *Encyclopédie:* "If the *Tent of Darius* is outshone by the color of the *Pilgrims of Emmaus* by Paul Veronese, placed alongside, the Frenchman surpasses the Italian in the beauty and wisdom of his composition and drawing."[141] Bachaumont relied on this famous example in his essay on painting precisely because of its didactic and patriotic resonance. It embodied the essential and eternally valid principles of criticism while simultaneously champi-

oning the cause of French painting. Like Félibien's *Entretiens,* Bachaumont's essay showed the aspiring amateur how to visit a gallery and look at pictures. It concluded with a passage illustrating the kind of polite dialogue and comparative viewing expected of the visitor to the Luxembourg:

Let us agree, if you will, that one has qualities the other has not, while the latter possesses a few which its neighbor wants; or better yet, let us say that these are two of the most beautiful paintings one could see and their authors two of the greatest artists that have ever lived.[142]

D'ANGIVILLER'S LOUVRE PROJECT

> *I know that His Majesty personally wants*
> *nothing short of perfection in the design*
> *of this national monument.*
>
> Comte d'Angiviller
> to the Royal Academy of Architecture
> on the museum, 1785

When the Luxembourg Gallery closed in 1779 to make way for the house-hold of the Comte de Provence, the younger brother of Louis XVI, to whom the palace had been given as his principal Paris residence, plans were already afoot to create a larger, more magnificent museum of art in the Grand Gallery of the Louvre.[1] The creation of that museum was the chief project of the king's director general of royal buildings, Comte d'Angiviller. No clearer indication of his commitment is needed than the portrait by J.-S. Duplessis (Fig. 22) showing the floor plan of the gallery draped conspicu-ously across his lap. Exhibited at the Salon of 1779, the portrait was a promise to the Parisian public that the gallery in the making would more than compensate for the one that had just closed. No mention is made of the plan in the Salon catalogue, but none was needed, for d'Angiviller's ambition to transform the Louvre into the most imposing museum in Europe had been common knowledge for some time.

The museum was the crux of the director general's grand scheme to revi-talize French art and to demonstrate to Europe and posterity the superiority of the French school and the magnificence of Louis XVI. The Louvre was to be a source of national pride as well as royal glory. Not only was the museum to contain the bulk of the king's unrivaled collection of Old Master paintings, it was also destined to be the showcase for the history paintings and statues of illustrious French men commissioned by d'Angiviller and for

goal of future Louvre

49

Figure 22. Joseph-Siffred Duplessis, *Comte d'Angiviller*. Oil on canvas, 1779, Musée de Versailles.

which he is best remembered. The moralizing and commemorative intent of those paintings and sculptures is of great importance in the history of the Louvre because they signal a desire to integrate the museum into the political fabric of the nation – to influence the public with respect to moral and political welfare as well as artistic taste. Owing to the infrequent occurrence and short duration of the Salon, the museum was the appropriate venue in which art could be used to guide public opinion. The Louvre's full assimilation into the body politic had to wait for the Revolution, but the way was prepared by d'Angiviller's unfulfilled Grand Gallery project of the 1770s and 1780s. Thanks largely to his efforts, the ideal of a museum as a princely cabinet, designed for an elite of artists and amateurs, was transformed into what in retrospect can be recognized as the modern museum of art, a state institution occupying center stage in the public life of the capital.

<p style="text-align:center">✵ ✵ ✵</p>

Notwithstanding d'Angiviller's strong personal identification with the museum project (he referred to it as "my project" as early as 1776),[2] the idea of replacing the Luxembourg with something more substantial preceded the start of his administration in 1774 by some years. For many, indeed, the Luxembourg seems never to have been more than a provisional arrangement that in time would give way to a final presentation of the royal collection in the Louvre. It should be recalled that since the mid-seventeenth century, dating from Poussin's proposal to decorate the vault of the Grand Gallery with casts of famous Roman antiquities, the Louvre had been the prime location for a ceremonial display of art.[3] Bernini, invited to Paris in 1664 to submit designs for the completion of the Louvre, also planned to display a portion of the king's collection in the palace.[4] But, of course, the royal collection followed Louis XIV to Versailles where many of the best pictures remained in the state apartments until the Revolution.[5] Through the eighteenth century it was hoped that the king would return to Paris and bring his art with him. The vision of a museum in the most famous of Parisian palaces died hard.[6]

There is some evidence that the Marquis de Marigny had interests in that direction. In 1755 word circulated that Marigny wanted to turn the Galerie d'Apollon into a museum.[7] In the following decade other more grandiose rumors surfaced, including the following reported by Reboul:

There is word of a grand and magnificent project which would form the most beautiful temple of the arts the world has ever seen. It is said the king's library will occupy the part of the old Louvre which borders the river; the Apollo gallery will be restored while the Salon, where the paintings are exhibited, will be suitably decorated; the collections of medals, engravings, and natural history [given by Pajot d'Onsenbray], as well as the king's precious picture collection, will be housed *en suite* in the immense gallery of the Louvre, displacing the scale-relief models which will be moved to the Ecole Militaire.[8]

Like La Font before him, Reboul invoked the authority of an anonymous public in support of an idea that was gaining currency. His report may have been a rhetorical device, yet it is clear that by the 1760s there was a groundswell of opinion in favor of seeing the Louvre transformed into a museum – not just a museum of the visual arts but one embracing multiple fields of knowledge. Significantly, the *Encyclopédie* endorsed the idea in its article on the Louvre.[9] Together with the utopian museum designs of Boullée (Fig. 5) and his contemporaries, these verbal evocations testify to the profound interest in the possibility of institutionalizing and displaying knowledge in the age of Enlightenment.

Even assuming a museum in the Louvre was on the list of Marigny's goals, he lacked the means to create even a fraction of what Reboul and others had in mind. Almost from the start his administration was starved of

funds for all but the most pressing projects (the Petit Trianon and the Place Louis XV), first by the Seven Years' War and then by an ambitious minister of finance, the Abbé J.-M. Terray. Appointed in 1769, Terray also had his eye on the directorship of the Bâtiments and to that end did his best to obstruct Marigny's plans. Bâtiments finances had been so severely depleted by the early 1770s that the Academy was threatened with closure: there was no money for a live model for advanced students, to heat artists' studios, or to pay for their supplies.[10] Shortly before he resigned in the summer of 1773, Marigny found himself unable even to order long overdue repairs to the leaking roof over the Grand Gallery. He wrote with resignation to the architect Soufflot: "I have been informed more than once in recent years of the poor state of the gallery roof. . . . But the total lack of funds has prevented me from ordering the needed repairs."[11]

In July 1773 Terray added the title of director general of royal buildings to his responsibilities as minister of finance. The change in administration brought forth new injunctions to create a museum in the Louvre.[12] By September Terray had been persuaded to go forward with a new museum in the Grand Gallery.[13] Work was set to begin in April 1774, but a month later Louis XV died and Terray fell from grace.[14] In August the position of director general passed to d'Angiviller.

Charles-Claude Flahaut de la Billarderie, Comte d'Angiviller, owed his appointment to the Bâtiments to his close relationship with the new king.[15] Following a brief though distinguished military career, d'Angiviller was made gentleman of the sleeve by the dauphin, by whose side he had bravely fought at the battle of Fontenoy (1745). In that capacity he was entrusted with the education of the royal princes, including the Duc de Berry, the future Louis XVI. D'Angiviller's years of faithful service were rewarded with the Bâtiments post on August 24, 1774. On the same day his good friend the physiocrat economist A.-R.-J. Turgot, was made *controleur-général des Finances*. Though nothing in d'Angiviller's past prepared him for his new responsibilities – he came from pure military stock and, unlike Marigny, had not been groomed in the arts – he proved an excellent civil servant, efficient, imaginative, and above all devoted to the king. Of all the eighteenth-century directors of the Bâtiments, he alone merits comparison with Colbert.

D'Angiviller turned his attention to the museum in 1776, though he had declared his intention of picking up where Terray had left off within months of taking office.[16] The museum project had the backing of the king and Turgot, whose friendly intentions were secured through his election to the Academy of Painting as "honorary amateur" as early as September 1774.[17] The financial difficulties that had stifled Marigny's initiatives evaporated – at least for the time being.

The first problem to be addressed was the conversion of the Grand Gallery into a space suitable for the public display of art. Since the late seventeenth century, the long gallery linking the old Louvre with the Tuileries Palace, measuring over 1,300 feet in length, was home to the famous scale-relief models of the fortified towns and harbors of France (Fig. 23). By the mid-eighteenth century the number of models had risen to 127, and they were highly valued for strategic and political reasons.[18] The Galerie des plans, as it was known, was the preserve of the minister of war, and permission to enter it was customarily restricted to high-ranking courtiers and visiting heads of state. The secret nature of this space combined with the observation that the models would be better utilized close to the Ecole Militaire fueled public demands to see the gallery turned into a museum.[19] Overcoming the objections of the then minister of war, the Comte de Saint-Germain, a sure sign of the king's favor, d'Angiviller had the models removed to the Invalides in the winter and spring of 1776–7.

In anticipation of a successful evacuation, the architect Soufflot, one of the *intendants généraux* at the Bâtiments and d'Angiviller's principal architectural adviser, was asked in October 1776 to draw up plans for the transformation of the Grand Gallery.[20] Repeated visits to the Louvre in the company of his pupil Maximilien Brébion led Soufflot to conclude that there were three main questions that needed to be resolved: Should the space be subdivided into smaller units or left as it was? Should Poussin's unfinished decoration in the vault be preserved? and, How should the gallery be lighted?[21] These questions, particularly the third, gave rise to a debate involving most of the art world that would run for close to a decade and contribute heavily to the undoing of d'Angiviller's Louvre project. The saga

Figure 23. Louis-Nicolas von Blarenbergh, *Choiseul Box.* 1770–1, Galerie des plans, Parıs.

was certainly in keeping with the indecisiveness that characterized the last years of the Old Regime. But at the same time the debate was prolonged because of the difficult challenge facing all concerned to determine criteria for the display of art in what was essentially a new building type: the public museum. D'Angiviller made perfectly clear that this was to be no ordinary picture gallery. In his own words, it was to be "a monument unique in Europe"; and, as he informed the architects of the Royal Academy, the king himself wanted nothing short of perfection in its design.[22] As mentioned in the Introduction to this book, this obsessive pursuit of perfection was no small factor in preventing the museum's completion before 1789.

Soufflot's report sat on d'Angiviller's desk for almost a year. Following the Salon exhibition in September 1777, the eight history paintings the king commissioned for the event were hung in the Grand Gallery in order to test the quality of available light from the windows on either side.[23] The easternmost section of the gallery, adjoining the Salon carré, was chosen for the experiment because the light was poorest there, owing to the irregular spacing of the windows (the spaces between them varied from 26 feet in the eastern section to roughly 16 feet in the west). With pictures in place, the architects Charles de Wailly and Charles-Louis Clérisseau were invited along with Brébion and Soufflot to give their opinions on the questions raised in the latter's first report. In March 1778 a second of the *intendants généraux,* Michel-Barthélémy Hazon, was also asked for his advice.

Joint consultation among the five in the spring of 1778 produced mixed results. A majority decided against any division of the gallery. Although an initial study of the plans (such as the one in Fig. 22) inclined the architects to think the space too long and monotonous for its purpose, the sight of the gallery itself changed their minds. The architect Charles-Axel Guillaumot, who was later brought into the decision-making process, recalled the excitement he and his colleagues felt on entering the Grand Gallery for the first time:

When we first saw the gallery plans at the Academy, we were virtually all agreed that some division of the space would be necessary. We differed only on the number of divisions that would be needed to create compartments comparable in dimension to existing picture galleries. . . . But once we had seen the gallery space with our own eyes a unanimous cry went up against altering in any way the spectacle of immensity that first meets the eye.[24]

It is precisely that "spectacle of immensity" that Hubert Robert captured in his numerous imaginary views of the museum, the first of which probably dates from the late 1780s (Fig. 24).[25] D'Angiviller agreed with the majority that the grandeur of the architecture and the unrivaled monumentality of the space would enhance the overall effect of the museum.[26]

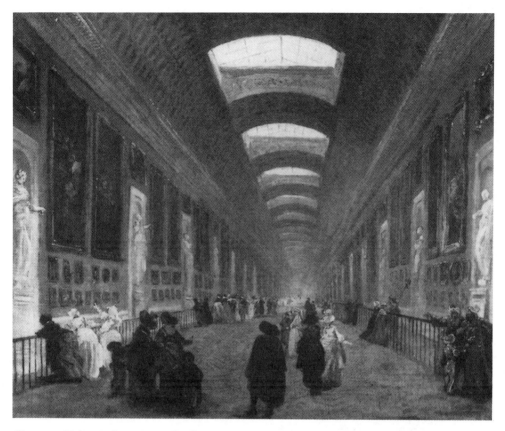

Figure 24. Hubert Robert, *Project for the Arrangement of the Grand Gallery of the Louvre.* Oil on canvas, 1780s, Musée du Louvre, Paris.

As for the ceiling, there was reluctance to see Poussin's original decoration (partially visible in Fig. 23) destroyed, even though it was in an unfinished state and had greatly deteriorated. However, it was decided that it could not be continued successfully throughout the gallery, and, even if it could, that it would detract from the works of art displayed below. Anticipating the modern museum in which the objects on display are allowed to speak for themselves, d'Angiviller insisted on only minimal decoration of the gallery's walls and ceiling.[27] Even the new frames ordered for the museum were characterized by elegant, neoclassical restraint.[28] Poussin's ceiling was also a great fire hazard, and, as the director general noted, if there should be a fire "nothing in the world could compensate for the loss."[29] The gallery's existing wooden barrel vault was rebuilt and lined with Burgundy brick (Fig. 25), and a network of trusses and struts was

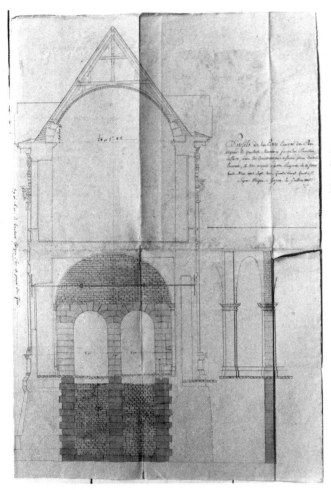

Figure 25. Grand Gallery of the Louvre, Section. Drawing, 1784, Archives Nationales, Paris.

introduced above to keep the inner vault away from the pointed roof.[30] Lighting rods were added as an extra precaution.

By far the most difficult of Soufflot's three questions concerned the gallery's lighting. The first impressions of those to visit the Louvre produced a wide range of responses; indeed, no two architects came up with the same solution. Soufflot, initially in favor of relying on light from the original windows, eventually voted for some form of top lighting. De Wailly seconded the idea of top lighting, but only in the western section of the gallery because he wanted to preserve Poussin's decoration. Clérisseau wanted intermittent top lighting throughout, but he also wanted to preserve and continue the Poussin frescoes. Hazon, meanwhile, worried that openings in the vault would ruin the external appearance of the gallery and thought

widening the existing windows was the answer. And Brébion, from early on the voice of conservatism, decided that nothing needed to be done at all.[31]

No doubt disconcerted by such an array of opinions, d'Angiviller appointed a committee of five architects, the *intendants généraux,* Soufflot, Hazon, and Richard Mique, together with Brébion and J.-F. Heurtier, the painters J.-B.-M. Pierre and Hubert Robert, and the sculptor A.-J. Pajou, to arrive at a consensus. All but Brébion and Hazon agreed on the necessity of bringing in light from above. The former argued that it was unnecessary and that it would add 1,500,000 *livres* to the 500,000 *livres* he estimated it would take to frame the pictures and decorate the gallery.[32] D'Angiviller was not prepared to settle the matter himself; it was too important to be decided by decree. But no sooner had Brébion delivered his dizzying estimate than France entered the American Revolution and d'Angiviller's budget was slashed. The question of lighting had to wait. During the war attention turned to more mundane structural repairs to the fabric of the gallery. The only significant innovation was the construction of a new staircase, designed by Soufflot, leading up to the Salon, which was to serve as the vestibule to the museum.[33]

Weighing against Brébion's financial prudence was d'Angiviller's explicit desire to make the Louvre the grandest, most modern gallery of its kind. In the view of the majority, such an ambition entailed lighting from above.

The benefits of top lighting in spaces dedicated to the display of art had been recognized in theory since antiquity. No less an authority than Vitruvius included a top-lighted *pinacotheca* in his treatise *De architectura,* widely known in France through Claude Perrault's edition of 1673. In the course of the eighteenth century several top-lighted spaces had been added to well-known Parisian collections, notably the Lantern Cabinet at the Palais Royal and the Duc de Choiseul's Octagon Room at the Hôtel Crozat de Châtel.[34] According to Soufflot, writing shortly before his death in 1780, those spaces had "so dazzled some artists that it seems one won't be able to display paintings in apartments that aren't lighted from above."[35] Once the issue had been raised in connection with the Louvre, other top-lighted galleries began to appear in Paris, putting still further pressure on d'Angiviller.[36] The architects Mique and Hazon, to whom the director general turned for further advice immediately following Soufflot's death, put the matter simply:

If you don't find the expense too great and provided you are willing to delay the opening in order to realize the gallery's full potential, our preference is for top-lighting. The effect of light which illumines all objects equally seems to us far superior to that which results from the existing windows.[37]

On a theoretical level there was nothing further to say, but, as their letter

implies, d'Angiviller had yet to decide if the anticipated benefits outweighed the costs – and the risks. What if top lighting the Grand Gallery proved a disaster? The effect in a space of such unusual dimensions was unpredictable. Soufflot's death only added to the confusion. When he died he was firmly resolved in favor of lighting the gallery from above; his modified design featuring a glazed attic was still on the table.[38] D'Angiviller's trust in Soufflot was such that had he lived top lighting might well have been introduced in the course of the 1780s. As it was, his place as architect of the Louvre and as d'Angiviller's chief adviser was taken by Brébion, a man of considerably less talent and narrow vision. Brébion was opposed to fancy new lighting schemes from the start and was no doubt responsible for persuading the director general that top lighting was an unnecessary and costly luxury. It was Brébion who supervised the construction of the new brick vault during the slow years of the war, an initiative that seemingly settled the question of how the gallery would be lighted. Evidently d'Angiviller had been persuaded, if only temporarily, that an imperfect museum was better than no museum at all.[39]

The end of the American conflict changed matters, however. Peace brought optimism and a much improved economic outlook. In 1783 the king promised the Bâtiments an impressive 13 million *livres* spread over six years.[40] Suddenly the cost of top lighting the museum seemed less of an obstacle. This infusion of money prompted renewed calls for bringing light into the gallery from the vault, and d'Angiviller himself was moved to confess that he had regretted having to abandon the idea in the first place.[41] Late in 1784 the director general commissioned the architect Jean-Augustin Renard to make a fresh study of the problem. Renard, an Academy outsider, was probably chosen because he had yet to be tainted by the gallery debate and was without allegiances to those already involved.[42] In July of the following year he submitted two designs. The first, recalling an early plan by Soufflot, proposed piercing lunettes in the flanks of the vault just above the cornice. The second featured a series of twenty-nine skylights placed at regular intervals along the spine of the vault, similar to the arrangement in Robert's imaginary views (Fig. 24).[43] The former had the advantage of being cheaper and involved the destruction of less of the new brick vault, but the latter was more exciting. D'Angiviller, again unwilling to cast the decisive vote, turned the designs over to the Academy, which liked neither. In May 1786 the Academy put forward its own proposal for a set of rectangular skylights along the summit of the vault but, at the same time, preserving the windows looking onto the Seine.[44] According to Guillaumot, this new plan was in turn passed on to an unidentified artist in whom d'Angiviller had "great confidence." That artist, perhaps Charles-

Nicolas Cochin, or possibly Brébion, found fault with the Academy's proposal and offered other ideas.[45]

Confounded once more by a failure to arrive at a consensus, d'Angiviller put the question to yet another committee. On March 13, 1787 the architects Mique, Hazon, C.-A. Guillaumot, Boullée, Heurtier, Brébion, J.-D. Antoine, N.-H. Jardin, and J.-A. Raymond were asked to decide once and for all what should be done.[46] In under a month, by a majority of eight to one (Brébion alone dissented), they ratified the Academy's report of the previous year. The committee traveled to a number of top-lighted spaces in Paris, including Germain Boffrand's Communion Chapel at the church of St. Merri (Fig. 26) and the gallery of the dealer J.-B.-P. Lebrun, where they were struck by "the beauty of the light and the advantage of being able to see all of the paintings equally well." They concluded that light from directly overhead was the only acceptable solution for the Grand Gallery.[47] Despite the fact that they had disregarded explicit instructions to consider

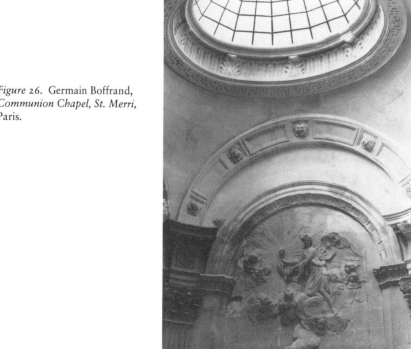

Figure 26. Germain Boffrand, *Communion Chapel, St. Merri,* Paris.

only alternative schemes for side lighting, the director general accepted their decision and considered the issue closed.

In 1788, after a further year's delay, Renard was finally told to prepare plans for the installation of lanterns in the summit of the vault. It was at this point, incredibly, that a proposal was put forward to replace the wooden framework of the roof with cast iron.[48] Once again the quest for perfection halted progress. The result of this latest plan would have been a forward-looking structure of glass and iron, but as events would reveal, the summer of 1788 was no time for expensive innovations. Consideration of the new scheme spelled further delays. D'Angiviller had always been attentive to the resources of his department: besides having the ear of the king, he had also maintained good relations with successive ministers of finance; and he was not above liquidating royal dependencies, including significant châteaux, in the interests of his favorite projects.[49] By 1788, however, he was forced to reckon with the nation's financial crisis. A year earlier he had been accused by the Assembly of Notables of contributing to the financial ruin of the state through his expenditure on the arts.[50]

Although circumstances postponed work on the gallery, d'Angiviller remained optimistic and welcomed a suggestion by Guillaumot in October 1788 to rehearse the problems of top lighting by building a lantern of iron and glass over the Salon (Figs. 27). Relatively inexpensive and straightforward in construction, the lantern would allow the public to judge the effect on paintings of light from above. Despite objections and further interference from Brébion, the project received royal approval and the lantern was constructed under Guillaumot's supervision in time for the Salon of 1789.[51] The lateral windows were blocked up and the lantern became the only source of light. A report to the king in November proclaimed the experiment a great success and added that "the public grows impatient to see the gallery lighted in the same manner."[52] As it happened, d'Angiviller, fearing for his safety after the fall of the Bastille on July 14, had fled the country by the time the Salon opened. He returned in January 1790 but emigrated again just over a year later, this time for good. The fate of the Louvre was left to the Revolution. Not surprisingly, when the museum opened to Revolutionary fanfare in 1793 the director general's efforts were nowhere acknowledged. D'Angiviller died a virtual recluse in 1809 in the small town of Altona near Hamburg. To the end he remained a loyal servant of the Crown.

* * *

D'Angiviller often referred to the museum as a "national" monument, one that would accrue fame and glory to France and the king. The imposing structure of the Grand Gallery was to do much of that ideological work,

*Figure 27. Salon Carré of the
Louvre, Section.* Drawing,
Archives Nationales, Paris.

but equal emphasis was placed on the objects that were to be displayed
there: the royal collection of art. Already the greatest princely collection in
Europe, d'Angiviller significantly enhanced its prestige. Between 1775 and
1789 over 200 new paintings were acquired, many of them masterpieces
that occupy pride of place in the Louvre collection to this day. If we add to
that number the dozens of history paintings and Great Men statues commis-
sioned by the Crown and destined eventually for display in the museum, the
debt to d'Angiviller is greater still.

In close to fifteen years the director general spent roughly one million
livres building up the royal collection.[53] Most of the money went toward
Old Master paintings and drawings but a sizable amount was also spent on
bronze and porcelain *objets,* including a specially commissioned set of
Sèvres vases destined for the Grand Gallery.[54] Total expenditure on art for
the museum rises to 1,500,000 *livres* when we include the amount paid out
to living artists every two years beginning in 1777 for the eight history
paintings and four Great Men.[55] Such largesse was in marked contrast to
Marigny's impoverished final years in office. If Marigny had ambitions to

create a museum in the Louvre it was to be without new works of art. In 1771 he had watched the Crozat collection leave France for Russia, bought by Catherine the Great. Two years later he was forced to admit to a tax farmer from Blaye, who was hoping to sell the king several of his pictures, that he lacked funds for even modest new acquisitions.[56]

The royal collection, strong in number at just over 1,800 pictures, was relatively weak in Northern and French painting, and it was primarily in those areas that d'Angiviller concentrated his buying.[57] Some Italian painting was acquired but it was less of a priority; it was also becoming hard to come by, and as fine Italian pictures grew scarcer the risks of buying fakes and copies increased.[58]

It seems that an official policy on new acquisitions was never formulated beyond the need to buy in certain areas when the opportunity arose. Two determining criteria emerged: quality and rarity. Then as now, the "ideal" purchase was a painting deemed of excellent quality and condition by an artist not already well represented in the king's collection. Also then as now, a distinguished provenance could enhance a picture's allure. A good example is Pietro da Cortona's *Reconciliation of Jacob and Laban* (Fig. 28), which had belonged to the Prince de Conti and the Comte de Vaudreuil before it was purchased for the Louvre for a staggering 35,901 *livres*. Whenever possible d'Angiviller bought pictures of the first rank as they came onto the market, and he was prepared to pay a top price, as at the Vaudreuil sale in 1784 where, in addition to the Cortona (the single most expensive painting bought at auction in France in the eighteenth century), he outbid competition for such masterpieces as Rembrandt's *Portrait of Hendrikje Stoffels,* Rubens's *Helena Fourment and Her Children,* and Bartolomé Murillo's *The Beggar's Toilet.*[59] At the same time, however, as much if not more attention was paid to buying representative works by artists of lesser stature, often for very little money. Louis de Boulogne's *Marriage of Saint Catherine,* for example, was bought for just 125 *livres* in 1777.

Time and time again during the 1780s, when the bulk of picture buying was done both abroad in the Low Countries and at the spectacular Parisian sales that highlighted the final years of the *ancien régime,* d'Angiviller's agents exercised great discretion, buying only masters previously unrepresented in the royal collection or pictures of superior beauty.[60] At the Chastre de Billy sale of 1784, for example, the Crown acquired paintings by an assortment of interesting, lesser-known Lombard and Bolognese masters – Carlo Cignani, Giuseppe Crespi, Donato Creti, Filippo Lauri, Giulio Cesare Procaccini, and Bartolomeo Schidone – all for a mere 11,769 *livres.*[61] A further 11,000 was spent the following year at the Biroust sale on paintings attributed to Schidone, Francesco Vanni, Albrecht Dürer, Bernini, and Parmigianino.[62] The Flemish dealer Bosschaert, with whom d'Angiviller had

Figure 28. Pietro da Cortona, *Reconciliation of Jacob and Laban.* Oil on canvas, 1630–5, Musée du Louvre, Paris.

frequent dealings, showed that he understood the importance of rarity when he commended the director general on his recent purchase of works by Gaspard de Crayer. By displaying his works at the Louvre, Bosschaert wrote, that excellent painter, "unjustly neglected until now," would be "raised from obscurity."[63] D'Angiviller must also be credited with a precocious interest in collecting Spanish art. During the 1780s five Murillos were bought from Paris collectors, and he hoped to find others. In 1779 he wrote to Charles-François de La Traverse, a former pupil of François Boucher then in the service of the French ambassador in Madrid:

I know there must be paintings by the great masters lost and forgotten in the attics of Spain, which the dealers have yet to explore. It occurred to me that one ought to be able to find inexpensive Titians, Velazquezs, Murillos, etc., which would enhance the king's magnificent collection at little cost. Please let me know if you foresee being able to find . . . any paintings or other curiosities.[64]

The evidence thus suggests that d'Angiviller's acquisition policy differed little from that of major museums today. Within budgetary constraints, the aim was to buy the best possible works of a wide range of recognized Old Masters; the better known the artist, the more examples of his work were collected. The final goal was to display the evolution of significant painting

from the Renaissance to the present.

These desiderata seem self-evident today, but in the late eighteenth century, at the dawn of the museum age, the priorities of a national museum were clear only to those closely involved with the Louvre project – at least to judge by much of d'Angiviller's correspondence on the subject with the general public. Once it was known that the king intended to create a new museum and, to that end, to buy new works of art, the Bâtiments received many offers of pictures from all over France, and beyond.[65] Frequently d'Angiviller found himself having to explain what the museum was about and the kind of art that was appropriate to hang on its walls. Clearly the public had little preconception as to either. In response to an offer from the Comte de Marenil of a portrait of a dog dating from the reign of Henry IV, the director general wrote, "The goal in establishing a royal picture gallery is not to assemble every painting that might be relevant to French history, but rather to collect only works by the great masters."[66] In 1785, he replied to one Liotard, who had sent a list of pictures for sale:

Certainly there are several entries which indicate paintings of great merit but that is not enough. Paintings by great masters are sometimes from their weakest periods, or they might be damaged or repainted, so that only careful examination can determine if they have sufficient merit to enter the king's picture gallery.[67]

More often than not a proper inspection of pictures submitted by hopeful owners proved they were neither "precious enough nor sufficiently well preserved to enter His Majesty's collection, which admits only works of rare beauty and in excellent condition."[68] We are reminded that the world of collecting stretched well beyond the circle of amateurs clustered around the Royal Academy in Paris.

As director general, d'Angiviller took responsibility for standards of quality and conservation in the royal collection, but the work of enforcing those standards was carried out by the first painter, Jean-Baptiste Pierre, Hubert Robert, appointed keeper of the king's pictures in 1784, and the dealer Alexandre-Joseph Paillet. It was they who inspected unsolicited pictures, previewed sales, and traveled abroad in search of good buys. Of the three, particular credit must go Paillet, who through his extensive contacts and experience as a dealer facilitated many of the most important acquisitions made by the king. His services were invaluable, and d'Angiviller's dependence on him underlines the extent to which dealers had by the third quarter of the century become essential middlemen in the picture trade.[69]

How Paillet first came into contact with the Bâtiments is unclear. He had been well established as a dealer for nearly a decade when he bought his first picture on the Crown's behalf at the Randon de Boisset sale in March 1777.[70] The relationship was cemented a month later at the auction of the

Figure 29. Louis Le Nain, *The Forge.* Oil on canvas, Musée du Louvre, Paris.

Conti collection when he found himself bidding against Pierre for Louis Le Nain's *The Forge* (Fig. 29). Though d'Angiviller had sent Pierre to the sale with instructions to buy the Le Nain at any cost, indeed to intervene with the auctioneer, Pierre Rémy, if necessary, it went to Paillet. After subsequent negotiations, however, Paillet agreed to pass the picture on to the king for what he had paid for it.[71] Putting the interests of the state above one's own was the kind of behavior that appealed greatly to d'Angiviller, as Paillet no doubt understood. Acknowledging qualities that were apparently hard to come by in the world of dealing, the director general was later to describe Paillet to Louis XVI as possessed "of a loyalty and disinterest virtually unknown in his profession."[72] To add to his character, he was a skilled dealer. He had proven himself adept in the sale room (where Pierre was clearly out of his element), and it was through public auctions that the best pictures were to be had. On the occasion of a well-publicized sale involving paintings of unquestioned pedigree, d'Angiviller could specify in advance what he wanted, as he did at the Conti sale. But for the most part Paillet and Pierre were responsible for selecting new paintings based on firsthand assessment of quality, authenticity, and condition.[73] It was surely Paillet's expert eye, for instance, that secured the rare paintings at the Billy and

Biroust sales. By 1784 it was Paillet who was now advising d'Angiviller what to buy from two upcoming sales that he himself was handling.[74]

Paillet also did much buying for d'Angiviller abroad, especially in Belgium, and there the decision to buy was his alone. Paillet went with Pierre to attend the sales in Brussels, Ghent, and Antwerp following the dissolution of religious houses in 1777. Credit of 120,000 *livres* was arranged with a banking house in Brussels, but the sales were disappointing. Catalogues (not illustrated as they are today) distributed in advance proved misleading, and Joseph II bought up the best of what there was.[75] Paillet stayed on in Belgium buying mainly for himself, but he did manage to secure one masterpiece for the king: Rubens's *Adoration of the Magi* (Fig. 30), bought from the Church of the Annunciation in Brussels for 27,770 *livres*.[76] After a break due to the American Revolution from 1778 to 1782, during which time buying was suspended, Paillet traveled regularly to the principal cities in northern Europe in search of pictures, both for himself and for the king. Between 1783 and 1788 he went to Holland no fewer than four times, London twice, and Belgium once, and never did he return empty handed.

On occasion d'Angiviller negotiated with other middlemen – Lebrun in

Figure 30. Peter Paul Rubens, *Adoration of the Magi*. Oil on canvas, 1626–9, Musée du Louvre, Paris.

Paris and P.-J. Sauvage and Bosschaert in the Low Countries (the latter went to Dusseldorf in an unsucessful attempt to buy the Elector of Palatine's gallery!) – but whenever possible he dealt with Paillet.[77] Lebrun was arguably the most successful dealer in Paris, but the director general considered him untrustworthy and thought he charged too much for his services.[78] For his part, Lebrun openly resented the preferential treatment given to his rival, and perhaps with reason. He accused d'Angiviller of using his influence to secure for Paillet responsibility for two important sales in the 1780s (the Aubert sale in 1786 and the Watelet sale in 1787) that he felt rightly belonged to him.[79] Whether or not d'Angiviller used his influence on those occasions, it was clearly to his advantage to have Paillet conducting sales at which the Crown intended to buy (as at the Watelet sale). Moreover, at least once and perhaps as a matter of course, Paillet declined the standard 10 percent buyer's commission when dealing with the Bâtiments.[80] In return for his services he received the benefits of association with the king, which would have been useful when traveling abroad and no doubt helped business at home.[81] Paillet continued to serve the Crown until the Revolution. We last hear from him in 1790 when he implored the director general to prevent the Orléans collection from leaving France. "It would add to the magnificence of France," he wrote in desperation, "to secure 20 or 30 of the best works for the king's museum. . . ." Assuming the king had had the money, the choice would have been a difficult one.[82]

A good number of French paintings were bought for the museum at public auctions, including some highly important recent works, such as Carle Van Loo's *Aeneas and Anchises,* from the collection of La Live de Jully, Joseph-Marie Vien's *Sleeping Hermit,* and Jean-Baptiste Greuze's *Village Betrothal* (Fig. 31), previously owned by Marigny. Drawings were also bought in large number, among them studies by Poussin, Eustache Le Sueur, Pierre Puget, Watteau, Bouchardon, and Pierre Peyron.[83] But the market could not be depended on to fill the glaring gaps in the Louvre's French holdings. D'Angiviller needed movable pictures, preferably history paintings by leading French artists, and he needed them fast. He decided that if such paintings could not be had through conventional channels, he would have to pursue them where they could be found in abundance: on the walls of Parisian hôtels and churches. That they might be *attached* to those walls or serving a useful purpose did not deter him: the art of transferral and the powers of royal persuasion would easily transform them into gallery pictures for the Louvre.

The director general declared his patriotic intent through his very first acquisition for the Louvre in 1775 – an extraordinary ceiling painting measuring 22 by 18 feet by Jean Jouvenet (now lost) from the Hôtel de Saint-Pouange in Paris. The hôtel was soon to be demolished and its owner, the

Figure 31. Jean-Baptiste Greuze, *Village Betrothal.* Oil on canvas, 1761, Musée du Louvre, Paris.

Marquis de Chabanais, had agreed to sell the painting (along with others) to the restorer J.-L. Hacquin. The latter in turn arranged to resell the picture to the dealer Lempereur once it had been transferred to canvas. D'Angiviller learned of the deal and sent Pierre to intervene on behalf of the king, remarking that he was not about to pass up "this work by one of the greatest painters of the French school."[84] In terms of size the painting was suited to the vast space of the Grand Gallery; it is harder to imagine what Lempereur had in mind for it. Most remarkable was the fact that no one batted an eyelash about Hacquin's transferral of the picture from ceiling to canvas. The operation would have been inconceivable a few decades earlier.

D'Angiviller followed this initiative with an even bolder move. In June 1776, after protracted negotiations, he persuaded the Carthusians of Paris to part with the celebrated cycle of paintings of the life of Saint Bruno by Eustache Le Sueur (Fig. 32). Dubbed the "French Raphael," Le Sueur had acquired a stature in eighteenth-century taste second only to Poussin's, and the Saint Bruno pictures were far and away his most famous works.[85] Their fame extended throughout Europe, making them prime representatives of the French school in painting. Horace Walpole went out of his way to see them in 1771, and on a visit to Paris in 1783 they were singled out by Baron Friedrich von Ramdohr (along with Rubens's Medici cycle) as the paintings in the royal collection he most wanted to see.[86] D'Angiviller

described their acquisition as a matter of national importance. He wrote to Louis XVI that the Le Sueurs were a part of the nation's heritage that he intended to preserve and glorify at the Louvre by displaying them alongside the "productions of foreign genius."[87]

While negotiations with the Carthusians were under way, d'Angiviller also managed to buy the celebrated decorative paintings by Le Sueur from the Cabinet des Amours and the Cabinet des Muses of the Hôtel Lambert. These works he described to the king as "perhaps the most splendid of the French school."[88] Before 1776, the Crown possessed only one easel painting attributed to Le Sueur (subsequently reattributed to Simon Vouet), but in the space of a month d'Angiviller had assembled nearly three dozen of his best works. Acquisition of the Le Sueurs was announced in both the *Mercure de France* and the *Gazette de France,* prompting praise and numerous offers of French pictures.[89] This early round of patriotic picture buying might well have been continued had the start of the war not curtailed Bâtiments expenditure (future purchases of French pictures were to be of a

Figure 32. Eustache Le Sueur, *Saint Bruno Investing Followers with the Habit of the Order.* Oil on canvas, 1645–8, Musée du Louvre, Paris.

more modest nature). Nonetheless, d'Angiviller had succeeded in underlining the national character of his museum.

<p style="text-align:center">*　　*　　*</p>

What the three lots of French pictures had in common and indeed what made it possible for d'Angiviller to acquire them for the Louvre were the skills of the restorer Hacquin. It is a mark of how accepted restoration techniques, particularly transferral, had become by 1775 that despite the publicity surrounding the Louvre and its new acquisitions no mention is made of the fact that all of the above paintings owed their survival to what only a quarter of a century earlier had been hailed as a miraculous invention. When Walpole saw the Saint Bruno pictures in 1771 he lamented that "one gazes at them as at a setting sun" and prophesied their eventual ruin. But d'Angiviller knew that they could be transferred from wood to canvas and given a new life. In the case of the Jouvenet and the Le Sueurs from the Hôtel Lambert, Hacquin transformed them from inset decorative panels to gallery pictures. Thus restoration made possible important acquisitions that would have been unthinkable before while it enabled d'Angiviller to take credit for preserving monuments prized by patriotic amateurs. Just a half century earlier an early apologist of the French school, Abbé Simon Mazière de Monville, could offer only engraving as a consolation for the recent loss during renovations at Versailles of a frescoed ceiling by Pierre Mignard, which "couldn't be saved despite efforts to do so."[90]

Beyond the need to display the king's pictures in good condition, a concern inherited from the Luxembourg Gallery, d'Angiviller was inspired by a vision of a museum in which time might be suspended and the art of past, present, and future preserved for posterity.[91] The Enlightenment belief in the power of science and conservation to defy natural decay was at once represented and embodied in a curious allegorical painting of 1783 by J.-J. Lagrenée the Younger showing Immortality receiving a portrait of the director general from Painting, Justice, and Charity. Behind Immortality the genius of the arts raised a curtain to reveal other geniuses hanging the Grand Gallery with pictures. Like the Louvre itself, it was a subject "worth preserving for posterity," according to Lagrenée, and to that end the surface of the picture had been stuck to glass to prevent contact with air.[92] The painting was given to d'Angiviller as a tribute to his efforts to create the museum. Unfortunately (and ironically), the painting has not survived, but in its central conceit of the museum's triumph over time, it was similar in spirit to (and could possibly have been inspired by) Anton Raphael Mengs's allegorical fresco of 1772 commemorating the creation of the Museo Pio-Clementino in Rome.[93]

The recent discovery of well-preserved ancient paintings at Herculaneum

had sharpened an awareness of how much had been lost to the march of time and fueled the fear that just as most ancient painting had not survived to the present, so recent and contemporary art was destined to deteriorate.[94] That fear, a dark side of Enlightenment thought, was dramatized in Robert's pendant views of the Grand Gallery in ruins (Fig. 33). By the eighteenth century it was widely believed that the great paintings of the Renaissance were in the process of deteriorating (this was one of the reasons for making students in Rome copy the Old Masters in oil).[95] The century witnessed growing interest in new and not so new methods of safeguarding art against the elements. The famous mosaic altarpieces of St. Peter's took on added significance, for example, and in 1786 a proposal was put forward to establish a mosaic workshop in Paris "similar to the one in Rome whose purpose is to convey the masterpieces of painting to posterity."[96] Encaustic painting was revived in good part for the same reason.[97] To these ancient practices must

Figure 33. Hubert Robert, *Imaginary View of the Grand Gallery in Ruins.* Oil on canvas, 1796, Musée du Louvre, Paris.

be added a host of experimental techniques, now unknown and forgotten, pioneered in the second half of the century in the interests of conservation.[98]

Through encouragement of such experiments, d'Angiviller demonstrated his own interest in mobilizing science for the benefit of art as well as the Crown's concern for the welfare of the nation's artistic patrimony. In addition, with the help of his able secretaries, J.-F. Montucla and C.-E.-G. Cuvillier, he rationalized restoration procedures at the Bâtiments. The director general did away with the custom of pensioning restorers, leaving him free to employ only the most talented on a free-lance basis.[99] No restorer was to be employed whose techniques had not first been tried and tested to the approval of the Academy. When in 1775 J.-M. Picault refused to divulge his "secret" of transferral, d'Angiviller turned to Hacquin.[100] Henceforth the government would be in the forefront of developments in restoration techniques. By the Revolution, standards of restoration in France were perhaps the most advanced in Europe.

Attitudes toward restoration and conservation shed light on ways in which art was viewed in the late eighteenth century, an aspect of contemporary aesthetics with clear bearing on the museum and too little understood by art historians today. The same tendency in aesthetic appreciation that gave new-found importance to drawings, bozzetti, and the question of finish in both painting and sculpture was carried over to the reception of Old Master paintings (and antique sculpture). Technical effects, traces of brush and chisel, the efficacy of glazes and varnishes, all became the stuff of connoisseurial discourse in the late eighteenth century. Connoisseurship of this sort presupposed close scrutiny of the work of art in a pristine state. In this regard, too, d'Angiviller's correspondence with collectors provides fascinating insights into the aesthetic preoccupations of the art world. As already mentioned, conservation was an important consideration in the acquisiton of new pictures for the museum: only those judged in top condition were suitable for admission. Conservation was recognized as one of the standards with respect to which the supremacy of the Louvre would be measured. When the gallery opened, flooded with strong zenithal light, all the paintings on display would have to be consistently clean and well restored. Indeed the connection between top-lighting and conservation was made explicit by d'Angiviller's final museum committee in 1787.[101]

Of the many pictures offered to the Crown for the museum, more were turned down on grounds of conservation than poor quality or doubtful authenticity. It is clear from d'Angiviller's correspondence that standards in the larger world of collecting varied considerably and often left much to be desired. Paintings occasionally arrived at the Bâtiments in such poor condition that d'Angiviller insisted that they be restored before an offer could be considered. In 1776 he replied to a dealer in The Hague who was looking to

unload a painting attributed to Phillips Wouwerman: "It is so dirty and covered in smoke that its worth cannot be judged. . . . I have ordered that it be cleaned by a reliable hand and once that has been done I will inform you of my decision."[102]

After cleaning the picture was determined to be of inferior quality. Some years later d'Angiviller replied more bluntly to another hopeful vendor that his picture might indeed be the work of a good hand, "but it is in such poor condition that if it were put up for sale, in all likelihood, it would not find a buyer."[103] Cleaning, in short, was a precondition of evaluation: to judge a picture, its quality and authenticity, one needed to be able to scrutinize the surface and apprehend the artist's hand. The monocled connoisseur – that stock figure in art world images and caricatures of the period – required access to a picture unimpeded by layers of smoke and varnish. Nor was examination at close quarters restricted to the study of paintings. It was equally the basis for the Comte de Caylus's pioneering study of ancient art and artifacts, published under the title *Receuil d'antiquités* (1752–67), as it was for later observations on ancient sculpture made by Winckelmann and Mengs.[104]

The standards enforced by d'Angiviller were symptomatic of a widespread concern about conservation in the Paris art world. By the 1770s, if not before, no collector of any sophistication would have made the mistake of buying a picture on the open market that had been poorly restored or was badly in need of restoration (and thus of uncertain status). It had become customary for dealers to clean and restore pictures before offering them for sale.[105] D'Angiviller felt obliged to explain this to a certain M. Schmidt from Aix, who after failing to interest the Crown in his pictures hoped to sell them in Paris. They were valued by a dealer at roughly 1,500 *livres,* but Schmidt was warned, "There will be preliminary expenses before they can be put up for sale, such as having them mounted on stretchers, and having them cleaned and restored where necessary."[106] Indeed, so common was the practice of restoring pictures before sales that the fluid market of the late eighteenth century was itself seen as a threat to the well-being of fragile Old Master paintings. "In today's fluid market," wrote the Marquis d'Argens, "with paintings changing hands so frequently, it would be hard for a picture to avoid injury, especially if it fell into the hands of a greedy dealer."[107]

Interest in preservation extended from dealers and their clients to churches, hospitals, and libraries in the capital.[108] The entire city was becoming accustomed to viewing pictures free of distorting repaints and yellowed layers of varnish. There was even the suggestion that responsibility for all paintings in the public domain fell to the government as they constituted a part of the nation's heritage. Pahin de La Blancherie wrote in 1783:

73

Artistic masterpieces belong less to those who own them than to the nation, especially when they are on public display. It is all too common an occurrence, even in this enlightened capital, that the most beautiful things are allowed to perish through negligence or ignorance. It would be worthy of the government's munificence to employ a reliable artist to supervise the conservation and restoration of all such paintings and valuable objects.[109]

The same artist, Pahin continued, could be consulted about the placement of pictures in public spaces, "for there are paintings in numerous churches that cannot be seen because they have been badly hung." The author thus linked the condition of a painting and the manner of its display relative to the eye of the beholder. All paintings, he suggested, should be fresh and hung at a height appropriate to their type. A similar connection was made by the artist J.-F.-F. Godefroid (son of Mme. Godefroid), who in 1781 restored the famous May pictures at Notre-Dame, which can be seen in a drawing by Jean-Louis Prieur (Fig. 34). In his pamphlet celebrating the completion of the project, Godefroid offered a vivid comparison of works by Le Sueur, Le Brun, Sébastien Bourdon, Jean Jouvenet, and so on, observed first "up close," in the course of cleaning, and then rehung in the nave.[110] The contrast prompted a reminder to the practicing artist to bear in mind how a picture will be hung, lighted, and seen by the beholder, because successful "illusion," especially important in large public works, depended greatly on the manipulation of those factors. Godefroid also told the visitor to Notre-Dame where to stand in order to view the pictures properly (from the arcade on the opposite side of the nave).

How one looked at art and how it was displayed were of greater concern to eighteenth-century students of art than to their counterparts today, whose expectations have been largely dulled by the standardized hanging conventions of museums. The sense of direct access to painting that we get reading much eighteenth-century Salon criticism, notably Diderot's, in which at all times the canvas under discussion seems immediately present to the beholder's gaze, conflicts with what we know about viewing conditions at the exhibition, where only a fraction of the works were accessible to close scrutiny (Fig. 36). (Diderot probably saw most paintings he reviewed in the artist's studio.)

Views of the Salon by Gabriel de Saint-Aubin and Pietro Antonio Martini reveal a logical hierarchy in the installation according to size, with small cabinet pictures generally hung below larger paintings – decorative panels, altarpieces, and, later, history paintings commissioned by the king. These hanging practices, carried over into (from?) the collector's cabinet, reflected the assumption that different kinds of pictures were painted to be seen from different points of view.[111] As we might expect, de Piles expressed himself clearly on the subject: "Every painting has an ideal viewing distance and it

Figure 34. Jean-Louis Prieur, *Benediction of the Flags of the National Guard in Notre-Dame, 27 September 1789.* Drawing, Musée Carnavalet, Paris.

is certain that its beauty will be compromised the more one moves from that point, either closer in or further away."[112] Specific settings dictated that one did not paint an overdoor or a large altarpiece in the same way one did an intimate boudoir scene. "When the painter knows in advance where his work will hang," remarked Watelet and Levesque, "he must set to work with that destination in mind."[113] Though such injunctions may strike the art historian as mere common sense, the point is worth emphasizing because conventions of viewing were more fully absorbed into artistic practice and reflected in the installation of early collections than museums today would lead one to believe. Michael Baxandall, in a recent discussion of vision and technique in the work of Jean-Baptiste-Siméon Chardin, pointed out that in 1703 the Academy of Architecture formulated precise viewing distances for buildings based on size, and he plausibly argues that analogous rules of thumb applied to painting.[114]

These aesthetic considerations had bearing on the museum project on a number of levels. Though we cannot be sure how the Louvre would have been hung under Louis XVI, there is no reason to doubt that the installation would have conformed to the model established in the views of Robert and

subsequently realized at the museum during the Revolution (Figs. 6 and 53). There we find a tiered arrangement with paintings increasing in size toward the ceiling – in other words, a more orderly version of the Salon and the private cabinet. The beholder could thus inspect cabinet pictures "up close" and gradually move back in the direction of the opposite wall to view the larger paintings at an appropriate distance.[115] Larger works were inclined away from the wall to minimize reflected glare and in an effort to maintain a perpendicular line of vision between beholder and canvas.

One implication of a tiered arrangement along these lines was the need for an ample number of pictures of various sizes. The immensity of the Grand Gallery, so impressive to the royal architects, at first worried d'Angiviller, faced with the logistical problem of filling the space with art.[116] As Pierre remarked, part of the appeal of Le Sueur's Saint Bruno paintings was their size and number: they were ideally suited to occupy the upper register of the walls in the Grand Gallery (as they did after 1815).[117] The same was true of the large Jouvenet from the Hôtel de Saint-Pouange. The smaller Le Sueurs from the Hôtel Lambert, meanwhile, complemented those from the Chartreux in subject as well as size, giving the museum an impressive range and displaying the artist's versatility. D'Angiviller also counted heavily on the history paintings commissioned from living artists to fill out the French school. Whereas the pictures commissioned for the official competitions of 1727 and 1747 were painted without specific destination and languished in storage (they were of general "cabinet" dimension, 4 by 6 feet, equivalent to the Academy's *morceaux de réception*), Louis XVI's history paintings were destined for the Louvre.[118] That destination was reflected in the format of each batch of eight pictures: 10 feet square for the four largest and two each at 8 by 10 and 7 by 10 feet.[119] The three sizes were surely ordered in part to accommodate different configurations on the museum's walls. D'Angiviller's history paintings, not the later canvases of Théodore Gericault, Eugène Delacroix, or Gustave Courbet, should be recognized as the first pictures created expressly for the walls of a museum.

The question arises of how a museum setting affected the artists involved. How did one paint for a museum, for posterity? The commission and the conditions of display were unprecedented. One artist who rose to the occasion was Jacques-Louis David, whose two great pictures, the *Oath of the Horatii* (Fig. 35) and the *Brutus,* appear at home in their intended destination in the Louvre. Putting aside the political content of those works and their reception at the Salon, we should bear in mind that both were painted to hang permanently in the Grand Gallery. David took great care throughout his career to dramatize the debut of his public works, but at the same time he was acutely conscious of his place in history and was driven by the knowledge that his important public works would enter the ranks of the

French school and be judged against his illustrious predecessors, Poussin, Lebrun, Le Sueur, and so on. Late in life he exhorted his pupil Antoine-Jean Gros: "Seize your brushes, do something grand that will assure you your just place."[120] David himself had been mindful of his posthumous reputation from the start. As he foresaw, it was in the midst of the Old Masters that the full measure of his own genius and pictorial daring would emerge. What Norman Bryson has called David's "iconoclasm" – his conscious subversion of academic norms in his broad handling of paint, dissonant, ruptured compositions, and rhetorical body language – would redouble in potency when his paintings were displayed alongside those that exemplified the tradition he sought to challenge.[121] Like the Luxembourg earlier, but on a grander, more comprehensive scale, the Louvre presented itself as the ultimate competitive field.

Through an aristocratic friend, David pressured d'Angiviller to have the *Oath* favorably placed at the 1785 Salon, and Martini's engraving reveals that he got his wish (Fig. 36).[122] What is remarkable about this view of the Salon is just how legible David's picture is: the visual economy of form, dramatic gestures, and tension between planar arrangement of figures and deep spatial perspective combine to distinguish the *Oath* from the works that surround it. And the same qualities that made the *Oath* work so well at the Salon would, as David anticipated, have guaranteed its success in the museum. As at the temporary exhibition, in the museum it would have been seen in the company of other paintings and hung high on the wall to be viewed at a distance.

David's attention to viewing circumstances is brought into greater focus when we compare the *Oath* and its position at the Salon of 1785 with L.-J.-F. Lagrenée's *Death of the Wife of Darius* (Fig. 37), also commissioned for the museum. Like David, Lagrenée had also asked that his picture be hung to good advantage, in this case "as low as possible, for if it is hung too high the finish will be completely lost."[123] His request was also granted, and the *Death of the Wife of Darius* can be seen to the left in the Martini engraving, beneath the pictures ordered by the king and just above eye level. The problem for Lagrenée was that his painting would never have been hung so low in the Louvre. He had painted a large-scale museum picture with the finish of one that belonged on the lower walls of a cabinet.

* * *

We cannot be sure in what order the pictures at the Louvre would have been hung – d'Angiviller's project never reached that stage; but almost certainly the mixed-school arrangement of the Luxembourg Gallery would have given way to an arrangement by school and chronology. In fact, there is no reason to think the hang at Louis XVI's Louvre would have differed

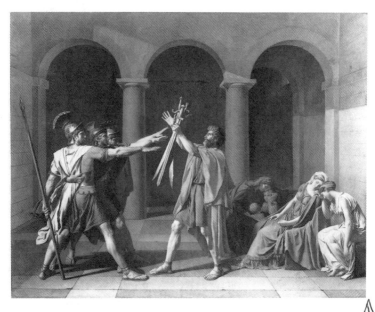

Figure 35. Jacques-Louis David, *Oath of the Horatii*. Oil on canvas, 1785, Musée du Louvre, Paris.

Placement of Painting effects
how artist designs work

simple
↓
complex
more detail

Coup d'œil exact de l'arrangement des Peintures au Salon du Louvre, en 1785.
Gravé de mémoire, et terminé durant le temps de l'exposition.
A Paris, chez Basset, Peintre en miniature, Rue Godequital N° 24.

Figure 36. Pietro Antonio Martini, *Salon of 1785*. Engraving, 1785, Bibliothèque Nationale, Paris

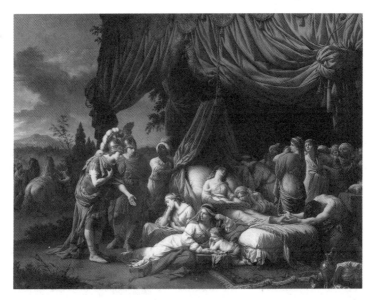

Figure 37. Louis-Jean-François Lagrenée, *The Death of the Wife of Darius.* Oil on canvas, 1785, Musée du Louvre, Paris.

[handwritten margin note: how things were hung @ Louvre]

from that realized at the Louvre in the late 1790s, with the French school displayed at the Salon end of the Grand Gallery followed by the Northern schools and then the Italians. Within each school some attempt would have been made to hang works by the same artist together and in chronological order.

D'Angiviller's pattern of acquisitions reflects a consciousness of national schools and the need to fill gaps in the historical sequence of acknowledged masters – in other words, to give what would have been viewed at the time as an adequate representation of the history of art from the High Renaissance. The Luxembourg's privileging of the pictorial qualities of individual works through a mixed-school arrangement would have been superseded by a concern, still with us today, to demonstrate historical development within regional schools.

Of great importance in prompting this change was the knowledge that galleries and collections elsewhere in Europe had adopted, or were in the process of adopting, an arrangement by school and chronology. In the years since Bachaumont recommended an arrangement by schools to Frederick the Great, the princely galleries at Dusseldorf (Fig. 3) and Dresden had made some attempt to implement such a system, and moves were afoot to do likewise at Florence and Vienna.[124] At the Imperial Gallery in Vienna in the early 1780s (Fig. 4) the man brought in to reorganize the collection, the Basel-based engraver and dealer Chrétien de Mechel, had gone an important step

Show evolution of paint

modern sense Vienna

further in demonstrating the history of each school through the way the pictures were hung. In the introduction to his 1784 catalogue, Mechel explained that as far as possible the works of a given painter had been brought together, facilitating comparison "of his different periods and the various genres he practiced." Moreover, he had tried to impose a chronological order on the entire collection, allowing the visitor to apprehend from one room to the next "the evolution and character of the centuries." "Everyone will agree," he concluded, "on the overwhelming advantages resulting from this systematic arrangement. It will be of interest to artists and amateurs of all countries to learn that there now exists a showroom for the visual demonstration of the history of art."[125] Vienna therefore has a claim to being the first art historical museum in the modern sense.

This twofold classification by school and chronology was in part due to the rise of historicism in the late eighteenth century, manifested first and foremost in the study of art history in Winckelmann's pioneering *History of Ancient Art* of 1764.[126] It was also a direct response to the binomial method of classifying plants and animals by genus and species introduced by Linnaeus and Buffon at midcentury.[127] Binomial classification quickly took hold in the arrangement of natural history collections, as we see in L.-J.-M. Daubenton's 1749 description of an ideal cabinet:

The most favorable arrangement for the study of [natural history] would be a methodical order that distributed its objects by class, genus and species. . . . The ordering of genera and species would be consistently applied throughout; the individuals of a species would be placed next to each other, never apart. One will be able to see species in relation to genus, and genus in relation to class. Such an arrangement will indicate the principles according to which one should study natural history; only through such an arrangement will those principles be realized. Everything in effect will be instructive; at each glance not only will one gain knowledge of the objects themselves, one will also discover relationships between given objects and those that surround them. Resemblances will define the genus, differences will mark the species; those marks of similarity and difference, taken and compared together, will present to the mind and engrave in the memory the image of nature.[128]

A well-disposed cabinet, reflecting the order of nature itself, was essential for purposes of study, and from midcentury didactic value became the measure of the serious collection. "Return your shells to the sea," exclaimed the *Encyclopédie,* "give back to the earth its plants and rid your apartments of their skeletons, birds, fish, and insects, if all you can make of them is a chaos where nothing can be seen distinctly, and where scattered and heaped objects provide no neat and clear ideas."[129] Following the lead of natural history, the reorganization of picture collections after 1750 along analogous lines testified to the growing belief throughout Europe that works of art,

like flora and fauna, were susceptible of rational classification and should serve a useful purpose through well-ordered public exhibitions.[130]

There are clear correlations between the organizing principles of genus and species in natural history and school and chronology in art: in painting, regional schools may be considered the genera and great masters the species, around whom are clustered their pupils and followers. Within a collection or text narrative direction is supplied by history. The influential dealer-connoisseur J.-B.-P. Lebrun (who, as noted in the Introduction, explicitly made the connection between art and natural history) employed precisely this organizational structure in his book *Galerie des peintres flamands, hollandais et allemands* (1792–6). As we shall see later, Lebrun was heavily involved in the arrangement of the Louvre in the late 1790s. At any rate, suffice to say that the system of school and chronology rapidly became (and has remained) the natural way of organizing museums of art. D'Angiviller, a noted scientific amateur and collector of shells, was certainly abreast of recent theories of taxonomy and would have understood that perfection in the Grand Gallery entailed a systematic and modern display of the collection. The stature of the museum would depend on the arrangement and presentation of the collection as much as on the works of art themselves.

An organization by school and chronology would further have served what I take to have been another chief goal of the museum: the glorification of French art and history. The display of French painting on view in the section of the gallery adjoining the Salon would have suggested continuity between past and present and a sustained prosperity made possible by state support via the Academy. Modern works making their debut at the Salon would, if deemed worthy, pass next door and take their place in the unfolding narrative of French painting from Vouet and Lebrun to the present. The Salon would provide a steady flow of new blood into the Grand Gallery, enriching the French tradition with the passing of each generation. Meanwhile no modern Italian or Northern paintings were bought for the Louvre, implying that those traditions were now moribund. Displayed chronologically by school, the Louvre collection would represent a thriving native tradition taking over from the spent artistic traditions of France's once dominant rivals. In Robert's imaginary Louvre (Fig. 24) one can imagine static foreign schools increasingly encapsulated in a receding past, overwhelmed by French painting marching triumphant into the future.

The ascendance of the French school in European art depended on the prominent display of history painting treating subjects of universal validity in a commanding, recognizably grand manner. Universal painting meant episodes from ancient history or mythology treated in a neobaroque, neo-

classical style; the works mentioned earlier by David and Lagrenée are prime examples. But, of course, d'Angiviller also commissioned paintings and sculptures drawn from modern French history. The primary audience for those works was domestic, and in order to communicate effectively to a French public their mode of address was particular and local rather than universal and ideal.[131] Costumes and settings were historically specific, and wherever possible images of heroes were based on reliable portraits. French subjects were ranked beneath ancient history – they paid less and tended to be given to younger or lesser artists; and when allowed to choose, artists invariably opted for ancient history.[132] Yet a closer look at the choice of those subjects in light of contemporary events reveals that many of them were intended to convey a timely political message to the museum-going public. Whereas the ancient history paintings, embedded in a diachronic display of art history, aimed to impress European amateurs and tourists, the French paintings and sculptures sought to represent national history and to define the French hero in a manner consistent with Bourbon ideology. If less esteemed on an international stage, the French works point to the government's intent to use the museum as a domestic platform for royalist politics. By way of conclusion, let us take a closer look at a few of the French works, and in particular the set of statues of Great Men.

In d'Angiviller's own words, the purpose of the government commissions was to inspire in the viewer "virtue and patriotic sentiments."[133] French subjects had the advantage of doing both at the same time: they presented stirring acts of heroism and virtue by French men to rival the exploits of the ancients. (No women were ever considered, indicating that history and its artistic representation were male preserves, and heroism and public virtue were male attributes.) But we might ask: What heroes and events were chosen, and why? What did it mean to be patriotic? Whose version of history was in evidence?[134]

Unlike earlier sculptural projects commemorating great men of France – Titon du Tillet's *Parnasse françois* or the Place Peyrou in Montpellier, both dedicated to Louis XIV, and the military heroes at the Ecole Militaire – d'Angiviller's series (see Appendix II) drew from different epochs in modern French history and from each of the four *états,* or estates: the military, the clergy, the magistrature, and the Third Estate, represented by writers, scientists, and artists.[135] Of equal importance, the criteria of selection were grounded as much in Enlightenment notions of virtue and disinterested service to humanity as in outstanding achievement in the courts or on the battlefield. Revealing the influence of the *philosophes*, d'Angiviller explained his thinking in a letter of 1776 to a professor of rhetoric at Beauvais:

I thought . . . I should reserve . . . the title of great man for those privileged beings who combined great actions or brilliant discoveries with virtuous conduct and the

disinterested pursuit of the common good. Thus, although we owe much to Francis I for in a sense introducing the arts and letters to France, to Gutenberg for the invention of the printing press, and to Christopher Columbus for discovering America, I didn't think they merited statues because the one was inspired by pleasure and his own inclinations, and the others by self-interest.[136]

To an enlightened way of thinking, the invention of the printing press and the exploration of new lands were vital to the progress of knowledge and should be encouraged for that reason alone. But enlightened though he was in many ways, d'Angiviller's first loyalty was to the king, and we can never forget that his goal as director general of the Bâtiments was to make the arts an "emanation of the throne," as the *Journal de Paris* put it in 1777.[137] Over and above brilliance and virtue, what linked the majority of Great Men was loyal service to the Crown. Thus the men represented were not only exemplary benefactors of their country and humanity, they were also model subjects of the king. Collectively the *Grands Hommes* (along with many of the French paintings) represented a vision of French history and society in which the unifying principle, reconciling differences of rank, estate, genius, and religion, was allegiance to the king. In Charles de Wailly's project for the Grand Gallery (Fig. 38) we see Louis XVI, represented as ruler and patron of the arts, at the center of and raised above the Great Men statues. Arranged symmetrically around the king, these men of genius signal a common debt to the enlightened support of a dynamic monarchy. And to the extent they were presented to the public as models for emulation, their devotion to the king mattered as much as their individual achievements. In conjunction with official historiography and incipient national education programs, these images composed an absolutist iconography of nationhood.

Another respect in which these statues differed from previous commemorative projects was that there was no finite plan or preconceived list of men. Every two years beginning in 1775 d'Angiviller ordered four new statues; no doubt he envisaged the series continuing indefinitely. As a consequence, the choice of new subjects was always open to influence from current events and shifting views of history. Such was the case in the choice of famous magistrates, beginning with Etienne Gois's statue of *Chancellor de l'Hôpital* of 1777 (Fig. 39), in light of the most important political event of the 1770s: the exile and restructuring of the Parlements under Chancellor René-Nicolas Maupeou and their subsequent recall in the first year of the reign of Louis XVI. Gois's statue and the magistrates that followed were commissioned as emblems of monarchical right in the wake of a bitter political debate that threatened to divide the nation. The circumstances of their production and reception offer vivid testimony to the increased politicization of art in the last quarter of the century in an effort to control public opinion.

Maupeou's exile of the Paris Parlement in 1771, followed by the remod-

Figure 38. Charles de Wailly, *Project for the Grand Gallery*. Drawing, c .1785, Musée du Louvre, Paris.

eling of the eleven provincial Parlements and reform of the judicial system, culminated fifty years of tension between the Crown and sovereign courts. The Parlements of France (not to be confused with the Parliament in England) were essentially courts of law that exercised legal jurisdiction in the king's name throughout the realm.[138] In addition to the exercise of law, they were involved in the legislative process through their responsibility to authorize royal edicts through the act of registration: only through registration did royal decrees acquire the force of law. The corollary of registration was the right to suggest amendments to those decrees, known as remonstrances. Though the king was not bound to listen to the Parlements' recommendations, the magistrates' license to criticize his edicts maintained the semblance of a tempered monarchy working within a system of checks and balances. During the course of the eighteenth century remonstrance evolved

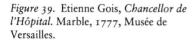

Figure 39. Etienne Gois, *Chancellor de l'Hôpital.* Marble, 1777, Musée de Versailles.

into a means of obstructing royal will while asserting Parlementary rights.[139] Maupeou's exile of the Parlements was an immediate consequence of the magistrates' refusal to accept an edict that sought to restrict their powers and remove their right of remonstrance *before* registration, rendering it politically mute.

There was fierce opposition to the *coup Maupeou,* as it was known. To judge by contemporary literature, public opinion was sharply divided between those who felt reform of the Parlements was long overdue and that in obstructing royal policy they had overstepped the bounds of their power and those who believed the Parlements represented the nation's interests and that their suppression augured the rule of despotism. At issue was the profound question of who governed France and the respective roles of king and Parlements in an absolute monarchy.[140]

For present purposes, the most interesting aspect of the conflict between the Crown and supporters of the exiled magistrates was the propaganda war that ensued as both parties tried to win over public opinion. In 1771–2 no fewer than 270 pamphlets appeared putting forward opposing points of view.[141] Not until the Revolution would public opinion again be courted so assiduously.

Though some of the anti-Maupeou propaganda was downright scurrilous, the bulk of it was in earnest.[142] Pamphlets warned of the danger of political innovations and insisted that it was only through the Parlements' right of remonstrance that the people had any say in the way they were governed. Influenced by Montesquieu's *De l'esprit des lois* of 1748, the Parlements portrayed themselves as indispensable intermediary bodies between the sovereign and the nation, serving the former while faithfully representing the interests of the latter.[143] Without the Parlements an unbridgeable gap would open up between the king and his subjects. For their part, Maupeou's supporters argued that Parlementary justice was corrupt, and the only real interests served by the magistrates were their own. In addition, the Parlements were reminded that the king was under no obligation to listen to remonstrances, let alone be moved by them.[144]

In order to support their respective positions, both parties turned to history in search of precedents. As one commentator put it:

Never before have circumstances created a more urgent and legitimate desire to examine and understand the nature of our government. As an impartial spectator, yet sensitive to the revolution that has affected French hearts differently, and astonished to behold such widely diverging views of the same issue, I believed that the principal facts recorded in our annals would shed the light of truth on the matter.[145]

The Comtesse d'Egmont remarked that the affair had taught people things about their history that they would have died happily without knowing.[146] Both sides tried to fill this void in knowledge with their own version of the facts, resulting in two competing representations of French history. Proponents of the magistrates argued that the Parlements were coeval with the monarchy and that they possessed legitimacy and powers independent of the king. Documents were quoted, and selected historical figures – l'Hôpital and d'Aguesseau, the magistrates' twin idols, Montesquieu, Bossuet, Fénelon, and others – were summoned in defense of the Parlements' traditional rights.

Maupeou's men did a little research of their own, however, and discovered that they could use the same sources and quote the same men to better effect in support of the government's position. It was merely wishful thinking and a willful manipulation of the records that were at the root of the Parlements' claims to direct descent from the earliest judicial and deliberative assemblies of the Franks. The annals also proved that the writers and statesmen conscripted by the Parlements, notwithstanding their Parlementary allegiances and progressive spirit, clearly drew the line at disobeying the king. It was implied that had they been present to witness the intransigence of the Parlements they too would have sided with Maupeou. In the most important collection of anti-Parlement literature, entitled *Code des françois,* edited by the Abbé Joseph Rémy, documents are cited and

reprinted to show, among other things, that the magistrates' "patriot king," Henry IV, was no less imperious in his dealings with the Parlements than Louis XV, and that the likes of l'Hôpital and d'Aguesseau had, in fact, advocated the ultimate authority of the king over the courts.[147]

In the end the government produced a more convincing view of history. Maupeou won his battle with the Parlements, and Louis XV vowed not to return to the old system. But upon Louis's death in May 1774, a new king and cabinet ushered in a change of mind and a perceived need for reconciliation.[148] The magistrates had been sufficiently humbled, and Louis XVI was persuaded that a good and just monarch had nothing to fear from the Parlements. The Paris magistrates were recalled in November, but on the understanding that they would be more obedient in the future.

At that juncture French constitutional history had become so politicized that no reference to a great Parlementarian of times gone by could be politically neutral. I would suggest that d'Angiviller's choice of l'Hôpital as one of the first *Grands Hommes* (a choice made in January 1775)[149] was intended as a final word in the recent ideological struggle to control the past – a battle the Crown felt it had won. Through Gois's statue, exhibited first at the Salon and destined for permanent display in the museum, the famous chancellor and idol of the magistrates had come to rest in the royalist camp and was to be identified henceforth as a loyal servant of the Crown. Gois's *L'Hôpital* was a gesture of reconciliation to the nation grounded in the government's confidence in its ability to keep the Parlements in line.

This reading of the statue when it debuted at the Salon on August 25, – the *jour Saint-Louis* – 1777 was enforced by a lecture given at the Académie Française on the same day. The king's name day in odd years was the occasion not only of the Salon's opening but of the reading of the winning essay in the biennial Académie competition, which had as its subject (from 1759) the eulogy of a great man from French history. The competition was a main fixture on the Parisian literary calendar. As Sébastien Mercier remarked: "If the roof fell in [on the Académie] that day, there would be no writers left in Paris."[150] Commentary and excerpts from the prize essay appeared in the journals. The *éloge académique* attracted many famous *philosophes*, not least because its didactic, moralizing purpose opened a door for comment on contemporary mores and politics under the cloak of historical biography.[151] Many eulogies were published clandestinely to coincide with the competition, and in these the biographical format often was little more than a pretext for explicit political critique.

There can be no doubt that d'Angiviller's *Grands Hommes* were inspired by the eulogies.[152] The director general was a close friend of the *philosophe* who won the first five competitions, Antoine-Léonard Thomas. Thomas wrote his winning essay on Descartes (1765) to please his friend, and we know that the eulogies were much discussed at the literary salon of

d'Angiviller's lover, Baronne de Marchais.[153] The first four and seven of the first twelve Great Men were eulogized by the French Academy (see Appendix II). The *Mémoires secrets,* that reliable source of Paris news and gossip, took the connection for granted.[154] Moreover, it was a commonplace of eighteenth-century art theory, derived from antiquity by way of the Renaissance, that sculpture's highest calling was the transmission of great men to posterity: in its memorializing capacity it complemented the eulogy perfectly.[155] Thomas himself, in his 1759 *éloge* of the Maréchal du Saxe, had dwelt at length on Jean-Baptiste Pigalle's magnificent tomb, then under construction at Strasbourg, and in subsequent essays he frequently commented on the need to erect monuments to national heroes.[156]

Thus it was no coincidence when in 1777 the Académie Française and the Royal Academy of Painting and Sculpture came together on August 25 to pay homage to l'Hôpital. When d'Angiviller selected his first four Great Men in 1775, l'Hôpital was the odd man out in the sense that the other three, Sully, Fénelon, and Descartes, had all been the subject of a recent eloquence prize. The choice of l'Hôpital as fourth man and subject of the next eloquence prize can only have been the result of deliberate collaboration between the sister academies.

Significantly, the winner of the prize that year was none other than the erstwhile Maupeou propagandist, Joseph Rémy. His eulogy served as a text for Gois's statue. Rémy had demonstrated in his *Code des françois* that l'Hôpital, while never disloyal to the best interests of the nation, believed unequivocally that the Parlements were subordinate to the king, and he repeated the message in his *éloge.*[157] In words clearly aimed at the recalled magistrates, he censured and ridiculed the magistrates' selfish and presumptuous behavior in the past. A few days after he was crowned, Rémy sent d'Angiviller a copy of his essay and received a warm reply.[158] On August 25, that most symbolic of days, word and image came together in the service of royalist politics.[159]

But whatever sense of satisfaction the government derived from the celebration of l'Hôpital was marred by the sudden appearance of an anonymous and clandestine eulogy of the chancellor attributed to the distinguished soldier and military strategist François-Apolline de Guibert. Thoroughly disillusioned by the Parlementary crisis, Guibert used his *éloge* to attack both the magistrates and the government in equal measure. First he mocked the former's claim to represent the nation:

l'Hôpital believed that the Parlements were not and must never be more than judicial courts. Their pretension to being the senate of the realm, the image and supplement of the Estates-General, seemed to him not only absurd and chimerical, but contrary to the interests of the nation. What right, in effect, have simple magistrates, created by the sovereign, holding venal office, born for the most part in

obscurity, and with neither mandate nor power from their fellow citizens, to consider themselves called to represent the nation?[160]

Turning next on the government, Guibert continued:

How could anyone fail to see that if the court temporarily indulged the Parlements' pretensions by appearing to regard their power of registration as a necessary sanction and integral part of the law, it was only to deceive the nation into believing that there existed a counterweight to the authority of the throne, and to discourage any thought of summoning the Estates-General.[161]

His solution was to call for the Estates-General, the nation's only true representative body. In the meantime the Parlements should obstruct the registration of edicts and thereby force the government to reveal itself for what it was: a despotism. As Guibert's text makes clear, the *coup Maupeou* had demonstrated the political impotence of remonstrance as well as the hollowness of parlementary claims to represent the nation. At the same time, the ease with which the Parlements were dismantled revealed that in practice as well as theory there were no limits to the king's power.

Guibert's intended audience was not so much the Parlements themselves but the public, and his text signals the extent to which public opinion emerged as a significant force in political discourse after the Maupeou affair. As Keith Michael Baker has argued, the government, by recognizing public opinion as something that needed to be addressed in pamphlets and works of art, "unwittingly conspired with its opposition to foster the transfer of ultimate authority from the public person of the sovereign to the sovereign person of the public."[162]

This transfer of authority was a gradual process, however, and in the late 1770s and early 1780s d'Angiviller continued to use his *Grands Hommes* to political advantage. At the Salon of 1779 statues appeared of two other progressive Parlementarians – d'Aguesseau and Montesquieu, both of whom had figured prominently in the pro- and anti-Parlements dialogue of the early 1770s. Though at times genuinely radical in what they wrote, their presence in the Salon and eventually in the Grand Gallery served to render them emblems of monarchical right and to neutralize them as sources of oppositional discourse.[163] Also exhibited at the 1779 Salon was François-André Vincent's painting of Matthieu Molé seen calming the mob during the Fronde. At the time of the Parlements recall in 1774 Molé had been described as "the buttress of the throne, the upholder of the law, the incorruptible organ of truth: a magistrate who combined the courage of a hero with all the virtues that define the citizen and public man."[164] (Etienne Gois later sculpted Molé for the 1785 Salon.) Great soldiers of the past predominated at the next three Salons (Catinat and Tourville, 1781; Vauban and Turenne, 1783; Duquesne and le Grand Condé, 1785) as a result of French involvement in the American Revolution. But by the late 1780s we witness

a sharp retreat from political intervention. The one statue that was properly commissioned but never executed was that of the famous seventeenth-century magistrate Guillaume de Lamoignon for the Salon of 1789. Commissioned from the sculptor Pajou in 1787, it was probably abandoned in the following year as opposition mounted to the Parlementary reforms of his direct descendant Chrétien-François de Lamoignon. Under fire, Lamoignon resigned as keeper of the seals in September 1788; days later an angry mob tried to attack his Paris hôtel.[165] Rather than risk a riot at the next Salon, the proposed statue of his ancestor was dropped. In August 1789, d'Angiviller wrote to the painter Vien with reference to the next round of paintings and statues to be commissioned by the king: "We must exercise the greatest caution in the choice of subjects."[166] Accordingly, the Great Men chosen – the artists Lebrun and Puget, the writer Boileau, and the admiral Duguai-Trouin – offered little scope for hostile interpretation.[167]

The Great Men – at least those with clear political significance – signal an important departure in state intervention in the arts. Arguably the arts had long been a weapon in the ideological arsenal of the French monarchy, but beginning with Gois's *l'Hôpital* we find royal commissions being used not simply to glorify the king but to influence public opinion on issues of immediate concern to the government. Pajou's unexecuted *Lamoignon* and d'Angiviller's anxiety over the choice of subjects in 1789 represent the inversion of that policy. Far from trying to dictate public opinion, in 1789 the director general feared a hostile reaction to any attempt or any gesture that could be read as an attempt to assert royal authority through the arts. It was, of course, at the moment of the *Grands Hommes'* retreat from significant political involvement that David came of age as a history painter. Whether or not his great canvases of the 1780s were painted with politically subversive intent (the debate continues), d'Angiviller's use of the Great Men in the service of the Crown would at least have heightened an awareness in David and his contemporaries of the political possibilities and tensions in the Salon, and makes it all the easier to understand why David's paintings could have taken on a radical identity on the eve of the Revolution.[168]

Those possibilities and tensions would have been transferred to the museum with the works of art intended for it. Even though completion of the museum eluded d'Angiviller and the Old Regime, his deliberate excursion into contemporary politics and historical representation through state patronage had nevertheless made of the Grand Gallery a deeply ideological space. The politicization of the Louvre would be carried steps further by the Revolution, but in a direction unimaginable to d'Angiviller before 1789.

THE REVOLUTIONARY LOUVRE

> *The museum is not supposed to be
> a vain assemblage of frivolous luxury objects
> that serve only to satisfy idle curiosity.
> What it must be is an imposing school.*
>
> Jacques-Louis David, *Second rapport sur . . .
> la commission du muséum,* 1794

The Revolutionary chapter in the history of the Louvre museum begins on the day the Bourbon monarchy finally collapsed – August 10, 1792, when the Tuileries Palace was overrun and King Louis XVI taken prisoner. Until then the Louvre had remained a royal palace and the museum a project supervised by the king's architects. As late as April of that year, the *bon du roi* had still to be acquired before the architect Mique could begin the long overdue structural repairs to the sloping stable walls that supported the Grand Gallery from below (Fig. 25). The repairs were paid for from the king's civil list.[1] However, with the fall of the monarchy, the royal collection was declared national property, and the National Assembly quickly announced its interest in accelerating the completion of the museum. On August 19, just days after the attack on the Tuileries, the following decree was issued:

The National Assembly, recognizing the importance of bringing together at the museum the paintings and other works of art that are at present to be found dispersed in many locations, declares there is urgency.[2]

That the museum was made the subject of an official decree so soon after August 10, and declared a matter of urgency no less, is remarkable. Yet, as a letter dated October 1792 from the minister of the interior, Jean-Marie Roland, to whom the museum had been entrusted, to Jacques-Louis David makes clear, the museum already had an important role to play in the Republican scheme of things.

This museum must demonstrate the nation's great riches. . . . France must extend its glory through the ages and to all peoples: the national museum will embrace knowledge in all its manifold beauty and will be the admiration of the universe. By

embodying these grand ideas, worthy of a free people . . . the museum . . . will become among the most powerful illustrations of the French Republic.[3]

Long before the first picture had been hung Republicans recognized in the Louvre a symbol of Revolutionary achievement and the cultural benefits of Liberty.

As Edouard Pommier has argued, this apparently spontaneous investiture of the museum with the power of a Revolutionary sign had its origins in the creation of a national patrimony following the state's appropriation of Church property in November 1789.[4] Overnight an immense artistic and historic heritage ceased to function meaningfully in a religious context and entered the public domain as *biens nationaux,* "at the disposition of the Nation." The property of émigrés, the royal academies and the Crown soon followed. In response to this unprecedented situation, commissions composed of artists and scholars were established in Paris – first the Commission des monuments (1790) and then the Commission temporaire des arts (1793) – to determine what should be preserved and what could be sold, reused, or destroyed. Guidelines were drawn up for distribution in the provinces, including the pamphlet *Instructions sur la manière d'inventorier et de conserver, dans toute l'étendue de la République, tous les objets qui peuvent servir aux arts, aux sciences et à l'enseignement* (1794), a landmark document in the history of conservation. More will be said about the work of these commissions in Chapter 5; what is important for present purposes is that from the start the destination of those objects deemed worthy of conservation was a museum. What better use could be made of the nation's new-found artistic and cultural wealth than to display it for the benefit of public instruction and pleasure? And what better use for abandoned churches than to house such collections? These were the early conclusions of the Commission des monuments, embodied in a clear-sighted report of December 1790:

1. All monuments so designated belong to the nation. It is necessary therefore to make them accessible to the general public, and nothing could better serve that purpose than bringing them together in repositories established in each of the eighty-three departments which now make up France, taking care that each repository is as complete as possible.
2. Each departmental repository will be located in a large town, preferably one where there is already an educational establishment, for it is clear how much public instruction will benefit from these *museums,* the name that will be given to the repositories.
3. The site will be easy to find in each of the chosen towns. The museum will be housed in one of the churches that are due to be closed and which would otherwise be without useful purpose.[5]

In the capital, the sight of overflowing storage depots rekindled earlier visions of transforming the Louvre into a physical encyclopedia of knowledge. The politician Bertrand de Barère, in an address to the National

Assembly of May 26, 1791, envisaged the Louvre as a national palace of arts and sciences, uniting under one roof "all the riches possessed by the nation."[6] Later that year the idea was taken up by Armand Kersaint in his *Discours sur les monuments publics*. But for Kersaint, the museum was to be more than a union of rare and useful objects. Located in an expanded (and finished) Louvre-Tuileries Palace complex, the museum would be a national monument, affirming at one and the same time the "will of the nation" and "the superiority of the new regime over the regime of old." Completing the Louvre, he stated, would demonstrate that the new regime had accomplished "in several years what ten kings and fifty prodigal ministers had failed to do in several centuries."[7] What is striking about Kersaint's project is his identification of artistic achievements with the creation of a new political order ("Show the world what a sovereign people can do"!) and the use of those achievements to confirm the triumph of Liberty in the public eye. More remarkable still in retrospect was his prophecy that the completed Louvre would make Paris the "capital of the arts" and the Athens of the modern world, a theme to which we will return later.[8]

Just as Kersaint preached the symbolic value of completing the Louvre after centuries of neglect, so Roland and his successors grasped the potential of opening the museum after years of frustrating delays during the final years of the Old Regime. Speed was of the essence. Roland assumed responsibility for the Louvre and all national property in September 1792 and duly appointed a panel of six men – five artists (J.-B. Regnault, F.-A. Vincent, N.-J.-R. Jollain, J. Cossard, and Pierre Pasquier) and one mathematician (C. Bossut) – known as the Museum Commission, to oversee the museum project.[9] To these six men fell the task of preparing the Grand Gallery for the display and deciding which objects should be chosen for exhibition from the huge collection now belonging to the nation. The encyclopedic schemes of Barère and Kersaint remained paper projects, last gasps of an Enlightenment dream, and attention focused, as it had prior to 1789, on the Grand Gallery and the fine arts. There was equally no question now of giving the museum the "perfection" d'Angiviller had sought. Even though a new experiment in the gallery as recently as 1791 had determined once more that the existing supply of light was inadequate and the space too narrow, the museum would have to open as it was.[10]

As the Museum Commission worked on the gallery through the winter and spring of 1792–3 it was inevitable that the museum's identity and political role would be shaped by developments in the world beyond its walls. A succession of events in 1793 – the execution of Louis XVI, royalist rebellions in the provinces, military setbacks on the eastern front, and the assassinations of Le Pelletier de Saint-Fargeau and Jean-Paul Marat – pushed the Revolution to the left and influenced the government's attitude toward the Louvre. Fear of royalist conspiracy and of failure during this uncertain

period fueled a campaign of "public instruction," the purpose of which was to effect the complete regeneration of society along Republican lines. As a prominent state institution, the museum had its part to play in the process. In April 1793, Dominique Garat, the *philosophe* and man of letters who replaced Roland as minister of the interior in January, wrote to the Museum Commission urging it to press on with the gallery, "the interest in which grows daily due to present circumstances." He continued:

> The achievement of this victory [i.e., the completion of the museum] at the present moment in time, over our domestic troubles as well as our external enemies, is by no means the least important of those to which the national effort should be directed; in particular, it would have an invaluable effect on public opinion, which is so often the sovereign mistress of empires.[11]

In addition to assuaging "the fury of our passions and the calamaties of the war" by demonstrating that in spite of troubles at home and abroad calm and order reigned in the capital, the museum would also show that the "political storms" of the Revolution had in no way extinguished the cultivation of the arts in France.[12]

A crucial step was taken in May when the Convention directed its Committee of Public Instruction (CPI) to draw up plans for a public festival commemorating the first anniversary of the birth of the Republic, to take place in Paris on August 10, 1793. Garat wrote to the president of the Convention a little over a month later to suggest that the museum and the Salon exhibition contribute to the celebration by opening on the same day. His idea was to associate the museum with the direction of the Revolution and to prove, in his words, "to both the enemies as well as the friends of our young Republic that the liberty we seek, founded on philosophic principles and a belief in progress, is not that of savages and barbarians." Furthermore, Garat reiterated Kersaint's observation that the inauguration of the museum on August 10 would underline the superiority of republican government over "the administrators of despotism."[13]

It was at this moment that the Louvre museum formally entered Revolutionary political discourse as a sign of both triumph over despotism and culture born of liberty. Garat's sensitivity to the latter symbolic value in particular may well have been due to his understanding of how the course of events in France was perceived abroad. In April 1792 he was attached to the embassy in London where he witnessed how "the principles and events of our revolution were disfigured in a most atrocious manner."[14] As anti-Revolutionary propaganda abroad intensified in step with the Revolution itself, Garat would have become increasingly aware of the the need to redirect attention away from recent atrocities (such as the September Massacres) and toward the ultimate, and in his view, positive goals of the Revo-

lution.[15] Through the museum Garat hoped to forge a link in the public eye, both at home and abroad, between the conservation and display of universally esteemed works of art and the perception of responsible Republican government. In order to counter anti-Revolutionary propaganda, publicity of Republican achievements had at least to equal the spectacle of the guillotine and dramatic acts of iconoclasm. And what better source of positive publicity than the founding of a museum Europe had been anticipating for twenty years? Garat's proposal to assimilate the opening of the Louvre into the Festival of National Unity, as it came to be known, was greeted with great enthusiasm, and from that moment the Museum Commission had a deadline to meet.

The Commission now had two months to put the museum in order. It complained that only half the Grand Gallery was available (repairs to the stables were still in progress) and that no one was satisfied with the quality of light, but to no avail.[16] It also ran into difficulties with members of the Commission des monuments, who, resenting the sudden appointment of an upstart commission to do work that they felt was rightfully theirs, obstructed access to storage depots.[17] Garat finally intervened but with no time to spare; pictures were still arriving at the Louvre less than two weeks before it was due to open.[18] Remarkably, the *Muséum Français,* as it was called, opened as planned on August 10, 1793. On display were a total of 537 paintings, plus 124 assorted marble and bronze sculptures, precious marbles, pieces of porcelain, clocks, and "other objects."[19]

The opening of the Louvre and the Festival of National Unity stand out as two signal Republican achievements of 1793, and it was highly appropriate that they occurred on the same day. To grasp the significance of this connection, we must consider briefly the purpose of the Revolutionary festival and the meaning of the Louvre in 1793.

In a tract addressed to the Convention in year II of the Republic (1793–4) entitled *Essai sur les fêtes nationales,* the deputy François de Boissy d'Anglas introduced his discourse on the crucial role of the festival in the emerging body politic by first stating the ultimate goal of the Revolution:

It is to bring together and to effect the permanent regeneration of mankind . . . it is to return man to his natural state of purity and simplicity through an understanding and the exercise of his rights. . . . It is finally to destroy once and for all the chains that oppress and enslave him.[20]

Revolutionaries realized that such grand ambitions could be fulfilled only through education. Authority alone was not enough to direct a revolution: the citizenry had to be molded through direct and willing participation.[21] The consent and participation of the people would be secured through a

comprehensive system of public instruction. "It is by educating a man," wrote Boissy d'Anglas, "that you will regenerate him in a manner complete and absolute."[22] Man had to learn to be free; he had to be taught to reject his old values and to place his faith in the future of the Republic. The public festival was designed to serve this end on two levels. On one, the program of festivals, which was gradually expanded as the Revolution progressed, gave legitimacy to the new order by filling the gap left by the discontinuance of royal celebrations and religious worship and lent the experience of the Revolution a sense of what Lynn Hunt has termed "psycho-political continuity."[23] On the other, the public festival generated a sense of community, an image of an ideal republican society based on the belief in transparency between individual citizens and between citizens and the state. In short, the festival was central to the concept of "public instruction," and didacticism was at the heart of Revolutionary politics.

The festival of August 10 combined and made manifest two themes that recur throughout Revolutionary literature and figure prominently in Jacobin discourse: national unity and the regeneration of the people. These concerns were conspicuous in the focal point of the festival – the procession and its attending imagery designed by David – but they were also implicitly present in the organized spectacle at the Louvre.

On the morning of August 10 the crowds assembled at the Place de la Bastille, where the people drank from a fountain of regeneration in the form of a neo-Egyptian statue of Nature squeezing water from her breasts, which at once cleansed them of any association with the past and "baptized" them citizens of the Republic (Fig. 40). The ordered masses (estimated at 200,000), decked with liberty caps, tricolored ribbons, fasces, garlands, and olive branches, then set out along a processional route punctuated by five stations established at the scenes of significant Revolutionary events from the Bastille to the Champs de Mars. The festival thus endorsed the reidentification of familiar Parisian landmarks as sites of Republican memory. The crowd envisaged by David in his proposal to the Convention was the very picture of a new society in which distinctions of class and race were dissolved. "All individuals useful to society," he wrote, "will be joined together as one; you will see the president of the executive committee in step with the blacksmith; the mayor with his sash beside the butcher or mason; the black African, who differs only in color, next to the white European."[24] From the second station at a triumphal arch on the Boulevard Poissonière, the procession moved on to the Place de la Révolution (now the Place de la Concorde), where Louis XVI had been guillotined months earlier. The people watched as representatives from the eighty-six regional departments set light to a symbolic pyre made up of the "debris of feudalism" placed before a statue of Liberty, which stood on a pedestal

Figure 40. Anonymous, *Festival of 10 August 1793*. Engraving, 1793, Bibliothèque Nationale, Paris.

that once supported Bouchardon's equestrian statue of Louis XV. Thousands of birds were then set free. At the fourth station, the Place des Invalides, the march halted in the shadow of a colossal statue of Hercules representing the French people smashing federalism, the antithesis of national unity, in the form of a hydra. Finally, at the Champ de Mars, the procession gathered before the altar of the Fatherland where the president of the Convention read the Constitution and led a pledge of allegiance. Music and dancing followed into the night.

It was a brilliant allegorical drama, sanctifying the new symbols of the Republic while doing away with those of the monarchy, and with the nation joined as one reliving the progress of the Revolution from the fall of the Bastille. In the words of Mona Ozouf, the festival was conceived as a *mise en scène* of the birth of the Republic and its citizens.[25] It was David's masterpiece of Revolutionary pageantry and was commemorated by an official medal and a five-act theatrical production by Gabriel Bouquier and P.-L. Moline.[26] The opening of the museum was no doubt overshadowed by the day-long festival, yet those who did visit the Louvre would have come away

with a similar sense of collective Revolutionary triumph over despotism. In important respects the museum may be viewed as an extension of the festival outdoors.

On that day above all others, the rich historical associations of the Louvre would have seemed particularly significant. The Revolutionaries' intent to regenerate society was put into effect on two levels. First, new symbols for public worship were substituted for those of old: the fasces replaced the fleur-de-lis, the female image of Liberty replaced the Virgin, and so on.[27] And, second, the past in all its manifestations was either destroyed or appropriated and revolutionized. David's festival skillfully blended the two possibilities: all the trappings of the new *culte révolution-naire* were paraded through the streets and squares, which now belonged to the people.

The occupation of spaces that had previously been tightly controlled was an inevitable response to the collapse of the Old Regime. As Ozouf has remarked, "The appropriation of a certain space, that must be opened and forced, is the first climactic pleasure afforded by revolutions."[28] This applied to internal spaces no less than to space outdoors, and of all royal buildings in Paris none (after the Tuileries, overrun in August 1792) was more conspicuous, and therefore more attractive to Revolutionaries, than the Louvre. Entry to much of the palace, and particularly the Grand Gallery, had been carefully regulated during the *ancien régime*. As we have seen, until 1776 the Grand Gallery was home to the strategic scale-relief models and, for obvious reasons, was kept under strict lock and key (Fig. 23). Permission to visit the Galerie des plans was customarily reserved for high-ranking courtiers, foreign ambassadors, and visiting heads of state. Even after the models were removed, the gallery was not generally accessible except to those involved with or interested in the museum project.[29] In the summer of 1793 the government would have been alive to the significance of "liberating" this formerly privileged space.

Inside the museum, the feeling of Revolutionary conquest was unequivocal. The works of art on display had been prized from their pre-Revolutionary settings and returned to their "rightful" owners: the people. According to the Abbé Grégoire, those treasures "which were previously visible to only a privileged few . . . will henceforth afford pleasure to all: statues, paintings, and books are charged with the sweat of the people: the property of the people will be returned to them."[30] Belonging to no one individual or institution, the gallery's contents were presented as "the property of all." Seizing works of art in private hands and reidentifying them as communal property brought together at the national museum paralleled the Revolutionary progression from liberty to unity dramatized by the festival of August 10; free

[handwritten margin note: National collection property of the people]

admission and circulation at the museum echoed participation in the street celebration. The perception of collective ownership helped fashion what Grégoire termed the "republican mold" and to confer on the citizen "a national character and the demeanor of a free man."[31]

In the weeks leading up to August 10, the Louvre was stocked with all manner of art objects in order to reveal the full extent of the nation's new-found artistic wealth. Paintings and sculptures, tables and vases of precious marbles and porphyry, bronzes and porcelain were brought from the various depots to dazzle and overwhelm the beholder. In July, Garat wrote to the Museum Commission:

It would be appropriate to bring together for the opening everything that will enhance our precious collection of treasures to impress upon those who are coming to Paris for the festival that our present political problems have in no way diminished the cultivation of the arts among us.[32]

At one and the same time, the museum symbolized the stability of the state and the triumph of the people. Furthermore, for a period of two weeks, beginning on August 3, the public was admitted to the central storage depot of the Petits-Augustins to view the vast hoard of property, most of it confiscated from Paris churches, arranged according to provenance. The event proved such a success that the depot's keeper, Alexandre Lenoir, was allowed to keep the exhibition open until the end of September.[33] As mentioned in the introduction, some time later at the Louvre the names of émigrés were attached to works of art that had come from their collections.[34]

*　　*　　*

The Louvre was not simply a royal space that had to be liberated: it was also home to the Royal Academy of Painting and Sculpture. Discontent with the Academy's monopoly of the Paris art world had grown steadily from midcentury, to the point where on the eve of the Revolution many people were eager to dismantle a system that had promoted the interests of a privileged few at their expense. Even within the Academy there was dissatisfaction with the hierarchy and customary distribution of honors.[35] After 1789 the academies were among the first institutions of the Old Regime to come under attack. The argument against the Academy of Painting rested on two beliefs. The first was that its hierarchical structure and the privileges its members enjoyed were incompatible with the political reforms that were transforming society. As the engraver S.-C. Miger stated in an important pamphlet of November 1789: "If everything else in society is undergoing reform, the constitution of the Academy must also change."[36]

The second argument was that the Academy's traditional teaching methods were ill suited to the proper development of artists. The museum entered the dispute because in the Republican plan for the regeneration of the arts it was to replace the Academy as the source of instruction for present and future artists.

This intent was made clear in an early statement of policy by the Commune des arts, the 300-strong group of dissident academicians, students, and previously disenfranchised artists that came together under David's leadership in September 1790. In an address delivered to the National Assembly in 1791, the Commune insisted that "In place of these public professors and their deceptive instruction . . . the huge collections of antiquities and works by the great masters, as well as many other artistic treasures currently hidden away" must be displayed "in a vast and suitable space" for the benefit of both students and the general public.[37] The Commune returned to the museum later in its address, after further criticizing traditional academic practice:

It is obvious how ill-suited this education is . . . to the formation of artists. Let us provide one that is more in keeping with liberty . . . one that doesn't raise students into servitude and commit them to a narrow path. Their goal as artists should be demonstrated in a more striking manner: let us evoke the memory of the great masters in a such a way that their wise and immortal masterpieces will inspire the artist enflamed with a love of his art to use them as his guide. It will be clear that we are calling for the creation of the national museum.[38]

According to the Commune, the main problem with academic instruction was the enforced dependence of a pupil on the teaching and protection of one master. The argument went as follows: an aspiring student was placed at an impressionable age in the studio of an established master. To get ahead and to benefit from his master's influence with patrons and in the Academy, the student had little choice but to imitate the master's manner. The faults of the master (no artist was perfect) would be transferred to the pupil, who in turn would pass them on to the next generation, and so on. Though the dangers of following one example too closely had long been a commonplace of art theory, after 1789 the contrasting notions of indentured servitude to a corrupting master, on the one hand, and freedom to choose one's own teachers from the field of great masters, on the other, became a central and irresistible figure in antiacademy rhetoric.[39] In the words of Alexandre Lenoir, before the Revolution "Paris had neither museums nor public collections; arrogant masters hid the works of the great men from their pupils and offered only themselves as models; students became slaves forced to wear their masters' livery."[40] The master-pupil argument was used by the

Jacobin deputy Gilbert Romme in a 1792 speech calling for the suppression of the directorship of the French Academy in Rome:

Surrounded by the works of Raphael and Michelangelo students full of youth and vigor are unlikely to receive fruitful instruction from a man inferior to those great masters and well past his prime. . . . Close supervision is inappropriate for students called by the nature of their art to exercise their genius freely.[41]

The closure of the Academy in Rome in the following year made the opening of the museum in Paris all the more urgent.

Rhetoric aside, there was a real commitment to giving artists access – indeed privileged access – to the Louvre collection for purposes of copying during the Revolutionary era. Lenoir exaggerated when he said that artists before the Revolution could not see Old Master paintings: apart from the Luxembourg, there was the Palais Royal (where Lenoir himself studied) and numerous other private collections open to well-connected academicians. But it is true that *copying* works of art in Paris was a problem. Despite initial intentions, copying was not permitted at the Luxembourg; nor was it allowed in the royal picture depots under Terray and d'Angiviller.[42] By contrast the Museum Commission in 1793 devoted five days of every *décade* (the ten-day week in the new Revolutionary calendar) to artists' study.[43] This was increased to seven days in ten in the mid-1790s.[44] As Dominique Poulot has noted, the activity of copying in the Grand Gallery testified to the useful purpose of the museum: more than a repository of past art, it was instrumental in *producing* art in the present (Fig. 6).[45] By the middle of the decade just about anyone was allowed to set up an easel in the Grand Gallery, but so popular did copying become (by year III over 500 people had been given permits)[46] that before long restrictions had to be introduced. Ironically, during the Directory, permission to copy was granted only upon presentation of a letter from one's master![47] Even though the atelier system was never, in fact, abolished and survived the temporary closure of the Academy (1793–5), copying did become a vital part of artistic training in Paris. If the museum did not in the end replace the master-pupil relationship, it nevertheless more than justified the pedagogic claims made on its behalf during the Revolution. Whereas the full impact of copying on contemporary artistic practice would be very difficult to gauge, surviving copies by early-nineteenth-century artists – Delacroix, Gericault, and so on – point to the great importance of the Louvre as a supplement to their formal training.

The turning point in the battle between the dissidents and the Academy was David's election to the National Convention as deputy from the "Museum" section of Paris, followed by his nomination to the influential Committee of Public Instruction (CPI) and Committee Public Safety (CPS).[48] David participated actively in the work of these committees, as he

did in the Jacobin Club, of which he served a term as president. His addresses to the Convention mostly concerned the arts, but when he spoke his opinions carried weight, especially during the Terror (1793–4), the era of Jacobin rule.

David's political campaign against the Academy began in November 1792 with his dramatic resignation from it during a speech on the floor of the Convention. In the months that followed, as Jacobin influence grew, David gradually won over his colleagues in the house. By July he had persuaded the Convention to order the CPI to report on the suppression of the Paris academies. Meanwhile the Commune gained official recognition on July 18 when it was instructed by the Convention to assist the Commission des monuments in the ideologically significant work of effacing remaining royal emblems from public buildings in Paris. When the Commune met to discuss this job, emboldened by the Convention's support, it decided to appropriate the Academy's rooms in the Louvre and hold its assembly there.[49] Finally, on August 8 – two days before the museum opened – following rousing speeches by David and the Abbé Grégoire, the Convention voted to dissolve the academies.[50] The CPI assumed responsibility for the arts, which in effect meant that power passed to the Commune.

In assuming control of the arts, the Commune was faced with the problem of taking over the Academy's functions while eschewing its methods and hierarchical structure. This it was evidently unable to do – at least to the satisfaction of the Convention. The Commune itself was suppressed in the autumn of 1793 and its place taken by a radical offshoot, the Société populaire et républicaine des arts (SPRA). As the name suggests, the SPRA was run along the lines of a popular society or club whose business it was to convert the people to the Republican cause. Artists were examined to ensure that only true Republicans were admitted; politics became a criterion of membership.[51] In keeping with its egalitarian charter, ranks within the Society were proscribed, and its meetings in the Louvre were open to anyone who wished to attend. So much for the abolition of privilege. But the SPRA, now that the traditional academic system was no longer available, was also obliged to address the question of how to provide artistic instruction to aspiring artists, and, more important, how to tailor that education to meet the political demands now placed on the fine arts. The history of the Academy's dissolution would be little more than a sideshow of the Revolution if it were not for the great store placed by Republicans on the regenerative powers of the visual arts and the efficacy of visual signs.[52]

It was through the arts that the people would become familiar with the history, symbols, and martyrs of the Revolution. The arts, in other words, would play a leading role in legitimizing the Revolution and, moreover, would record the heroic achievement for posterity. The experience of revo-

lution was so different from what had gone before, the break with the past so radical, that a new artistic style was called for to characterize in visual terms the magnitude and nature of the upheaval. The art of the Old Regime came to be viewed as effeminate and debased after 1789 (building on earlier efforts by La Font and others to characterize the rococo in those terms) and unfit for either public scrutiny or emulation by young Republican artists. In a remarkable June 1794 address to the Convention, which sought to bring painting in line with the masculine republic of virtue promoted by the Jacobins, the painter turned politician Gabriel Bouquier had this to say about the art of the Old Regime and that which must replace it:

It is time to do away with the traditional French system, that monarchical routine which, in subjugating art to the whims of false taste, corruption and fashion, has narrowed its genius, mannered its methods, and perverted its goals. . . . It is time to replace the dishonorable productions [of the Old Regime] with paintings worthy of a republican people who cherish morality and who honor and reward virtue. . . . Effeminate works by the likes [of Boucher, Vanloo, and Pierre] are incapable of inspiring the virile and energetic style that must represent the revolutionary exploits of the defenders of equality. In order to capture the energy of a people who, in breaking the chains that bound them, has voted for the liberty of mankind, we need dignified colors, an energetic style, a bold brush, a volcanic genius.[53]

Republicans advocated that it was in the museum that these qualities would be acquired.

It was the question of how the museum, or rather what kind of museum, could best serve the needs of Republican artists that led David into his next confrontation – this time with the Museum Commission. As we have seen, the Commune had insisted from the start that hand in hand with the abolition of the Academy must go the creation of the national museum, and it is clear from its polemical pamphlets that its campaign to replace the Academy was at the same time a declaration of its interest in taking control of the museum.[54]

David's move on the Museum Commission coincided with an effort to do away with the Commission des monuments. The CPI was behind both initiatives, and both were motivated by a desire to bring all aspects of arts administration under centralized control. This meant doing away with agencies that were created by and owed allegiance to now defunct or discredited authorities – the Municipality of Paris in the case of the Commission and the Girondin minister Roland in that of the Museum Commission. Not surprisingly, the charges leveled against the two commissions were the same as those that had destroyed the Academy: incompetence and inconsistency with the ideals of the Revolution. All three were held guilty by association with past regimes.

The Commission des monuments was the first to go. Waiting in the wings

to take its place was the Commission temporaire des arts (CTA), created in August 1793 and attached to the CPI.[55] On December 18 the deputy from Oise and CTA president, Jean-Baptiste-Charles Mathieu, delivered a speech in the Convention on behalf of the CPI demanding the abolition of the Commission des monuments. In retrospect, his charges of ineptitude and lack of dedication are difficult to justify; the CTA cannot be said to have done a better job, and even they were the first to admit – after Thermidor – that they had merely continued the work begun by their predecessors.[56] But at that moment any defense of the Commission's performance would have been overwhelmed by Mathieu's further accusation that its members were lacking in patriotism. His words are a vivid reminder that "terror" was now the order of the day:

> Your committee has decided that talent and expertise are insufficient unless accompanied by a pronounced patriotism. Given the direction of current events, the civic spirit of several members of this committee seems to have stood still, and indeed in some cases to have regressed. Today it is essential that everything march forward together . . . and those who are called upon to serve on such commissions must possess an unwavering republicanism . . . a firm and rapid step in harmony with public opinion.[57]

David followed Mathieu's speech to the Convention with one of his own denouncing the Museum Commission and calling for its replacement by a Conservatoire of ten men (the painters J.-H. Fragonard, J. Bonvoisin, P.-E. Le Sueur, J.-M. Picault, and J.-B. Wicar; the sculptors R.-G. Dardel and A.-L. Dupasquier; the architects F.-J. Lannoy and David Le Roy; and Casimir Varon) accountable to the CPI, whose professional standing was sound and whose patriotism beyond reproach.[58] The Museum Commission, David claimed, was made up of men who were either unqualified for the job, such as Cossard and Bossut, or who, though possessed of talent, like Vincent and Renard, were at best lukewarm Republicans. David failed to persuade the Convention on this occasion, perhaps in part because the Commission had tangible proof of its accomplishments in the form of the museum itself. In a second report on the subject, delivered on January 16, 1794, David challanged that achievement and argued that in different hands the display could be much improved.[59] He focused on two issues that had become controversial almost as soon as the Commission began preparing the museum late in 1792: picture restoration and the choice and arrangement of works of art in the gallery. Because of incompetence in those two areas, David explained, the Louvre, that "temple of liberty," was a source not of glory to the Republic but of shame.

Not for the first time the issue of conservation proved an effective weapon against those in whose trust the nation's heritage had been placed. The equation between a well-ordered museum and responsible government

once again came into play, only this time there was even more at stake because the Republic was relying on the museum to counteract outward signs of civil and political chaos. Failure to maintain the art it had inherited jeopardized the Revolution's self-image as the engine of progress and Enlightenment ideals. As the Abbé Grégoire remarked in his report on vandalism, "barbarians" detest and destroy works of art, but "free men" love and preserve them.[60] Appealing to such sentiments, David's report gave details of botched restoration work under the Museum Commission: a Raphael disfigured by clumsy repaints, a Claude landscape stripped of its magical light and color, a famous Guido Reni scrubbed to the bone, and so on.[61] By implication, Commission members were vandals in their own right. David emphasized that his criticisms of restoration practices were backed by "the best-qualified experts in Europe." He was referring to Jean-Michel Picault, son of Robert, the "inventor" of the transferral technique, and Jean-Baptiste-Pierre Lebrun, both of whom had recently published pamphlets attacking the Museum Commission. Frustrated in their own attempts to win a place on the Commission, they joined forces with David to help in the destruction of the Commission.

As early as October 1792 Lebrun applied unsuccessfully for a position at the museum as a restorer.[62] A month later he tried again, this time presenting himself to Roland, then minister of the interior, as a connoisseur. David went along to the interview to lend his support, but to no avail.[63] Apparently the Revolution had done nothing to erase Lebrun's questionable reputation. Having failed to persuade the authorities, Lebrun appealed to the public. In January 1793 he published his *Réflexions sur le muséum national,* condemning the Commission's restoration policy and reiterating the familiar point that only connoisseurs were qualified to run the museum, because they alone had the ability to make attributions and to distinguish original pictures from copies and good pictures from bad. Roland countered with a letter to the press exposing Lebrun's intrigue and suggesting that David had been seduced by it.[64]

Picault, meanwhile, was making a simultaneous bid to secure the position of chief restorer at the museum. Like Lebrun, Picault had been rebuffed by d'Angiviller and no doubt counted on the Revolution to improve his fortunes. In October 1792 he was asked by the Museum Commission to take part in an open competition to determine the best-qualified restorers. Like his father before him, he refused to divulge the family's "secret" technique and proposed a different restoration competition of his own design. When this was in turn rejected Picault angrily withdrew and joined forces with Lebrun and David.[65] In March 1793 Picault published a letter in the *Chronique de Paris* calling on the Commune to petition the Convention to look into what he claimed were the Commission's abuses at the Louvre.[66]

Restoration was halted briefly but was allowed to resume again later in the month. Despite the subsequent publication of Picault's *Observations . . . sur les tableaux de la République,* repeating his accusations, and further letters of protest from Lebrun, the Commission was left to get on with its business.[67] Not until David's campaign in December do we hear from Picault and Lebrun again.

David's charges of incompetent restoration, supported by the "expert" testimony of his fellow conspirators, were effective because they were difficult to disprove. As the recent debate over the cleaning of Michelangelo's Sistine Ceiling shows, restoration remains a contentious subject, notwithstanding the considerable technological advances of the past two centuries. But in the case of David and the Museum Commission it seems clear that restoration was used simply as a strategy. Surviving documents show that great care was taken under the Commission; the main restorers used – Roeser, La Porte, Michau, and Hacquin and his pupil Fouque – were well respected and continued to be employed at the Louvre through the Directory and Empire.[68] Nevertheless, Picault and Lebrun both found themselves in positions of power when the museum passed into the hands of the Conservatoire.

The other point of contention between the Museum Commission and its critics was the choice of objects for the museum and their arrangement in the Grand Gallery. As we have seen, the Commission deliberately set out to dazzle the beholder, to create a spectacle revealing the full extent of the nation's artistic wealth, and it did so evidently with the approval of Garat. In August 1793 the government was not concerned to put too fine a point on the distinction between a museum and a depot of *biens nationaux.* The Commission understood its mission to be the creation of an all-encompassing museum, displaying under one roof "all the riches of the Republic in all branches of art and science."[69] But to David and his Jacobin colleagues this eclectic display was at once all too reminiscent of the aristocratic cabinets of the Old Regime and too heterogeneous to function as a school for artists. As he declared in his speech of January 16: "The Museum is not supposed to be a vain assemblage of frivolous luxury objects that serve only to satisfy idle curiosity. What it must be is an imposing school."[70]

In addition to the decorative arts and scientific instruments, the gallery had also to be cleared of paintings that, in David's words, "could only encourage bad taste and error" – paintings, in other words, that were seen to embody the decadent, effeminate taste of the Regency and the reign of Pompadour. For it was precisely this taste that the museum was supposed to eradicate from French art: "By offering young students only the most beautiful of models, we sill soon see the end of that mannered and artificial taste which has characterized up till now the work of every master of the French

school."[71] Finally the critics insisted that if the museum was to contribute properly to public instruction and the formation of Republican artists, the collection must be divided into schools and arranged chronologically.[72]

The question of how to arrange the Louvre collection had been the subject of much debate in 1793. Even before the museum had opened the Museum Commission felt obliged to justify its preference for a mixed-school arrangement. In response to the criticisms of Lebrun, Picault, and others, the Commission presented its argument in a polished memoir dated June 17:

The arrangement we have adopted is like that of an abundant flowerbed that has been planted with great care. If, by choosing a different arrangement, we had demonstrated the spirit of art in its infancy, during its rise and in its most recent period; or if we had separated the collection into schools, we might well have satisfied a handful of scholars, but we feared being criticized for having ordered something which, in addition to serving no useful general purpose, would actually hinder the study of young artists, who, thanks to our system, will be able to compare the styles of the Old Masters, their perfections as well as their faults, which only become apparent upon close and immediate comparison.[73]

Aware of the "scholarly" alternative to their installation, the Commission decided against its implementation. In its view, a strict arrangement by school and period would do nothing for the man in the street and would impede the young artist's development. Roland himself had recommended an eclectic display as one that would please "everyone."[74] As artists (five of the six men on the Commission were artists, it will be recalled) they reverted naturally to a Luxembourg-type arrangement (Fig. 20) when it came to the pedagogic needs of young students. Their report said as much in its insistence on the benefits of stylistic comparison. As mentioned in Chapter 1, Veronese's *Supper at Emmaus* and Lebrun's *Tent of Darius* were still paired at the Muséum Français when it opened, as they had been at Versailles for more than a century.

The Louvre's role in the education of Republican artists became the focal point of the argument between the Museum Commission and its opponents. Both parties advocated the superiority of their respective systems in a bid to claim higher pedagogic ground, but in the final analysis one system was not demonstrably better for young painters than the other.[75]

In essence the dispute about hanging the Grand Gallery represented a clash of alternative modes of pictorial display: the one, favored by artists, was ahistorical and derived from critical categories established by de Piles; the other, preferred by connoisseurs, was historical and characterized by a scientific taxonomy. The former aimed to concentrate the beholder's attention first and foremost on pictorial qualities within the frame, whereas the latter encouraged appreciation of a given painting in terms of its place in a

diachronic, national sequence.

As with virtually everything else in France during the Revolution, the debate over rival strategies of display was inflected by broader ideological concerns. For the Museum Commission's critics, the issue of pedagogic efficacy and student needs masked a straightforward ideological discontent with an approach to pictorial display that signified a return to the bygone Luxembourg era. The mixed-school arrangement of pictures together with the exhibition of assorted luxury objects recalled too closely both discredited academic practices and, in the words of Bouquier, "the luxurious apartments of satraps and the great, the voluptuous boudoirs of courtesans, the cabinets of self-styled amateurs."[76] Even the Commission's likening of the museum to a cultivated flowerbed smacked of what had come to be seen as the leisured dilettantism of the Old Regime.[77] The system of school and chronology was by now well established in important northern European galleries, as we have seen, but it had yet to make an appearance in a significant public collection in France (thanks to the failure of d'Angiviller's museum project), and thus its implementation at the Revolutionary Louvre could be hailed as a break with the past and a forward-looking Republican innovation.

<p style="text-align:center">✻ ✻ ✻</p>

When the Conservatoire came to power in January 1794, composed of David's men, its agenda was already determined by the issues over which the Museum Commission and its critics had fought: restoration and the gallery installation.[78]

In June the Conservatoire scheduled the restoration competition demanded by Picault and Lebrun.[79] In the event it proved a failure. A week after it was announced in Paris only a few people had come forward.[80] A second date was planned for the summer of the following year, and it was hoped that better publicity would yield a larger field of candidates. In September 3,000 notices were distributed to provincial towns throughout the land.[81] As it happened, the Conservatoire was not to get a second chance, for by September 1794 paintings seized as war booty in Belgium had begun to arrive in Paris, the majority in need of restoration.[82] The political pressure to put them on display immediately exceeded the desire to see justice done to a handful of would-be restorers. Besides, even without the Belgian intervention, there were doubts about the effectiveness of such a competition owing to the impossibility of determining "in a matter of days how successful a restoration would prove several years later," as J.-F.-L. Mérimée put it.[83] Ironically, though inevitably, the practice of restoration at the Louvre from 1794 was conducted much as it had been at the Bâtiments during the final years of the Old Regime.

The pamphlets of Picault and Lebrun, together with the guidelines for the

failed competition, reveal the extent to which attitudes toward restoration had changed in fifty years. The crucial aspect of restoration was no longer the ability to perform transferrals, though this was still of the utmost importance in certain cases. What made a good restorer was the ability to discern the techniques and materials of the various Old Masters and the skill to proceed with the restoration on the basis of that knowledge. As defined by one contemporary restorer, the main purpose of restoration was to return a given work of art to its "original state."[84] There was no greater threat to a picture than the ignorant restorer who in cleaning the surface mistook layers of glazes for coats of varnish or who in repainting a damaged area substituted his own hand for the style of the master.

The removal from the gallery of works of art that were deemed unsuitable began in February. The Conservatoire's word for this was "purification."[85] During a period of some months the gallery was closed to all but artists and foreigners (a special open day for the general public was held on July 14, 1794, the fifth anniversary of the Bastille).[86] The special concession to étrangers remained in place throughout the 1790s and is a clear indication of the propagandistic function of the museum.

What is particularly interesting about the process of "purification" is the difficulty the Conservatoire had in deciding what to do with certain types of art. Disdain for objets de luxe, porcelain, and so on, was outright, but the criterion for what pictures should be banished from view was not so clear-cut.[87] The confusion was not so much over style as content. For example, the few paintings in the original exhibition embodying "the French routine" (their presence had been exaggerated by the Conservatoire) were removed because of their potential corrupting influence. Problems arose, however, in cases in which indisputable masterpieces by canonical artists portrayed what since the Revolution had become sensitive subjects. The desire to create the perfect museum conflicted with the Revolutionary ambition to eradicate the memory of former customs and loyalties.

A good case in point was Rubens's Medici cycle (Fig. 9), whose original purpose was, of course, the glorification of the monarchy. (We should bear in mind that by the summer of 1794 the streets of the capital had been cleared of all royal monuments and insignia.[88]) The fate of those paintings was discussed by the Conservatoire in August. On the one hand, there was concern that the sight of the "tyrant Henri IV and his wife" (Marie de Medici) might reawaken royalist sentiments. But, on the other, it was understood that this famous series had long been regarded by artists and connoisseurs as one of the supreme monuments of the history of art.[89] In the end a compromise was reached whereby two of the less overtly royalist episodes from the series – The Treaty of Angoulême and The Conclusion of the Peace (Figs. 41 and 42) – were chosen. Removed from their narrative

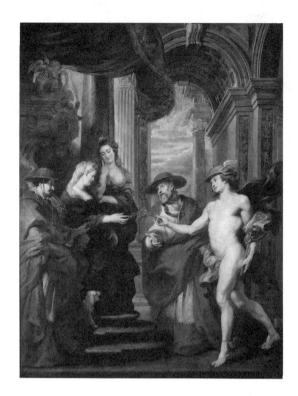

Figure 41. Peter Paul Rubens, *The Treaty of Angoulême.* Oil on canvas, 1621–5, Musée du Louvre, Paris.

Figure 42. Peter Paul Rubens, *The Conclusion of the Peace.* Oil on canvas, 1621–5, Musée du Louvre, Paris.

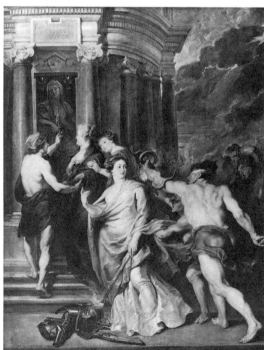

sequence, the dense allegory of the scenes rendered them illegible except as figurative paintings and examples of Rubens's brush; the nude foreground figures became all the more prominent as signifiers of the Ideal. All the same, as an added precaution all "feudal signs" in the paintings were painted over.[90]

A second difficult class of paintings was Northern genre scenes. Though genre painting had proven highly popular with the Parisian public, appealing equally to aristocratic collectors and visitors to the Salon, the lowly subject matter of much Dutch and Flemish art was deemed inconsistent with the didactic, moralizing aims of the museum during the Terror. In strict Republican eyes the activities of farmyard and tavern would not mold and inspire the young artist or citizen along desired lines. In the spring of 1794 genre painting was denounced more than once in meetings of the SPRA. On one occasion the sculptor J.-J. Espercieux exclaimed that he would not give eighty *sous* for any Flemish picture.[91] It was proposed that a separate room be created at the Louvre for selected genre pictures judged useful to artists from a purely technical point of view but inappropriate for general viewing. J.-B.-P. Lebrun, author of a recent book on the Northern schools of painting, came forward to defend the Flemish school and "the virtues of the cottage," yet he need not have worried.[92] In practice, the exclusion of genre painting was never systematically applied. Indeed many Northern artists – David Teniers, Albert Cuyp, Adriaen van de Velde, Adriaen van der Werff, Bartolomeus Breenbergh, and Gérard de Lairesse – figured on the list of works requisitioned by the Conservatoire from Paris depots at the height of the Terror.[93] Misgivings about exposing the public to less than edifying subjects were outweighed by the demands of completeness at the museum.

Another potential problem was religious art. The public exhibition of miracles, saintly ecstasies, and martyrdoms ostensibly clashed with the government's policy to suppress "fanaticism" and to replace the worship of Catholicism with the Cult of Reason. But, of course, if religious paintings were to be excluded, the museum would be deprived of countless masterpieces of all schools and periods.[94] The dilemma intensified in September 1794 with the arrival of confiscated Belgian pictures. The first consignment contained numerous religious works, including Rubens's magnificent *Descent from the Cross* from Antwerp Cathedral (Fig. 43). An article in the *Décade philosophique* questioned the wisdom of importing such pictures to France and imposing their "catholic mythology . . . on a people delivered from the superstitions of catholicism."[95]

Whatever doubts people may have had along these lines, public criticism was rare (it is significant that the above comment figured in a review of a travel book and not a discussion of the museum). The potential corrupting influence of religious art, or any other type of painting, though a serious

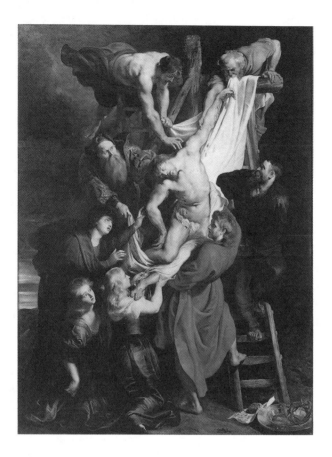

Figure 43. Peter Paul Rubens, *Descent from the Cross.* Oil on panel,
1611–12, Antwerp Cathedral.

concern, especially during the Terror, was finally not great enough to
impede the momentum of the museum or to detract from its ultimate per-
fection. On the one hand, the ideal of a comprehensive museum tran-
scended mundane political concerns; on the other, precisely because it was
an ideal shared by all enlightened Europeans of the late eighteenth century,
it was something the Republic aspired to realize in order to demonstrate its
political, cultural, and ultimately military superiority.[96] Besides, for the sake
of consistency and appearances, a potent rationalization was at hand.

A solution to the apparent contradiction between Revolutionary ideology
and the purpose of much past art lay in the secularizing power of the
museum and the reidentification of iconic paintings as art objects occupying

a place in the history of art. A transformation from *imago agens* to work of art, a shift in emphasis from function to form, from signified to signifier, would, it was suggested, result from displacement to a museum and an arrangement of the collection by school and chronology.[97] This was implicit in the October 1793 law outlawing vandalism of significant art objects bearing feudal signs: the alternative to destruction was removal to the "nearest museum."[98] The power of the museum to elide original meanings and to substitute for them new aesthetic and art historical significances is well understood today, but it is an attribute of museums first recognized and exploited during the Revolution.

As promised by David in his reports to the Convention, the Conservatoire set out to replace what it viewed as a disorderly jumble of pictures with what its spokesman Casimir Varon described as "a continuous and uninterrupted sequence revealing the progress of the arts and the degrees of perfection attained by various nations that have cultivated them."[99] If the program was not in itself radically new, what is remarkable is that its implementation in the Grand Gallery was recommended at this time on grounds of political expediency. In Varon's fascinating report to the CPI of May 1794 explaining the changes that the Conservatoire had so far effected, he proposed that the new installation would neutralize the regrettable content of many of the paintings:

An involuntary sense of regret interferes with the pleasure of spreading before you our riches; art has diverged far from its true path and celestial origins . . . a multitude of dangerous and frivolous experiments, the results of long centuries of slavery and shame, have debased its nature: wherever one turns one sees that its productions bear the marks of superstition, flattery, and debauchery. Such art does not recount the noble lessons that a regenerated people adores: it does nothing for liberty. One would be tempted to destroy all these playthings of folly and vanity if they were not so self-evidently unworthy of emulation. But nevertheless there is some point in trying to veil these vaults, to obliterate these false precepts. This is our task and we shall strive to achieve it. *It is through the overall effect of the collection that this can best be done.* It is by virtue of an air of grandeur and simplicity that the national gallery will win respect. It is through a rigorous selection that it must command the public's attention.[100]

Simplicity, method, and rigorous selection were key at the Louvre during the Terror. In his report on the Commission des monuments, Mathieu envisaged a national museum in which "everything will be ordered and arranged with method, explained and embellished by method itself."[101] Just as Varon contrasted the "flattery" and "debauchery" of the Old Regime with the "simplicity" and "rigor" of the new, so he compared the laxness and disorganization of the Museum Commission with the efficiency of the Conservatoire, whose conduct he described in like masculine, militaristic terms: "Our

administration in contrast exudes order, precision, and the strictest exactitude."[102]

The methodical reordering of the collection promised by the Conservatoire proved easier said than done, however. Pressure to keep the museum open to artists and the public made changes hard to institute. Still only half of the Grand Gallery was available (the other half was still under repair), and money to expand exhibition space elsewhere in the Louvre, to accommodate the separate rooms for antique and modern sculpture, medals, cameos and gems, drawings, and engravings called for by Varon in his report, was not forthcoming. Frequent requests for funds through the winter of 1794–5 fell on deaf ears.[103] Most troublesome of all was the steady arrival of new works of art and the constant need to revise the existing installation. Despite close monitoring of the various Paris depots, keeping track of what was available proved difficult, to say the least. By September 1794, the Louvre depot alone had swelled to between six and seven hundred pictures – no one was sure of the exact number.[104] Any additions or substitutions in the permanent collection had both to comply with the demands of school and history and the dictates of visual symmetry.

The problems of choice and hanging were, of course, greatly compounded by the arrival from September onward of art seized in conquered lands. The Revolutionary Louvre would not be complete, or more than provisional, until the fruits of foreign conquest had been successfully assimilated. An account of the process of assimilation and permanent installation must wait until the next chapter. In the meantime we must turn our attention abroad, to the plundering of northern Europe and the systematic despoilation of Italy by Napoleon Bonaparte.

<div style="text-align:center">* * *</div>

Official confiscation of art, as opposed to random looting by troops, was authorized by a report made by the CPI to the CPS on June 27, 1794, the day after the French victory at the battle of Fleurus, which marked the turning point in the two-year-old war with Austria. The CPI recommended that a handful of artists and men of letters be sent to Belgium in the wake of the Republican army in order to confiscate selected "monuments of interest to the arts and sciences."[105] On July 8 the CTA appointed a committee of four men – J.-B.-P. Lebrun, the Abbé Grégoire, A.-C. Besson (an early advocate of confiscation),[106] and Varon from the Louvre – to draw up instructions for generals in the field in the event they happened upon objects worth taking. The CTA was the obvious body to supervise such business since the elaboration of guidelines for selection and confiscation complemented the work that had gone into their earlier manual on cataloguing and conserving valuable objects throughout the land.[107] Belgium, after all, was now another

French province whose monuments might enrich Parisian institutions: the Louvre, the Bibliothèque Nationale, and the Jardin des Plantes. In due course a number of experts were chosen in various fields to direct the operation, including the painter J.-B. Wicar (who was forced to resign following the fall of Robespierre), the architect de Wailly, the botanist André Thouin, and the antiquarian and former secretary of the Commission des monuments, G.-M. Leblond. At about the same time, however, apparently at the behest of the CPS, the distinguished chemist L.-B. Guyton de Morveau, then serving with the French army at Brussels, authorized two men to do precisely what the CTA's experts were being sent to do. Morveau's delegates were the painter and former pupil of David, Luc Barbier, then an officer in the Hussars, and one Léger. In the event, they sent the first spoils of war back to France.

Regarding the choice of paintings and other objects, much if not all direction was provided by the CTA in Paris. In the realm of art, Lebrun's knowledge of the Low Countries, accumulated in his years as a dealer and in the preparation of his three-volume *Galerie des peintres flamands, hollandais et allemands* (1792–6), proved invaluable.[108] Whatever reservations contemporaries may have had about his character and professional conduct, Lebrun was a formidable connoisseur, perhaps the greatest of his age, and his experience was essential to the formation of the Louvre during the 1790s. Cecil Gould was probably right to suspect his influence in Barbier's choice of pictures and to note that the first three sent back from Belgium, Rubens's *Descent from the Cross* (Fig. 43), the *Erection of the Cross*, and the *Crucifixion*, had been singled out for special praise in his recent book.[109] At the same time, they were obvious choices and topped the register of Flemish pictures that had, in the words of one Convention delegate, "long attracted travelers from all over Europe as well as the admiration of painters."[110] More significant, no doubt, was Lebrun's influence in the selection of representative works by dozens of lesser Flemish and Dutch masters. The list, featuring two works by twenty-one artists and single pictures by more than sixty others, is at once too varied and too specific to have been the product of chance. It is as if Lebrun's *Galerie* provided the model, and perhaps it did.[111]

The first of the 150 paintings to be confiscated in Belgium arrived in Paris in September. Political pressure to display these treasures was such that they went on view at the Salon just five days after their arrival, ousting pictures by contemporary French artists submitted for the annual *concours*.[112] This special exhibition in the Salon set a precedent for all future convoys of war booty arriving at the Louvre. A day after their arrival in Paris, Luc Barbier, who had escorted the convoy in person, appeared before the Convention and made a speech important for its rhetorical justification of foreign conquest:

The fruits of genius are the patrimony of liberty. . . . For too long these master-pieces have been soiled by the gaze of servitude. It is in the bosom of a free people that the legacy of great men must come to rest. . . . The immortal works of Rubens, Van Dyck and the other founders of the Flemish school are no longer on alien soil . . . they are today delivered to the home of the arts and of genius, the land of liberty and equality, the French Republic.[113]

Pre-empting obvious criticism that these paintings had been removed from native soil and their proper purpose, Barbier claimed that they had found their rightful home in the bosom of liberty, the true home of creativity and genius. Just as the Revolution had freed Frenchmen and would soon liberate all of Europe, so confiscation had freed these paintings, too long subjected to the "gaze of servitude." Furthermore, once deposited at the Louvre the museum would become a universal source of inspiration, drawing artists from around the world. Finally, recent conquests served "to make known to the Republic the order and discipline of its armies."

In one speech Barbier managed simultaneously to defend French confiscation on ideological, pedagogic, and military grounds. His address became the basis for all subsequent public justifications of French conquest, and there were many. Yet it is worth noting that the Louvre was already the focus of imperialist dreams before the battle of Fleurus. Kersaint, for example, writing in 1791 on the Louvre and other monuments, envisaged a new Paris, "peopled by a race of men regenerated by liberty," succeeding Rome as the "capital of the arts."[114] A similar vision preoccupied Boissy d'Anglas early in 1794:

Imagine Paris . . . as the capital of the arts: imagine the inestimable advantages of it becoming the home of all the treasures of the mind . . . it must be the school of the universe, the hub of human science, and command the respect of the whole world through knowledge and instruction.[115]

Most familiar is the Abbé Grégoire's call to enrich France with cultural treasures at the expense of its vanquished enemies, culminating in the acquisition of the greatest prize of all: the *Apollo Belvedere* and the other ancient marbles of Rome.[116] It was fitting that Paris, capital of what Revolutionaries perceived as a new political world in the making, should naturally become the capital of art and knowledge as well. With this premise in place, confiscation became a matter of taking from the ignorant and giving to the enlightened for the ultimate benefit of all. In the new cultural order, the Louvre would become museum to the entire world.

In 1796 the policy of confiscation was taken south to Italy by General Napoleon Bonaparte where it was raised to new levels of sophistication.[117] Though Bonaparte manifested little personal interest in art, he well understood its value in the realm of politics and war. After a quick victory over

the Piedmontese in April, he turned inland toward Parma. Before entering the city he sought information from the French minister at Genoa about collections of art to be found not only in Parma but also in Milan, Modena, Piacenza, and Bologna.[118] Breaking with the informal looting of collections in the Low Countries, Bonaparte stipulated the surrender of works of art as part of the armistice he signed with the Duke of Parma on May 9, setting a precedent for future campaigns (Fig. 44). Though confiscation was on occasion ordered in retaliation for local resistance, as in Verona following the revolt of April 1797, or in Rome a year later to avenge the assassination of General M.-L. Duphot, in the main it was legitimized (and tied directly to battles won) through treaty agreements.

In advance of the armistice with the Duke of Parma and in anticipation of great victories to come, Bonaparte wrote to Paris on May 6 asking that "three of four known artists" be sent to Italy to assist in the choice and transport of his booty.[119] But already in Paris, in the wake of the fall of Piedmont and apparently in ignorance of Bonaparte's innovative armistice of May 9, the Directory had decided to authorize the continuation of the looting that had proved so successful north of the Alps. In due course five commissioners were chosen: the chemist C.-L. Berthollet, the mathematician Gaspard Monge, the botanists Thouin and J.-J. de La Billardière, and the painter J.-S Barthélemy (who was later assisted by Wicar and Gros).[120] Though our concern is with the paintings and sculptures taken for the Lou-

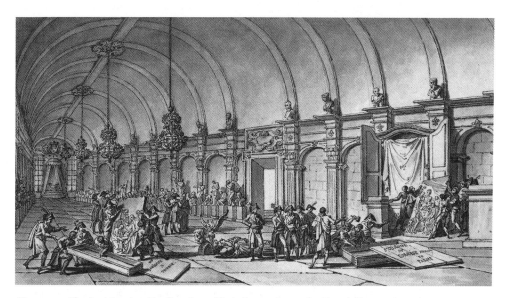

Figure 44. Charles Meynier, *Confiscation of Paintings at Parma by French Troops.* Drawing, Musée du Louvre, Paris.

vre, the composition of the commission reminds us that art was by no means all that was confiscated in Italy.

Following their arrival in Milan in early June (conquered a fortnight earlier), the commissioners were kept busy as Bonaparte marched victorious toward Rome. In rapid succession Parma, Piacenza, Milan, Cremona, Modena, Bologna, and Cento fell to the French and were surveyed by members of the commission. In each case works of art were ceded by treaty; in some cases the number was specified, in other cases not. In Bologna on June 23 an armistice was signed with papal delegates whereby 100 paintings and statues from Rome, chosen by the commissioners, were to be given over to France.[121] Between then and the spring of 1797 further works of art were ceded by Modena, Verona, Mantua, Perugia, and Venice. According to General F.-R.-J. de Pommereul's list, published in year VI (1797–8), in all just under 200 paintings and 100 sculptures were chosen during this first phase of French conquest. For all that was taken, certain important cities, notably Florence, Naples, Turin, and Brescia, remained untouched, as did most private collections not belonging to heads of state. Some of these cities would later be at least partially stripped, while Bonaparte eventually found ways of acquiring desired treasures in noble collections.[122]

The question of who selected the works of art and according to what principles arises again. As in Belgium, the commissioners' choice met with almost complete approval at home, suggesting that they were given clear guidelines if not detailed lists of objects. The one exception to the rule supports such a conclusion. After the first French victories in northern Italy, Bonaparte, impatient for the arrival of the commissioners from Paris, appointed the artist J.-P. Tinet, who happened to be on hand, to begin the process of confiscation.[123] By the time the experts from Paris arrived, Tinet had already been to Milan, Cremona, and Modena and partially filled the stipulated quota of works of art. On May 17 Tinet dispatched seven cases of assorted antiquities and works of art, which proved a dismal anticlimax when they were unpacked at the Louvre six months later. The *Décade philosophique* was forced to admit to an expectant public that "with the exception of five etruscan vases . . . there is nothing worthy [in the convoy] to be offered to the French Republic."[124] Acting on his own and in haste, Tinet had put together a less than satisfactory collection of objects.

The official commissioners were altogether more professional. They went about their business with an assurance that suggests a guiding hand. At least with respect to art, it is more than likely that they knew in advance what to look for. Between common knowledge of what constituted the major artistic monuments of Italy and detailed guidebooks providing information about less obvious works of art, a list of desiderata could easily have been compiled in Paris. A guidebook had been used to scout works of

art in Germany and (at least) one was most probably used for Italy as well.[125] Thouin, in his otherwise discreet account of his stay in Italy, tells us that he traveled with J.-J. Le Français de Lalande's popular *Voyage d'un Français en Italie* (1769), and this may well have been the common source.[126] If at first the use of guidebooks to direct the confiscation of foreign art seems ironic in the sense that a central museum in Paris undermined the purpose of the Grand Tour, we should recall that the point of building the Revolutionary Louvre was precisely to alter the priorities of European tourists and artists and to make Paris the artistic capital of the modern world. Where relevant, other sources of information must have been used. A list of antiquities from Verona, for example, refers throughout to Scipione Maffei (1675–1755), the erudite friend and correspondent of the Comte de Caylus, who had published several antiquarian studies of that city.[127] In their choice of 500 manuscripts from the Vatican, the commissioners closely followed the requests of the Institut and Bibliothèque Nationale in Paris and referred constantly to the "printed catalogue" issued by the latter.[128] For paintings, Luigi Lanzi's two-volume *Storia pittorica della Italia* might also have been consulted. Published at Bassano in 1795–6, it was the most up-to-date and authoritative account of Italian painting. Certainly Lanzi's book was used in about 1800 when the Louvre drew up a list of Florentine artists (mainly "Primitives") not yet represented in the museum.[129]

Works of art were chosen according to one of two criteria: first, celebrity; second, rarity. In the first category were those canonical paintings and sculptures esteemed the world over. The final list of objects taken from Rome begins with famous antiques from the Vatican and Capitoline Museum – the *Apollo Belvedere, Laocoon, Belvedere Torso,* and so on. Eighty-three of the 100 works of art ceded by the pope were antique marbles. Though many of those chosen are unfamiliar today, at that time they were universally admired by amateurs. In the words of Haskell and Penny, the selection "implied a tribute to consecrated taste."[130] The same could be said of paintings from Rome. That list opens with two of the three paintings thought by the French (following Poussin) to be the greatest in Rome: Raphael's *Transfiguration* (Fig. 52) and Domenichino's *Last Communion of Saint Jerome* (the third, Daniele da Volterra's fresco of the *Descent from the Cross* at S. Trinita dei Monti, was immovable).[131] It continues with other scarcely less famous altarpieces: Guercino's *Saint Petronilla,* Caravaggio's *Deposition* from the Chiesa Nuova, Andrea Sacchi's *Vision of Saint Romuald,* and Reni's *Martyrdom of Saint Peter.* These paintings, long admired by amateurs, had also been faithfully studied and copied by generations of students at the French Academy in Rome; their capacity to inspire future students in Paris was an important consideration.

If little guidance would have been needed to select these obvious master-

pieces, the same was not true of the large number of paintings chosen for their rarity. The commissioners' second task was to bring back pictures that would fill gaps in the museum's Italian holdings. This complementary ambition, stemming from the desire to provide instruction in the *history* of art, accounts for the inclusion in the booty of works by the likes of Giorgione, Simone Cantarini, Dosso Dossi, Elizabetta Sirani, and Carlo Bononi – artists who would not have been recommended to students for copying. Where art historical rather than artistic instruction was concerned only a representative sample of a given artist's work was required.[132] Who to include in the survey of each school was surely a matter decided by the museum authorities. Directions from Paris must also explain the commission's excursions to Perugia and Cento in search of works by Perugino, Guercino, and his pupil Ercole Gennari. A total of seventeen Peruginos, twenty-eight Guercinos, and three Gennaris were brought to Paris. Such disproportionate numbers (compared with, say, fifteen Raphaels, nine Renis, and three Domenichinos) were less an aberration on the part of the commissioners than the product of the museum's didactic program, to which I will return in the following chapter.

The removal of art from Italy, culminating in the mighty third convoy from Rome and Venice, was presented to the public at home as an exotic pageant, in which Bonaparte's Grand Army, the commissioners, and invaluable masterpieces of art played leading roles. Through press reports the public followed the progress of the most eagerly awaited convoy through successive stages of its tortuous journey to Paris, each step on the way reported like installments in a serialized adventure. Descriptions of the bumpy road and curious bystanders between Rome and the port of Livorno (Leghorn), and the threat of English frigates on the open seas, lent the reports local color and a touch of suspense. A pair of letters published in the *Décade* give us, in one, a fascinating account of how the paintings were rolled in waxed cylinders and the statues encased in plaster and straw and then transported overland on specially constructed carts to the coast, whence they traveled by ship to Marseilles.[133] The other letter gives an improbable, though no less interesting, account of the arrival of the third convoy at Livorno, pulled by 120 buffalo and 60 large-horned oxen:

The whole town came out to greet the convoy; everyone was amazed by the power of a nation which, four hundred leagues from native soil . . . had managed to transport such a large and precious cargo across the Apennines from Rome in order to decorate the capital of its empire. What a nation, this France, they said. So impressed were they that they called her THE NATION, as if she were the only one on earth deserving of the title.[134]

It was indeed a miraculous achievement, especially as, by all reports, so lit-

tle damage was suffered by those fragile works of art. The whole operation was a large-scale propaganda exercise managed with the precision of a military campaign, which in an important sense it was, since the prime beneficiary was General Bonaparte. To the people at home these trophies of conquest spoke more loudly and enduringly of his success in war than reports of victorious battles ever could.

As a result of Bonaparte's Italian campaign the Louvre took on an increasingly military air. The symbolism of war and military might replaced that of popular triumph over despotism. Artists and the public now had the army to thank for the museum as much as the Revolution. Witness the tribute offered by the artist Baltard: "The National Museum and its precious contents are recompense for the lives and blood of our fellow citizens spilled on the field of honor. French artists are worthy of this prize; they fully recognize its importance."[135]

The press, eager to fan the flames of patriotism, predisposed the public to view the art from Italy as the bounty of war. In May 1797, for example, the *Décade* announced the arrival of a small consignment from Mantua, augmenting "the number of trophies that will celebrate until the end of time the memorable exploits of our armies."[136] By 1798, according to an account of the new exhibition of booty from Lombardy, the new national flag, the *tricolore,* displayed in the gallery four years earlier, had been displaced by an ornamental arrangement of captured enemy arms and battle standards:

A trophy of arms and flags taken from the enemy decorate the door of the Salon. In the middle an inscription reads: "To the Army of Italy." The sight of this trophy warmed my blood, the words brought tears to my eyes. . . . One day we will raise monuments of marble and bronze to our warriors. Unnecessary efforts! The true and lasting monuments to their glory will be in our museums.[137]

Bonaparte's personal identification with the museum was secured in December 1797 at a dinner held in his honor in the section of the Grand Gallery destined to house the Italian schools.[138]

Of all events connected with the removal of art from Italy none was more dramatic than the festival organized in 1798 to mark the arrival in Paris of the third convoy containing the long-awaited marbles and paintings from Rome, central Italy, and Venice (Fig. 45). After lengthy delays caused by a combination of political problems in Rome (resolved by the Treaty of Tolentino, signed in February 1797), a shortage of funds for transportation, and bad weather en route, the convoy finally arrived at Paris in July 1798.[139] Though previous convoys had arrived at the Louvre with little fanfare, the contents of the third and last convoy called for a celebration. It was commissioner Thouin who it seems pushed for a spectacular entry into Paris. In his letter to the Directory of August 1797, written once the convoy

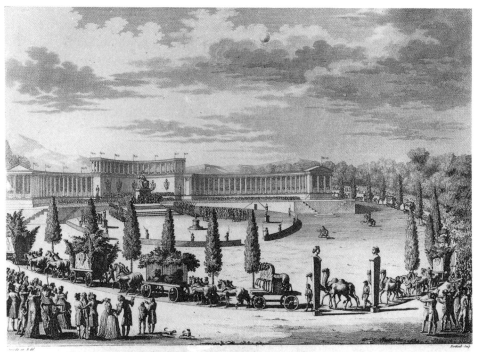

ENTRÉE TRIOMPHALE DES MONUMENTS DES SCIENCES ET ARTS EN FRANCE ; FÊTE À CE SUJET.
les 9 et 10 Thermidor, An 6.^{me} de la République.

Figure 45. Pierre-Gabriel Berthault, *Triumphal Entry of the Monuments of the Arts and Science, 9 and 10 Thermidor Year VI.* Engraving, 1798.

was under way, he calculated the enormous political benefit of a "triumphal procession" traversing the length of the French Republic.[140] By September, as he prepared to escort his precious cargo up the Rhone from Marseilles, he had conceived in considerable detail an elaborate parade through the capital.[141] His plans were followed to the letter when the barges eventually reached the banks of the Seine.

Originally the festival was planned for Bastille Day, but last-minute delays caused the ceremony to be rescheduled to coincide with the annual Festival of Liberty marking the anniversary of the fall of Robespierre and the end of the Terror.[142] On the morning of 9 thermidor (July 27), forty-five cases were loaded onto the carts that had borne them overland in Italy. The procession, divided into three groups – natural history, books and manuscripts, and fine arts – made its way from the Museum of Natural History on the Left Bank to the Champs de Mars, where it arrived late in the afternoon. In addition to carts decked with oak garlands and tricolors, the

parade consisted of cavalry and marching troops, musical bands, and representatives of the three divisions. Since for safety's sake all of the artistic treasures were kept in their packing cases (with the lone exception of the bronze Horses of San Marco), visual interest was confined to the exotic plants and animals, dromedaries, lions, and so on, that led the way. Banners and inscriptions described what could not be seen. Introducing the sculptures at the front of the arts division was a banner that read: "Monuments of Antique Sculpture. Greece gave them up;/ Rome lost them; / Their fate has twice changed; / It will not change again."[143] Inscriptions on individual cases repeated the full array of metaphors and apologies for the museum that had been introduced since 1793. That on the Horses of San Marco, for example, read: "Horses transported from Corinth to Rome, and from Rome to Constantinople to Venice, and from Venice to France. They are finally on free soil." That on the cart bearing the *Apollo Belvedere* and *Clio*: "Both will reiterate our battles, our victories." The banner preceding the paintings exclaimed: "Artists hurry! Your masters have arrived." Meanwhile a song composed for the occasion resounded with talk of prize trophies, vanquished tyrants, and the Republic's eternal right to its plunder.

Upon the arrival of the procession at the Champs de Mars, Thouin gave a speech loaded with more of the same fuzzy rhetoric. What better way of commemorating the end of the Terror, he insisted, than a festival that will wash away memories of tyranny and replace them with thoughts of nature, the arts, and liberty! Though Thouin described the triumphal ceremony as uniquely suited to that anniversary, others (and no doubt Thouin himself) had earlier prepared to emphasize the appropriateness of the convoy's arrival on the anniversary of the Bastille. Certainly the *Décade* had committed itself by declaring July 14 a day well chosen, for it was after all the fall of the Bastille that had triggered "this great revolution which has given us so much precious plunder."[144] Had the convoy been delayed further, the anniversary of August 10 would have done just as well. Cutting through the rhetoric, what mattered most was the acquisition of the world's most highly prized works of art. A refrain in the song said it all: "Rome is no more in Rome; / Every Hero, every Great Man / Has changed country: / Rome is no more in Rome, / It is all in Paris."[145]

Chapter

4

THE MUSÉE CENTRAL DES ARTS

France is an a position to form the richest
and most comprehensive collection of art
the world has ever known.

Louvre Conservatoire, 1795

Three days after the Festival of Liberty the museum held its own nocturnal
celebration of the third convoy's arrival from Italy in the courtyard of the
Louvre. A bronze Apollo was set in the middle of sixteen torch-lit pyramids,
creating an effect at once reminiscent of Boullée and uncannily similar to
the glass and steel pyramids of I. M. Pei (Fig. 46). Two inscriptions placed
above portals to the courtyard read: "The Arts seek the land where laurel
trees grow" and "To the Armies of the Republic and the French Govern-
ment, the Arts are grateful."[1] The "most attractive" wives and daughters of
artists led dancing into the early morning hours.

Figure 46. I. M. Pei, Pyramids, Louvre Museum.

The administration on hand to greet the masterpieces of Rome and Venice at the Louvre was altogether different from that which had been in office at the start of the Belgian campaign. In 1798 not one member of the original Conservatoire remained. Two of David's right-hand men, Wicar and Le Sueur, were purged following the fall of Robespierre (David himself was briefly imprisoned). Eight members stayed on: J.-H. Fragonard, Casimir Varon, J.-M. Picault, David Le Roy, Jean Bonvoisin, R.-G. Dardel, F.-J. de Lannoy, and A.-L. Dupasquier. Of the eight, only Fragonard and Picault survived a subsequent, deeper restructuring of March 1795. Hubert Robert, A.-J. Pajou, and F.-A. Vincent joined Picault and Fragonard to form a leaner and, what the government hoped would prove, more efficient administration. The new appointees signal a clear return to the old order: Vincent was brought back from the Museum Commission, whereas Pajou and Robert had acquired their administrative experience under Louis XVI (Pajou had been in charge of the so-called Salle des antiques, the central repository of royal sculpture). This reformed Conservatoire remained in office for just under two years before it was, in turn, replaced in January 1797 by yet another administration. At that time the Louvre was renamed the Musée central des arts in order to single it out as the nation's first museum and "center of the arts in the Republic."[2] In recognition of the museum's growing size and increasing importance as a national and international institution, the new administration consisted of three full-time bureaucrats – Léon Dufourny, Bernard-Jacques Foubert, and Athanase Lavallée – in addition to the connoisseur Lebrun and a panel of artists, in this case made up of Robert, Pajou, de Wailly, J.-B. Suvée, and N.-J.-R. Jollain (Robert's fellow keeper of pictures at d'Angiviller's Louvre).[3] Possessing social and administrative skills as well as a discerning eye, these bureaucrats signaled the emergence of the professional museum man. After 1802 the customary panel of artists was done away with altogether.

Notwithstanding changes in personnel, inspired in good part by political shifts after the Terror, the museum's "mission" remained constant. The vision promulgated by the Conservatoire in 1794 of a museum devoted to the "high" arts and instruction in art history was passed on from one administration to the next and eventually realized in 1803 by the man Napoleon Bonaparte made director of the Louvre, Dominique Vivant-Denon.

As noted in Chapter 3, the first Conservatoire had difficulty rearranging the collection left by the outgoing Museum Commission. Its promise of a rigorously ordered museum proved difficult to keep owing to the physical constraints of the Grand Gallery (primarily the high walls and intrusion of windows) and the need to accommodate a rapidly growing collection. The Conservatoire received little sympathy from the public or the government:

both were impatient to see the museum completed, and neither understood the problems involved. In January 1795, no doubt reflecting the public's frustration, the *Décade* published a withering report on the state of the Louvre:

For a long time we have wanted to give our readers an account of this superb museum, which contains the greatest and most valuable collection of paintings in Europe; but we have been waiting until the paintings were placed in a permanent, rational order. Yet it seems those in charge take pleasure in constantly rearranging them. A given picture that could be seen near the entrance to the gallery one week will be found at the far end a week later, or will have disappeared altogether. It is hard to imagine that the only goal in rearranging these many paintings was to place them in *schools*.[4]

Of course, the aim of the Conservatoire was to do considerably more than organize the collection by schools. Possibly in anticipation of this complaint, Varon published a second report on behalf on the Conservatoire. Unlike the first report, this one was short on rhetoric and promises and long on demands. First among them was the need for more room. The report insisted that in its incomplete state the Grand Gallery was barely large enough to display the former royal collection and that the paintings from Belgium alone would require at least another 600 feet of wall space.[5] The Conservatoire had a point, but the government was eager for a fresh approach.

The second Conservatoire initially had no more success than the first in arguing for the need for more room. In fact, in May the museum lost valuable storage space when picture depots located beneath the Galerie d'Apollon were taken over by the stock exchange.[6] Shortly thereafter the issue of space was again raised when the Belgian pictures displayed in the Salon had to be taken down to make way for the exhibition of contemporary art. There was nowhere else for the Belgian works to go but the section of the Grand Gallery still closed off for repairs.[7] Rather than violate the Revolutionary principle of public access to national treasures, the government duly granted funds to extend the museum by a further 560 feet, the length stipulated by the first Conservatoire.[8] By March 1796 the new section of the gallery was ready. But no sooner had the work been completed than it was realized that the original part of the gallery was now badly in need of renovation. The flooring, hastily laid in 1793, was worn, and the walls needed painting. It was decided to continue the new parquet back to the Salon and to give the entire gallery a fresh coat of paint: the walls were painted olive green, the cornice stone gray, and the ceiling sky blue.[9] The Louvre's resident architect, Auguste-Cheval de Saint-Hubert, called Hubert, promised to have the museum ready to be hung in six weeks; but when the gallery closed in April for work to begin it was to not to reopen for a full three years.

To compensate for the closure of the Grand Gallery between 1796 and

1799, the public was treated to a series of temporary exhibitions in the Salon and a permanent exhibition of Old Master drawings in the Galerie d'Apollon next door.

The first of the Salon exhibitions, held between May and September 1796, featured a selection of paintings of the three schools drawn from the collection as it existed prior to the arrival of the Italian convoys. The masters of each school were represented more or less in proportion to their fame. Thus, for example, from the French school there were eight Poussins, four paintings each by Lebrun, Le Sueur, and Vernet, three each by Rigaud and Bourdon, and one token work by painters such as La Fosse, Jouvenet, Mignard, Santerre, Chardin, and Drouais. The structure of the exhibition as well as the balance of paintings anticipated the eventual hang in the museum in that the schools were separated and in proper sequence, with French pictures followed by those of the Northern and Italian schools.[10] Most remarkable, however, was the reappearance of types of paintings that had been flatly condemned during the Terror. After Thermidor the political climate gradually relaxed and with it the museum administration's concern about what could and could not be put on display. No excuses were made, for example, for the inclusion of Chardin's *Still-life with Skate* or Santerre's erotic *Suzanna at Her Bath,* not to mention scenes from Rubens's Medici cycle – *The Education of Marie de Medici* and *The Birth of Louis XIII* – that were kept out of sight in 1794. And it is with a voice not heard since before the Revolution that the apocryphal identification of Mary Magdalen with Louis XIV's mistress, Louise de la Vallière, in Lebrun's famous painting (Fig. 84), is noted in the catalogue:

The portrait of Madame de la Vallière, mistress to Louis XIV. The charms and painful sacrifices of this woman known for her sensitivity add to the real merit of this painting, so much so that its beauty would be diminished if the illusion were destroyed.[11]

Henceforth, until the reopening of the museum in 1799 (and beyond), the exhibition schedule for the Salon was dominated by the convoys from Italy, which began arriving at the Louvre late in 1796.

In the meantime the Conservatoire turned its attention to hanging the Grand Gallery and the exhibition of Old Master drawings in the Galerie d'Apollon, first discussed in 1794. The drawings gallery (Fig. 47) took only months to prepare and opened in August 1797 under the new administration of the Musée Central.[12]

Though a handful of drawings had been displayed at the Luxembourg (and a similar arrangement may have been planned for d'Angiviller's Louvre), the exhibition at the Musée central was the first to be devoted exclusively to them. (The catalogue made much of the fact, seizing on the oppor-

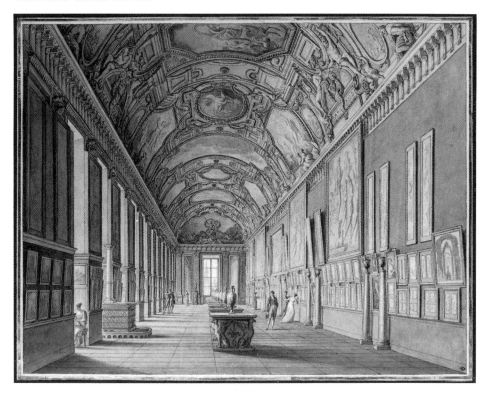

Figure 47. Constantin Bourgeois, *The Drawings Exhibition of Year V.* Drawing, 1798, Musée du Louvre, Paris.

tunity to contrast once more the secrecy of the Old Regime with the openness of the Republic.) From the three schools 415 drawings were chosen from a collection of more than 11,000. A recent reconstruction of the original exhibition staged at the Louvre revealed a highly imaginative selection, ranging from large-scale cartoons to nature studies and finished drawings and featured many superb works (Figs. 48 and 49).[13] Despite the differing functions of the drawings, the installation rendered them aesthetically equivalent. Matted and framed uniformly under glass, as in a modern exhibition, they were presented and appreciated as spontaneous, unmediated expressions of artistic genius.[14] The intent of the exhibition was primarily didactic (here, too, aspiring artists were given privileged access), and the administration even composed an exercise book for use in the gallery.[15] Following the example of the recent Salon exhibition and in anticipation of the Grand Gallery, the drawings were arranged sequentially in schools and vertically according to size. Stretching clockwise from the entrance (at the far end of Fig. 47), Italian drawings, numbered 1 to 189 in the catalogue, occupied the upper register of the wall opposite the windows. As in the Grand

Figure 48. Annibale Carracci, *Paris*. Drawing, Musée du Louvre, Paris.

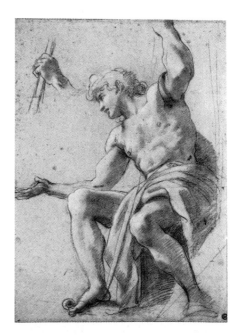

Figure 49. Nicolas Poussin, *Study for the Holy Family of the Steps*. Drawing, Musée du Louvre, Paris.

Gallery, the area high above eye level was reserved for large compositions, mainly cartoons by Giulio Romano and Pelegrino Tibaldi. Flemish drawings, numbered 200 to 287, filled the bays between the windows; and, starting over from the entrance, French drawings, numbered 300 to 415, occupied the lower register between the dado and the Italians. A strict chronological arrangement was planned but had to be abandoned in the interests of maintaining "a symmetry pleasing to the eye."[16]

Midway through the installation of drawings, the final selection of pictures also got under way. In preparation for a definitive hang of the Grand Gallery, the administration took advantage of a key 1796 ruling on the museums of the Republic in order to dispossess rival institutions of desired objects. This ruling, issued by Pierre Benezech, the energetic minister of the interior, defined the limits of the museums in the Paris area and stated categorically that "all must tend toward the perfection of the Musée central."[17] The decree was aimed primarily at Lenoir's Museum of French Monuments and its motley collection of antique and modern sculpture, but it also paved the way for the appropriation of important former royal paintings and sculptures from Versailles that had escaped earlier efforts to bring them to the Louvre.

In the confusion of August 10, 1792, 125 of the king's pictures from Versailles had been spirited off to Paris.[18] To prevent further losses local authorities decided to create their own museum in the château, which was opened with the approval of the Convention in 1794.[19] Nevertheless, the Louvre continued to covet many of Versailles' pictures, chief among them works by Leonardo, Volterra, Piombo, Palma Vecchio, and other Italian masters.[20] Under the Directory the central government in Paris together with the Louvre administration devised a scheme to turn Versailles into a museum of French art and to appropriate everything else for the Musée central. In February 1797 Benezech announced the creation of the Musée spécial de l'école française, opening the way for an exchange with the Louvre, which on the face of it appeared equally beneficial to both institutions.[21] In return for its Italian paintings, Versailles was to receive French paintings that would contribute to a comprehensive chronological display of the French school from the Renaissance to the present. Following d'Angiviller's lead, the works of living artists would be included in the exhibition. Not surprisingly, however, Versailles lost out in the exchange because it was operated within a framework determined by Benezech's ruling of the previous year entitling the Louvre to keep the best of all categories of art for itself, including French paintings. The jury appointed to select paintings from and for Versailles determined how the French school should be represented and hung at the Louvre before deciding what could go to the Musée spécial.[22] Benezech himself reminded the jury: "the Musée central des arts must offer the most beautiful productions of all genres and all schools."[23] It was essential, of course, that good French pictures remain in Paris since the French school was to be displayed first in the Grand Gallery and would have to hold its own against the best Northern and Italian paintings in the world.

Having surrendered objects deemed aesthetically superior to the Louvre, the Musée spécial (along with the Museum of French Monuments) took on

the dubious identity of a "historical" museum.[24] This is not to say that Versailles received only second-rate art. Among the 240 or so paintings sent from Paris were such favorites as Le Sueur's Saint Bruno series and Vernet's Ports of France. In itself the Musée spécial was an important, even innovative museum (the inclusion of living artists in chronological sequence, though intended by d'Angiviller, was so far unprecedented). But the fact that it displayed what the Louvre did not want, and that its emphasis was on historical exegesis rather than on superior painting, caused it to suffer in the public's estimation. Soon after the museum opened, General Pommereul dismissed it as "a repository of the second order." "Why should artists and amateurs travel to Versailles," he asked, "when they can see better [French pictures] at the Musée central?"[25] A decade later, in 1809, a German guidebook declared that the collection "contained little of interest" and that to see the French school at its best one must go to the Louvre.[26] Removed from the capital, the Musée spécial languished in relative obscurity, and to this day not a great deal is known about it.

<p style="text-align:center">* * *</p>

The hanging of the Grand Gallery was further delayed by the arrival in July 1797 of the paintings from Lombardy and their preparation for immediate exhibition. As with the Belgian pictures earlier, virtually everything in this Italian shipment was judged in need of restoration. Outside help was called in to assist the resident staff of restorers, Michau, Roeser, Hacquin and Fouque.[27]

Within two months in the summer of 1797 the administration had simultaneously to deal with the exchange of pictures from Versailles, the convoy from Italy, and final details of the drawings exhibition. During this hectic period, with works of art coming and going in large numbers, a controversy of major proportions erupted over the way the museum was run and in particular over the conduct of restoration. On this occasion criticism came not from self-interested pamphleteers but from a deputy to the Council of Five Hundred, one Anthelme Marin from Mont-Blanc. Claiming firsthand knowledge of conditions at the Louvre, Marin accused the administration of negligence and worse in the maintenance of the nation's pictures: paintings, he said, were stored pell-mell in stairwells and humid storerooms, and misguided restoration had permanently damaged priceless masterpieces.[28]

Exacerbating already serious accusations made in the most public of forums was the heavy burden of responsibility attending foreign conquest. The systematic confiscation of art had aroused widespread indignation, especially with respect to Italy, which for centuries had been looked upon as Europe's museum and the high point of the Grand Tour. Even Frenchmen protested Bonaparte's spoliation of Italy. Republican claims to moral and

ideological right to its booty were tenable only on condition that it was held safely in trust for posterity. The eyes of Europe were on the Louvre. From the first, meticulous records were kept of the condition of each painting as it arrived at the Louvre. Appended to the report on the first convoy from Belgium was the following note by Lebrun: "These scrupulous observations will prove to posterity that we were worthy of such conquests, and that the degradations these pictures have suffered must be attributed to the idle monks who possessed them before us."[29] Upon inspection, the great majority of paintings seized abroad were judged in need of attention, and a set pattern quickly evolved whereby pictures would undergo restoration between their arrival and their exhibition at the Salon. Thus it could be claimed that not only was France capable of looking after these works of art but, as a result of their confiscation, the pictures had been given a new lease on life. If the reports are to be believed, so poor was the condition of certain paintings in their original settings that without French intervention they would have deteriorated past the point of repair. Finally, it was hailed as a virtue that restoration, followed by exhibition in the Louvre, permitted works of art to be seen properly for the first time since they left the artist's studio, a claim that implicitly justified the museum by privileging direct apprehension of the artist's hand over an understanding of the work of art in the context for which it was intended.[30]

Greatest consideration was given to works of art from Italy. As noted in Chapter 3, the care taken by French agents in packing and transporting the most famous paintings and statues was reported in the press in minute detail.[31] The safe arrival of convoys in France was a source of relief as much as delight. Witness Vivant-Denon's report to the Institut after the last of the antique statues had been unpacked: "One hundred cases have been opened: not one accident, not one fracture has diminished our happiness in acquiring these rare treasures."[32] One of the organizers of the Festival of Liberty in 1798 claimed that that event would "cleanse . . . the French nation of the recurrent reproach of vandalism."[33]

Against this background Marin's claims were taken seriously indeed. If valid, enemy cries of Republican barbarism would prove to have been well founded. As two Roman delegates warned the French government following the armistice of Bologna in 1796: "You will have to answer to posterity should harm or loss befall these masterpieces, which are the admiration of the entire world."[34] The Directory ordered an official inquiry. Fearing public opinion, yet confident of its conduct, the museum administration promptly exhibited a painting chosen from the recent Italian convoy that had been half cleaned in order to demonstrate the need for restoration as well as the exaggeration of Marin's accusations.[35] We are reminded of a similar exercise fifty years earlier at the Luxembourg Gallery involving the

display of del Sarto's *Charity* alongside what purported to be its original wood support.

The Directory's commission went ahead with its report nevertheless. On December 31, 1797 a panel of thirty-two artists and experts gathered at the Louvre to examine the charges point by point.[36] A thorough investigation found in favor of the museum. The commission's conclusions, brought together and published as *Observations sur l'administration du Musée central des arts,* vindicated the administration and offered a defense of restoration remarkable for its modernity and good sense.[37] The report determined, among other things, that restoration was necessary for the material survival of a work of art and in order for the beholder to perceive the master's brush, and that it was the museum's responsibility to return a given painting to its original state (and dimension) and preserve it in that condition.[38]

The commission recognized that the government was on trial as much as the museum administration.[39] Concerned that news of Marin's complaints had reached foreign shores (as indeed it had), the minister of the interior wrote to the foreign minister, Talleyrand, asking that he distribute copies of the official report equally to French representatives abroad and foreign ambassadors in Paris.[40] Such was the need to maintain the appearance of order at the Louvre.

Two years later, after the museum had opened, rumors of misconduct circulated once more. The administration responded this time by inviting a distinguished panel of artists and scientists (including the chemists C.-L. Berthollet and Guyton de Morveau) from the Institut to supervise the complete restoration of one of the world's most famous paintings, Raphael's *Madonna di Foligno* (Fig. 50). Having arrived at the Louvre in what was described as a pitiful state, the painting was successfully restored and put on display in the Salon in March 1802. Fully revived, the Raphael *Madonna* epitomized the Republic's effort to justify its policy of confiscation through conservation. The Institut's report, describing the restoration process in more detail than most would care to know, concluded in a self-congratulatory tone:

If a protective power had not charged itself with several monuments from ingenious Italy, the name of Raphael would soon have been no more meaningful, even in his homeland, than that of Apelles. The arts must therefore be grateful to the genius of victory that has gathered these dispersed and neglected monuments together at the heart of her republic, entrusted them to an enlightened, vigilant administration, and presented them, as in a vast sanctuary, to the admiration of Europe.[41]

Rhetoric aside, this report was the most sophisticated statement on restoration to date. Reprinted in the Salon catalogue at the time of the exhibition, it silenced the critics once and for all (at least in France).[42]

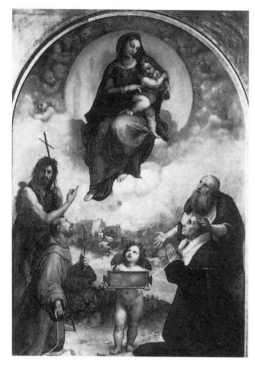

Figure 50. Raphael, *Madonna di Foligno.* Oil on canvas (transferred from panel), c. 1512, Vatican Pinacoteca, Rome.

In February, shortly after the Marin affair had died down, the paintings that had sparked the controversy in the first place, in other words, those recently arrived from Lombardy, went on display in the Salon. The installation, as far as it can be reconstructed from contemporary accounts, is important for what it reveals about the choice of paintings in Italy and thus about the pedagogic aims of the museum. Our primary source of information is the official catalogue, which set out to provide the visitor with essential information, including a set of correct aesthetic priorities.[43] Paintings were grouped under artists, who were listed alphabetically, as had become the norm. Where relevant the pictures were described "in chronological order." The same perhaps applied to their arrangement in the Salon, though as before visual symmetry may have compromised pedagogic concerns. But since the pictures were numbered, the sequence in which they were listed in the catalogue to a good extent controlled the order in which they were viewed. The same strategy, it will be recalled, had been used at the Luxembourg, though to different effect. The catalogue also provided the artist's dates, the name of his master and the main artistic influences on his development, as well as the odd anecdote culled from Vasari, Bellori, Malvasia, Lomazzo, Passeri, and Baldinucci.[44]

Particularly interesting is the case of Guercino, twenty of whose works figured in this show (twenty-eight in all were brought back from Italy). Guercino had been popular with French students in Rome throughout the eighteenth century, particularly his earlier tenebrist paintings. He was recommended to David by his master Vien, and to all artists leaving for Italy by Charles-Nicolas Cochin.[45] His *Saint Petronilla* was among the most famous pictures in Rome. Yet as an artist or a model of study he was arguably no more important than his fellow Bolognese painters, Domenichino and Guido Reni, only three and nine of whose works were confiscated, respectively. What accounts for the numerical imbalance? The disproportionate presence of Guercino's work at the Louvre was justified because his career – more precisely his stylistic development – followed what was perceived to be a clearly visible path from early subjection to and assimilation of the manners of others (the Carracci and Caravaggio) to independent mature production and finally to feebleness in old age. In the words of the catalogue:

> The national museum has just been enriched with many works by Guercino, which are all the more precious as they include representative pictures from age 22 to 72, that is to say, during his life as a painter. They are described in chronological order so that the connoisseur may follow the progress of this able master, and behold his strength as well as his decadence.[46]

A number of telling juxtapositions were offered to challenge and sharpen the connoisseur's skills: a painting of *Christ's Charge to Peter* (no. 69), for example, revealed the influence of the Carracci when preceded by two works (nos. 67 and 68) executed before the young Guercino moved from Cento to Bologna in 1618. Nearby, Guercino's *Crucifixion of Saint Peter* (no. 72) showed his full mastery of the light and color of Caravaggio following his move to Rome three years later.[47] But whereas such subtleties were of primary interest to connoisseurs, the collected oeuvre also provided an object lesson to young artists of the possibilities – the potential for success and decline – within an artistic career. Guercino's life was a paradigm of the biological model of growth and decay, which, as Hans Belting has remarked, carried didactic power to inspire in the idea of growth and to warn in that of decay.[48]

Such concerns were even more powerfully articulated in an alternative guide to the exhibition by J.-B.-P. Lebrun, entitled *Examen historique et critique des tableaux*.[49] The main purpose of Lebrun's catalogue was to foreground the question of stylistic development within both an artist's *oeuvre* and the broader context of regional school. Where applicable, after treating the works of a painter he moved on to consider those of his pupils, examining the ways in which they imitated and departed from their master. Lebrun

here employed the same organizational strategy used in his recent *Galerie des peintres flamands*. As he explained in the introduction to that book, his aim was to draw attention to the unfolding of independent genius and the process of attaining artistic maturity:

> It will be most interesting, I believe, to behold the diversity of talent hatched under the same eyes and in the same studio, and to follow the progress of a few men who share the same point of departure as they develop over time and move further away from each other, yet each of them at times achieving happy results in his own way.[50]

The flowering of individual style from the common ground of academy and master's atelier was a phenomenon of particular interest to the French where it had been successfully institutionalized and had become the basis of the national tradition. At that moment, David's studio, with its constellation of rising stars, provided a good case in point. Because grounded in artistic practice, the issue of master–pupil filiation was of primary concern to connoisseurs and art historians. Determining the limits of stylistic transmission and the extent of inheritance and transgression became (and remains) a central task of connoisseurship, and no one was better at it than Lebrun.

Guercino perfectly suited Lebrun's needs. In the *Examen* Lebrun began by informing the reader that paintings from Guercino's different periods and illustrating his various styles were represented in the exhibition; he identified four such periods and characterized each. After the section on Guercino, Lebrun next considered the works of his pupil, Ercole Gennari, who in his opinion at times imitated his master so faithfully that "it is all too easy to mistake the works of one for those of the other."[51] But beyond testing the connoisseur, this degree of imitation also demonstrated the age-old warning to students against following one's master too closely. For as clearly as Guercino had absorbed and benefited from the lessons of the Carracci and Caravaggio on the way to creating his own style, his pupil Gennari had failed to advance beyond the studio and forever remained in his master's shadow. The commissioners in Italy brought back three paintings by Gennari to serve a negative example. Closing out his discussion of Guercino and Gennari, Lebrun remarked: "Artists, be sure this lesson is not lost on you! Never forget this precept: Invent and you will flourish."[52]

The interest in Guercino's career and in documenting his relationship with Gennari paled in comparison with the attention, bordering on obsession, paid to Raphael and his master Perugino. Just as the commissioners had gone out of their way to visit Cento in search of Guercino and Gennari, so they plundered Perugia for evidence of Raphael's early development under Perugino's tutelage. "Rapacious excess," no less, was how the press at home characterized the pursuit of paintings in Perugia.[53] A total of seven-

teen Peruginos were confiscated in Italy to go along with the fifteen by his illustrious pupil. The majority of the latter required no justification. In the late eighteenth century Raphael was considered the greatest of all painters; his *Transfiguration* (Fig. 51) was designated "his masterpiece and that of painting" by the popular Empire critic Charles Landon. Many of his other compositions – the *Madonna di Foligno* (Fig. 50), *Saint Michael* (Fig. 13), *Belle Jardinière,* and *Saint Cecilia* – were not far behind in reputation. In themselves these paintings had much to offer the aspiring student. But more than the individual works there was the man himself: Raphael the artist. As Martin Rosenberg has pointed out, he was the "model Academic" – his career, as described by Vasari, embodied French artistic ideals in that his achievement could be construed as a product of careful study and synthesis of well-chosen models.[54] Raphael and Gennari represented two sides of the same coin. Having started under Perugino, whose manner he dutifully imitated, Raphael gradually freed himself from juvenile dependence and progressed toward a mature, individual manner through reflection and judicious selective imitation of past masters. His life exemplified the academic method of instruction and the idea of artistic invention. (Significantly, the exhortation "Invent and you will flourish" was inscribed on the case containing Raphael's *Transfiguration* in the 1798 Festival of Liberty.)[55] Moreover, it did so with great legibility. Each stage on the path from indebted pupil to independent master could be seen as clearly in his paintings as it had been described by Vasari. Illustrating that path was one of the Louvre's primary didactic goals. When the Raphaels from central Italy made their debut at the Salon in November 1798, displayed next to the *Transfiguration* was the *Coronation of the Virgin* from S. Francesco al Prato in Perugia (Fig. 52). As the catalogue explained, the latter owed its place less to aesthetic merit than to its status as Raphael's first independent work:

It is the earliest known work by the immortal Raphael, a work that illustrates the start of a career that culminated after twenty years of study in the perfection we see in the *Transfiguration*. These two works, the first and last fruit of this great master, are today exhibited next to each other so that by comparing them one will easily judge the immense distance his genius traveled.[56]

Completing the sequence required illustrating Raphael's early dependence on his master – hence the presence of so many Peruginos among the Italian booty. As the Salon catalogue informs us, Perugino was not highly thought of as an artist in his own right. His claim to fame was to have been Raphael's teacher: "The honor of having had such a disciple would be enough to guarantee his fame even if one couldn't detect in his works the germ of those qualities that would later distinguish his illustrious pupil."[57]

In April 1799, while the exhibition of long-awaited Italian paintings was

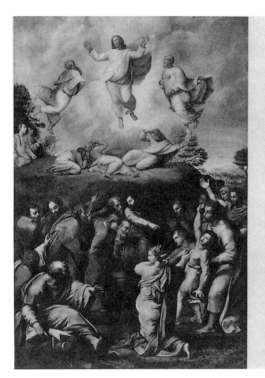

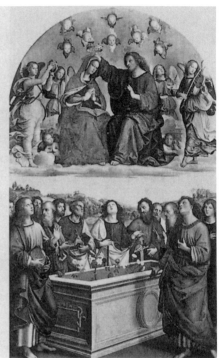

Figure 51. Raphael, *The Transfiguration*. Oil on panel, 1518–20, Vatican Pinacoteca, Rome.

Figure 52. Raphael, *The Coronation of the Virgin*. Oil on canvas (transferred from panel), c. 1503, Vatican Pinacoteca, Rome.

still on view in the Salon, the equally anticipated reopening of the Grand Gallery took place (Fig. 53). At that time only half the gallery, comprising the bays devoted to the French and Northern schools, was opened. The walls had been painted according to plan, marble columns punctuated the space, and sculptures both ancient and modern (including at least one, Bouchardon's *Amour,* originally intended for d'Angiviller's Louvre) occupied the niches.[58] Two years later, on Bastille Day 1801, the other half of the gallery containing the Italian schools was opened. The museum was now complete.

Unfortunately, a precise, detailed record of how the pictures were hung has not survived. The museum administration met in February 1798 to discuss the arrangement and conferred frequently thereafter in the gallery itself. It was decided that the method employed in the temporary Salon exhibitions should be used in the museum as well – that is, an arrangement by school and chronology (though not before arguments in favor of a mixed-school approach were heard!).[59] The catalogue printed for the inauguration of the French and Northern schools in 1799 announced:

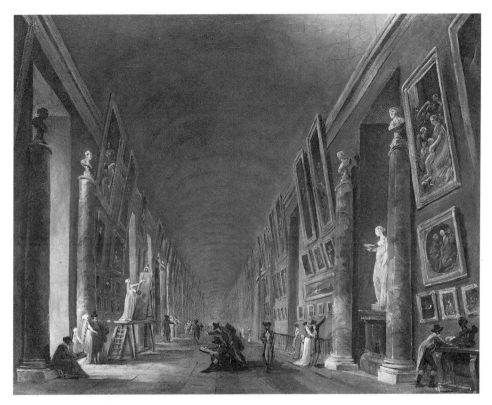

Figure 53. Hubert Robert, *Grand Gallery of the Louvre after 1801.* Oil on canvas, Musée du Louvre, Paris.

In the section of the Grand Gallery that has just opened, the paintings have been arranged by schools. . . . In both schools, the artists – especially the history painters – have been hung according to their date of birth, and as far as possible the works of each master have been brought together.[60]

Lebrun was on hand whenever hanging was discussed, and he may have had an important say in the details of the arrangement.[61] Assuming this was the case, the system of school and chronology advertised in the catalogue may have conformed more closely to Lebrun's schema, in which artists are grouped according to their affiliation with famous masters, who are in turn arranged in historical succession, than to strict order of birth. It is perhaps significant in this regard that Lebrun presented a copy of his *Galerie des peintres flamands* to the museum administration in July 1797.[62] Furthermore, in 1801 Lebrun gave the Louvre a painting by Gerbrand van den Eeckhout with the idea that it hang "beside [the works of] Rembrandt since van de Eeckhout was among his first students and closest imitators."[63] In any

case, the one firm piece of evidence we have concerning the arrangement in 1799 – bills submitted by the blacksmith paid to hang the pictures – shows clearly that strict chronological order was not adhered to.[64] A quick glance at a partial reconstruction of the hanging scheme (Appendix III) reveals two paintings by Jouvenet (1644–1717) placed *before* works by Vouet (1590–1649) and Lebrun (1619–90), whose paintings are not all hung in sequence. Once again it seems decorative demands compromised the goal of historical demonstration. Each bay, or *travée*, was hung as a separate unit, and each had to be symmetrical: this much can be ascertained from contemporary views (Fig. 53). The full quota of large paintings chosen for exhibition had to be accommodated, and no more than two could fit comfortably in each bay. These paintings were hung first and then surrounded by medium-sized and small pictures.[65] The same method was no doubt also used in the hanging of the Italian schools, begun in the spring of 1799.[66]

We learn nothing further about the gallery's organization until Dominique Vivant-Denon was appointed director of the Louvre (in fact, of all Paris art museums) on November 19, 1802. Diplomat, courtier, émigré, engraver, author of erotica – Denon had lived many lives before 1802, none of which would seem to have prepared him to head the Louvre.[67] Yet he proved a strong leader, and in hindsight his blend of diplomatic skills and worldly experience established a norm for museum directors that still applies. One of Denon's first actions was to dismiss Lebrun (surely a sign of the latter's influence theretofore). Gould noted that this cleared the way for Denon to supervise future confiscations of foreign art without the aid of "experts" or commissioners.[68] But it also allowed the new director to take full responsibility for the arrangement of the Grand Gallery.

The desire to assert his own vision and to replace an installation that may have owed much to Lebrun accounts for Denon's swift reworking of the arrangement he inherited from the outgoing museum administration. On January 1, 1803 Denon wrote to Bonaparte, who had been made first consul for life the previous May, inviting him to inspect a new installation of paintings by Raphael of which he was especially proud:

It is like a life of the master of all painters. The first time you walk through this gallery, I hope you will find that this exercise [i.e., the new hang] already brings a character of order, instruction, and classification. I will continue in the same spirit for all the schools, and in a few months, while visiting the gallery one will be able to have . . . a history course in the art of painting.[69]

Denon's plan was to start at the top, so to speak, with the bay containing Raphael's *Transfiguration,* and to work his way down, transforming the Grand Gallery into a visual lesson in the history of art.

Denon's account, however, tells us nothing about the precise order of the

pictures. He described his new installation as an innovation, but how, if at all, did it differ from earlier attempts to represent the history of art? Unless the configuration of paintings on the wall can be established we cannot determine what kind of history lesson Denon had in mind. Fortunately, a series of little-known etchings (Figs. 54–56) by the English artist Maria Cosway and her assistant, François Couché, can be called upon to supplement Denon's verbal record. Executed in 1802–3 during the Peace of Amiens, the etchings constitute the fragmentary remains of an ambitious project to document, in Cosway's words, "the exact distribution of this wonderful gallery."[70] Only a handful of plates were completed before the resumption of war forced her to leave the country. Nevertheless, those that do exist are extremely revealing and allow us to draw important conclusions about the arrangement of the Louvre Museum during its heyday.

Not surprisingly, Cosway started where Vivant-Denon did, with the sections of the gallery devoted to Raphael and the Italian masters. The wall depicted in one of the plates (Fig. 54) is none other than that described by Denon in his letter to Bonaparte. In an article printed in the *Moniteur Universelle* on January 3, 1803, the Louvre's new director explained how the history of art had been demonstrated through the way the paintings were hung. The Raphaels in this bay were chosen, he wrote, in order that "one could see at a glance the extent of this artist's genius, the astonishing rapidity of his progress, and the variety of genres which his talent encompassed."[71]

According to Denon, the two paintings by Perugino crowning the arrangement on either side, "perfectly preserved and in his best manner," acquaint the beholder with "the refined, precious, and delicate school where Raphael imbibed the principles of an art that he carried to the highest degree of perfection." The paintings that fill out the bay offered a concise, metonymic overview of Raphael's career from indebted pupil to mature master. As in the 1798 Salon exhibition, his first and last works were juxtaposed. The *Coronation of the Virgin* (Fig. 52), manifesting a style virtually indistinguishable from that of Perugino – at least according to Vasari, from whom Denon derived much of his information – can be seen center left of the *Transfiguration* (Fig 51). The predella panels centered beneath the latter belong with the *Coronation*, whereas those to the left in grisaille, representing Faith, Hope, and Charity, are from the Baglione altarpiece of 1507, considered a transitional work revealing the first fruits of Raphael's study of Florentine art. Moving to the right of the bay, evidence of his development and successful assimilation of Leonardo can be seen in his portrait of *Baldassare Castiglione* and his *Belle Jardinière,* a famous version of a favorite Raphaelesque type.[72] Shortly after the etching was executed, Denon replaced the *Belle Jardinière* with the equally famous *Holy Family of Fran-*

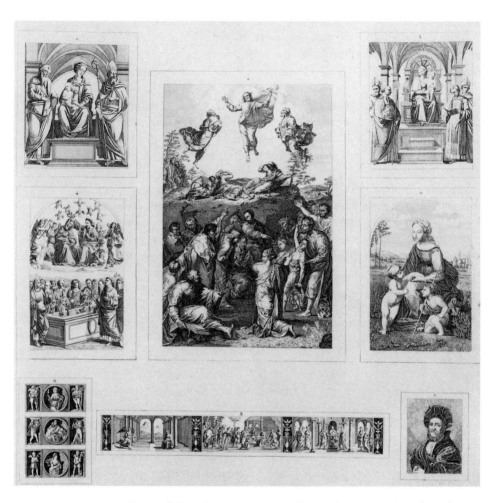

Figure 54. Julius Griffiths and Maria Cosway, *Collection de gravures à l'eau-fortis des principaux tableaux . . . dans le Musée Napoléon*. Paris, 1806. *Transfiguration* Bay.

cis I, probably because the latter was closer in size to the *Coronation* with which it was paired (the *Belle Jardinière* is smaller than Couché's engraving leads one to believe). Of this revised pairing, Denon wrote:

If one compares this work [the *Coronation*] with the immortal production of the same brush which one sees on the other side and which was executed twenty years later; if one compares the symmetrical stiffness of Perugino's compositions with the complex harmony of the movement of the characters which form the group in the painting of the *Holy Family,* one can see to what point Raphael was favored by nature and one will have at the same time before one's eyes the beginning and end (so to speak) of the most far-reaching and brilliant career which the genius of man has ever pursued in the arts.[73]

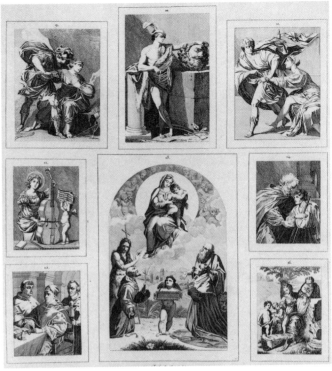

Figure 55. Julius Griffiths and Maria Cosway, *Collection de gravures à l'eau-fortis. . . .* Paris, 1806. *Madonna di Foligno* Bay.

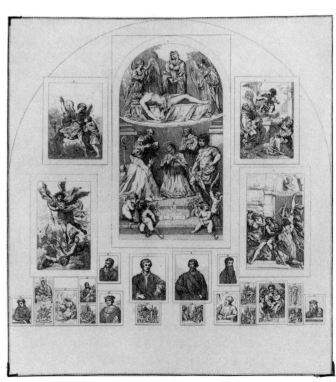

Figure 56. Julius Griffiths and Maria Cosway, *Collection de gravures à l'eau-fortis. . . .* Paris, 1806. Reni's *Mendicanti* Bay.

143

Dominating the bay was the *Transfiguration*, which, as the climactic work in Raphael's *oeuvre*, needed no explanation. A model of didactic display, this bay is also exemplary in its attention to visual harmony. Within an overall symmetrical configuration the two Peruginos balance the composition through the mirrored poses of the Virgin and Child and the repetition of arched canopies, echoed in turn in the two Raphaels on the middle register. The predella panels play out their function by forming a base on which the large altarpiece, flanked by its wings, rests.

Proceeding to an adjoining wall, also featuring famous paintings by Raphael (Fig. 55), we find a similar emphasis on harmonious, symmetrical display, but, surprisingly, we also witness a breakdown in the kind of art historical narrative that characterized the *Transfiguration* bay. Anchoring the composition is Raphael's *Madonna di Foligno*. To the left and right, respectively, are his group portrait of Pope Leo X and a *Holy Family* by his best student, Giulio Romano. Whereas this sequence conforms to the established model of progress from master to pupil, how can we explain the sudden jump above to diverse masters of the seventeenth century? Clockwise from Domenichino's *Saint Cecilia,* center left of the Raphael *Madonna*, we have Alessandro Tiarini's *Rinaldo and Armida,* Guido Reni's *David and Goliath,* and two paintings by Leonello Spada of *Joseph and Putiphar* and *The Return of the Prodigal Son.* The paintings are all by Italians, of course, but they represent different regional traits and cannot be linked in a clear chronological sequence. Yet whatever the arrangement lacks in art historical coherence, it makes up for in decorative symmetry. The pyramidal composition of the *Madonna di Foligno* is echoed in the disposition of pictures in the bay. The vertical thrust of the Madonna is continued in the upright pose of David above but balanced by the compressing sideward movement to right and left of Rinaldo and Joseph. The pictures by Tiarini and Spada on top work so well together that they appear to have been painted as a pendant pair. The competing verticals, horizontals, and diagonals in the eight pictures combine to create a well-balanced composition.

A third bay (Fig. 56), dominated by Reni's altarpiece from the Mendicanti in Bologna, presents a similar preference for internal visual harmony over art historical narrative. As in the previous bay, or *travée*, paintings from different Italian schools spanning two centuries are happily co-mingled. But again they are juxtaposed with a careful eye to symmetry, and one can only admire the ingenuity of the pattern achieved. A central axis divides two groups of portraits and small devotional works on the bottom register that mirror each other. Above, the violent diagonal of Saint Michael's lance in Raphael's painting to the left is repeated by Christ's tormentor in Titian's *Christ Crowned with Thorns* to the right. Along the top register, the three religious paintings by Fetti, to the left, Reni, in the middle, and Guercino, to

the right, are linked by the wings of angels. The four subsidiary pictures on either side of the Mendicanti altarpiece mimic the relationship of wings to body, whereas the figures within the Reni painting are positioned in relation to the kneeling Saint Francis as the surrounding canvases are to the altarpiece itself.

To judge by the evidence of these three etchings, we must conclude that Denon's commitment to art historical demonstration was outweighed by a desire to achieve a visually pleasing, symmetrical hang. If in the *Transfiguration* bay the demands of art history and symmetry have been met with equal success, in the other two visual appeal appears to have won out, and the tissue of history that bound the Peruginos and Raphaels together in a tight narrative sequence is conspicuously absent. How are we to explain the visual evidence in light of Denon's initial statement of intent? Was it that the pressure to display so many masterpieces in a confined space, together with the need to obey the laws of visual symmetry, forced Denon to compromise his ambition to provide a lesson in art history on the walls of the Louvre? Was the example of the *Transfiguration* bay simply too hard to follow? Decorative concerns were, as always, an important factor, but could there have been more to it than meets the eye? I believe that there was and that we should consider Denon's conception of the history of art.

In front of the *Transfiguration* the beholder was made witness to the unfolding of Raphael's genius and the birth of modern art. As mentioned earlier, Denon's terms of reference derived from Vasari's *Lives* (a new French edition of which appeared in 1803).[74] At the Louvre, as in Vasari, progress and artistic perfection were measured in formal terms, primarily sophistication of composition and depiction of form, or *disegno*. The eye moved from the stiff, formal compositions of Perugino to the figural complexity of the *Holy Family* or *Transfiguration* of Raphael; from the "hardness of manner" perceived by Vasari in the former to the graceful drawing style, easy and delicate brushwork of the latter.[75] So far so good, but the obvious problem for Denon was that he began where Vasari left off – with the transition we now understand as that from Early to High Renaissance. In 1803 Perugino was among the earliest artists in the Louvre collection, yet, of course, he figures midway through Vasari's account of modern painting. (The desire to acquire a representative sample of Italian "primitives" for the Louvre dates to the mid-1790s but was not realized until after 1811.)[76] The progression from Perugino to Raphael and with it the passage from what he characterized as the Second to the Third Age of painting represented the climax of Vasari's story. With the paintings of Raphael the development toward artistic perfection measured against a classical norm inherited from antiquity was seen to have attained its goal.[77]

Notoriously, Vasari ended his *Lives* with an unclear sense of what the

future held in store. If art had already attained its goal, what was the way forward? How was further progress possible? How Vasari envisaged the future continues to intrigue art historians to this day. But more important for our purposes is the question of how later writers accounted for post-Renaissance art in light of his account.[78]

The root of the problem lay in Vasari's belief that the history of art conformed to a cyclical, biological model of rise and decline, growth and decay. In his view, art had risen gradually to a point of perfection in classical antiquity, fallen into decadence during the Middle Ages, and then with Cimabue and Giotto began its ascent by stages toward a second peak of perfection reached by Raphael and Michelangelo in Vasari's own day.[79] If, according to the cyclical theory, decadence followed perfection, then surely the arts were doomed to decline with the passing of those great masters.

From the seventeenth century, art historians dealt with Vasari's difficult legacy in one of two ways. The first, adopted by French authors like André Félibien and Roger de Piles, sidestepped the issue of rise and decline by presenting post-Renaissance art as a collection of individual achievements structured only loosely by chronology.[80] Take, for example, de Piles's *Balance of Painters* (Fig. 14), in which, as we saw in Chapter 1, sixteenth- and seventeenth-century masters are ranked irrespective of nationality or date of birth according to their performance in fixed categories. Historical sequence was not an issue.

The second solution sought to adapt the model of rise and decline to developments in art from the sixteenth century. Bellori, writing in the mid-seventeenth century, thought that decline had indeed set in after Michelangelo but argued that another peak of perfection had been reached by the Carracci and their pupils.[81] A century later, in his *History of Ancient Art* of 1764, Winckelmann proposed strict parallels between the development and the rise and fall of ancient art and those of modern art.[82] In modern art, an archaic style, "dry and stiff" in character, gave way to a brief classic style embodied in the art of Michelangelo and Raphael, which was followed in turn by an imitative phase and eventual decadence. The imitative phase corresponded to the Carracci whose achievement he placed on a lower level than Raphael's, whereas decadence was seen to have set in after Maratta at the end of the seventeenth century. Though the main purpose of the parallel was to demonstrate the general validity of the pattern of historical development Winckelman perceived in Greek art, his views had a profound influence on French writers who came of age in the 1790s, in particular, A.-C. Quatremère de Quincy.[83]

Developing Winckelmann's thesis that Greek art was the unique product of Greek customs and government, Quatremère maintained that a revival of that art was impossible in modern times and that generally the cultural and

political circumstances obtaining in modern Europe were unfavorable to the production of great art. "All sorts of factors militate against the arts becoming again what they once were," he wrote.[84] He agreed that the Renaissance represented a period of excellence but thought that art had gone into decline thereafter. He dismissed the eighteenth century as a "generation of pygmies."[85] His was a doctrine of historical pessimism that condemned the art of the previous two centuries and painted a gloomy picture of the possibilities open to living artists. Quatremère doubted a museum full of confiscated art would make any difference.

In 1803 these two incompatible interpretations of the development of modern art were available to Vivant-Denon as he set out to demonstrate the history of art on the walls of the Louvre. The evidence of Cosway's etchings indicate which account he favored. Upon closer inspection, Denon's hang is consistent with what might be termed the optimistic, noncyclical view of post-Renaissance art; and insofar as it substantiated that view it implicitly rejected the cyclical interpretation of Winckelmann and Quatremère. The *Transfiguration* bay stood for the progress of art in the Renaissance, culminating in the perfection of Raphael. The juxtaposition of sixteenth- and seventeenth-century masters on subsequent walls aimed to show how later artists successfully assimilated the lessons of their predecessors to form valid, individual styles. With Raphael and the High Renaissance masters the history of art ceased to be a linear development toward a set of clearly defined artistic goals and became instead the record of gifted artists successfully exploiting and refining different aspects of a developed tradition.[86] The opportunities for further refinement available to successive generations expanded with the canon of artists worthy of study. The museum, by enshrining the canon and preserving the lessons of the past for present and future generations of artists, theoretically ruled out the possibility of art degenerating again. Arguably, forestalling decline through the propagation of aesthetic norms was the purpose of the art academy envisaged by Vasari, in which an ideal study collection of past art was to have been an integral part.[87] At the Louvre the French were realizing a centuries-old academic ideal.

Although Denon did not go into print himself in support of an "optimistic" view of art history inscribed in the Louvre, significantly, one of his chief spokesmen on the arts did.[88] This was T.-B. Eméric-David, a writer and theorist equal in verbosity if not in stature to Quatremère. In an historical essay on modern painting that forms a preface to a volume of Le Musée français, a semiofficial publication of 1805, he flatly rebutted the pessimistic account of continuous decline from the Renaissance. "By following in the footsteps of the Old Masters," he wrote, "art, instead of declining, will make still greater progress."[89]

Denon's decision to inscribe this upbeat interpretation of art history in the Louvre rather than the cyclical alternative was rooted in the museum's political and pedagogic function. The historical pessimism of Quatremère ran counter to Revolutionary and Napoleonic faith in the power of state institutions to effect meaningful reform and lasting achievements.[90] This was no time for pessimism in official circles, as Denon, the erstwhile courtier and diplomat, well understood. Through its inspirational power, the Louvre, in conjunction with a revived Academic system (in the form of the Institut from 1795) and state patronage, would produce French art of sufficient greatness to compare the Napoleonic era with that of Alexander the Great, Augustus, and Julius II. The museum was necessary for the production of the grand manner in France, and only French art had a future.

Turning Quatremère's argument on its head, artists insisted that owing to their position in history and their geographic disadvantage north of the Alps a great museum was all the more vital to their success:

The more unfavorable our climate seems for the arts, the more we need models to overcome the obstacles that could interfere with progress here. . . . The Romans, once crude, managed to civilize their nation by transplanting every product of vanquished Greece to their soil. Let us, following their example, use our conquests and bring from Italy to France everything that may empower the imagination.[91]

High on any artist's list of works of art capable of strengthening the imagination were paintings by the baroque masters: Carracci, Guercino, Reni, Cortona, and so on. (Denon himself engraved Luca Giordano's *Adoration of the Shepherds* as his reception piece for the Academy in 1787.) For this reason these masters figured prominently among the works chosen by the commissioners. In condemning post-Renaissance art as eclectic and degenerate, Winckelmann and Quatremère openly went against prevailing taste and artistic practice.[92] Furthermore, to endorse the idea that all art after Raphael belonged to a phase of decline would have made a mockery of the French policy of confiscation, not to mention the heroic efforts of Bonaparte's army, whose victories were symbolized in the masterpieces of the Louvre. Second-rate works of art make for illegitimate trophies of war. In short, the speculations of Winckelmann and Quatremère were out of place politically and aesthetically in this celebration of the genius and diversity of painting.

*　　*　　*

We turn finally to the last project undertaken by the administration of the Musée central, the antique sculpture galleries. The need for a museum of antiquities to accompany those already created or planned for painting, natural history, and arts and crafts (*arts et métiers*) was recognized as early as

1794, but at that time it was far from clear what form such a museum should take. The range of objects that qualified as antiquities made the task of organizing a coherent display seem daunting. As J.-P. Rabaut Saint-Etienne remarked in an address to the Convention on behalf of the CPI, "Archaeology, or the science of antiquity," included the study of inscriptions, religious, military and civil instruments, statues, bas-reliefs, gems, paintings, mosaics, and medals, "each one of which would be enough to consume the life of an industrious scholar."[93] Moreover, the collection would have to be systematically arranged, "assembled and classified as in a table," in order to feed the eye and mind of the beholder.

J.-B.-P. Lebrun, in a report on the Bibliothèque Nationale, had earlier proposed a simple solution whereby antiquities deemed useful to the arts should go to the Louvre, whereas those pertaining to "erudition" belonged at the national library. Following discussion of where to draw the line between the two categories, his idea was adopted in the summer of 1795.[94] In November the architect de Wailly put forward a plan for the new gallery, which took the form of a covered arcade, using columns from Charlemagne's tomb at Aix-la-Chapelle, built alongside the wall of the museum courtyard.[95] It would have been a humble affair, but at the time the number of available objects "worthy to be offered as models of study" was not large. It is not clear how much progress, if any, was made on this early incarnation of the *musée d'antiques* before the invasion of Italy a year later created a need for something far grander.

It went without saying (though the Abbé Grégoire had said it anyway in his famous 1794 report on vandalism) that Italy's greatest prize was its antique marbles.[96] As noted earlier, of the one hundred works of art ceded by the pope, eighty-three were universally admired ancient sculptures already on public display in the Pio-Clementino and Capitoline museums and in the Palazzo dei Conservatori. Certain recognized masterpieces could not be carted off by the French owing to their size (e.g., *Trajan's Column* and the *Discouri*) or respect for private property (a number of private collections, such as those of the Borghese and Albani, were later acquired). Outside Rome confiscation of sculpture was limited to celebrated individual pieces – notably, the *Horses of San Marco* and the *Venus de Medici*.[97] De Wailly's courtyard gallery was clearly inadequate for the most famous sculptures in the world. So, too, was an alternative idea put forward by the commissioners to use one of the many abandoned churches in the capital.[98] It is indeed hard to picture the statues from the Belvedere courtyard happily relocated to any of the churches that survived the Revolution. Those consulted insisted that conditions of display must at least equal those at the Vatican, especially with respect to lighting.[99] It was decided finally that the suite of rooms beneath the Galerie d'Apollon

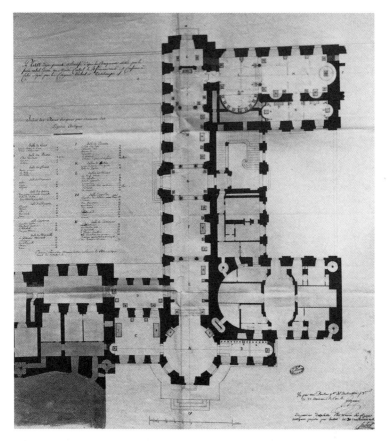

Figure 57. Auguste-Cheval de Saint-Hubert, *The Antique Sculpture Galleries,
Louvre Museum, Plan.* Drawing, Archives Nationales, Paris.

would be an appropriate location. The Directory gave its approval on condi-
tion that the *Laocoon* be placed prominently in good light and the *Apollo
Belvedere* in "its own temple."[100]

The Directory turned to the museum's resident architect, Hubert, who
completed his scheme for the new gallery in October 1797 (Fig. 57).[101]
Replacing existing walls with pairs of columns, Hubert proposed a sweep-
ing sequence of thirteen interconnected rooms along two axes. The main
axis extended from the new entrance to the museum in the Salle de Ceres
(replacing the entrance through Brebion's 1781 staircase and the Salon) to
the *Laocoon,* offering the visitor a magnificent vista and creating a spatial
flow similar to the Grand Gallery above (Fig. 58). The second axis, parallel
to the Seine, terminated in the "temple" setting for the *Apollo Belvedere.*
According to the plan, each statue had a prearranged place; the more

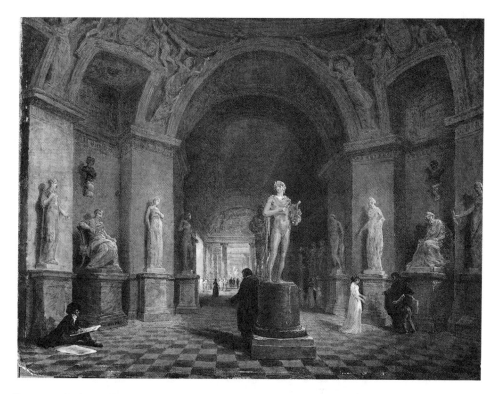

Figure 58. Hubert Robert, *Project for the Arrangement of the Mars Rotunda, Louvre Museum.* Oil on canvas, Musée du Louvre, Paris.

important the statue, the more prominent its position. Some attempt was made to group the sculptures iconographically, but that classification took second place to a desire to showcase famous marbles and to achieve a decorative ensemble.

Before work could begin Hubert died suddenly, and his place was taken by Jean-Armand Raymond. Raymond modified his predecessor's design by reducing the number of galleries from thirteen to seven and simplifying the dimensions of the Salle du Laocoon, the Salle de l'Apollon, and the galleries clustered around the entrance. Hubert's two main vistas were preserved. Raymond's alterations entailed some reworking of Romanelli's original ceiling frescoes dating from the reign of Louis XIII (heavily restored during year II when Republican symbols were substituted for those of Bourbon rule). Additional frescoes depicting appropriate allegories such as The Arts Giving Homage to Victory and The Origins of Sculpture (Prometheus and Minerva) were commissioned from a group of young artists: P.-A. Hennequin, G. Lethière, J.-F.-P. Peyron, P.-P. Prudhon, and P.-N. Guerin.[102] The

paintings were set in a framework of interlacing gilded stucco borders. Below, the whiteness of ancient statuary was enhanced by pinkish-gray walls, marble floors, and richly colored columns.[103] The overall effect was one of opulence. It must have been particularly impressive during candle-light tours of the collection, which enjoyed a vogue during the period.[104]

Raymond's modifications took some years to complete. At the time of Hubert's death in March 1798 the museum was broke. The cost of prepar-ing the Grand Gallery – laying new floor boards, painting the walls, unpacking cases from Italy, restoring pictures, and gilding frames – had put a huge strain on the museum's already meager resources. Under constant pressure to open the museum, the administration found itself desperately short of funds. From the outset in 1793 money was a source of anxiety for museum authorities. The government could be relied upon to cover annual expenses but not the cost of expansion.[105] And when funds for specific pro-jects were forthcoming, the museum was still expected to cut corners wher-ever possible. Thus, for example, scaffolding from the building site of the Madeleine was used to parquet the Grand Gallery;[106] pedestals for the *Apollo Belvedere* and *Laocoon* were cut from the block that had originally supported Bouchardon's *Louis XV*.[107] Many of the picture frames in the Musée Central would have been familiar to anyone who had known the Orléans collection before the Revolution.[108] From the mid-1790s the pro-ceeds from sales of museum and Salon catalogues, which had initially gone to the poor, went straight into the museum coffers.[109] To raise money for the antiques gallery, a public auction was held in July 1798 of objects for which the museum had no use (the first example of deaccessioning?). Thanks largely to the auctioneer Paillet's expertise, the sale realized enough to cover initial building costs.[110] Finally, in October the government came through with 200,000 francs to defray the museum's "extraordinary expenses."[111]

Work evidently progressed in the months that followed, and in May 1799 it was announced that the gallery would be ready in three months.[112] Not for the first time, however, official predictions were overly optimistic. When Bonaparte visited the Louvre in December, shortly after the *coup d'état* of 18 brumaire, he was annoyed to find much still to be done. The administra-tion complained that it had so far received only 1,000 of the 200,000 francs promised by the government a year earlier. The first consul saw to it that the balance soon arrived. Further, in an effort to vitalize the administration, the eminent antiquarian and director of the Pio-Clementino Museum, E. Q. Visconti, who had recently fled to France following the collapse of the short-lived Roman Republic, was made keeper of antiquities. Within a year the first six rooms were opened to the public. In that space of time, Visconti reordered the marbles and renamed the galleries recently modified by Ray-

mond. The new arrangement owed much to the plan of the Pio-Clementino: statues were grouped roughly according to subject in a sequence of rooms named after the Belvedere Torso, the Seasons, Illustrious Men, Romans, the Laocoon, Apollo, and the Muses.[113] Visconti left in place the *Laocoon* and the *Apollo Belvedere*.

Given the theoretical commitment to chronological demonstration in the Grand Gallery, together with the huge impact of Winckelmann's *History of Ancient Art* (the CTA wanted copies of the Jansen translation of 1790–4 placed in "each museum and principle library" in the country),[114] it is at first surprising that historical sequence was not an issue in the organization of the antique sculptures. The reason for this is twofold. First, the aim of the commissioners in Italy had been to secure only the most celebrated ancient marbles: the priority was never to include "lesser" objects (equivalent to Perugino or Gennari) for the sake of historical demonstration. The inclusion of any sculpture in the museum, beyond token decorative works, became a serious consideration only following the conquest of Italy, and once it had, the overriding ambition was to capture and exhibit those antiques long regarded as the best of their kind.

Second, even if constructing an historical sequence was desirable (and it was clearly as an ideal),[115] there were great problems with dating ancient sculpture. In the wake of Winckelmann's pioneering efforts to establish a sound chronology for ancient art, closer scrutiny of ancient texts and of the marbles themselves had begun to raise unsettling questions about the status of the canonical works. Inconsistencies between text and statue together with sensitive formal analysis led Winckelmann's friend and disciple Anton Raphael Mengs to conclude that the majority of the most highly esteemed statues excavated in Italy since the Renaissance were not Greek originals, as was previously assumed, but later Roman copies.[116] While Mengs's views hardly affected the reputation of the celebrated marbles (he himself insisted on their superiority regardless of origin), he had made the task of dating antiquities more problematic at the same time that he exposed the inadequacy of surviving examples to document the historical development of Greek and Roman art as described by the ancients and Winckelmann himself. E. Q. Visconti's own brilliant scholarship, manifested in essays like that on the *Venus de Medici*, which appeared in *La Décade philosophique* in 1802, tended to heighten awareness of how little was really known – perhaps ever could be known – about ancient Greek and Roman art.[117] In short, it was clear that veneration of the universally accepted masterpieces of antiquity could not be reconciled with a chronological system of display.

The most famous of all statues, the *Apollo Belvedere*, was subjected to what must to many have seemed an unseemly amount of new scrutiny. Though Mengs had identified the *Apollo* as a Roman copy as early as 1779,

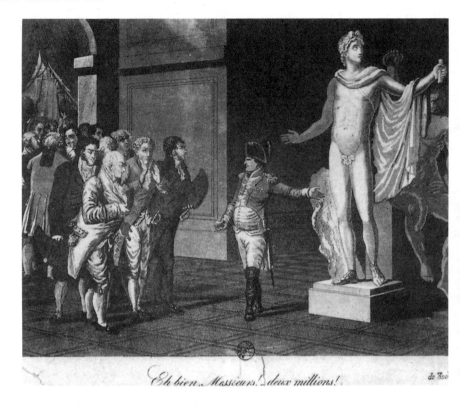

Eh bien.. Messieurs! deux millions!

Figure 59. Anonymous, *Napoleon Bonaparte Showing the Apollo Belvedere to His Deputies.* Etching with aquatint, Bibliothèque Nationale, Paris.

Visconti continued to insist on its Grecian pedigree until forced by geological evidence to concede that it might be Roman in origin after all.[118] Refusing nevertheless to accept that the statue was anything less than a masterpiece, he reasoned that it was an "improved" Roman version of an earlier Greek bronze. Visconti found it impossible to accept that the *Apollo* was a mere copy; the adulation of centuries could not easily be overthrown. Just as Denon was personally as well as politically bound to reject the pessimist's vision of post-Renaissance painting, Visconti was equally committed to defend the *Apollo's* integrity. As the Louvre's authority on antiquities, Visconti was in no position to discredit the work of art that more than any other symbolized Napoleonic triumph and the new glory of Paris (Fig. 59).[119]

ALEXANDRE LENOIR AND THE MUSEUM OF FRENCH MONUMENTS

Barbarians and slaves despise the sciences and destroy artistic monuments; free men love and preserve them.

Abbé Grégoire, *Rapport sur les destructions operées par le vandalisme*, 1794

The Museum of French Monuments was the second great Revolutionary museum of Paris. Officially recognized in 1795 and remaining open until the Bourbon Restoration, it was largely the creation of one man, Alexandre Lenoir, and differed in fundamental respects from the Louvre museum of the 1790s. Unlike the Louvre, whose roots lie deep in the *ancien régime* and in the Enlightenment ideal of a museum, the Musée des monuments was the product of circumstances unique to the Revolution and would have been inconceivable before 1789.[1] Instead of paintings and antique marbles, it contained French sculpture and tomb monuments from the Middle Ages to the early nineteenth century – not then (or since) in many people's canon of "great" art. This lack of recognized masterpieces pushed Lenoir to create a museum more strictly chronological than any that had gone before and to design the first "period rooms" in museum history in order to display his collection sympathetically. Unable in contemporary eyes to stand on their own as works of art, many of Lenoir's monuments required historicizing and exoticizing through context to become museum objects.

The Musée des monuments was born of the contradictory Revolutionary desires, on the one hand, to obliterate the past in pursuit of a regenerated society and, on the other, to preserve past monuments as evidence of Republican enlightenment. As we have seen, many works of art and historical artifacts represented subjects and memories antithetical to Republican principles; in Varon's powerful words, they were marked by the "superstition,

flattery, and debauchery" of a corrupt, discredited regime. At the same time to destroy testaments of human progress and the fruit of individual genius was to go against everything the Enlightenment stood for. As the Abbé Grégoire observed, only a barbarous people despises science and destroys artistic monuments (see the epigraph for this chapter).

The question was, however, what qualified as an artistic monument no civilized people would destroy? And who was to decide? There was never serious discussion of destroying Old Master paintings destined for the Louvre; it proved simple enough to veil certain "offensive" signs (the fleur de lis, for example), and to rationalize their public display in aesthetic terms. But objects that failed in contemporary eyes to qualify unambiguously as works of art, such as commemorative monuments, religious sculpture, and stained glass, were as a class treated with much less respect. We should remember that just days before the Louvre museum opened in August 1793 many royal tombs at Saint-Denis, the traditional burying place of the French kings, were systematically destroyed by order of the government (Fig. 60). In virtually the same breath Jacques-Louis David could plead the cause of responsible conservation at the Louvre and propose the erection of a colossal statue of the French people on a base composed of "feudal debris," to include statuary torn down from Notre-Dame and other church façades.[2] Simply put, at work during the Revolution was a distinction between a great work of art embodying transcendent, eternal aesthetic values and objects whose worth was measured primarily in terms of historical importance and local memory. A devotional painting by Raphael, despite its subject, was protected as the inviolable patrimony of world civilization, whereas the tomb of a cardinal was prone to Revolutionary iconoclasm and the fury of the mob. Rubens's paintings of Marie de Medici were masterpieces of the Flemish school, whereas Bouchardon's equestrian statue of Louis XV was identified not as the masterpiece of France's most acclaimed eighteenth-century sculptor but as a prominent representation of a recent French king that had to be torn down. An implicit distinction between works of art and historical monuments is still very much with us: the former, located in museums and *outside* history, are rarely defaced (when they are the result is public outrage), whereas the latter, burdened by their identity as political-historical representations, are prime targets for graffiti and vandalism. Who stopped to question the recent toppling of Communist icons in eastern Europe and the former Soviet Union?

By and large monumental Renaissance and later sculpture was not highly prized in late-eighteenth-century France and was notably absent from the three museum projects discussed in previous chapters (aside from d'Angiviller's *Grands Hommes*, whose primary value was commemorative). At the Revolutionary Louvre even Michelangelo's *Slaves*, confiscated from the

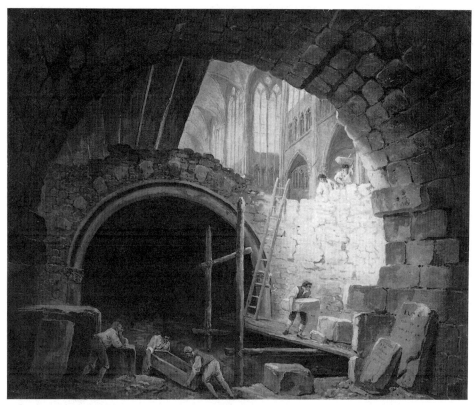

Figure 60. Hubert Robert, *Desecration of Royal Tombs at Saint-Denis in 1793.* Oil on canvas, Musée Carnavalet, Paris.

descendants of Cardinal Richelieu, settled for a decorative role, framing but not crossing the entrance to the Grand Gallery. Meanwhile few if any at the time saw aesthetic merit in medieval sculpture. It took Lenoir's vision, energy, and ambition to make of non-antique sculpture material fit for a museum.

<div align="center">*　*　*　*　*</div>

Until its dissolution in December 1793, the forces of conservation were represented by the Commission des monuments, created to designate and safeguard objects of artistic and historical importance following the nationalization of Church property in November 1789. The Commission was made up of two dozen learned men – antiquarians, artists, and scientists, drawn in large part from the various Paris academies.[3] As the Revolution progressed they were further entrusted with property confiscated from émigrés and, at the same time, forced to contend with the rise of vandalism, which became

particularly severe after August 10, 1792. Their responsibilities were enormous, and their charge as mind-boggling in scope as it was unprecedented. Guidelines and criteria were formulated as work proceeded, resulting eventually in the publication of the comprehensive *Instructions sur la manière d'inventorier* (1794). Despite its official status and dedication, the Commission struggled to keep one step ahead of the vandals; all too often it learned only after the fact that a monument had been vandalized or a church had been turned into a barracks or warehouse, often with disastrous consequences for its contents.[4] It was not until April 1793 that laws were passed outlawing vandalism, and even then the Commission continued to find itself at odds with government agencies and local authorities over crucial monuments (Lenoir later blamed the Commune of Paris for most of the destruction).[5] During the Terror the rational determinations of the Commission were often swept aside by a desire for revenge. And existing laws notwithstanding, the government maintained a highly ambivalent attitude toward iconoclasm. Witness the Committee of Public Instruction's (CPI) response to an appeal to halt the destruction of tombs at Saint-Denis in September 1793:

The members of this committee are of the opinion that the tombs of the kings are not worth the effort of preserving them, that this was not the intention of the National Convention, and that, moreover, it would be difficult to prevent them from being smashed by the people.[6]

Speaking of the same monuments, the influential politician Bertrand de Barère (also, paradoxically, a protector of Lenoir) told the Convention that "the powerful hand of the Republic should without pity or remorse demolish these haughty epitaphs and mausoleums, which bring back frightening memories of kings."[7] Only the fall of Robespierre brought Revolutionary iconoclasm to an end.[8]

From early in 1791 works of art earmarked by the Commission were removed for safekeeping to a depot in the former convent of the Petits-Augustins, located on the Left bank of the Seine opposite the Louvre (what is now the Ecole des Beaux-Arts).[9] (Other spaces were appropriated to hold books, manuscripts and further works of art.) They would remain there until it was decided how best they might serve the state. No one at the time foresaw turning the Petits-Augustins into a permanent museum.

In June 1791 Alexandre Lenoir was officially appointed guardian of the depot (he had been there unofficially since January). Seemingly nothing in his past qualified him for the post. Born in Paris in 1761, the son of a successful merchant on the rue Saint-Honoré, Lenoir received a traditonal education at the Collège Mazarin before deciding on a career in painting.[10] He enrolled at the Royal Academy in 1778 as a pupil of the distinguished history painter Gabriel-François Doyen. None of Lenoir's work seems to have survived, which might suggest a certain indifference to his chosen metier. By

the late 1780s he had also tried his hand at writing, producing an undistinguished one-act comedy and a piece of Salon criticism whose critical tone (Cochin numbered it among the more irritating pamphlets of 1787) surely signals his rejection of the Academy.[11] The evidence points to an uncertain career and an obscure destiny. But as with so many other educated, ambitious young men of his generation, the Revolution presented Lenoir with new and unforeseen possibilities.

Whether or not Lenoir had, in fact, abandoned painting, he had remained in touch with his master, Doyen, for he it was who recommended Lenoir to his friend, the mayor of Paris, J.-S. Bailly, as guardian of the *dépot des Petits-Augustins*.[12] His duties included keeping a register of all objects entering the depot and sending a weekly list of new acquisitions to the Commission des monuments. Each item was numbered, ticketed, and stored so as to be immediately accessible.[13] Lenoir proved a meticulous administrator and quickly made himself indispensable. Although he was not a member of the Commission (for which he would be grateful when it was dissolved), he participated in its daily work of surveying churches and compiling inventories.[14] He clearly enjoyed the work and was taken under wing by one of the Commission's more powerful members, Abbé Leblond. Before long he was acting on his own. In April 1793, for example, Lenoir was sent to Saint-Denis, by now renamed Françiade, to collect certain paintings withdrawn from a forthcoming public auction. While he was there he made notes about a number of tombs and stained glass windows that, "though barbarous in taste and style," he thought worth preserving. At the offices of the municipality nearby he salvaged further works of art previously overlooked by the Commission, including Germain Pilon's tomb of Henri II.[15] Presumably Lenoir was on his own at the Sorbonne when he was stabbed in the hand trying to protect Richelieu's tomb from a vandal's bayonet, an incident he was fond of recalling and which became central to the Lenoir mythology. It may well have been the inspiration for a remarkable (but surely apocryphal, later) image of Lenoir defending the tomb of Louis XII with his bare hands (Fig. 61).

Over time Lenoir came to identify with his collection. Though his writings make perfectly clear that he was neither precociously disposed toward pre-Renaissance art nor unusually enamored of sculpture, what he lacked in aesthetic sympathy for much in his collection he made up for in a fierce possessiveness common to collectors and museum curators. Even more than the members of the Commission, Lenoir saw it as his mission to acquire and preserve whatever fell within the depot's alotted domain (as well as much that did not). Hence the extraordinary exploits on which his reputation so largely rests: the encounter with vandals at the Sorbonne, the disguising of statues sought by government agents in need of bronze for cannon, and so on.[16] His dedication verged on obsession, and he has been justly criticized for appropriating monuments under the guise of "protection" long after the

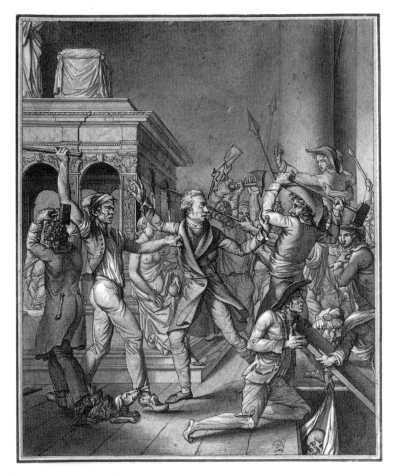

Figure 61. Pierre-Joseph La Fontaine, *Lenoir Defending the Tomb of Louis XII at Saint-Denis*. Drawing, Musée Carnavalet, Paris.

threat of vandalism had subsided. If at first he perceived the Petits-Augustins as a source of livelihood during difficult times, the depot soon became a path to fame and power.

Although the Petits-Augustins was intended as a temporary storage facility, a clearing house at the service of the government, once Lenoir laid claim to a work of art it was only with the greatest reluctance that he would let it go. His dealings with the Museum Commission are a case in point. From 1792 he tried all manner of evasive tactics to avoid handing over works of art to the Louvre, even though it was the obvious and proper destination for much that entered the depot.[17] Frustrated by his obstinacy, J.-B. Regnault and his colleagues schemed unsuccessfully to have Lenoir removed.[18] In June, the minister of the interior, Garat, was on the verge of dismissing Lenoir, who was

saved only by the intervention of Barère.[19] Lenoir eventually backed down and the Louvre got what it wanted, but this early confrontation was merely the first of many between Lenoir and rival institutions with claims on his collection. Whether he liked it or not, he saw the depot gradually stripped of paintings, antique (and some modern) sculpture, and precious marbles, such as the columns from Charlemagne's tomb at Aix requisitioned by the Louvre for the antiques gallery. All that remained were assorted sculptures and stained glass from the Middle Ages to the present, objects too valuable historically to sacrifice but without obvious use to the Republic.

Lenoir's initial reluctance to cooperate with the Museum Commission was motivated by a combination of self-interest and frustration with Roland's handling of the Louvre. Lenoir and the Commission had every reason to expect being directly involved in the creation of the national museum. The implicit goal of their brief – to preserve and classify objects of artistic, historic, and scientific worth – was an institution, or set of institutions, dedicated to public instruction. Several times in Commission meetings the subject of the museum was discussed. As works of art rapidly accumulated at the depot during the first months of 1792 the nucleus of a collection took shape. One can imagine the Commission's disappointment when Roland suddenly named a museum administration in which Commission members were not represented. The latter were being denied the satisfaction of seeing their work through to a logical conclusion, a conviction Lenoir made plain in a letter to Garat dated April 1793:

The guardian of the depot of the Petits-Augustins wishes to point out that the steady removal [of works of art] destined for another repository most certainly destroys the evidence of the huge amount of work he has done over the past four years, and with it his right to reap the fruit of his labor.[20]

Already in the strictly personal emphasis of this letter ("*his* hard work, *his* right") we get a clear sense of Lenoir's self-centered ambition. Others had greater cause for complaint than he. In any event, shortly before the Commission was dissolved we find him distancing himself from it and taking credit for more than his share of the work. He must have sensed that the Commission's days were numbered and that it was time to establish an independent identity. Lenoir soon resolved his differences with Garat and obtained permission to open the depot to the public during the festivities of August 10, which proved a great success.[21] This temporary public spectacle foreshadowed the opening of the museum proper two years later.

To some people, however, the Petits-Augustins had already begun to take on more the appearance of a permanent installation than a provisional storage depot. The artist J.-M. Moreau le jeune, for one, was struck by the formality of the display:

> Work is under way on a serious and permanent installation of the marble monuments originally taken there for temporary safekeeping. . . . I have seen tomb monuments that have been almost completely rebuilt, and a large number of columns that have been reunited with their bases and capitals and placed upright against the walls.[22]

To the annoyance of Commission members, Lenoir published a catalogue of the depot's holdings to accompany the exhibition without the participation of the Commission and in which the Commission's work went unacknowledged.[23] To judge by the catalogue, Lenoir arranged his motley collection around the main cloister (see Fig. 67) with a view to visual effect. Sculptures and architectural fragments sharing the same provenance, which when they entered the depot had been described together in Lenoir's register, were here presented to the public out of order, indicating a deliberate intervention.[24] The catalogue's numerical sequence reveals an attempt to achieve a rich mixture of object type, material, color, and even period. The effect could be described as eclectic, resembling at first glance the display of paintings across the Seine in the Grand Gallery.

Like the many other catalogues of the collection that Lenoir produced over the next twenty years, the 1793 *Notice succincte* served both to guide the visitor through the exhibition and to assert Lenoir's own authority over the depot and its contents. In a way that museum catalogues still do, it legitimized the collection as well as the expertise of its author. At the end of the *Notice* Lenoir announced that he would soon publish a catalogue of the depot's paintings (then on display in the convent church). As a taste of what was to come and in order to demonstrate his knowledge of restoration – a hot issue in 1793, it will be recalled – he included mention of a few of his outstanding pictures, among them a *Deluge* attributed to Tintoretto, which he claimed to have discovered in "three hundred pieces" and restored after transporting it "religiously in a sack" back to the depot.[25]

Lenoir had not yet begun to think in terms of establishing a separate museum devoted exclusively to French sculpture. At that point he was looking forward to an eventual merger of the Petits-Augustins and Louvre collections to form a larger, more comprehensive national art museum. When that moment came he would be the obvious choice to look after modern sculpture. His competence in picture restoration could only strengthen his case. In other words, his post at the depot was, he hoped, a stepping stone to a position in the Louvre administration.

Soon after the overthrow of the monarchy in 1792 Lenoir inquired about a role on the Museum Commission itself. An anonymous correspondent, replying to what was clearly a self-seeking appeal by Lenoir, thought his qualifications and contacts sufficient for a place:

Taken together these considerations create a most flattering impression of you; but it will still be necessary to impress the minister [Roland] if you want a place on the com-

mission. It seems that organization is open only to members of the Academy rather than to men who know what needs doing. . . . If, as I suppose, citizen Barère is well disposed toward you, he could be of great use in presenting your case to the minister, so that even if you aren't named to the commission you might be attached to the museum.[26]

The Revolution had done little to alter the routes to power. On this occasion Barère's friendship was evidently of little help. Nor did he have friends among those tapped for the Commission. On the contrary, as we have seen, one of its members, J.-B. Regnault, plotted to have Lenoir replaced at the depot by a member of the Academy.

During the Terror Lenoir kept a low profile. He welcomed the creation of the Commission temporaire des arts (CTA) and knew better than to protest the shabby treatment of the outgoing Commission des monuments.[27] He responded promptly to every official demand and provided no cause for complaint. For the sake of appearances he tore down statues of the Virgin and "grimacing monks" from the façade of the Petits-Augustins.[28] He offered no resistance to local authorities when asked to produce "portraits of nobles, prelates, and so on" to be burned at popular street festivals.[29] Lenoir was on hand throughout the grizzly exhumation of French kings at Saint-Denis in 1793 and made drawings of some of the cadavers as well as of the curious Republican shrine built to Marat and Le Pelletier from the mingled royal bones. There was perhaps a touch of irony in his description of the latter, but he kept whatever disapproval he felt to himself.[30]

Despite his friendship with David and his sound record of resistance to Roland's museum policy, Lenoir apparently made no bid to join the first Louvre Conservatoire after the Museum Commission was relieved in January 1794. But after thermidor Lenoir began a second campaign of self-promotion. Once again, his object was not the creation of a separate museum but a place in what he anticipated would be a reformed Conservatoire at the Louvre. And once more he banked his hopes on the assumption that the existing national museum would be enlarged to include a collection of French sculpture.

On 19 thermidor an II (August 6, 1794), Lenoir sent both the CTA and the CPI a manuscript copy of his recent, updated *Catalogue des objets réunis au Dépôt provisoire* with a request for permission to have it published. His reasons for compiling a new catalogue are explained in a covering letter to the CPI:

Enlightened representatives, the task of educating France rests on your shoulders. It is therefore up to you to open the administration of the Muséum Français to a competition of your own device; only then will you benefit from the knowledge of true artists and banish intrigue, which up to now has been all too prevalent.

It is in order to facilitate such a competition that I present you with a chronological catalogue of the monuments I have collected and put in order at the provisional depot.[31]

If the connection between his catalogue and the competition seemed obscure, Lenoir's underlying purpose could not have been clearer. Two weeks later he sent the CPI a copy of his printed *Essai sur le Muséum de peinture,* in which he called for a national collection embracing all the arts, including modern sculpture. He further proposed the implementation of a chronological display in the nation's museum by means of which the development of the arts in various countries could be witnessed simultaneously.

> As a result of this system the beholder will be forced to confront the causes of a retarded development in the arts among certain peoples while they flourished elsewhere. . . . The arrangement of the museum will be based on a division of centuries, which will clearly demonstrate the various revolutions that have occurred. Each type of art will be displayed separately, forming in a sense museums within a museum. Thus works of sculpture will be separated from paintings . . . and the different arts will be given priority according to their historical precedence in order not to interrupt the flow of art history.[32]

Throughout the essay Lenoir's stance is that of a disinterested adviser whose only concern is public instruction and the glory of France. But, of course, he was once more demonstrating his knowledge of the arts and the energy he would bring to the administration of the Louvre. Lenoir was most probably inspired by the pamphlets published earlier by that other master of self-promotion, J.-B.-P. Lebrun, as part of his own campaign to gain a post at the museum. (Interestingly, the two men seem to have disliked each other intensely.) Unlike Lebrun, however, Lenoir had little experience with anything but modern sculpture, which no one else thought appropriate for the Louvre, and his appeal was turned down. The CTA replied that it was satisfied with his work at the depot; it ordered two copies of his catalogue but regretted that it would be unwise for several (unstated) reasons to have it published and circulated.[33]

It was Lenoir's second failure to secure a position in the Louvre administration that prompted the idea, or rather determined him to pursue an idea that had must have occurred to him (and probably others) before, to create a separate museum based on the collection of monuments and sculptures at the Petits-Augustins. In October 1794 we find him pressing the CTA for permission to reassemble in their entirety significant monuments in his care. He expressed particular concern for works of the sixteenth century, the century of Francis I, "considered the best period in French art."[34] He pleaded the cause of conservation – "a monument left dismantled in a corner will slowly but surely deteriorate" – but the CTA, composed of men like Varon, Picault, and Lebrun, no strangers to a self-serving ruse, understood well enough that his argument veiled a desire to aggrandize his depot and refused the request.

Not to be denied, Lenoir went over the CTA's head to the CPI. In Novem-

Title [handwritten annotation]

ber the latter, recently reorganized, confirmed Lenoir in his place as _conser-vateur des monuments_.[35] Taking this as his cue, he went to the CPI a month later with a plan for the establishment of "a museum in Paris of French monuments." The committee welcomed the idea. Lenoir presented a second report in July 1795 elaborating on the first, followed by a third report three months later, which produced the following decree:

> The Committee of public instruction of the National Convention, having heard citizen Lenoir's report on the foundation of a Museum of French monuments in Paris, decrees that the depot of the Petits-Augustins will be named the National Museum of French Monuments; and that there will be a museum of French monuments in Paris in which the monuments will be arranged in chronologial order.[36]

No doubt instrumental in winning the CPI's approval was the timely publication of a new catalogue of the depot's holdings.[37] In this instance the catalogue provided more than a list of monuments: it also gave a clear sense of the eventual structure of the museum. To the newcomer the Petits-Augustins presented a scene of disarray – an English visitor remarked that its contents were "piled up without order or care and form a strange chaos of rare and remarkable objects"[38] – but Lenoir's _Notice historique des monumens des arts_ offered a vision of those same objects organized in four coherent groups: Celtic antiquities, ancient sculpture, medieval monuments, and monuments since the Renaissance.[39] On 19 germinal an V (April 8, 1796), Pierre Benezech, minister of the interior, officially recognized the museum. In the process he paid Lenoir the highest compliment: "I have nothing but praise for the zeal and intelligence with which you have formed this depot. . . . The energy you have demonstrated assures me that you will continue to merit the confidence and esteem you have thus far acquired."[40]

<div align="center">✻ ✻ ✻</div>

The sudden enthusiasm for Lenoir's museum had everything to do with timing. Lenoir astutely perceived that a museum of French monuments could be presented to the government as an institution at once useful to the public, and thus essentially Republican in nature, and ideally suited to the mood of the country in the wake of the Terror. The Abbé Grégoire's famous reports on vandalism – the last dating from December 1794 – and each as rhetorical as anything written during the Terror itself, fueled a backlash against Revolutionary iconoclasm that Lenoir turned to his advantage.[41] As politicians distanced themselves from recent events and cast about for scapegoats, Lenoir emerged as a hero who had stood alone against the vandals, who, in the words of one deputy to the Convention, "devoured our monuments" (Fig. 61).[42] In various reports and petitions to the government, and in his _Notice historique_ of year IV, Lenoir drew on the antivandal rhetoric of Grégoire and Boissy d'Anglas to underline his achievement and

the value of his museum. "Vandalism has destroyed everything," he declared in the introduction to the *Notice*, "A new museum rises up. . . . There, in a scholarly disorder, are piled high cenotaphs . . . religious monuments . . . historical objects . . . beautiful masterpieces by the moderns." In years to come, Lenoir continued, the visitor would be prompted to ask "which century gave birth to these marvels, which century dared to raise a sacrilegious hand against them, and which conceived the noble project of repairing the crimes of ignorance and vandalism?"[43] Thus the Museum of French Monuments took part in the complicated Thermidorian process of internalizing and historicizing the Terror. The day before Benezech officially recognized the museum, the following account of the Petits-Augustins appeared in the *Journal de Paris*:

> It is with regret [that visitors to the depot] will come across debris here and there, yet where can one go to avoid it! All the same they will admire . . . a collection of monuments that have been spared the destructive fury of the vandals . . . and far from finding the confusion of a stonemason's yard, they will be struck by the imposing spectacle of the history of art presented under one roof.[44]

The most evocative thermidorian response to the museum was that of Sébastien Mercier, for whom a visit was at once historically fascinating and cathartic. His account is worth quoting at length:

> It was one of the most remarkable phases of the Revolution, a time when the ferocious murderers to which it gave birth momentarily suspended their executions and turned their swords instead on statues and bronzes. They saw marble and bronze breathe with life and they killed love, virtue, charity, and genius once more for good measure.
>
> Their furious gangs, having staged operas in temples, having put singers on the altar, eaten mackerel off the paten and drunk plonk from the chalice . . . toppled effigies of martyrs and popes with their triple tiaras from their niches; they opened graves and disturbed the sleep of the dead; they threw the ashes of Heloise and Abelard to the wind.
>
> Lead tombs were turned into bullets, feudal parchments into cartidges, iron gates into pikes, and bronzes into cannon. . . .
>
> Those frenzied days passed. . . . All that had escaped the blind fury of a people who destroyed their own altars was brought together [at the Petits-Augustins].
>
> What a source of reflections for the contemplative beholder! The same cart that days before had led a friend to the scaffold now slowly guided the funerary urn of a beloved wife . . . to the depot.
>
> The result is a unique spectacle, one which I found as curious and impressive as it was novel, and as striking to the eye as it was to the imagination. Saints and mythological gods, heroes, virgins, antiquities, cardinals, Etruscan vases, holy water basins, medallions, columns, colossal statues of Charlemagne and Saint Louis . . . all have been collected with care . . . and lend this museum a peculiar but striking sensation of the centuries confused.
>
> It was the true mirror of our revolution: what contrasts, what bizarre juxtapositions, what twists of fate! What extraordinary chaos!
>
> I walked on tombs, I strode over mausoleums. Every rank and costume lay

Vandalism during Rev.

beneath my feet; I spared the face and bosom of queens. Lowered from their pedestals, the grandest personages were brought down to my level; I could touch their brows, their mouths, whisper in the ear of Richelieu and interrogate Turenne and Malebranche.

There, all the centuries yielded themselves to me, and overwhelmed by a thousand ideas, stumbling over one monument after another, I wandered lost as in a valley of Josaphat in relief.[45]

Lenoir's museum proposal also answered the question of what to do with the works of art left unclaimed at the depot by rival institutions and without significant market value. His ambition aside, Lenoir seems to have been sincerely committed to the Republican ideal of public instruction. He believed that his museum, organized along chronological lines, could be useful to artists and beneficial to the public. Inspired by antiacademic rhetoric and his own contempt for the Academy of Painting, Lenoir joined forces with those who argued that museums should take the place of organized schooling as the source of artistic instruction. "We no longer have schools," he wrote, "and our only source of instruction is monuments, statues, and paintings: they are our academies."[46] However, the nature of his collection dictated pedagogic goals less straightforward than those at work at the Louvre. On one level, certain of his monuments, those dating from the sixteenth century, the French Renaissance, were second to none in terms of correctness, grace, and nobility and were as capable of inspiring good taste in the young artist as anything produced in Italy at the same time. The museum's masterpiece, the tomb of Francis I (Fig. 62), designed by Philibert de l'Orme and sculpted by Jean Goujon, was displayed in its own "temple" where it could be contemplated and admired in a manner akin to the *Apollo Belvedere* at the Louvre. On a second level, the large number of sculptures considered inappropriate for emulation, those described by Lenoir as "barbarous" in style, were nonetheless valuable as "mannequins dressed in the costume of their age" – in other words, as evidence of past costumes and customs.[47] Lenoir was appealing here to a late-eighteenth-century historicizing impulse that demanded increased accuracy in the artistic representation of ancient as well as modern historical subjects. D'Angiviller's series of French history paintings and *Grands Hommes* sculptures had called attention to the need for an accessible catalogue or compendium of national costumes to match the one on ancient costumes produced by Dandré Bardon (C.-N. Cochin embarked on such a project in 1775 but it was never finished.)[48] And finally, Lenoir argued that because art necessarily embodied the values and politics of the age in which it was created, the history of art laid out in linear chronological order could yield important insights into not only artistic evolution but the relative merits of different political regimes. As we shall see, Lenoir aimed to construct a history of French art in keeping with Revolutionary ideology.

Figure 62. Jean-Baptiste Réville and Lavallée, *Vues pittoresques et perspectives des salles du Muséum des monuments français.* Paris, 1816. Tomb of Francis I.

While Lenoir believed generally in the virtues of chronological display (he recommended it for all forms of art in his *Essai sur le Muséum de peinture*), the contents of his museum made its implementation imperative. The bulk of his collection consisted of tomb monuments whose original purpose was to perpetuate the memory of powerful individuals – individuals for the most part seen as enemies of the new Republic. Iconoclasm may have subsided after the Terror, but those monuments remained potent reminders of a still discredited past. If in their original settings prior to the Revolution those sculptures were commemorative monuments before they were works of art, Lenoir's task was to invert that perception, to privilege the maker, artistry, and historicity of the monument over its subject. Late in 1794 the CPI questioned Lenoir about his request to reassemble the tomb of Francis I, which, like every other tomb, had been dismantled in transport: "It is not the memory of Francis I that I hope to rekindle in restoring his monument," he responded, "the progress of the arts and instruction are my only concern."[49] Neutralizing the associations of such monuments would result from their removal from an original setting and their reidentification at the museum as art historical landmarks.[50] At the Musée des monuments, the tomb of Francis I was presented anew as a masterpiece of the artists de Philibert de l'Orme and Jean Goujon and as a supreme example of sixteenth-century French art. Relocation entailed the substitution of the new and alien discourses of art history and the museum for the discourses of ancestral chapel

and royal abbey. Royal tradition and local memory were ruptured in the interests of a comprehensive national history of art through monuments. Not for nothing did Benezech insist at the outset that the museum "above all follow chronological order."[51]

Arranging monuments by date alone served the further Revolutionary purpose of confounding former hierarchies and values by juxtaposing kings and commoners, the sacred and profane. In its confusion of signs and "bizarre juxtapositions," as Mercier put it, the museum was a "true mirror" of the Revolution. Those who mourned the passing of the *ancien régime* took offense at the mingling of classes and the revision of history. Witness the royalist sculptor Louis-Pierre Deseine, one of Lenoir's most persistent critics, from his *Opinion sur les musées* of 1802: "Saving monuments from the vandals was certainly a commendable undertaking; but . . . those same monuments must be preserved as sacred objects . . . they must be preserved as they were before the Revolution and must not be democratized."[52] The leveling intent of the Revolution was vividly demonstrated through the accessible display of the once untouchable. Famous historical figures were brought down to eye level – so close that Mercier could whisper in Richelieu's ear.

<p style="text-align:center">* * *</p>

Late in 1795 the Petits-Augustins contained approximately 200 marble sculptures, 350 marble columns and fragments, and over 2,000 paintings, mostly from churches in or near Paris.[53] A variety of factors prevented Lenoir from being able to use everything at his disposal. First, Benezech's recognition of the Musée des monuments was part of a larger ruling on the Revolutionary art museums, which simultaneously created the Musée spécial at Versailles and gave absolute precedence to the Louvre.[54] The minister's ruling that "everything must contribute to the completion of the Musée central" meant, in effect, that Lenoir lost control of the many paintings and antique sculptures he had amassed. At the same time, the museum at Versailles, which was given priority over the Musée des monuments, laid claim to French mythological sculpture. The jury appointed to fix the terms of the exchange between the Musée spécial and the Louvre regarded the park at Versailles as "the only true museum of French sculpture."[55] Through subtraction more than design, the Musée des monuments became primarily a showcase for tomb sculpture and commemorative monuments.[56]

The loss of ancient sculpture was a serious blow. To judge by the early classification of the collection, recorded in the *Notice historique* of year IV, Lenoir had in mind to present the history of French sculpture against a background of ancient art. The latter provided a point of departure as well as a touchstone of artistic excellence against which subsequent French

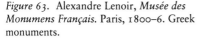

Figure 63. Alexandre Lenoir, *Musée des Monumens Français.* Paris, 1800–6. Greek monuments.

Figure 64. Charles-César Baudelot de Dairval, *Description des bas-reliefs anciens trouvés . . . dans l'église Cathédrale de Paris.* Paris, 1711.

efforts, and indeed all modern art, had to be measured. In 1795 Lenoir divided his collection into four categories: antiquities, Celtic antiquities, monuments of the Middle Ages, and monuments from the Renaissance. In each of the two main galleries deployed at that time a selection of each category was arranged in sequence. His aim was to display the broad sweep of art history from ancient times to the present. He had few outstanding Greco-Roman sculptures, mostly second-rate pieces seized from émigrés, and certainly nothing to match Bonaparte's booty. But what he had functioned within the collection as metonyms of the antique, embodiments of the Classical. So important were these works as such that descriptions and illustrations of them continued to figure in successive editions of the museum catalogue (Fig. 63) after the marbles themselves had been transferred to the Louvre.[57] Bridging the ancient world and medieval France was a set of "Celtic altars" (Fig. 64) that had been discovered beneath Notre-Dame in 1711.[58] They were thought to be pagan altars carved by ancient Gauls during the reign of Tiberius. Owing to their "true Roman style" they

were for Lenoir crucial transitional documents, evidence of the migration of the imitative arts to French soil.[59]

Deprived of ancient archetypes, Lenoir turned his attention to French sculpture and the elaboration of a chronological narrative within the confines of the Petits-Augustins. He decided to create a series of galleries around the cloister of the former convent and to devote separate rooms to the sculpture of the thirteenth through nineteenth centuries (Fig. 67). In his own words, he aimed to build "a museum devoted to history and chronology in which the different ages of French sculpture will be displayed in individual rooms, with each room decorated exactly in the style of the particular century."[60]

Figure 65. Jean-Baptiste Réville and Lavallée, *Vues pittoresques et perspectives des salles du Musée des monuments français,* Paris, 1816. Entrance to the museum.

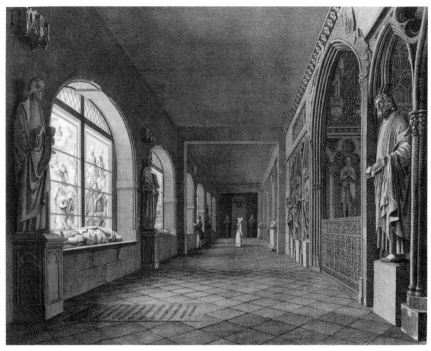

Figure 66. Jean-Baptiste Réville and Lavallée, *Vues pittoresques et perspectives*. Cloister.

Figure 67. Jean-Baptiste Réville and Lavallée, *Vues pittoresques et perspectives*. Plan of the museum.

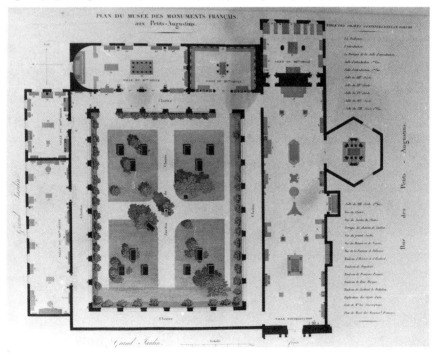

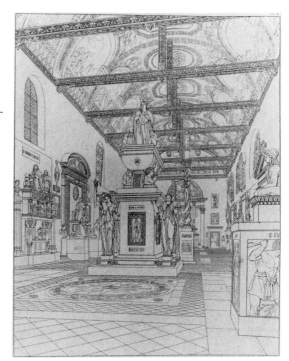

Figure 68. J.-E. Biet and Jean-Pierre Brès, *Souvenirs du Musée des monumens français.* Paris, 1821. Salle d'Introduction.

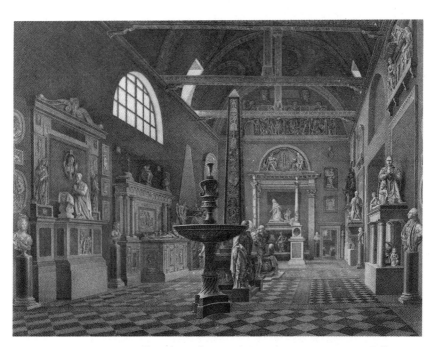

Figure 69. Jean-Baptiste Réville and Lavallée, *Vues pittoresques et perspectives.* Salle d'Introduction.

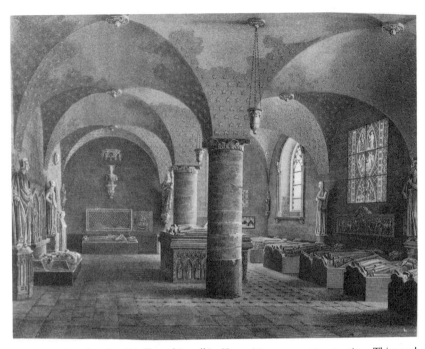

Figure 70. Jean-Baptiste Réville and Lavallée, *Vues pittoresques et perspectives.* Thirteenth-Century Room.

Figure 71. Jean-Baptiste Réville and Lavallée, *Vues pittoresques et perspectives.* Fourteenth-Century Room.

Figure 72. Jean-Baptiste Réville and Lavallée, *Vues pittoresques et perspectives.* Fifteenth-Century Room.

Figure 73. Jean-Baptiste Réville and Lavallée, *Vues pittoresques et perspectives.* Sixteenth-Century Room.

Figure 74. Jean-Baptiste Réville and Lavallée, *Vues pittoresques et perspectives.* Seventeenth-Century Room.

Figure 75. Jean-Baptiste Réville and Lavallée, *Vues pittoresques et perspectives.* Seventeenth-Century Room.

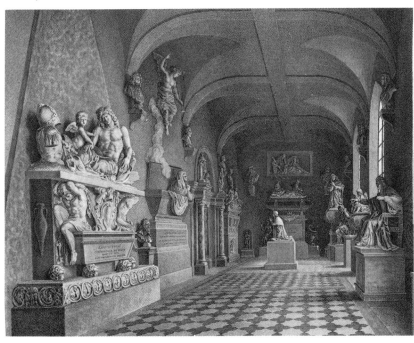

Figure 76. Jean-Baptiste Réville and Lavallée, *Vues pittoresques et perspectives.* Elysée.

Figure 77. J.-E. Biet and Jean-Pierre Brès, *Souvenirs du Musée des monumens français.* Tomb of Heloise and Abelard.

The circuit began with the Salle du XIIIe siècle, located in what had been the church sacristy, and ended with the Salle du XVIIe siècle in the far corner of the courtyard. The latter was to have been succeeded by galleries of eighteenth-century and contemporary sculpture, but these were never completed. Access to the rooms was from the cloister (Fig. 66) which Lenoir filled with additional sculptures and stained glass. The visitor entered the museum through a portal salvaged from the Château d'Anet (Fig. 65) which issued into the former convent church. Lenoir turned the church into a Salle d'Introduction (Figs. 68 and 69), featuring fine examples of sculpture from all periods.

Fitting the galleries involved huge expense. Bills from 1796 alone, the year in which construction started, covering masonry, carpentry, and painting, as well as the placement, cleaning, and restoration of monuments, totaled over one million *livres*.[61] Antoine-Marie Peyre, architect of the Bâtiments civils under the Directory and son of the late Marie-Joseph Peyre, supervised building work, but it was Lenoir who was responsible for the design of the rooms, from the ceiling decoration to the shape of the windows and the disposition of sculptures. Peyre merely followed orders. Lenoir insisted on full responsibility for he understood that it was through the character of each room that the flavor of different periods and the sense of historical progress he was so keen to impart would be most clearly felt. When, for example, in 1801 Peyre's successor, Moreau, contested Lenoir's authority over architectural detail at the museum, the director fired off the following appeal to the minister of the interior:

To deprive me of the pleasure of organizing my centuries according to the style appropriate to their age is to destroy all the charm of my work . . . I implore you not to relieve me of the right I have enjoyed for the past twelve years, and to which I am fully entitled . . . to place the monuments, bas-reliefs, and tombs, in their respective centuries and to give to each century the style that is fitting.[62]

In their aim to provide a sympathetic architectural environment for the sculptures on display, the galleries at the Musée des monuments should be recognized as precursors of the modern "period room," commonly used in today's museums for the exhibition of decorative arts and "lesser" works of fine art. As mentioned at the outset, the ambivalent status of Lenoir's collection in the late eighteenth century required an elaborate, historicizing frame. Stephen Bann has argued that Lenoir's rooms, because fabricated from a variety of heterogeneous elements (including some made to measure by Lenoir's workmen), lacked that quality of authenticity that enables the imaginative visitor to "touch" history and to be seduced by an illusionary transparency on events and people hundreds of years removed; and judged by nineteenth-or twentieth-century standards the Musée des monuments is

wanting.[63] What Lenoir aimed for, however, was a level of "general truth," a persuasive and credible setting like, if not identical to, that which originally surrounded the monuments displayed.[64] Rather than accurately recreating precise environments for each century (the chapel of a fourteenth-century convent, say, or the hall of a Renaissance château), he needed to fashion a set of evocative but not too specific milieus for a selection of sculptures bound (at times loosely) only by date and style.

Lenoir began at the end with the seventeenth-century room in the southwest corner of the cloister (Figs. 74 and 75), most probably because in his opinion it needed little architectural embellishment. Because the sculptures in this gallery postdated the Renaissance in France they required less in the way of a supporting frame. In the summer of 1796 a new floor was laid; two doors were opened in the east wall securing access to and from the cloister.[65] Above the doors, framing the pediments and looking down on the monuments below, Lenoir placed small statues of the artists Le Sueur, Poussin, Puget, and Sarrazin.[66] Light filtered through stained glass carrying designs by Le Sueur and Elye taken from Saint-Gervais and the convent of the Feuillants.[67] Among the monuments on display were those of Colbert, Louvois, Lully, Bérulle, and Charles Lebrun; there were also statues of Henry IV, Sully, Louis XIV, Corneille, and Rollin, as well as numerous busts of other illustrious figures.

The presence of so many great men in the gallery led some people to question the eventual purpose of the museum. Was it a museum of French art or a shrine to the nation's great men? Peyre, for one, described it more in terms of the latter in January 1797.[68] Of the seventeenth-century room Lenoir himself said: "I propose to include busts of the great men of France . . . who are, I believe, essential to historical narrative."[69] In part the ambiguity stemmed from the nature of the collection: tomb monuments, busts, and so on. Lenoir no doubt also subscribed to the view that sculpture's highest calling was the commemoration of great men. Beyond such considerations, however, he did, in fact, think of his museum from early on as a "pantheon" and resting place for numerous historical figures whose tombs had been violated by the Revolution.[70] In the late 1790s he collected actual bodily remains almost as zealously as he did celebrated monuments. He found the body of Turenne, for example, at the Jardin des Plantes, where it had been stored like a natural history specimen on account of its remarkable state of preservation following its exhumation at Saint-Denis. The remains of Molière and La Fontaine, installed at the seat of the Paris section of La Fontaine–Molière but abandoned in 1793 when that section switched allegiance to Brutus, were likewise saved by Lenoir and taken to the museum.[71]

The burial ground for these and many other bodies of great men (mostly writers, scholars, and *philosophes*) collected by Lenoir over the years was the garden attached to the museum, adapted from 1796 and appropriately baptized the "Elysée" (Fig. 76). Fashioned in the style of a *jardin anglais*, the garden proved immensely popular with the public and with artists.[72] Far and away the Elysée's most famous occupants were Heloise and Abelard. Lenoir reunited the star-crossed lovers in a monument (Fig. 77) he fabricated from fragments of assorted medieval monuments. The tomb was later transferred to Père-Lachaise cemetery where it may be seen to this day.

Lenoir also commissioned busts and memorials of individuals he particularly admired, such as Montaigne and the sculptor Goujon, Winckelmann and the composer Gluck, and found room for others dedicated by family members, such as the bust of Charles de Wailly given by his widow, or the monument to Marie-Joseph Peyre designed by his son. Lenoir paid a personal tribute to his contemporary Jean-Germain Drouais, whose untimely death in 1788 at the age of twenty-four had robbed the French school of one of its most promising painters, by commissioning a replica of the tomb monument erected in his memory by his fellow *pensionnaires* in the Roman church of S. Maria in Via Lata.[73]

Lenoir and Peyre next set about the Salle du XIIIe siècle (Fig. 70). In contrast to the seventeenth-century room, much was done to this room to give it the character Lenoir believed appropriate to the age.[74] A sea of painted gold stars against a background of deep blue decorated the heavy vaults in the ceiling. The walls were painted yellow. The inscription over the ogee-shaped door, "State of the arts in the XIIIth century," appeared in red uncial characters. According to Lenoir, the three primary colors, blue, yellow, and red, were symbolic of the sky, sun, and fire and were used extensively in the decoration of medieval churches. The stained glass windows came from Saint-Germain-des-Prés. Sepulchral lamps suspended from the ceiling cast long shadows across the room and lent it a suitably somber air. Indeed, according to Lenoir, the dim light intentionally evoked the "magic by which people terrified by superstition were kept in a perpetual state of submission."[75] Additional "authenticity" was guaranteed by fragments salvaged from Saint-Denis and Saint-Victor, decoration framing the door (the remains of a monument destroyed by vandals), and the rosettes in the groins of the vaults. Whether or not the materials were genuine, the flavor of the architecture is persuasive, suggesting that Lenoir had studied medieval buildings and somehow found masons competent in medieval building techniques.

By no means everything in the room was datable to the thirteenth century – the tombs of Clovis I (d. 511), Hugues Capet (d. 996), and other members of the first races of French kings preceded those of the thirteenth-century monarchs, Louis IX and Philip III, and the numerous sculptures of indeter-

minate age. The Salle du XIIIe siècle was, strictly speaking, a misnomer. It contained a sampling of French sculpture from what most of Lenoir's generation conceived as the "Dark Ages," a period of artistic decadence and stasis stretching from the fall of the Roman Empire through the thirteenth century. Like the antique marbles in his collection, the sculptures in this room served as exemplars of the medieval. In an important sense, the dates (and authorship) of individual pieces were irrelevant in this context since no stylistic progress or change was apparent. To contemporary eyes, all products of this era were uniformly anonymous and barbarous in execution.

In Lenoir's museological scheme the thirteenth-century room superseded his missing antiquities as the point of departure, the backdrop against which to measure the development and evident improvement in French art over the course of subsequent centuries, which became the ultimate goal of his museum. Like many of his day, Lenoir subscribed to a cyclical theory of history, according to which civilizations rose and fell, passing through successive stages from infancy to decadence before experiencing rebirth. As we have seen, the recent translation of Winckelmann's *History of Ancient Art* (1764) had given the theory wide currency in Paris.[76] (Lenoir expressed his personal admiration for Winckelmann through the monument erected in his memory.)[77] The influence of Rousseau's *Social Contract,* in which the "causes of revolutions in empires" are explored, may also be felt in the passage that opens the many editions of Lenoir's museum catalogue: "The arts experience revolutions just like empires: they progress in stages from infancy to barbarism, and gradually return to the point at which they began."[78]

In the winter and spring of 1796-7, Lenoir created the sixteenth-century gallery (Fig. 73), which in his opinion represented the high point of French culture, as well as the "temple" for the tomb of Francis I (Fig. 62) in the small hexagonal chamber adjoining the church, originally known as the *chapelle des louanges.* According to Lenoir, the French Renaissance represented the first peak of perfection in the history of French sculpture, when artistic developments reaching back to the thirteenth century culminated in a sculptural style that appeared "most in harmony with our national character and civilization."[79] The reliance on a Vasarian model of art historical development is clear; what is new is the national emphasis, the attempt to establish a native sculptural tradition underpinned by a coherent internal logic. Francis I was largely to thank for the flowering of French art, and fittingly his tomb was singled out by Lenoir as the period's masterpiece. This heroization of Francis was justified in the context of a Republican institution by stressing his enlightened patronage and generosity to artists, which created an atmosphere of artistic freedom in marked contrast to the imperious and condescending patronage of later kings.[80]

The decoration of the Salle du XVIe siècle embodied the classical style that Lenoir wished to promote as characteristic of that century. Peyre's immaculate Corinthian portal set the requisite tone. Painted arabesques – for Lenoir the quintessential French Renaissance decorative form – adorned the ceiling. Stained glass attributed to Jean Cousin, Bernard Palissy, and Durer filled the windows. Among the more prominent sculptures in the room were the statues of Francis I, Henry II, and Catherine de Medici, all attributed to Pilon; the sepulchral urn that contained the heart of Francis I by Bontemps; and the Admiral Chabot tomb by Jean Cousin. Other monuments commemorated significant men and women of the age: the poet Desportes; Erasmus's antagonist, Albert Pio; and Catherine de Clermont-Tonnerre, "one of the most knowledgeable women of her day."[81] By way of personal tribute, Lenoir designed handsome memorials to the artists Pilon, Goujon, Cousin, and de l'Orme.

In contrast to the anonymity of earlier art, very few sculptures in the sixteenth-century room were not attributed to a known master or his circle. The Renaissance, as represented at the Musée des monuments, witnessed the emergence of individual genius. This sudden manifestation of personal styles marked a watershed in French sculpture and was a sign of its coming of age. That the sixteenth century stood at the peak of a cycle, the apex of a progression from crude anonymity to refined self-expression, was further emphasized by the amount of light illuminating the monuments. By his own admission the lighting of successive century rooms was in direct proportion to the sophistication and beauty of the sculptures: "All the rooms were lighted according to the period, which is to say that the amount and force of light entering each room was in proportion to the beauty of the monuments."[82] The dim light obtaining in the Salle du XIIIe siècle (dimmer than it appears in Fig. 74) was appropriate to the "timid artists" of the Middle Ages, those "servile copyists of nature and costumes," who had done no more than give a "sort of form to their statues."[83] The crepuscular mood of the room conjured up the Dark Ages at the same time that it discouraged connoisseurial appreciation of the sculpture. In the sixteenth-century gallery, on the other hand, an abundance of light encouraged the viewer to scrutinize the marbles and recognize in them the work of individual masters and the emergence of a beautiful and uniquely French style in sculpture.

The last two period rooms to be completed were the fourteenth- and fifteenth-century galleries (Figs. 71 and 72) on the north side of the quadrangle. They were the most demanding in terms of decoration and the most fascinating in the context of Lenoir's program.

The Salle du XIVe siècle, begun last in 1799 and never quite completed to Lenoir's satisfaction, was the most fantastic of all his rooms and also the

most popular with the public. Using what Lenoir described as "debris" from various sources, including Saint-Denis and the Sainte-Chapelle, Lenoir aimed to capture the lightness and elegance of the Gothic style introduced to France, so he thought, from the East by artists returning from the Crusades with St. Louis. The striking differences between the thirteenth-and fourteenth-century rooms were explained in terms of a fundamental shift in architectural style: "Elegant and slender ogive arches replaced heavy, depressed vaults and before long majestic temples, in imitation of mosques, arose on our soil; and their interiors, charged with gilt and brilliant stained glass, displayed the greatest luxury."[84]

In his characteristically idiosyncratic way, Lenoir brought together a host of historically and sylistically incompatible fragments to make an exotic concoction intended to be more impressive than the sum of its parts. The integrity of individual elements was so completely masked and sacrificed in the interests of the decorative ensemble that the identity and origin of much in the room is difficult to determine. Take the structure in the center of the room. The statue of Charles V, from Saint-Denis, lies reunited with that of his wife, Jeanne de Bourbon, from the Paris church of the Célestins, atop a reworked carved wooden coffer dating from the early sixteenth century originally in the Sainte-Chapelle. Four Corinthian columns from Maubisson framed the structure and supported a monumental stone tabernacle supposedly from Saint-Denis.[85]

Around the walls on a raised bank members of the Valois dynasty rubbed shoulders with the last of the Capets. In the blank trefoil arcade Lenoir stood upright twenty *gisant* figures collected from Saint-Denis and assorted religious houses in and about Paris. In the ceiling he installed rib vaults, and in the walls to the north and south he opened six large tracery windows, which he filled with richly colored glass from the Célestins.[86] Finally, statues of four apostles and the Virgin and Child hung high on the walls, which were covered with a kind of sculptural mosaic that Lenoir planned to have gilded and painted.

The unambiguous "gothic" flavor of the fourteenth-century gallery gave way to a room of less certain character. A letter to Bonaparte dated March 1801 recapitulating a recent visit he had paid to the museum reveals that Lenoir intended the Salle du XVe siècle (Fig. 72) to herald the coming of the Renaissance:

Passing from the fourteenth- to the fifteenth-century room, you were struck by the presence of bold new features – the columns, the arabesque ceiling, and the magnificent giltwork on a background of blue and purple, imitating faience and terrcotta, in the taste of the age. The monuments appear more impressive in their volume, materials, and the personnages they represent. Everything in this century of regeneration signals the first epoch of the renaissance in art.[87]

It was during the fifteenth century, according to Lenoir, that artists brought back from Italy the first elements of the classical style that characterized the Renaissance. These classicizing impulses, not yet fully assimilated, combined with the native Gothic manner to produce stylistically "hermaphrodite" works of art, admirable for their invention and perfect execution but lacking either "the elegance of arab architecture or the purity of Roman monuments."[88] The tomb of Louis XII (Fig. 78) by Paul Ponce, the focal point of the display, was a perfect example of a monument caught in midstream, so to speak, between the Gothic and the Renaissance.

The decoration of the room, begun in 1798 and modeled on the Ponce tomb, entailed loading the walls and ceiling with arabesques, the quintessential Renaissance motif. What appears a cohesive whole was once more an amalgam of fragments salvaged from different locations, the church of Saint-Père at Chartres and the châteaux of Blois and Gaillon among them. An ample amount of light filtered through the stained glass taken from the church of the Minimes at Passy, enough at least for the visitor to appreciate the "impressive volume" and materials of the monuments.

It was so important to Lenoir to convey the transitional character of fifteenth-century art that he resorted to disfiguring certain sculptures, at times beyond recognition, in order to make them conform to his idea of the proto-Renaissance monument. This process might generously be described as "creative restoration." The Ponce tomb of Louis XII became an obvious candidate, as Lenoir tells us with remarkable candor: "This tomb was so badly damaged during the Revolution that I felt justified in dividing it into three parts in order to make it conform to the style of the period and to render it compatible with the general effect of the fifteenth-century room, of which it is a part."[89]

In many instances Revolutionary iconoclasm became a pretext for Lenoir's own brand of vandalism; the hybrid quality of many of his monuments, especially those dating from this "transitional" era in art history, was due to his own intervention. As C.-J. Lafolie wrote in 1819, Lenoir filled art historical gaps in his collection with "figures made to order and baptized according to need," with the result that "the majority must be consulted with extreme caution."[90] Consider another example, the monument to Charles d'Orléans (Fig. 79). Before the Revolution, Charles's effigy had been part of a much larger tomb commemorating members of the Orléans family located in the family chapel at the Célestins.[91] Salvaged by Lenoir after the chapel had been ransacked by vandals, the single statue was then mounted on a base featuring an anonymous alabaster relief of the Death of the Virgin from Saint-Jacques-la-Boucherie and framed by Corinthian columns and decorative arabesque moldings that Lenoir claimed were

Figure 78. Alexandre Lenoir, *Musée des monumens français*. Paris, 1800–6. Tomb of Louis XII.

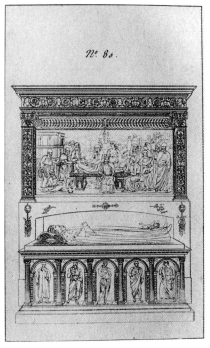

Figure 79. Alexandre Lenoir, *Musée des monumens français*. Paris, 1800–6. Tomb of Charles d'Orléans.

authentic period pieces but that seem rather to have been manufactured to his design by his restorer Lamotte.[92]

Creative restoration could equally be used to impose a more strictly classical identity on sculptures of the sixteenth century. The tomb of Chancellor de l'Hôpital, badly damaged during the Revolution, was reincarnated at the Musée des monuments complete with a bust of l'Hôpital's son, two allegorical figures by Pilon from Saint-André-des-Arts, and a relief, appropriate for a magistrate, of the Judgment of Solomon in the base.[93] According to the sculptor L.-P. Deseine, who was employed by Lenoir in the late 1790s, the tomb of Diane de Poitiers (in the foreground of Fig. 68), attributed by Lenoir to Goujon, was rendered unrecognizable by the addition of parts foreign to it, namely, four statues by Pilon that had once supported the reliquary of St. Genevieve, a dog symbolizing fidelity, and enamel portraits of Francis I and Henry II.[94]

In Lenoir's defense, it must be remembered that many sculptures came into his possession in a mutilated state. Moreover, those that were spared the vandal's axe had to be taken apart piece by piece in order to be transported to the depot. A mason's sketch of Michel-Ange Slodtz's famous tomb of Languet de Gergy from Saint-Sulpice (Figs. 80 and 81), indicating which pieces went where for eventual reconstruction, serves as a poignant reminder of what was involved in dismantling and transporting complex tomb monuments.[95] Once at the depot, dismembered parts (such as the bronze accessories from the Gergy tomb) often fell prey to government agents in search of raw materials to aid the war effort. Partly for this reason, Lenoir was keen to reconstitute whatever monuments he could; in the process of doing so, however, faced with hundreds, even thousands, of loose fragments, he gave in to the temptation of fashioning new monuments that better suited his museological goals. Pre-Renaissance sculptures were especially vulnerable because to Lenoir and his contemporaries they lacked a "classical grammar" and thus had no recognizable order or logic, no integrity that commanded respect.[96] Their value as antiquarian documents, as "mannequins dressed according to the period," was not diminished by the addition, subtraction, or rearrangement of parts. Lenoir was not, in the end, a medievalist before his time. Yet he also interfered with later monuments – some, like the Poitiers tomb, of impeccable provenance and valued by Lenoir himself as aesthetic models. In hindsight it is easy to condemn Lenoir, and virtually everyone that has written on the Musée des monuments has done so. But we might also ask, What does it say about Lenoir's contemporaries that so little was done to stop him? Certainly it is a mark of the relative disregard for French sculpture at the time that Lenoir openly carried out his often outrageous reconfiguration of famous monuments

Figure 80. Augustin de Saint-Aubin,
Slodtz's Languet de Gergy Monument.
Engraving, 1765.

Figure 81. Anonymous, *Sketch of Slodtz's
Languet de Gergy Monument.* Drawing, 1794,
Archives Nationales, Paris.

throughout a decade when the restoration of paintings at the Louvre was often in the news and more than once a source of public controversy. Where the Louvre administration was held accountable for the museum's contents by all of Europe, Lenoir was free to do as he pleased.[97]

The reworked tomb of Diane de Poitiers was displayed in the so-called Salle d'Introduction (Figs. 68 and 69), begun in 1799, the first room one entered, located in what had been the convent church. Rather like the *Victory of Samathrace* in today's Louvre, the Poitiers monument, as a masterpiece of the golden age of French art, greeted the museum goer at the entrance and established the Renaissance ideal as the touchstone of excellence in sculpture.[98] A selection of monuments ranging chronologically from the Celtic altars to contemporary plaster reliefs by A.-D. Chaudet and J.-G. Moitte gave the visitor a glimpse of the historical breadth of the collection – an overview of the history of French sculpture before proceeding to the individual period rooms.[99] Its summary nature entailed the display of many of Lenoir's masterpieces – Pilon's *Three Graces,* the tombs of Richelieu and Mazarin, Pigalle's Harcourt monument, and so on – and of sculptures

thought to be representative of their age. And as one would expect, the room contained significant examples of Lenoir's imaginative restoration work.[100]

Framing the entrance to the museum (and thus the Poitiers tomb as well), and further emphasizing the supremacy of sixteenth-century art, was the main portal of the Château d'Anet (Fig. 65), Philibert de l'Orme's masterpiece. Acquired by Lenoir in exchange for miscellaneous statues and "debris" from speculators who had planned to tear down the château and sell it for scrap, the portal was in place by 1800.[101] The acquisition of fragments from Anet not only provided a suitable entrance to the museum; it also gave rise to a plan to decorate three courtyards within the museum complex with architecture representative of the fourteenth, fifteenth, and sixteenth centuries.[102] Lenoir explained his idea to Bonaparte in a letter of 1801:

It occurred to me that, without harming the fabric of the building, I could decorate the courtyards in a manner corresponding to the rooms inside. . . . The museum must give students an idea of the architecture of the different ages as well as the sculpture, since the majority of monuments are decorated with architecture and the setting they occupy should be in harmony with them.[103]

Echoing the demonstration of stylistic change inside the museum, the three courtyards were to suggest a parallel transition in architecture from the Gothic to the Renaissance. Lenoir never built the fourteenth-century courtyard, but he found in the Château de Gaillon (Fig. 82), which, like Anet, was sold for scrap by the government, the ideal example of a building caught between the "Arab taste" of the fourteenth and fifteenth centuries and the classical elegance of the sixteenth century.[104] Gaillon, built according to Lenoir by Italians at the close of the fifteenth century, prepared the way for the full assimilation of classicism and the triumph of the French Renaissance, embodied at Anet.

<div style="text-align:center">* * *</div>

Lenoir's celebration of French Renaissance art was not as novel as it might seem. The years immediately preceding the Revolution witnessed a surge of new interest in sixteenth-century French sculpture, particularly the work of Jean Goujon and Germain Pilon. French neoclassical taste responded warmly to the sinuous grace and sensuous line of prominent Parisian monuments like Pilon's *Three Graces* and Goujon's *Fontaine des Innocents*.[105] There was, in particular, much interest in the restoration of Goujon's fountain in 1787, and works after both artists figured in fashionable interiors of the period.[106] Further research would undoubtedly reveal that late-eighteenth-century sculptors like Houdon, Pajou, and Julien owed as much to their sixteenth-century countrymen as they did to the antique.

Figure 82. Jean-Baptiste Réville and Lavallée, *Vues pittoresques et per-spectives.* Château de Gaillon.

What is significant and new, however, is that in the museum's representation of French art history the Renaissance was promoted *above* the seventeenth century, the century of Louis XIV, as the golden age of French sculpture. For most of the eighteenth century Francis I was admired for having imported the Renaissance to France, but important though this was, the art produced during his reign was considered inferior to that produced under the Sun King. The reign of Louis XIV was viewed as one of the four high points of civilization alongside Periclean Athens, Augustan Rome, and Renaissance Italy.[107] One anonymous commentator went even further: "His century was the century of the fine arts. Never has there been such sublime genius, so many able politicians, war heroes, literary prodigies, excellent artists, and masterpieces of all kinds."[108]

High standards of excellence were sustained through the reign of Louis XV – or so it was believed by the guardians of those standards, the royal academies and their supporters. Lenoir revised this prevailing view with respect to developments in the visual arts and identified the reign of the Sun King as the start of a phase of artistic decadence that extended until the third quarter of the eighteenth century and the arrival of David's teacher, Joseph-Marie Vien, who by the Revolution had come to be seen as the father of the revitalized French school. In other words, where traditional pre-Revolutionary historiography had charted a gradual improvement in art, reaching a point of perfection under Louis XIV, which was sustained thereafter by royal support through the Academy, Lenoir adjusted the his-

torical cycle so that the sixteenth century became the pinnacle of artistic achievement and succeeding Bourbon reigns an era of gradual degeneration.

Lenoir's motives were overtly political. This was how he introduced the section of his museum catalogue devoted to the seventeenth century: "The degradation of the visual arts following the century of the renaissance . . . is striking. It is to the morality and politics of the government that we must look to find the root cause."[109] The seventeenth century was the century of political absolutism, the system of government revolutionaries had committed themselves to destroying. Absolutism was the antithesis of republicanism, and for revolutionaries art produced in its service must of necessity be corrupt. Witness Pierre Chaussard from his *Essai philosophique* of year VI:

Despotism, perverting [the direction of the arts], humbled talent into submission at the foot of throne and altar. The government commissioned nothing but objects of adulation, the church nothing but objects of horror. The progress of philosophy and the flight of human imagination ground to a halt.[110]

In Republican eyes, the arts under Louis XIV were reduced to a base form of flattery. Instead of serving the public good, as they would in a republic, the arts immortalized the king's vanity and personal tyranny over the arts. A 1797 review of Lenoir's most recent catalogue went so far as to compare the art of Louis XIV unfavorably with Gothic art! "Under Louis XIV art was degraded to such a degree that the Goths themselves would have been embarrassed to claim responsibility for its productions."[111] Disenchantment extended beyond the art world, as a strongly worded passage from a book subtitled *Louis XIV Judged by a Free Frenchman* by one Joseph (de) Lavallée, an ex-army officer from Brittany, made clear:

The century of Louis XIV, far from being the era of French glory, was instead the century of her shame; for it is the final degree of depravity for a nation to place all the talent she has produced in the hands of one man; and it is despicable to then claim on top of it that that talent was due entirely to that man. Seen in this light, how many vaunted masterpieces from the reign of Louis XIV must now be reconsidered! Remove the flattery ground into the pigment of these paintings; remove the adulation that drapes these statues; remove the slavery imprinted on the columns of every monument, and what will remain of this century's art? Because it is a fact that paintings must only represent virtue; statues, men who have set an example; and buildings, sanctuaries of public utility.[112]

Lenoir's repudiation of the art of Louis XIV must be seen as part of a larger Republican effort to turn history as conceived prior to 1789 on its head. What is remarkable about Lenoir's contribution to the cause was that he went beyond verbal rhetoric and attempted to *illustrate* the adverse effects of absolutism on the arts through his museum display.

Lenoir's revision of seventeenth-century French art was directly tied to the antiacademic movement of the 1790s. Lenoir, having earlier turned his

back on the Academy and who as late as 1799 described himself as a "victim" of its "perfidious system," shared the Republican view of the Royal Academy as a corrupt, and corrupting, institution founded by Louis XIV for purposes of self-glorification.[113] Charles Lebrun, remembered as Louis's first painter and founding father of the Academy, was singled out as the great corrupter of taste and artistic standards. He more than anyone was held responsible for introducing and then enforcing the "routine" and "monotony" that fueled the apparent decline in the arts. The Republican journal *La Décade* described Lebrun in 1798 as "more of a poseur than a painter" and the person who "above all harmed our school."[114] And here is Lenoir from the museum catalogue: "Artists, seduced by Lebrun to pursue a new style that he introduced into his academies, completely abandoned the simplicity of nature and the taste of the antique. This system took hold and inaugurated an era of decadence in the fine arts."[115]

Lebrun's "tyranny" over sculptors forced to execute his designs was particularly reprehensible, and Lenoir included examples of the practice in the seventeenth-century gallery, including the tombs of Richelieu, Turenne, and Lebrun's mother.[116] In marked contrast to the previous room, a number of the sculptures on display were of uncertain authorship – a clear sign of the loss of individual expression. If the rise of distinct personal styles in the fifteenth and sixteenth centuries heralded progress and a new sophistication, the resurgence of anonymity and unattributable works of art in the following century signaled a return to less civilized times.

According to Lenoir four artists of the seventeenth century resisted the court of Louis XIV and retained a personal vision: the painters Poussin and Le Sueur and the sculptors Puget and Sarrazin. Le Sueur and Sarrazin rejected the constraints and hierarchies of official institutions, whereas Poussin and Puget sought artistic freedom in exile far from Paris.[117] The various obstacles they faced and the pressures they endured were manifestations of a system that was held to be antithetical to artistic creativity. Their defiance prefigured the Revolutionary struggle to destroy the Academy. By way of compensation for injustices suffered during their lifetimes, Lenoir commissioned portrait statues of the four artists from the sculptor Foucou and placed them over the two doors to the seventeenth-century room, literally and metaphorically above and removed from the other sculptures.

The museum catalogue was vital to Lenoir's efforts to rewrite, or more precisely re-present, French art history. As already mentioned, early editions served to legitimize the museum and its author by giving the former a permanency and coherence it lacked in actuality and the latter an authority over the collection. As the museum took shape along chronological lines, the catalogue provided the historical and interpretative frame through which to perceive its contents. By means of introductory essays at the start

and before each gallery description, Lenoir imposed a rigid identity on the artistic production of individual centuries and constructed a clear historical narrative for the visitor as he or she moved from one room to the next. The effect was analogous to the prefaces in Vasari's *Lives,* which gave a historical and stylistic context for the works of art discussed in the individual biographies that followed.[118]

Sold at the entrance at little cost (12 *sous*), the catalogue went through many editions and proved popular with the visiting public.[119] An anonymous reviewer for the journal *La Clef du cabinet des souverains* noted the novelty of Lenoir's catalogues (they were indeed the first of their kind and the forerunner of the modern museum catalogue) as well as their influence on the beholder: "The usefulness of such catalogues is much greater than one might imagine. It is through them that the public learns to understand and appreciate its national monuments." The journal added that this was especially true given the reputation and status of Lenoir's sculptures: "Not all of these monuments are masterpieces; they cannot all speak for themselves. Words are needed to supplement those lacking in expressive power; an inscription should indicate the sculptor's intention and reveal the thought he was trying to express."[120] At the same time, however, the same review cautioned that the power of words to impose a prejudicial reading of an object made it imperative that the catalogue avoid "overly harsh judgments."[121] In particular the author felt Lenoir's attack on Lebrun too extreme. But, of course, rendering absolute judgments was precisely Lenoir's intention, especially with regard to seventeenth-century sculpture. The opinions expressed in the introductory essays and elsewhere, his references to the "feebleness" of artists and the "uniformity" and "degradation" of their work, aimed to create an unfavorable impression of the art of the Sun King.[122]

Certain visual cues within the Salle du XVIIe siècle furthered a negative reading. The lack of supporting decoration – so essential to the effect in earlier rooms – combined with an abundance of natural light, made the sculptures appear uncomfortable and out of place. The drama of those baroque tombs, highly affective in their original settings, rang hollow and overly theatrical in an alien, secular environment. When the sculptor L.-P. Deseine later argued on aesthetic as well as moral grounds for the return of church monuments to their original locations, it was the baroque tomb of Languet de Gergy (Fig. 81) that best served his purpose. In Saint-Sulpice, Deseine argued, the monument "appeared to be the masterpiece of Michelange Slodtz, isolated at the Petits-Augustins . . . it is no more than a roughly hewn marble."[123] After passing through a succession of richly decorated rooms, the visitor entered the strikingly austere Salle du XVIIe siècle. Owing to the diminished decoration of this room compared to those that went

before, the monuments in this gallery belonged as much, if not more, to the spectator's space than to a hermetic and distant historical realm; the mighty men commemorated appeared more accessible and vulnerable than they had in their intended place of rest before the Revolution. Anticipating in intriguing ways a postmodern strategy, Lenoir seemingly wanted the sculptures in this room to look like displaced fragments denied the closure of history afforded to earlier monuments through an evocative period setting.

<p style="text-align:center">✻ ✻ ✻</p>

Lenoir was not the first to question the artistic achievement of the seventeenth-century – as we have seen, Winckelmann as well as Lenoir's countryman and contemporary Quatremère de Quincy had done so already. But where Lenoir parted company with the latter in particular was in his belief that the Revolution and its institutions would return art to its true path. Had the eighteenth- and nineteenth-century galleries been built we may be sure that the catalogue would have interpreted recent developments as the dawn of a new great age of sculpture.[124] Just as the politics of "despotism" had fueled artistic decline, so "liberty" ushered in by the Revolution would inspire another era of perfection. In trying to demonstrate the idea of a bankrupt past giving way to a bright future, Lenoir's museum participated in the Revolution's central perception of itself as the agent of a new and better world, a new beginning in time.[125] The causal link between politics and the state of the arts derived from Winckelmann, but in the chronological display at the Musée des monuments Lenoir adapted Winckelmann's politico-historical model to suit Republican ideology. Faith in Revolutionary institutions to restore the arts was a commonplace in Republican discourse, but Lenoir's innovation was to have embodied the idea in his demonstration of the history of art at a public museum.

The beauty of Lenoir's historiographic scheme, in which contemporary art rises phoenix-like from the decadence of the Old Regime, was that it could be transferred to and made to glorify successive regimes with equal success. During the Empire the Musée des monuments served Napoleon as well as it had the Revolution. Without compunction Lenoir declared in 1809 that upon completion the nineteenth-century gallery would be renamed Salle des faits héroiques de l'Empereur Napoléon le Grand.[126] In 1814 Lenoir switched the museum's allegiance to Louis XVIII, only to switch it back again to Napoleon during the Hundred Days. In 1815, after Napoleon's definitive defeat at Waterloo, the museum was renamed the Musée royal des monumens français. References to decadent art under Louis XIV remained in the 1815 catalogue, but now the inability of artists was held to blame and not the political system under which they worked. On the contrary, Lenoir paid tribute to "the great Colbert" and reaffirmed

his place in the pantheon of French *mécenats*. Meanwhile, Napoleon's name had disappeared completely.[127] Better than most in that tumultuous age, Lenoir adapted quickly to shifting political ground. That he retained control of a prominent public institution through the Revolution and Empire is a testament to his ability and diplomacy. Pondering Lenoir's remarkable career long after the museum's demise, the distinguished nineteenth-century antiquarian Baron de Guilhermy noted the changes in successive editions of the museum catalogue: "The earliest are written in a heathen, democratic language; succeeding ones in an imperial, philosophic style; and the most recent in a devout, monarchical prose. These variations, dictated by circumstance, lend the different editions a genuine fascination."[128]

<p style="text-align:center">* * *</p>

The museum flourished during the Directory and Consulate, during a period when an institution at once Republican and anti-Terrorist was in full harmony with government policy and public opinion. All significant construction took place between 1796 and 1802; in that time, Lenoir's wish was virtually his command. But the official return of religion following the Concordat of 1802 suddenly reversed his fortunes and put a stop to further development.[129] Where the museum had for years exercised a cathartic effect on a collective imagination haunted by the Terror, from 1802 the revival of the Church cast over it a shadow of sacrilege and impiety. Reopened churches requested the return of their altarpieces and monuments.

The campaign for restitution and against the continued existence of the Musée des monuments was led by Quatremère and the sculptor Louis-Pierre Deseine. As early as thermidor of year VIII (1800), Quatremère, in his capacity as a member of the city council of Paris, argued that because the Terror was long over it was time to return tomb monuments to their families and churches.[130] He referred to the Petits-Augustins as a "veritable cemetery of the arts." Deseine, in his *Lettre sur la sculpture,* published after the Concordat, echoed Quatremère's call to replenish empty churches and rid Paris of "the shameful traces of vandalism that have dishonored the French Revolution."[131] Deseine had worked for Lenoir at the museum in the late 1790s, but from 1802 he was employed by Notre-Dame to search out works of art "suitable for the decoration of the church."[132] He had been an advocate of restitution for some years, but only after 1802 did he join forces with Quatremère and turn publicly against Lenoir.[133]

Their antagonism toward the Musée des monuments was rooted in politics. Quatremère and Deseine both held right-wing views and saw in Lenoir's museum a painful reminder of the Revolution's destruction of the pre-existing social order and the Church. Both believed that the restoration

of Catholicism was a precondition of a return to political and social stability, and to that end they demanded the return of sacred objects to their original destination and purpose. But interestingly, both men butressed their appeals with a compelling historical-aesthetic argument against the very idea of displaying in a neutral museum space works of art originally intended for other specific locations. They argued that to remove a work of art from its original setting was to lessen its affective power as well as its aesthetic impact and historical resonance. In his *Opinion sur les musées* of 1803, Deseine wrote:

Artistic monuments are comparable to certain indigenous plants that will not endure transplanting. All monuments derive their appeal from the place in which they are displayed and from which they cannot be removed without killing them or stripping them of all historical, moral, and political relevance. It is the destination of a monument that gives it beauty and where it must be appreciated: only there can the historian enter into dialogue with it and discover the causes of its production; only there will that monument make known to posterity the state of the arts and the spirit of the age in which it was made.[134]

The same sentiments had already been expressed by Quatremère in his report of year VIII. The following passage from that report was reused several times in subsequent attacks on Lenoir:

Let us pretend no longer that works of art can be preserved in these repositories of ignorance and barbarism. Yes, you have transported the physical matter, but have you also brought that train of sensations, tender and profound, melancolic, sublime, and touching, that enveloped them? Have you transported the interest and charm that they drew from their location, from the religious atmosphere that surrounded them, from that sacred aura that added to their luster? Have you transferred to your magazines that ensemble of ideas that lends productions of the chisel and brush the charm of illusion, that corrects their faults, veils their weaknesses, and embellishes their beauty? . . . All these objects have lost their effect in losing their purpose.[135]

Quatremère's observation that the museum "kills art to make [art] history" is at the root of the now familiar complaint about the idealizing, fetishizing function of the art museum. But, of course, Lenoir's strategy in good part was precisely to sever a monument from the associations and memories that gave it life and to reidentify it as a "democratized" art object located within the hermetic discursive space of art history.

The critique of Quatremère and Deseine applied implicitly to all museums, but their primary target was the Musée des monuments. Despite Lenoir's (rhetorical) efforts, his motley collection resisted complete aestheticization, for, unlike paintings, even the most charged altarpiece, religious sculptures, and tomb monuments were never fully assimilated into the realm of art. As Lenoir well knew, much of the appeal of his collection lay in its

power to recall the memory of historical figures. Though fascinated by a new and compelling sensation of history, many visitors to the museum were disturbed by the seeming impropriety of exploiting the remains of the dead.[136]

Fueled by their campaign and a groundswell of public opinion, restitution of church art began in 1802.[137] Little that Lenoir considered important was lost, but public debate about the museum and its contents weakened his position and tarnished his image. Criticism began to replace admiration and gratitude in the popular press; what for many years had been overlooked or excused in his conduct of the museum now drew disapproving scrutiny.[138] Emboldened by public opinion, local authorities began to resist Lenoir's continued attempts to remove monuments from *situ*.[139] From 1802 Lenoir and his museum were placed under the direction of Vivant-Denon, a move intended, in the words of one observer, to "restrain the bold imagination of this artist, whom no one dared oppose at first because of the great debt the arts were felt to owe him."[140] Henceforth Lenoir's financial requests and reports had to pass through Denon, even as all restoration work had to receive his prior approval.[141] Lenoir continued to plan for expansion, but his moment had passed. In 1804 Denon denied yet another request for a new acquisition. His response sounded a peremptory note: "It is time at last to respect the ashes and tombs of great men, and to stop stripping the churches of France . . . of statues consecrated by filial piety and communal respect."[142]

Though hurt by changes in public sentiment, the Musée des monuments survived the duration of the Empire.[143] Napoleon seems to have respected Lenoir, and the museum effortlessly adopted the façade of an Imperial institution.[144] The suggestion of continuity between centuries of monarchy and the Empire in the sequence of rooms no doubt struck a favorable chord. Lenoir's most effective defense, however, may have been the threat posed by restitution to the integrity of the Louvre; for if claims were successfully pursued against the Musée des monuments, where would restitution end? The risk of setting a dangerous precedent was directly addressed in an editorial published by the *Journal des arts* in the summer of 1802:

If today monuments are carted back to their churches from the Petits-Augustins, tomorrow the same carts will return empty to the door of the Louvre. We will be obliged to fill them with the masterpieces of Rubens, Van Dyck, Crayer, and Jordaens, bound for churches in Antwerp, Brussels, etc.; the masterpieces of Raphael, Domenichino, Guido Reni, and the Carracci will also have to be returned. And then we will have to take down the *Apollo Belvedere*, for it came from the pope's palace, and surely the palace of a pope counts as a temple.[145]

Lenoir's museum may have been expendable, but too much had been invested in the Louvre to see it compromised by the demands of the Church.

In the end restitution was limited to works of art not considered "essential for the study of art" – which meant in effect objects neither museum had a desire to display.[146] Initially Lenoir's great rival, the Louvre became his ally and protector.[147]

The Bourbon Restoration finally put an end to the Musée des monuments. Just as Revolutionaries sacked Saint-Denis in order to obliterate royal tradition and memory, so Louis XVIII was committed to reviving that tradition by returning his ancestral tombs to their former place and function. Lenoir, of course, tried to prevent the inevitable: in addition to renaming his museum the Musée royal des monuments, he proposed erecting a *chapelle expiatoire* on its grounds in memory of those whose remains had been disturbed by the Revolution.[148] Even after the return of the royal tombs, he asked to keep the museum open and suggested that plaster casts could take the place of the originals.[149] But the museum was too closely identified with the Revolution to survive. A law of April 24, 1816, recalling Quatremère's original proposal, restored monuments to their churches and families. In October the buildings of the Petits-Augustins were given over to the newly formed Ecole royale des Beaux-Arts; Quatremère was named its permanent secretary. On December 18, 1816 the museum officially closed. Not everything was removed, however; until recently numerous fragments remained in the forecourt, and a few may still be seen.[150]

As for Lenoir, he was made keeper of royal tombs and was put in charge of transporting them back to Saint-Denis. In recognition of his work, and notwithstanding his years of faithful service to both the Republic and the Empire, Louis XVIII made him Chevalier de la Légion d'Honneur.[151] He spent the next twenty years living the life of a gentleman scholar, writing numerous memoirs and treatises on a wide range of subjects, from a biographical sketch of his friend Jacques-Louis David to studies of Egyptian hieroglyphs, suicide, and the history of Freemasonry. Lenoir died in 1839 at the age of seventy-six. His museological legacy was carried on by his son, Albert, who was instrumental in founding the Musée de Cluny in 1844.

CONCLUSION

If during the Napoleonic era the Musée des monuments did little more than
survive, the Louvre during the same period grew in size and stature to
become a wonder of the modern world. It became a popular tourist attrac-
tion, and has remained one ever since.[1] Many people were overwhelmed,
almost blinded, by the spectacle. One Thomas Jessop wrote: "The effect
upon a stranger's mind when he 1st enters this magnificent museum is better
conceived than described. The eye is lost in the vast and original perspec-
tive; the sense is bewildered amid the vast combinations of art."[2] Even a
seasoned artist like Martin Archer Shee was forced to confess: "All is confu-
sion and astonishment: the eye is dazzled and bewildered, wandering from
side to side – from picture to picture."[3] Nevertheless, everyone agreed it was
the greatest collection of art ever assembled under one roof. "Such a mag-
nificent collection of the finest works in the art of painting, such a blaze of
general excellence, have never before gratified the eye of the connoisseur,"
wrote Julius Griffiths, publisher of Maria Cosway's Louvre etchings.[4]

Under the direction of Vivant-Denon, and thanks to further military con-
quests, the Louvre expanded significantly between 1804 and 1814.
Napoleon's victory at Jena in 1806 yielded hundreds of paintings and other
objects from Prussia and neighboring German states.[5] Vienna ceded 400
more in 1809. Further Italian collections, overlooked or left alone during
the first Italian campaign, were also sacked.[6] In 1811, following the sup-
pression of monasteries in Tuscany, Parma, and the Roman States, Denon
went to Italy in search of "primitive" pictures beginning with Cimabue, "in
order to complete the imperial collection that . . . still lacks that scholarly
and historical dimension which a true museum must have."[7] A grand new
staircase serving the museum and Salon was constructed, and the Grand
Gallery itself received substantial modifications. Between 1805 and 1810

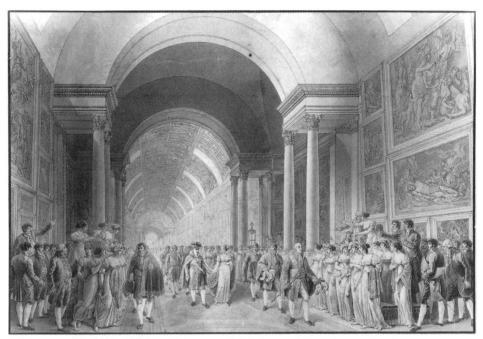

Figure 83. Benjamin Zix, *Wedding Procession of Napoleon and Marie-Louise.* Drawing, 1810, Musée du Louvre, Paris.

the architects Percier and Fontaine divided the gallery by means of columned arches into nine sections, and the long-awaited skylights were installed in the large bays nearest to and furthest away from the midpoint of the gallery.[8] But significant though they were, these developments should be seen as the continuation or realization of earlier initiatives rather than as innovations in their own right.

The restructuring of the gallery after 1805 called for a new hang, which is partially recorded in Benjamin Zix's drawings of the wedding procession of Napoleon and Marie-Louise in 1810 (Fig. 83).[9] Of the nine new sections, the first, closest to the Salon, remained French; bays two through five were given to Northern painting; and the remaining four bays displayed the Italian schools. The Zix drawings show the large new expanses of wall that replaced the pre-existing small bays between the windows. Paintings cover every inch of the walls, defying discriminating viewing. The elegance and restraint of earlier installations have given way to an overcharged tapestry effect, reminiscent in perhaps significant ways of princely cabinets of the Old Regime (Figs. 1 and 2). No wonder visitors were dazzled and overwhelmed.

Quatremère's call for the return of confiscated art, first publicized in his

Lettres à Miranda of 1796, was answered by the Bourbon Restoration. Not that Louis XVIII was keen to see the Louvre dismembered: on the contrary, he viewed Revolutionary and Napoleonic conquests as the legitimate fruits of war.[10] By the same token, however, and especially after Napoleon's return and his final defeat at Waterloo, the allies demanded their repatriation. The Duke of Wellington recognized that works of art in the Louvre functioned as military trophies and insisted that France must be made to acknowledge its defeat by returning its booty.[11] The losses were devastating, yet when the dust had settled, through a combination of diplomacy, bureaucratic obstruction, and the inability of weak nations to reclaim what was theirs, nearly half of what had been taken by Napoleon's armies remained.[12] Some very famous paintings, including Veronese's *Marriage at Cana* and Titian's *Crown of Thorns,* are still prominently displayed at the Louvre. Many others still occupy pride of place in the provincial museums of France, created during the Consulate.[13]

Quatremère won his battle with Lenoir and the Musée des monuments, but he was to lose the war with the Museum. The Louvre rebounded from restitution and quickly regained its status as the world's premier museum. In 1815 an English traveler described the Grand Gallery as "a wilderness of frames,"[14] but the gaps on the walls were soon filled with works originally intended for the Louvre prior to the Revolution: Le Sueur's Saint Bruno paintings, Rubens's Medici series, and Vernet's Ports of France, among others.[15] Because new Old Masters were hard to come by, a national emphasis naturally emerged at the Louvre. In 1818 the Luxembourg Palace became home to a new museum of contemporary French art, superseding the defunct museum at Versailles and realizing an idea dating back to La Font de Saint-Yenne.[16] In time selected works passed from the Luxembourg to the Louvre and became part of the great French tradition.

Had Quatremère lived further into the nineteenth century (he died in 1849) he would surely have been dismayed by the gradual emergence of the museum as the primary destination and dominant space for art both new and old.[17] Even in his lifetime Quatremère witnessed the spread of museums throughout Europe and to the edge of the New World. By 1850 public museums had become a chief ornament of virtually every European capital. A number of prominent nineteenth-century museum directors – Gustav Waagan, Johann Passavant, Georg von Dillis, Charles Eastlake – visited the Louvre at its height and were greatly influenced by what they saw.[18] Indeed Dillis, future director of the Munich Alte Pinakothek, insisted that "one should take it as a pattern for all institutions."[19] And so it came to pass. As Carol Duncan and Alan Wallach have noted, Napoleon's Louvre became the model for the "universal survey museum" as we know it today.[20]

Particularly significant is what happened in Italy after 1815. In that year

the sculptor Canova, appointed by Pope Pius VII to retrieve Papal treasures from the Louvre, reprinted Quatremère's *Lettres à Miranda* in the hope of gaining allied support for restitution. Canova returned to Rome triumphant, of course, but instead of restoring everything to its original location, as Quatremère would have wished, the pope appropriated the best of the paintings for his new museum.[21] Raphael's *Transfiguration* from S. Pietro in Montorio, Caravaggio's *Deposition* from the Chiesa Nuova, and Domenichino's *Last Communion of St. Jerome* from S. Girolamo della Car-ità, to name only three, became showpieces of the Vatican Pinacoteca, opened in 1817. The museum age had arrived.

In front of such paintings Quatremère's objections hold true: their affec-tive power is undoubtedly weakened out of context.[22] In decontextualizing these works of art the museum has fundamentally and irrevocably altered their identity and value. And yet they remain strong and justifiably famous paintings. For better or worse – and the debate continues – the aura of the work *in situ* has not been destroyed so much as replaced with a new aura: that of the museum masterpiece. (It would be unfair, of course, to accuse museums of having initiated the aestheticization of religious art; one has only to read Vasari's lives of Raphael and Michelangelo to realize that the phenomenon was coeval with their recognition as great artists.)[23]

What Quatremère's argument disregards is the pleasure and intellectual stimulation afforded by close visual engagement with a work of art in a well-tempered environment, such as the new Sainsbury wing of the National Gallery, London, or the British Art Centre at Yale University.[24] Seemingly there was no room in Quatremère's view of art for the pleasure principle advocated by pre-Enlightenment theorists ("the greatest painter," remarked the Abbé Dubos, "is the one who gives the greatest pleasure").[25] Qua-tremère insisted that great art must serve a "useful and noble purpose" and required a destination to match. The picture gallery was fit only for the lesser genres and luxury goods designed to please. On the one hand, he feared that gallery culture would debase contemporary art by privileging the decorative over the didactic; and on the other, he deplored the increased commodification of past art hastened by the upheavels of the Revolution. (It suited his argument to ignore d'Angiviller's plans to install his Great Men statues and moralizing history paintings in the Louvre.)

Quatremère also chose not to recognize the museum's potential to stimu-late the historical imagination through the juxtaposition of previously dis-persed or overlooked monuments.[26] Not only did the museum make possi-ble new ways of looking at individual paintings and sculptures, it also prompted new insights into the history of art. A survey of early visitor responses to the Louvre and the Musée des monuments is beyond the scope of this study, but by way of example the observations of one particularly

perceptive visitor to the Louvre, Friedrich von Schlegel, are worth mentioning. Schlegel noted on his own that many of the paintings he viewed had lost their bearings through displacement (he found it easy "in the works of the really good masters to trace their destination"),[27] yet he found inspiration in Vivant-Denon's recent arrangement of the collection for a radical reevaluation of the development of Italian painting in the Renaissance. After pondering Denon's great bays in the Grand Gallery (Figs. 54–56), Schlegel came to the conclusion that the Louvre's emphasis on Raphael, his followers, and the *seicento* masters represented not the greatest moment of Italian art but its decline. The true flowering of the Italian school, he believed, occurred *before* Raphael with the early Renaissance masters. He had brought these revolutionary ideas with him to Paris in embryonic form, but he was able to confirm them by sight in the Grand Gallery. At the same time that museums erase old meanings, they have the potential to allow new significances to be discerned. It becomes a question of how and in what ways museums encourage (or discourage) the viewer to see new or different possibilities in art.

Most paintings at the Revolutionary Louvre overcame displacement and adapted to their new exclusive identity as works of art, despite traces of an original destination. But at least a few evidently did not. Those objects proved inseparable from the network of aesthetic constraints and sentimental associations that issued from an original setting. Dislocation revealed, as Quatremère said it would, that certain works of art possess a spatial identity and history as well as a temporal one.[28] This was clearly the case with baroque monuments at the Musée des monuments, and it was also the case with certain baroque paintings.[29] Most of both returned to their proper homes (or at least ones like them) after 1815, but we should spare a thought for those that were not so fortunate. Deprived of their original purpose, they survived in limbo, orphans of the Revolution yet uneasy on the museum's walls. By way of conclusion, let us consider the critical fortunes of a once famous work that is famous no more: Charles Lebrun's *The Penitent Magdalen* (Fig. 84).

Commissioned in 1656–7 by the Abbé Le Camus, Lebrun's painting was the centerpiece of an ornate chapel devoted to the Magdalen in the Carmelite church of the Faubourg Saint-Jacques, Paris. Mary Magdalen was shown not as she so often was in the seventeenth century, as a penitent hermit, but renouncing earthly riches and pleasures.[30] Facing the painting, as if in prayer before it, was a statue of Cardinal de Bérulle (by Jacques Sarrazin), who was known for his devotion to the Magdalen and whose writings had inspired Le Camus to follow her example and renounce the world after a dissipated youth. Adding to an already complex commemorative tribute, the image of the Magdalen in Lebrun's painting came to be identi-

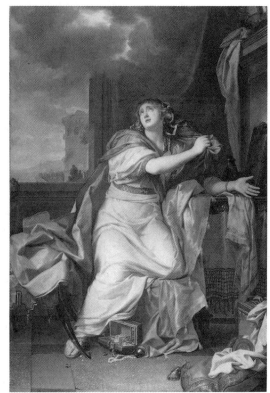

Figure 84. Charles Lebrun, *The Penitent Magdalen.* Oil on canvas, 1656–7, Musée du Louvre, Paris.

fied with Louise de la Vallière, mistress to Louis XIV, who retired to the Carmelite convent in 1674 and led a life of exemplary piety until her death in 1710. The latter's connection with the convent and the obvious parallels between her life and that of Mary Magdalen fueled the identification that, though apocryphal, persisted well into the nineteenth century.

Until the Revolution, the *Magdalen* passed for one of Lebrun's finest pictures, if not his masterpiece.[31] It was kept behind a curtain that was drawn on request, adding to its mystique. The convent was destroyed in 1792, and the painting was removed to the Petits-Augustins from whence it passed to the Louvre storerooms a year later. In 1797 it was sent to the new museum at Versailles after failing to qualify for admission to the collection of Lebruns at the Louvre. In the following year a keeper at the Musée spécial, François Lauzan, was moved to write an essay on the strange fate of the painting since 1789. How could it be, he asked, that a painting everyone had praised just ten years ago had since fallen into oblivion?

In times gone by, an informed traveler who would have left Paris without having seen Lebrun's *Magdalen* would have appeared as someone ignorant of the arts;

today, if the same person dared to compliment himself on having made the trip to Versailles in order to pay the same homage to this picture as it received generally before '89, he would be considered a rather superficial connoisseur.[32]

The painting's fall from favor, Lauzan claimed, had mainly to do with politics. The identification of Lebrun's *Magdalen* with Louis XIV's mistress, which made of the painting "a secular cult object" before the Revolution, caused the public to turn away from it once memory of the Sun King became anathema to good Republicans. It is an attractive argument, but one that is contradicted by the painting's presence in the Grand Gallery when it first opened in 1793 and its reappearance three years later in a temporary exhibition of "highlights" from the permanent collection. Indeed, as we have seen, the catalogue to that exhibition insisted that the connection with Louise de la Vallière had become an inherent part of its appeal.[33]

More persuasive is Lauzan's second point, that the *Magdalen* had suffered from removal from its physical context. In particular he noted that Lebrun had carefully matched the light represented in the picture with the flow of real light in the chapel, creating an illusion common in baroque decorative schemes. Removed from the crafted environment that gave it life and purpose, the *Magdalen* appeared exposed and out of place in the company of other paintings, especially ones that had not been so privileged theretofore.[34] The painting was not seriously compromised by its pre-Revolutionary identity, any more than the Rubens Medici series, but subjected to the searching scrutiny of the connoisseur and judged now simply as a painting on the blank wall of a museum, it was found wanting; it had lost its magic.

Fittingly, Quatremère concluded his 1815 polemic against museums, the *Considérations morales sur la destination des ouvrages de l'art,* with a rhetorical set piece grieving the *Magdalen*'s removal from its original setting and the irony of its display at Versailles, the world that la Vallière had renounced. "The colorless picture," he wrote, "exposed in splendid galleries to the vain curiosity of chilling criticism, appears a ghost of its former self. It hardly attracted notice. . . . I saw it . . . and I turned away my eyes."[35] Quatremère was on the committee that decided in 1797 which pictures should represent the French school at the Louvre; it is tempting to think he had a hand in banishing the *Magdalen* to Versailles so that he would not have to look upon it again.[36]

The *Magdalen* remains in storage, denied a place among the other Lebruns in the grand new seventeenth-century French galleries atop the Louvre. Evidently it is still an awkward museum piece.

APPENDIX I

First Room

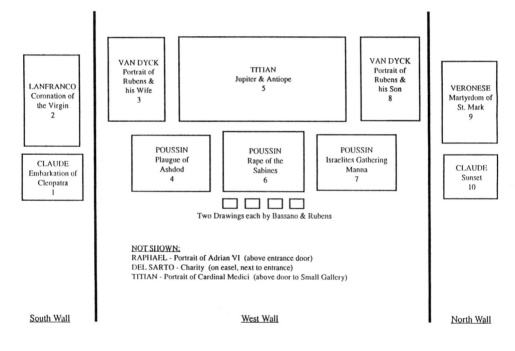

LANFRANCO
Coronation of
the Virgin
2

VAN DYCK
Portrait of
Rubens &
his Wife
3

TITIAN
Jupiter & Antiope
5

VAN DYCK
Portrait of
Rubens &
his Son
8

VERONESE
Martyrdom of
St. Mark
9

CLAUDE
Embarkation of
Cleopatra
1

POUSSIN
Plaugue of
Ashdod
4

POUSSIN
Rape of the
Sabines
6

POUSSIN
Israelites Gathering
Manna
7

CLAUDE
Sunset
10

Two Drawings each by Bassano & Rubens

NOT SHOWN:
RAPHAEL - Portrait of Adrian VI (above entrance door)
DEL SARTO - Charity (on easel, next to entrance)
TITIAN - Portrait of Cardinal Medici (above door to Small Gallery)

South Wall West Wall North Wall

Appendix 1

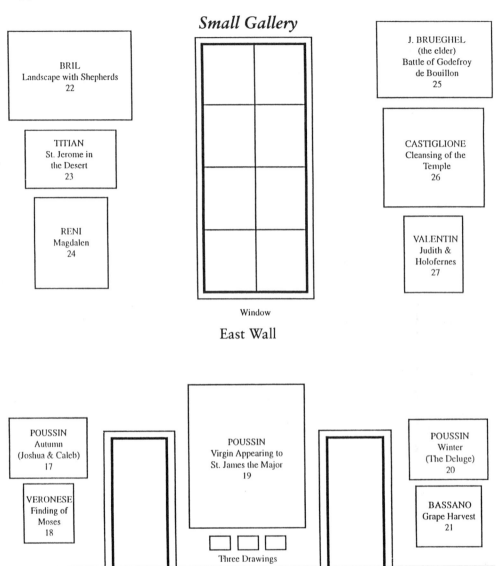

Small Gallery

BRIL
Landscape with Shepherds
22

J. BRUEGHEL
(the elder)
Battle of Godefroy
de Bouillon
25

TITIAN
St. Jerome in
the Desert
23

CASTIGLIONE
Cleansing of the
Temple
26

RENI
Magdalen
24

VALENTIN
Judith &
Holofernes
27

Window

East Wall

POUSSIN
Autumn
(Joshua & Caleb)
17

POUSSIN
Virgin Appearing to
St. James the Major
19

POUSSIN
Winter
(The Deluge)
20

VERONESE
Finding of
Moses
18

BASSANO
Grape Harvest
21

Three Drawings

Door

Door

North Wall

Small Gallery

VALENTIN
The Fortuneteller
30

POUSSIN
Bacchanal
29

MIGNON
Still-life
28

Window

West Wall

RENI
Roman Charity
33

MOLA
St. Bruno in
the desert
32

REMBRANDT
Tobias &
the Angel
31

VALENTIN
Judgement of
Solomon
12

POUSSIN
Triumph of Flora
14

VALENTIN
Susannah and the Elders
Before Daniel
16

POUSSIN
Spring
(Adam & Eve)
11

BASSANO
Entombment
13

POUSSIN
Summer
(Ruth &Boaz)
15

South Wall

Throne Room

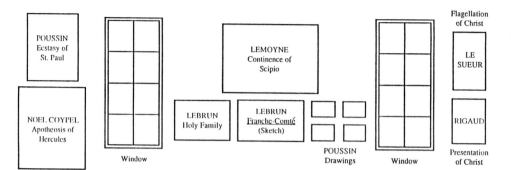

East Wall

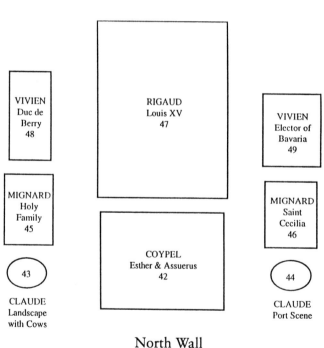

North Wall

Throne Room

MIGNARD Virgin & Child 56	
SANTERRE Magdalen 55	
54	
MIGNARD Faith	Window

LEBRUN Christ Raised on the Cross 52

LEBRUN Christ Bearing the Cross 53

VOUET Victory Holding the Infant Louis XIII 51

LA FOSSE Mary Before Jesus Christ 50

Window

West Wall

POURBUS Peace of Archduke Albert with Holland 34

58 — JEANNET Henry II

57 — POURBUS Henry IV

Fireplace

South Wall

Grand Gallery

| RUBENS Kermesse 69 | | RUBENS Pastoral Landscape with Rainbow 62 | | CARRACCI Village Wedding 59 |

DOMENICHINO Concert 70

67 | RUBENS Virgin & Child in Glory 61 | 68

65 | | 66

63 | | 64

Window Window

63 ALBANI - Apollo & Daphne
64 ALBANI - Biblis & Cana
65 WOUVERMANS - Amazon & Horse
66 WOUVERMANS - Stable Scene
67 BERCHEM - Landscape
68 BERCHEM - Landscape

East Wall

CORREGGIO Jupiter & Antiope 74

CARAVAGGIO Portrait of Alof da Wignacourt 72

ALBANI St. John in the Desert 73

ALBANI Baptism of Christ 71

Fireplace

North Wall

Grand Gallery

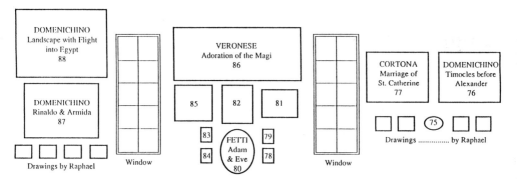

DOMENICHINO Landscape with Flight into Egypt 88	VERONESE Adoration of the Magi 86	CORTONA Marriage of St. Catherine 77	DOMENICHINO Timocles before Alexander 76

DOMENICHINO
Rinaldo & Armida
87

85 82 81

Drawings by Raphael

Drawings by Raphael

Window

83
84
FETTI
Adam
& Eve
80
79
78

Window

78 RENI - Holy Family
79 RAPHAEL - St. Michael
81 TITIAN - Vierge au Lapin
82 LEONARDO - Holy Family & SS. Elizabeth & John
83 RAPHAEL - St. George
84 RENI - La Couseuse
85 DEL SARTO - Holy Family

75 ALBANI - God theFather & Gabriel

West Wall

| MOR
Portrait of a Man
93 | RENI
Flight into Egypt
92 | VAN DYCK
James Stuart,
Duke of Lennox
91 |

VERONESE
Crucifixion
94

VERONESE
Sacra
Conversazione
90

MOLA
Ermina and
her Flock
95

RAPHAEL
La Belle
Jardiniere
96

MOLA
Tancrid and
Ermina
89

Raphael Drawing

South Wall

APPENDIX II

D'Angiviller's *Grands Hommes* of France, by Salon.
Cities and dates in parentheses indicate the place and date eulogies were delivered as *prix d'éloquence*.

1777

Etienne Gois, *l'Hôpital* (Paris, 1777; Toulouse, 1777)
Félix Lecomte, *Fénelon* (Paris, 1771)
L.-P. Mouchy, *Sully* (Paris, 1763)
Augustin Pajou, *Descartes* (Paris, 1765)

1779

Pierre Berruer, *d'Aguesseau* (Paris, 1760)
J.-J. Caffieri, *Corneille* (Rouen, 1768)
C.-M. Clodion, *Montesquieu* (Bordeaux, 1780)
Augustin Pajou, *Bossuet* (Dijon, 1772)

1781

Claude Dejoux, *Catinat* (Paris, 1775)
J.-A. Houdon, *Tourville*
L.-P. Mouchy, *Montausier* (Paris, 1781)
Augustin Pajou, *Pascal*

1783

C.-A. Bridan, *Vauban* (Dijon, 1784; proposed Paris, 1787)

J.-J. Caffieri, *Molière* (Paris, 1769)
Pierre Julien, *La Fontaine* (Marseille, 1774)
Augustin Pajou, *Turenne*

1785

L.-S. Boizot, *Racine*
Etienne Gois, *Molé*
C.-N. Monnot, *Duquesne*
P.-L. Roland, *Grand Condé*

1787

C.-A. Bridan, *Bayard* (Dijon, 1769)
Félix Lecomte, *Rollin*
L.-P. Mouchy, *Luxembourg*
J.-B. Stouf, *St. Vincent de Paul*

1789

Louis Foucou, *Duguesclin*
Pierre Julien, *Poussin* (Rouen, 1783)
J.-G. Moitte, *Cassini*
Augustin Pajou, *Lamoignon* – not executed

1791/2/3 (NOT EXECUTED)

J.-J. Caffieri, *Lebrun*
Pierre Berruer, *Boileau*
Félix Lecomte, *Duguai-Trouin*
L.-P. Deseine, *Puget*

APPENDIX III

Partial Reconstruction of the Hanging Scheme at the Musée Central des Arts in 1797–8
Based on records of work done by the blacksmith Blampignon (*Archives Nationales*, F¹⁷ 1060. "Mémoire serruries (sic) pour le Muséum," *an VI*). The titles of paintings and numbers are from the catalogue *Notice des tableaux des écoles française et flamande . . . et des tableaux des écoles de Lombardie et de Bologne*, Paris, 25 messidor an IX.

ENTRANCE TO GRAND GALLERY

North Wall	South Wall	North Wall	South Wall
Travée no. 1 "Un grand tableau d' Alexandre" (Lebrun, *La défaite de Porus*, no. 17; or *L'Entrée d'Alexandre dans Babylone*, no. 19); ". . . tableau du bas du millieu de du Poussin . . ."(?)	"Un grand tableau d'Alexandre famille de Darius" (Lebrun, *La Famille de Darius aux pieds d'Alexandre*, no. 18)	*No. 4* "Un grand tableau représentant une descente de croix" (Jouvenet, *La Descente de Croix*, no. 54?)	No details given
No. 2 "La mort de Méleagre" (Lebrun, *La Mort de Méléagre*, no. 20); "au bas du grand tableau . . . un tableau du Poussin . . ." (?)	"Un grand tableau de Jesus renversé sur la croix" (Lebrun, *Le Crucifix aux anges*, no. 16?; Le Sueur, *La Descente de croix*, no. 99 ?)	*No. 5* "Un grand tableau représentant Jesus-Christ au temple" (Vouet, *La Présentation de J.-C. au temple*, no. 140?)	No details given
No. 3 Tableau représentant la famille de Darius" (Lebrun, *La Famille de Darius aux pieds d'Alexandre*, no. 18); "Le tableau de dessous le grand représentant la mâne dans le désert; par Poussin" (Poussin, *La manne dans le désert*, no. 70)	"Jesus-Christ chasse les marchands du temple" (Jouvenet, *Les Vendeurs chassés du Temple*, no. 52)	*No. 6* "Jugement de St Gervais et St Protais" (Le Sueur, *Saint Gervais et Saint Protais amenés pour sacrifier aux idoles*, no. 101); "cinq petits tableaux représentant le Musée" (?) *No. 7* "Apparition et la gloire de St Gervais et St Protais" (P. de Champaigne, *Apparition de Saint Gervais et Saint Protais*, no. 212)	"La martyre de St Etienne" (Lebrun, *Saint Etienne lapidé*, no. 12) "La décolation de Bourdon" (Bourdon, *La Décolation de Saint Protais*, no. 2)

213

North Wall	South Wall	North Wall	South Wall
No. 8 "La peste" (?); "St Jean-Baptiste par Crayer" (Crayer, *Hérodiade recevant la tête de S. Jean-Baptiste*, no. 226); "Ezau et Rebecca" (S. Koninck, *Jacob, aidé de Rébecca, surprenant à son père Isaac*, no. 221?); "St. Augustin par Crayer" (?)	"Un grand tableau de St Gervais et St Protais" (P. de Champaigne, *Translation des corps de Saint Gervais et Saint Protais*, no. 213?); "un mouton sacrifié" (Holbein, *Le Sacrifice d'Abraham*, no. 316?)	*No.* 13 "Grand tableau de milieu représentant l'adoration des mages par Rubens" (Rubens, *L'Adoration des Mages*, no. 517; two wings, nos. 518, 519); "Un tableau de Kermesse par Rubens" (Rubens, *La Kermesse*, no. 526)	"L'accouchement de la reine par Rubens" (Rubens, *L'accouchement de Marie de Médicis*, no. 480); "Tableau represt. l'education" (Rubens, *L'Education de Marie de Médicis*, no. 479); "deux tableaux de Rubens faisant suite" (?)
No. 9 "Jesus mort sur les genoux de sa mère la Madeleine lui baise les mains" (Van Dyck, *Le Christ mort dans les bras de la Vierge*, no. 252?); "Un tableau represt. Charles I" (Van Dyck, *Charles I*, no. 254?); "Ecce-Homo" (?); "les marchands chassés du temple" (Jordaens, *J.-C. chassant les Vendeurs du temple*, no. 349?)	No details given	*No.* 14 "Adoration des mages par Rubens" (Rubens, *L'Adoration des Rois*, no. 512?); "la peste de St Roch" (Rubens, *S. Roch guéri de la peste par l'ange*, no. 515?)	"Tableau represt. l'Ascension" (Rubens, *L'Elévation du Christ en croix*, no. 486?); "la Communion de St . . ." (Rubens, *S. Francis mourant, recevant la Communion*, no. 485?)
No. 10 "Un grand tableau represt. un possedé du démon"? (?)	No details given	*No.* 15 "Un Crucifix" (Rubens, *Le Christ en croix*, no. 510?); "tableau de Rembrandt"(?)	"Un grand tableau représentant l'assomption" (Rubens, *L'Assomption de la Vierge*, no. 484?)
No. 11 "Le tableau du taureau de Paul Poter" (Potter, *Un vaste pâturage*, no. 446?); "Une chasse de Louis XIV" (?); "St Augustin par Vandyke" (Van Dyck, *St Augustin ravi en extase*, no. 253); "le tableau de Venus" (?)	No details given	*No.* 16 "Tableau de milieu, Descente de Croix par Rubens" (Rubens, *La Descente de Croix de la cathédrale d'Anvers*, no. 503; two wings, nos. 504, 505; or *Le Christ descendu de la Croix*, no. 489; two wings, nos. 490, 491)	"Une Descente de Croix par Rubens" (Rubens, *Le Christ descendu de la Croix*, no. 489; or *La Descente de Croix de la cathédrale d'Anvers*, no. 503)
No. 12 "Tableau du milieu, la pêche miraculeuse . . . les deux volets . . . du grand" (Rubens, *La Pêche miraculeuse*, no. 528; two wings, nos. 529, 530); "le tableau d'Isaac Ostade, l'Hyver" (Ostade, *Un Hiver*, no. 434); "posé au milieu le grand tableau de Vouwermans" (?); "le portrait de Philippe Champagne" (Champaigne, *Philippe de Champagne peint par lui-même*, no. 217)	"Un Christ" (?)		

ABBREVIATIONS USED IN NOTES

ARCHIVES

Arch. Nat.	Achives Nationales, Paris
Arsenal	Bibliothèque de l'Arsenal, Paris
BN	Bibliothèque Nationale, Paris
Deloynes	Bibliothèque Nationale, Cabinet des Estampes, Collection Deloynes
Doucet	Bibliothèque Doucet, Université de Paris IV
Sorbonne	Université de Paris, Sorbonne

PUBLISHED WORKS, JOURNALS

BM	*Burlington Magazine*
BSHAF	*Bulletin de la société de l'histoire de l'art français*
CDD	A. de Montaiglon and J.-J. Guiffrey, eds., *Correspondance des Directeurs de l'Académie de France à Rome avec les Surintendants des Bâtiments, 1666–1804,* 17 vols., Paris, 1887–1908
GBA	*Gazette des Beaux-Arts*
JWCI	*Journal of the Warburg and Courtauld Institutes*
MMF	*Inventaire général des richesses d'art de la France. Archives du Musée des monuments français, 3 vols., Paris, 1883–97*
NAAF	*Nouvelles archives de l'art français*
PVABA	M. Bonnaire, ed., *Procès-verbaux de l'Académie des beaux-arts, 3 vols., Paris, 1937–43*
PVAR	A. de Montaiglon, ed., *Procès-verbaux de l'Académie royale de peinture et sculpture, 10 vols., Paris, 1875–92*
PVARA	H. Lemmonier, ed., *Procès-verbaux de l'Académie royale d'architecture, 9 vols., Paris, 1911–26*
PVCM	L. Tuetey, ed., *Procès-verbaux de la Commission des monuments, 2 vols., Paris, 1901–2*
PVCTA	L. Tuetey, ed., *Procès-verbaux de la Commission temporaire des arts, 2 vols., Paris, 1912–17*
PVSPRA	H. Lapauze, *Procès-verbaux de la Commune général des arts et de la Société populaire et républicaine des arts, Paris, 1903*

NOTES

I have retained eighteenth-century spellings and accents in quotations that appear in the notes. All translations are mine unless otherwise noted.

INTRODUCTION

1. The Louvre's importance as a model for the survey museum is persuasively argued by C. Duncan and A. Wallach, "The Universal Survey Museum," *Art History*, 3 (1980), pp. 448–69.
2. The royal gallery at Dresden also featured a mixed-school arrangement. On collecting and display strategies in late-eighteenth-century Germany and Vienna, see D. J. Meijers, *Kunst als natuur: De Habsburgse schilderijengalerij in Wenen omstreeks 1780*, Amsterdam, 1991.
3. J.-B.-P. Lebrun, *Observations sur le muséum national*, Paris, 1793, p. 15; quoted by C. B. Bailey, "Conventions of the Eighteenth-Century *cabinet de tableaux:* Blondel d'Azincourt's *La première idée de la curiosité*," *Art Bulletin*, LXIX (1987), p. 445. On the ordering of art and objects of natural history in eighteenth-century discourse, see K. Pomian, *Collectionneurs, amateurs, curieux. Paris, Venise: XVIe–XVIIIe siècle*, Paris, 1987, pp. 61–80, 163–94, and passim.
4. J. Clifford, *The Predicament of Culture: Twentieth-Century Ethnography, Literature, and Art*, Cambridge, MA, 1988, p. 219.
5. N. de Pigage, *La Galerie Electorale de Dusseldorff*, Basel, 1778, p. viii.

6. C. de Mechel, *Catalogue des tableaux de la galerie Impériale et Royale de Vienne*, Basle, 1784, p. xv. Mechel's reorganization of the collection is discussed at length by Meijers, *Kunst als natuur*, p. 41ff and passim.
7. See M. Foucault, *Les mots et les choses. Une archéologie des sciences humaines*, Paris, 1966; and B. M. Stafford, *Voyage into Substance. Art, Science, Nature, and the Illustrated Travel Account, 1760–1840*, Cambridge, MA, 1984.
8. There is mention of the studio in eighteenth-century discussions of the museum; see Arch. Nat., O1 1670, ff.109, 132. The purpose of restoration was held by all experts to be the return of paintings to "leur premier éclat, leur premier beauté." See, for example, A.-L. Millin, *Dictionnaire des beaux-arts*, Paris, 1806, III, p. 434ff. During the Revolution, when copying was widely practiced in the Louvre, the museum was itself a studio, and was described as such by *La Décade philosophique* in year II (vol. 2, p. 23).
9. The accessibility of princely *kunst* and *wunderkammern* remains to be determined, though it seems complete freedom of access was a late-eighteenth-century phenomenon. In the *avertissement* to his *Recueil d'antiquités* (1752), the Comte de Caylus makes an impassioned appeal to collectors to open their collections to the public in the interests of the progress of knowledge:

> On ne scauroit trop exhorter ceux qui

rassemblent des monumens de les communiquer au public. . . . L'éclairecissement d'une difficulté historique dépend peut-être d'un fragment d'antiquité qu'ils ont entre leurs mains. Ce motif m'a engagé à publier ce petit recueil et à léguer au cabinet du Roy les monumens qu'il renferme.
Quoted by J. Guillerme, *L'atelier du temps,* Paris, 1964, p. 135.

10. Sally Price has noted the use of similar arguments to justify Western appropriation of "primitive" artifacts; see Price, *Primitive Art in Civilized Places,* Chicago, 1989, pp. 75–6.

11. *Journal de Paris,* March 31, 1777, p. 2.

12. I discuss the emergence of nationalism in the Louvre in, "Nationalism and the Origins of the Museum in France," *Studies in the History of Art,* CASVA, National Gallery of Art, Washington, DC (forthcoming).

13. L. Petit de Bachaumont, *Essai sur la peinture, la sculpture et l'architecture,* Paris, 1751, pp. 9, 14.

14. In 1754, the Princesse de Talmont was given her own key to the Luxembourg so that she could visit the gallery whenever she liked! Arch. Nat., O1 1908 (54), ff.6–7. Private viewings were arranged for the king of Denmark, Countess Razomovsky, and Emperor Joseph II in 1768, 1776, and 1777, respectively [O1 1922a (Godefroid), ff.91–3; O1 1914 (76), f.362; O1 1914 (77), ff.146–8]. Similar arrangements were made at the *Surintendance* at Versailles for Prince Yusopov (1776), Grand Duke Paul of Russia (1782), Prince Henry of Prussia (1784), and Richard Cosway (1786) [O1 1913 (76), f.247; O1 1916 (82), f.156; O1 1922a (Godefroid), f.4, (Hacquin), f.13; O1 1919 (86), f.245].

15. Cited by P. Conisbee, *Painting in Eighteenth-Century France,* Oxford, 1981, pp. 45–6. On the increasing complexity of the public for art in eighteenth-century France, especially relating to the Salon, see T. E. Crow, *Painters and Public Life in Eighteenth-Century Paris,* New Haven, CT, 1985, pp. 1–22 and passim.

16. See J. Leith, *The Idea of Art as Propaganda in France, 1750–1799,* Toronto, 1965. On public opinion in eighteenth-century France, see M. Ozouf, "Public Opinion at the End of the Old Regime," *Journal of*

Modern History, 60, suppl. (September 1988), pp. S1–S21; and K. M. Baker, *Inventing the French Revolution,* New York, 1990, pp. 167–99.

17. Expectations were high abroad as well; see Valentine Green, *A Review of the Polite Arts in France,* London, 1782, pp. 25–6.

18. J.-H. Meister, *Souvenirs de mon dernier voyage à Paris (1795),* Paris, 1910; cited by D. Poulot, "Le public, l'Etat et l'artiste. Essai sur la politique du musée en France des Lumières à la Révolution," *EUI Working Paper HEC No. 92/13,* Florence 1992, p. 15.

19. See Y. Cantarel-Besson, *La naissance du Musée du Louvre,* 2 vols., Paris, 1981, II, pp. 27ff, 227.

20. William Shepherd, *Paris in 1802 and 1814,* London, 1814, p. 52. Thirty years later in a report to Parliament, Samuel Woodburn noted with approval the presence of the "lower orders" on Sundays; he saw "soldiers and people with their wooden shoes; I thought it a very fine sight. . . . " *House of Commons. Reports from the Select Committee on Arts,* 1836 (vol. IX.1 of Reports, Committees). My thanks to Carol Duncan for the last reference.

21. *La Décade philosophique,* 10 pluviôse an III, p. 213.

22. *La Décade philosophique,* 10 prairial an VII, p. 434.

CHAPTER 1. THE LUXEMBOURG GALLERY, 1750–79

1. Arch. Nat., O1 1914 (77), f.15; O1 1915 (80), ff.206–7. These ornaments were brought from the *garde meuble.* On the Gallery, see J. Connelly, "Forerunner of the Louvre," *Apollo,* XCV (1972), pp. 382–9; and J. Laran, "L'Exposition des tableaux du Roi au Luxembourg," *BSHAF* (1909), pp. 154–202.

2. Arch. Nat., O1 1073, f.26.

3. Anonymous, *Tableaux du roi placés dans le palais du Luxembourg,* 1750, Deloynes, LII, 1427, p. 91.

4. Arch. Nat., O1 1907b (47), f.16. For the copy in Bachaumont's papers, see Arsenal, MS 4041, ff.427–8. Louis Courajod reproduces this document in the introduction to *Alexandre Lenoir, son journal et le musée*

des monuments français, 3 vols., Paris, 1878, I, p.xxx, with a date, November 23, 1744, but without giving an author or a source.

5. On Lenormand and his family, including Pompadour, see Y. Durand, *Finance et mécenat: les fermiers généraux au XVIIIe siècle*, Paris, 1976, p. 28ff.

6. Crow, *Painters and Public Life*, Chap. 4.

7. The exception to the rule was the history painting competition organized by the Duc d'Antin in 1727, for which see P. Rosenberg, "Le concours de peinture de 1727," *Revue de l'art*, 37 (1977), pp. 29–42; and C. Clements, *Unexpected Consequences: The "Concours de peinture" of 1727 and History Painting in Early Eighteenth-Century Paris*, Ph.D. dissertation, Yale University, 1992. The office of Surintendant des Bâtiments du Roi was changed in 1726 to Directeur-Général des Bâtiments du Roi in order to limit the financial independence of the office.

8. Crow, *Painters and Public Life*, p. 110.

9. Ibid., p. 111.

10. H. Lapauze, *Histoire de l'Académie de France à Rome*, 2 vols., Paris, 1924, I, 225–6. A good account of the Prix de Rome can be found in Louis Courajod, *L'Ecole royale des élèves protégés*, Paris, 1874.

11. On Marigny and his administration, see A. R. Gordon, *The Marquis de Marigny, Directeur-Général des Bâtiments du Roi to Louis XV, 1751–1773: A Study in French Royal Patronage*, Ph.D. dissertation, Harvard University, 1978.

12. On Coypel, see J. Locquin, *La peinture d'histoire en France de 1747 à 1785*, Paris, 1912, pp. 2–13 and passim; and C. B. Bailey, *First Painters of the King*, New York, 1985.

13. Lenormand de Tournehem (1684–1751); La Font de Saint-Yenne (1688–1771); Petit de Bachaumont (1690–1771); Comte du Caylus (1692–1765); C.-A. Coypel (1694–1752).

14. Concerning Bachaumont's friendship with Coypel, see Arsenal, MS 4041, f.50. It seems the idea of a gallery also struck Coypel as a good solution to a problem he was thinking about at much the same time, namely, how to secure the best pictures in the royal collection from loss or theft; see

Arch. Nat., O1 1907a, f.15: "Idée offerte à monsieur de Tournehem pour mettre les Tableaux du Roy en sûreté ce qui a donné lieu à former le cabinet du Luxembourg," signed by Coypel. An appended note in the same hand reads: "L'idée d'en composer un cabinet public au Luxembourg fut acceptée et ordonnée peu de tems après par M. de Tournehem."

15. On Bachaumont, see L. Olivier, *"Curieux," Amateurs, and Connoisseurs: Laymen and the Fine Arts in the Ancien Régime*, Ph.D. dissertation, The Johns Hopkins University, 1976; also see L. Gossman, *Medievalism and the Ideologies of the Enlightenment: The World of La Curne de Saint-Palaye*, Baltimore, MD, 1968; Crow, *Painters and Public Life*, p. 113ff. and passim; R. Tate, "Petit de Bachaumont: His Circle and the *Mémoires Secrets*," *Studies on Voltaire and the Eighteenth Century*, LXV (1968); and R. Ingrams, "Bachaumont: A Parisian Connoisseur of the Eighteenth Century," *Gazette des Beaux-Arts*, LXXV (January 1970), pp. 11–28.

16. See Crow, *Painters and Public Life*, pp. 114–16; and P. Lacroix, ed., "Jugements de Bachaumont sur les meilleurs artistes de son temps," *Revue Universelle des Arts*, 5 (1857), pp. 418–27. Bachaumont's reputation crossed the French border into Prussia; in 1748 he was asked by Frederick the Great for his advice on setting up an academy and the royal picture collection; see idem, "Conseils d'un ami des arts [Bachaumont] à Frédéric II," *Revue Universelle des Arts*, 3 (1856), pp. 351–7.

17. Arsenal, MS 4041, ff.440–5; Olivier, *Curieux*, p. 192.

18. Arsenal, MS 4041, f.144ff., "Mémoire sur le Grand Salon du Louvre, donné en 1746 à Monsieur de Tournehem." Bachaumont also expressed his approval of Lenormand's painting competition. The following was included as a note at the end of the memoir:

> On croit vous faire plaisir, Monsieur, de vous donner avis que parmi les Tableaux du Roy qui sont à Versailles à l'hotel de la Surintendance ou au Louvre à Paris dans la Gallerie dite d'Apollon, il y en a plusieurs de la premiere beauté qui auroient besoin d'être nettoyés, remis sur toile et sur de nouveaux chassis, et qui meriteroient des bordures, –

Entr'autres plusieurs beaux et grands Tableaux du Poussin, surtout un Enlevement des Sabines, un Triomphe de Flore, etc. (f.151)

The *Sabines* was included at the Luxembourg in 1750 (no. 6).

19. [Etienne La Font de Saint-Yenne], *Réflexions sur quelques causes de l'état de peinture en France avec un examen des principaux ouvrages exposés au Louvre le mois d'aoust 1746*, The Hague, 1747. He repeats the complaint in the first edition of his *L'Ombre du grand Colbert,* The Hague, 1749, pp. 19–20, where Versailles is described as "une obscure prison . . . où ils périssent depuis plus de 50 années." The first to attribute the idea of the public gallery to La Font was T. Arnauldet, "Lafont de St.-Yenne," *Gazette des Beaux-Arts* (October 1859), pp. 45–52.

20. La Font, *Réflexions,* pp. 40–1; Joachim C. Nemeitz, *Séjour de Paris,* 2 vols., Leiden, 1727, II, pp. 371–2, 384.

21. [Etienne La Font de Saint-Yenne] *L'Ombre du grand Colbert,* 2d ed., Paris, 1752, p. xxxv.

22. In a later work of 1756, *Le génie du Louvre aux Champs-Elysées,* chiding the government for failing to keep its promise to complete the Louvre and to free it from the mass of jerry-built structures that obscured its façade and courtyard (a promise made in response to La Font's 1749 *l'Ombre du grand Colbert* and a campaign mounted by Bachaumont), La Font dismissed the French as "une nation qui préfere tous les nouveautés les plus frivoles aux plus belles & aux plus sages anciennetés" (p. viii).

23. See the MS copy of "Lettre de l'auteur de l'Ombre du Grand Colbert à M. Remond de Ste. Albine" in Bachaumont's papers; Arsenal, MS 3036, f.25, signed by La Font. For an overview of La Font's place in eighteenth-century art criticism, see H. Zmijewska, "La Critique des Salons en France avant Diderot," *Gazette des Beaux-Arts* (July–August 1970), pp. 1–144.

24. The history painting competition was announced late in 1746; see *PVAR,* VI, pp. 35, 45. As we have seen, most of the concerns raised by La Font – the state of the royal pictures and of the Louvre and the idea of a public gallery – had been the subjects of previous discussion and memorandums by Bachaumont.

25. We know that Charles Coypel's Academy lecture, "Dialogue sur la prochaine exposition" of August 5, 1747 was delivered in response to the *Réflexions;* a note attached to the Academy's copy of the script states, "Dialogue réflechit indirectement sur une brochure repandüe vers ce tems dans le public sous le titre: Réflexions sur quelques causes . . . " (Sorbonne, MS 1009, p. xxxv); Mariette independently tells us that Coypel's lecture was given "peu de tems après la publication du Livre" (Deloynes, II, 23, p. 237); and the Abbé Raynal in the first volume of his *Nouvelles littéraires,* begun apparently on July 29, 1747, writes of the *Réflexions:* "Un homme qui sait écrire et qui connait les arts vient de juger de leurs derniers travaux avec assez de précision, de finesse et de politesse" (*Correspondance littéraire,* M. Tourneux, ed., I, p. 74).

26. In the *Journal de Trévoux* for December 1749 appeared an article (attributed by Bachaumont to La Font) entitled "Remerciement des Habitans de la Ville de Paris à Sa Majesté au sujet de l'achèvement du Louvre," which began, "Le Public a si bien reçu *L'Ombre du grand Colbert,* qu'il en resulte une verité tres glorieuse à notre siecle. Cette verité qui meriteroit d'être publiée dans toute les langues, c'est qu'on estime encore le zele des bons Citoyens, c'est que le langage qu'inspire ce zele, trouve encore des Protecteurs" (Arsenal, MS 3036, ff.27–8). Praising the government for something it had yet to do as a means of forcing it into action was a novel tactic that did not go unnoticed at the time; when Bachaumont used it a few years later, it drew the following remark from Baron Grimm:

> M. de Bachaumont . . . a fait courir dans les rues une chanson sur cet événement [the rumored completion of the Louvre]. C'est une assez bonne méthode de louer le gouvernement sur les belles choses qu'il a envie de faire, comme si elles étaient déjà faites. La honte empêche souvent de reculer, et fait

achever les choses dont on a reçu les éloges d'avance. Quoted by Olivier, "*Curieux*," p. 236. As early as 1746, Bachaumont had sent Lenormand a memoir on the Louvre; discouraged by the failure of his private memorandums and encouraged by the success of La Font's publications, Bachaumont himself took to publishing his ideas. Both Bachaumont and La Font were employing tactics used to great effect by the Parlements in their disputes with the Crown. See Baker, *Inventing the French Revolution*, p. 170.

27. See Crow, *Painters and Public Life*, pp. 111–12.

28. Coypel compared Lenormand to Colbert in his Academy lecture "De la nécessité de recevoir des avis" given on June 23, 1747:

 Renouveller en faveur des Arts le beau siècle du grand Colbert c'est son projet. Deja nous voions recommencer ce tems heureux; nos successeurs en verront la continuation. Gouvernés par un si digne Chef, et persuadés comme nous le sommes des sentimens de son jeune Collègue [Marigny], nous pouvons promettre à cette Académie une longue prosperité.

 Sorbonne, MS 1009, f.74; also *PVAR*, VI, p. 59. The Abbé Raynal described *L'Ombre* as "une satire contre notre ministère" (Descourtieux, as in the following note, p. 36).

29. See the study by Patrick Descourtieux, *Les théoriciens de l'art au XVIIIe siècle: La Font de Saint-Yenne*, Mémoire de maîtrise, University of Paris-Sorbonne, 1977–8. I am grateful to Professor Francis Haskell for allowing me to consult the copy of this thesis in the library of the History of Art Department at Oxford University and to Richard Wrigley for bringing it to my attention. La Font was employed at Versailles for only one quarter of the year, suggesting that he had a private income. Late in 1729 he traveled to Belgium where he met the "fameux curieux" Vanhaggen, who alerted him to the deteriorated condition of the Rubens Medici cycle.

30. Deloynes, II, 23, pp. 235–6.

31. Bachaumont left a fascinating account of their meeting and subsequent relationship in the late 1740s, for which see Arsenal, MS 4041, ff.109–11, reproduced by Tate, "Petit de Bachaumont," pp. 260–1. Crow uses the text to great effect; *Painters and Public Life*, pp. 122–4.

Bachaumont insisted that they met only after the appearance of the *Réflexions*. Brought together thereafter by mutual interests, age, and background, they were in fairly close contact until at least the early 1750s. Copies of everything La Font wrote are to be found among Bachaumont's own papers. Crow is probably right in arguing, therefore, that they collaborated on *L'Ombre*. However, another passage in this account by Bachaumont reveals that they had their differences of opinion. La Font wanted advice, or so he said, on how to repair the damage the *Réflexions* had inflicted on the artistic community:

 Je conseillay à l'auteur de faire une Lettre par la quelle il justifieroit ses intentions, et leur feroit une espèce d'excuse, il me remercia de mon Conseil et me promit de le suivre; effectivement il fit cette Lettre et la fit imprimer sans me la communiquer avant l'impression; quand elle paru je la lue; je fus assez content du commencement où je trouvai qu'il s'efforçoit de réparer en quelque façon le tort qu'il pouvoit avoir fait à ceux qu'il avoit trop critiquez. Mais quelle fut ma suprise quand je trouvai vers la fin de la Lettre un endroit où il disoit que l'Ecole françoise dépérissoit tous les jours au lieu d'augmenter, etc. Je fus indigné de cette double méprise de sa part et lui en fis de vifs reproches; il m'avoua que cela lui était échapé et qu'il en étoit bien fâché: Le mal étant sans Remède je le priay avec Instance de ne plus Ecrire sur ces Matières, il me le promit, et effectivement il laissa là cette discussion.

Tate, "Petit de Bachaumont," p. 261. Bachaumont was set up much as Mariette had been.

Crow also argues that the two were supporters of the parlementary cause (p. 120ff.), which is amply documented in Bachaumont's case but not at all in La Font's. For the record, it should be said that the passage quoted by Crow in defense of

his reading of La Font's parlementary sympathies, taken from the latter's *Sentimens sur quelques ouvrages de peinture* of 1754, pp. 137–8, is framed in the text by an equally warm recommendation of the salutary effects on public morale of portraits of good kings and virtuous queens, their loyal ministers, brave soldiers who risk life and limb in defense of country, and men and women of genius in the arts and sciences (*Sentimens,* pp. 134–40). Quite apart from the ambiguity of this passage, parlementary sympathies are hard to reconcile with La Font's fierce nostalgia for the Sun King, who, of course, silenced the Parlements after the Fronde. Perhaps his support of the Parlements was merely another strategy.

32. See Olivier, "*Curieux,*" pp. 178–9. It was the intemperate, public nature of La Font's criticisms that had piqued Charles Coypel: "Les vrais connoisseurs," he wrote in his *Dialogue* of 1747, "ne hasardent pas volontiers de décisions. Ils proposent leurs avis aux gens de métier" (quoted by A. Fontaine, *Les doctrines d'art en France,* Paris, 1909, pp. 216–17).

33. The *Essai* was favorably reviewed by six different critics, including G.-F. Berthier, the Abbé du Resnel du Bellay, the Abbé de La Porte, Elie Fréron, and the Abbé Raynal; see Olivier, "*Curieux,*" p. 214ff; also see Tate, "Petit de Bachaumont," pp. 236–41.

34. Charles Perrault, *Parallèle des anciens et des modernes en ce qui regarde les arts et les sciences,* Paris, 1688, pp. 220–24.

35. The caricature was by Watelet, another well-connected amateur and engraver. The counterattack against La Font was led by Charles Coypel. On August 5 he delivered a lecture to the Academy discrediting the idea of a unified "public" ("le public change vingt fois le jour") as well as the right of nonpracticing critics to judge painting. The lecture was later published as "Dialogue entre Dorsicour et Céligny" in the *Mercure de France* (November 1751), pp. 59–73. Lenormand's friend, the Abbé Leblanc, soon to accompany Marigny to Italy, also published a rebuttal, *Lettre sur l'exposition des ouvrages de peinture,* n.p., 1747, in which he noted that the *Réflexions* had attracted "la curiosité du public au Sallon"

and "a fait tant de bruit parmi les Peintres" (pp. 1–2). La Font himself remained unapologetic. In 1748, he defended himself in the *Mercure* by insisting that only the disinterested critic could speak "the language of truth." He took the opportunity to condemn the history paintings commissioned by Lenormand, recently exhibited at the Galerie d'Apollon, as a collection marked by "tant de sterilité, & du défaut de génie dans le choix des sujets, que de la froideur de la médiocrité dans l'exécution" *(Lettre de l'auteur des Réflexions sur la peinture,* Deloynes, II, 22). To this gratuitous attack the Academy responded by canceling the Salon in 1749.

36. Deloynes, II, 23, p. 236.

37. For Bachaumont, see Tate, "Petit de Bachaumont," p. 260; Raynal praised the *Réflexions* in the *Mercure de France* for July 1748, and also in *Les Nouvelles littéraires;* see *Correspondance littéraire,* I, pp. 74–5, 181; and *Mémoires pour l'histoire des sciences et des beaux-arts,* known as the *Journal de Trévoux* (October 1747), especially pp. 2074–8: the gallery is described as "un projet magnifique . . . qui feroit beaucoup d'honneur à la nation, s'il étoit jamais exécuté." In addition, each and every criticism La Font makes, about the superiority of the Orléans collection, the condition of the Medici cycle, and so on, is reported as fact. Also see Descourtieux, *La Font,* p. 32ff.

38. Arch. Nat., O1 1685, f.455; similar arrangements were made in the gallery proper from 1750; O1 1684, ff.145–6.

39. Arch. Nat., O1 1684, f.109, "Ordonnance de Monsieur le Directeur Général pour la police à observer au Palais du Luxembourg," article VII, dated January 15, 1748. Also see [Baillet de Saint-Julien], *Lettre sur la peinture, sculpture et architecture à M*** *,* n.p., 1748, p. 36.

40. See, for example, Germain Brice, *Description de la ville de Paris,* Paris, 1713, II, pp. 68–9; and J. Thuillier and B. Foucart, *Rubens: La Galerie Médicis au Palais du Luxembourg,* Paris, 1969.

41. Arch. Nat., O1 1908(53), ff.189,194. The king personally asked Marigny to do all he could to accommodate d'Onsenbray's wish.

By March 1754, Gabriel had drawn up a plan to convert "les cabinets de Bercy," but he told Marigny, "Je suis obligé de vous prevenir que l'etat actuel des lieux exige des reparations qui malgré votre impatience prendrot un tems considerable" [O1 1908 (54), f.18]. Evidently the plan was shelved and the collection was assimilated into the Cabinet du roi.

42. On the *place royale* project and Bouchardon's equestrian statue, see P. Lavedan, *Histoire de l'Urbanisme à Paris. Nouvelle histoire de Paris,* 17, Paris, 1975, pp. 243–51; *La Place Louis XV,* exhibition catalogue, Musée Carnavalet, Paris, 1982; and Gossman, *Medievalism,* pp. 129–30. Bachaumont assembled a dossier of the numerous projects for the square; Arsenal, MS 3103.

43. J.-B. de La Curne de Sainte-Palaye, "Lettre à M. de la Bruere sur le projet d'une place pour la Statue du Roy," *Mercure de France* (July 1748), pp. 147–53.

44. Arch. Nat., O1 1907b(47), f.17: "Nouveaux moyens proposés pour l'exécution du projet arreté par Monsieur de Tournehem, à l'effet de faire un Inventiare général, contenant une description historique de tous les tableaux du Roy." According to Coypel, the purpose of the inventory was to

> etablir en cette importante partie de son administration, l'esprit d'ordre et de regle qui fait la baze de toutes ses opérations, et de faire connoître en même tems à l'Europe la magnifique collection des Tableaux du Roy. Il fera plus, il accellera infiniment le travail, arrêtera les critiques, et flatera tous les curieux en les mettant en liberté de prononcer eux-mêmes sur le mérite de ces Tableaux.

The inventory was ordered from Lépicié in June 1748 [O1 1907b (48), f.8; also AP 392 (1), f.87]. N. Bailly's inventory was published by Fernand Engerand, *Inventaire des Tableaux du Roy rédigé en 1709 et 1710,* Paris, 1899. Coypel was also responsible for the gallery catalogue; O1 1907b (50), f.19.

It is worth noting that Lenormand's successor, Marigny, used Lépicié's catalogue, handsomely produced by the royal presses,

to gain favorable publicity for his administration. When the first volume appeared in 1752, complimentary copies were to have been sent to members of the royal family, the amateurs attached to the Academy, and a handful of important nobles: the Maréchal de Richelieu and the ducs d'Aumont, Gevres, Fleury, Béthune, Villeroy, and Luxembourg. But at some point the original list was revised; such was the perceived need to improve public opinion that the noblemen were crossed off, and substituted were a number of influential journalists and men of letters: G.-F. Berthier, P.-C. Duclos, and the abbés de la Porte, Sallier, and du Resnel du Bellay; O1 1907b (52), f.91. Furthermore, in response to Fréron's positive review in his *Lettre sur quelques écrits de ce tems,* VII, pp. 98–120, Marigny asked Lépicié to convey his appreciation, adding cryptically, "J'entre bien volontiers avec vous dans les frais de la reconnoissance que nous lui devons" [O1 1908 (53), f.8].

45. Arch. Nat., O1 1965(7), "Un état de tableaux du Roi qui ne servant point à Versailles . . . demandés par M. Coypel pour former le cabinet du Luxembourg," dated May 1750. In 1754, J.-S. Bailly's suggestion to add more paintings to the exhibition was rejected because many of those he had in mind were in the apartments at Versailles; *NAAF,* 1903 (1904), pp. 75–6. On the hanging arrangements at Versailles and the problems of attaching the "tableaux permanents" to the walls, see the fascinating letter from J.-A. Portail to Marigny, dated July 1759; O1 1909 (59), f.60.

46. J.-S. Bailly, *Catalogue des tableaux du cabinet du Roy,* Paris, 1750, p. 18.

47. At least sixty new frames were made especially for pictures at the Luxembourg; Arch. Nat., O1 1907b (48), f.20.

48. The Rubens cycle, on the other hand, had been cleaned at least once; see Thuillier and Foucart, *Rubens,* pp. 140–1. Sometime between 1725 and 1733 they were restored by the painter Carel van Falens, who, according to Mariette (*Abécédario de P.-J. Mariette,* ed. P. de Chennerières and A. de Montaiglon, 6 vols., Paris, 1851–60, II, p. 233) was employed by the Duc

d'Orléans to look after the Odescalchi pictures; also see *Au temps de Watteau, Fragonard et Chardin,* exhibition catalogue, Musée des Beaux-Arts, Lille, 1985, pp. 18–19; and C. Brossel, "Charles van Falens," *Revue Belge d'Archéologie et d'Histoire d'Art,* 34 (1965), pp. 211–26.

49. On Colins and Godefroid, see Arch. Nat., O1 1909 (60), f.11; O1 1907 (40), f.7; Louis Courajod, ed., *Livre-Journal de Lazare Duvaux, marchand-bijoutier ordinaire du roy, 1748–1758,* 2 vols., Paris, 1873; and D. Marot, "Recherches sur les origines de la transposition de la peinture en France," *Annales de l'Est* (1950), pp. 241–83.

50. On Colins, see Courajod, *Livre-journal,* I, p. lxxxviff. Also *Mercure de France* (April 1756), II, pp. 170–4; Bachaumont thought his prices were too high, a mark of his professional standing, perhaps; see Crow, *Painters and Public Life,* p. 114.

51. E.-F. Gersaint, *Catalogue raisonné des tableaux . . . Charles Godefroy,* Paris, 1748, pp. vi–vii:

> Les talens supérieurs que M. Godefroy le Peintre avoit pour remettre sur toile, & pour rétablir les Tableaux les plus endommagés, le firent aussi choisir pour prendre soin de ceux de Sa Majesté, & pour veiller à leur conservation. Le mêmes talens ayant été reconnu, après sa mort, dans Madame Godefroy, sa veuve, qui avoit travaillé avec lui aux mêmes Ouvrages pendant plus de vingt années, ont fait avoir à cette veuve l'agrément de la survivance, qu'elle exerce conjointement avec M. Colins, étant chargés tous deux du mêmes soins. Madame Godefroy est journellement occupée à ce travail pour la plus grande partie de Curieux, qui tous sont extrêmement satisfaits de ce qu'ils lui confient, & qui se louent ouvertement de l'intelligence, de l'adresse & de sa patience qu'elle a pour rétablir les morceaux les plus ruinés, desquels on croiroit ne devoir espérer aucune ressource.

Contrary to Gersaint's remark that they performed the same duties, there was in fact a clear division of labor: Godefroid

assumed responsibility for cleaning and relining, and Colins for removing and replacing discolored repaints.

52. What little is known about the restoration of the royal collection before 1750 is discussed by Engerand in his edition of Bailly's *Inventaire;* also see the interesting document that gives an account of the Bailly family and its involvement with the royal collection during the eighteenth century; Arch. Nat., O1 1912 (74), f.143. It should be mentioned that the *gardes* at the royal châteux continued to supervise much routine restoration after this date. In 1748, for example, Bailly was asked to reline two flower pieces by J.-B. Monnoyer and to enlarge two others for the dauphin's apartments at Versailles; meanwhile a certain Prevot was paid for cleaning, repainting, and enlarging unspecified paintings for Pompadour's apartments at Compiègne; Arch. Nat., O1 1934a (47/48). At Versailles as late as 1777, "plusieurs hommes" were paid a grand total of 12 *livres* for cleaning "tous les tableaux des plafonds de la grande Gallerie, comme aussi ceux des grands et petits Appartemens du Roy, de même que les tableaux de Madame et des Mesdames"; O1 1934b (77), f.11. The archives are full of such references.

53. Arch. Nat., O1 1923a (48), f.22. In addition to their annual pension, they were now to be paid for each day spent working on royal pictures.

54. Arch. Nat., O1 1922a and b; copies of the bills are among Coypel's official papers, indicating Lenormand's serious intent; O1 1965 (7). Bachaumont applauded this restoration work in his *Essai,* p. 26. It would be appropriate here to record that La Font also praised Lenormand for the Luxembourg Gallery and for preserving the Rubens paintings in the second edition of the *Réflexions,* 1752, pp. 227–8, 233. La Font was capable of giving credit where it was due. In 1756, after Marigny had ordered repairs to the Louvre, La Font sent him the first copy of his latest work, *Lettre sur les réparations du Louvre,* together with the following letter:

> Il y a déja plusieurs mois que j'aurois dû faire paroître cet écrit pour publier

en votre faveur la reconoissance de tout Paris, et la mienne en particulier, des réparations que vous faites faire au Palais du Louvre, et de l'etat d'indécence d'où vous le tirez si honteuse à vos prédécesseurs, et à toute la nation. . . . Je me flatte, Monsieur, que vous recevez favorablement l'hommage que j'ai l'honneur de vous faire par cet écrit, de mon admiration, de mon estime, et de celle de tout Paris et de toute la Nation. C'est uniquement pour célébrer la grandeur at la dignité de votre entreprise que j'ay hazardé la publication de ce petit ouvrage. . . . J'ai voulu vous en présenter le premier exemplaire. J'aurai l'honneur d'aller vous faire ma coeur dès que vous serez à Paris, et de vous assurer de mes sentimens d'admiration, d'une reconnoissance sans bornes, et de mon respect le plus sincère.

Marigny sent a polite response; Arch. Nat., O1 1908 (56), ff.47–8.

Was La Font "hounded back into obscurity" in the mid-1750s as Crow has claimed [*Art History*, 5 (1982), p. 110], or did he voluntarily give up writing, having accomplished much of what he had set out to do? His final literary effort – passages on the arts in a new 1765 edition of Piganiol de la Force's *Description historique de la ville de Paris* – shows that his reputation remained alive and well a decade after his last piece of criticism. The editor of the *Description historique* warned the reader:

Les changemens et augmentations qui concernent les Beaux-Arts et les jugemens, quelquefois un peu sévères, portés sur les productions des artistes, sont l'ouvrage . . . de M.D.L.F. de S.Y***, amateur distingué, connu d'ailleurs très advantageusement dans la République des Lettres.

Quoted by Descourtieux, p. 37ff. La Font died six years later, age eighty-three, at his home in the Marais.

55. F.-B. Lépicié, *Catalogue raisonné des tableaux du Roy*, 2 vols, Paris, 1752–4, I, pp. 43–4. For an excellent account of the restoration, see G. Emile-Mâle, "La première transposition au Louvre en 1750: La

Charité d'Andrea del Sarto," *Revue du Louvre*, no. 3 (1982), pp. 223–30.
56. Arch. Nat., O1 1922b (Picault), f.20. Apparently he was successful for we find him at Fontainebleau again fifteen years later doing further restoration; O1 1922b (Picault), f.24; *La Feuille Necessaire*, 1759, p. 281; and G. Emile-Mâle, "En marge de l'Ecole de Fontainebleau," *BSHAF*, 1973 (1974), pp. 33–6.
57. *Salon livret*, Paris, 1745, p. 34. The paintings were of the Four Seasons; see F.-B. Lépicié, *Vies des Premiers peintres*, 2 vols., Paris, 1752, II, p. 45. On Picault's career, see Marot, "Recherches."
58. *PVARA*, VI, pp. 69–71.
59. Arch. Nat., O1 1907b (48), ff.18–19; also Emile-Mâle, "La première transposition."
60. Arch. Nat., O1 1922b (Picault), f.1.
61. Arch. Nat., O1 1907b (48), f.7.
62. Arch. Nat., O1 1907b (51), f.1; inspected by Coypel, Lépicié, Portail, and Van Loo.
63. Arch. Nat., O1 1907b (50), f.10. Later in the month the Academy went along with the idea; O1 1925b (50), Lépicié to Lenormand, June 27, 1750.
64. *PVAR*, VI, pp. 241–3.
65. Arch. Nat., O1 1922b (Picault); and Engerand, *Inventaire 1709*, pp. 12–15.
66. Emile-Mâle, "La première transposition," p. 225.
67. Arch. Nat., O1 1907b (52), f.124; AP 392 (1), f.22.
68. For the origins of the technique, see Marot, "Recherches." Charles Poerson, director of the French Academy in Rome from 1704 to 1725, was the first Frenchman on record to have witnessed transferral performed when he supervised the restoration of the Odescalchi collection at the time of its sale to the Duc d'Orléans in 1721; *CDD*, VI, pp. 66, 82. The Président de Brosses also left us a vivid account of his encounter with the process in Milan two decades later; *Lettres d'Italie du Président de Brosses*, F. d'Agay, ed., 2 vols., Paris, 1986, II, pp. 244–5.

In 1753, in a competition arranged by Lépicié on behalf of Marigny, Mme. Godefroid transferred a painting attributed to Holbein using only "l'eau chaude, et . . . la patience." A year later the painting was on

show at the Luxembourg; *NAAF*, 1903 (1904), pp. 69, 72; the 1766 edition of the Gallery catalogue announced: "Ce portrait a été sur bois et a été enlevé par Mme Godefroid qui ne le cède rien à M. Picault"; quoted by Engerand, *Inventaire 1709*, p. 226. In 1752, Godefroid exhibited four paintings transferred from wood at the Academy of St. Luke; J.-J. Guiffrey, *Livrets des expositions de l'Académie de Saint-Luc*, Paris, 1872, p. 41. Godefroid's methods evidently were very similar to and perhaps inspired by those described by J. Gautier d'Agoty in his *Observations sur l'histoire naturelle*, Paris, 1752, p. 133ff. Gautier was outraged by Picault's claims and engaged in a running argument about him with Père Berthier in the pages of the *Journal de Trévoux*, reproduced in the *Revue universelle des arts*, 18 (1863), pp. 37–83.

69. For example, in the 1774 edition of the Luxembourg catalogue, following the customary note on Picault's *Charity*, one finds "plusieurs personnes aujourd'hui possèdent ce Secret." By this time methods of transferral could be found in practical handbooks on the arts, such as Arclais de Montamy's *Traité des couleurs*, Paris, 1765; also see the *Journal Economique* (May 1757), pp. 115–22.

70. Arch. Nat., O1 1922a (Hacquin), f.9.

71. Arch. Nat., O1 1913 (76), f.71; d'Angiviller was unwittingly repeating an observation made by Gautier d'Agoty, *Revue universelle des arts*, 18 (1863), p. 381.

72. NAAF, 1903 (1904), pp. 269, 276. Two notable exceptions to the rule deserve to be mentioned here for the further evidence they offer of the equation forged between responsible government and care for works of art in the public domain. In 1756, or possibly a year earlier, Mme. Godefroid began cleaning a set of sixteen paintings, including Jouvenet's splendid *Descent from the Cross*, owned by the Capucine convent in Paris. [Arch. Nat., O1 1922 (Godefroid), ff.56–7]. The project was commissioned by the wealthy collector and amateur, the Baron de Thiers, but once under way the government stepped in to assume responsibility for it and to earn the gratitude of the convent and the public. In addition, J.-B. Restout made a copy of Jouvenet's *Descent* for the main altar, whereas the original entered the royal collection and was put on display in the rooms of the Academy (see Count Francesco Algarotti, *Essai sur la peinture*, Paris, 1769, p. v). Seven years later, in 1763, the director general intervened once again to clean the pictures of a Paris church, this time the famous Carmelite church on rue Saint-Jacques, home to a number of significant French seventeenth-century paintings, including Lebrun's *Penitent Magdalen*, discussed in the Conclusion to this book.

73. See E. H. Gurian, "Noodling Around with Exhibition Opportunities," in I. Karp and S. Levine, eds., *Exhibiting Cultures: The Poetics and Politics of Museum Display*, Washington, DC, 1991, pp. 176–90.

74. P. Bourdieu, "Outline of a Sociological Theory of Art Perception," *International Social Science Journal*, 20 (1968), p. 597. We should also recall the example of the Chinese encyclopedia that opens M. Foucault's *Les mots et les choses*.

75. André Félibien, *Entretiens sur les vies et sur les ouvrages des plus excellens peintres anciens et modernes*, Paris, 1666–88. Quotations that follow are from a second edition published in two volumes between 1685 and 1690. Also see the 1987 edition of *entretiens* 1 and 2, with a stimulating introduction by René Démoris.

76. On the tradition of active discourse in seventeenth-century art, see E. Cropper, *The Ideal of Painting: Pietro Testa's Düsseldorf Notebook*, Princeton, NJ, 1984, especially pp. 98–9. Poussin's studio was also the source of Charles-Alphonse Du Fresnoy's *Observations sur la peinture*, for which see J. Thuillier, "Les 'Observations sur la peinture' de Charles-Alphonse Du Fresnoy," in G. Kauffmann and W. Sauerlaender, eds., *Walter Friedlaender zum 90. Geburtstag*, Berlin, 1965, pp. 193–209. On Poussin's art theory at the time of Félibien and Du Fresnoy's stay in Rome, see D. Mahon, "Poussin au carrefour des années trente," in *Nicholas Poussin, Colloques internationaux*, CNRS, 2 vols, Paris, 1960, I, p. 254ff; idem, "Poussiniana," *Gazette des Beaux-Arts*, 60 (1962), p. 97ff; and J.C. Forte, *Political Ideology and Artistic Theory in Poussin's Decoration of the Grande Galerie of the Louvre*, Ph.D. dissertation, Columbia University, 1983, p. 197ff.

77. André Félibien, *Conférences de l'Académie royale de peinture et sculpture*, Paris, 1669. Also see B. Teysèddre, *Roger de Piles et les débats sur le coloris au siècle de Louis XIV*, Paris, 1957, p. 70ff; and A. Fontaine, *Les doctrines d'art*, p. 61ff.

78. N. Sainte-Fare Garnot, "La Galerie des Ambassadeurs au Palais des Tuileries (1666–71)," *BSHAF*, 1978 (1980), pp. 119–26. Also see A. Brejon de Lavergnée, *L'inventaire Le Brun de 1683*, Paris, 1987, pp. 26–7. This exhibition lasted from 1668 to 1671. By the time Félibien's sixth conversation was published (1679) the paintings had been removed from the Tuileries to the Louvre.

79. Félibien, *Entretiens*, II, p. 3. The sixth *entretien* was written in 1679; two years earlier, Roger de Piles published his *Conversations sur la connoissance de la peinture*, presented as a dialogue between Damon and Pamphile, which also stresses the need to teach the aspiring art lover from example. After a tour of the royal collection, Pamphile, the initiate, says to Damon: "il faudroit estre sur les lieux, & voir les Tableaux, pour vous faire remarquer ce qu'il y a de beau, & ce qui ne l'est pas" (p. 3; also pp. 16–17).

80. The most heated debate was of course that between the Poussinists and Rubenists, sparked by Gabriel Blanchard's 1671 *conférence* on color; see Teysèddre, *Roger de Piles*, passim; and T. Puttfarken, *Roger de Piles' Theory of Art*, New Haven, CT, 1985. In 1669 Sébastien Bourdon gave the first of six projected lectures on the individual "parties de la peinture": light, composition, drawing, expression, color, and harmony; see H. Jouin, *Conférences de l'Académie royale de peinture et sculpture*, Paris, 1883, p. 123 and passim. Bourdon's parts formed the basis of Henri Testelin's "table of precepts" published in 1680 as *Sentimens des plus habiles peintres sur la pratique de la peinture et sculpture, mis en tables de preceptes*, Paris (1680). Also see N. Coypel, "Dissertation de feu M. Noel Coypel . . . sur les Parties essentielles de la Peinture (1698)," *Revue universelle des arts*, 18 (1863), p. 211ff.

81. De Piles's *Balance* first appeared in his *Cours de peinture par principes*, Paris, 1708. Leon Battista Alberti divided painting into Circumspection (drawing), Composition, and Light (color) in his treatise *On Painting* (1435–6), J. R. Spencer, trans., New Haven, CT, 1966, p. 68ff. A century later Ludovico Dolce, formulating equivalents to branches of rhetoric, defined painting as the sum of Invention, Design, and Color; see M. W. Roskill, *Dolce's "Aretino" and Venetian Art Theory of the Cinquecento*, New York, 1968, p. 116. This threefold division of painting was introduced to France through Du Fresnoy's *De Arte Graphica*, translated by de Piles as *L'Art de la peinture*, Paris, 1668. R. Fréart de Chambray, borrowing from Franciscus Junius, divides painting into five parts – Invention, Proportion, Color, Expression, and Composition – in his *Idée de la perfection de la peinture*, Le Mans, 1662 (Farnborough, U.K., 1968).

82. Ernst Gombrich, in *Norm and Form*, London, 1966, p. 76, refers to the *Balance* as a "notorious aberration." Quoted by T. Puttfarken, *Roger de Piles' Theory of Art*, New Haven, CT, 1985, p. 42, who himself dismisses the *Balance* as a "playful *divertissement.*"

83. Algarotti, *Essai sur la peinture*, p. 205ff. Algarotti approved of the idea of evaluating past artists part by part. The Balance was subjected to a mathematical analysis by the distinguished scientist and mathematician J.-J. Dortous de Mairan at the Academy of Science. "L'idée de M. de Piles est ingénieuse & nouvelle," he wrote, "mais s'il mérite des éloges pour l'invention, il n'en est pas même du coté de l'exécution." Among other things he complained that it made no sense to give a score of zero in any category! But Dortous concluded that with improvements in the method of computation, "Cette Balance . . . nous présentera un plan d'estimation à consulter & un modèle à suivre, non seulement quand il s'agira de peintres & de peinture, mais en bien d'autres cas où nous aurons à porter un jugement de quelque conséquence sur le mérite des concurrens." He also approved of de Piles's division de peinture into four parts of equal importance. See *Histoire de l'Académie royale des sciences avec les mémoires de mathématiques* (1755), Paris, 1761, pp. 79–83; and Mairan's memoir,

"Remarques sur la balance des Peintres de M. de Piles," delivered April 4, 1755.

84. Teysèddre, *Roger de Piles,* p. 251; also p. 321. Comparison was central to the epistemology of many of de Piles's contemporaries; see, for example, John Locke, *Essay Concerning Human Understanding,* London, 1689–90, Book 3, XXV, "Of Relation." Chevalier de Jaucourt, in his article "Comparaison" for the *Encyclopédie,* III (1753), p. 744, argued that comparison fortifies memory, the imagination, and powers of reflection. The act of comparison, he wrote, requires the simultaneous presence of objects side by side to be apprehended by the eye in the same *coup d'oeil* or in immediate succession. L. A. de Caraccioli stated in *The True Mentor; or an essay on the Education of Young People of Fashion,* London, 1760, p. 50: "There is no judging but by comparison, nor can we form any true decision but by bringing together, and examining with each other, the objects we had before seen in a separate state." In the context of painting, Alberti stressed "all things are known by comparison" in his *Della pittura* of 1435; Alberti, *On Painting,* p. 55.

85. E. G. Holt, *The Triumph of Art for the Public,* New York, 1979, p. 7: "Visitors [to the Salon] initially based their aesthetic judgements on the same principles that had guided the artists in making the works. A treatise such as Roger de Piles' had a useful table of values [i.e the Balance] for determining whether or not a work approximated academic standards." On p. 29 Holt reproduces a critique of David's *Oath of the Horatii* from the *Journal de Paris,* which makes obvious use of de Piles's categories: "I note drawing that is correct and of the highest character . . . the colors are true and harmonious . . . a composition full of energy, reinforced by the strong and fearsome expressions of the men."

86. De Piles, *Conversations,* p. 7. This passage is repeated in his *Abrégé de la vie des peintres,* Paris, 1699, p. 91.

87. See D. C. Stanton, *The Aristocrat as Art,* New York, 1980; also, N. Elias, *The Court Society,* New York, 1983, pp. 105–10.

88. See Bernard Beugnot, *L'entretien au XVIIe siècle,* Montreal, 1971, p. 33ff. Beugnot notes that Félibien was one of numerous authors who used dialogue to "mettre à portée d'un public cultivé les traités des spécialistes." Bernard Le Bovier de Fontenelle said it allowed him to discuss philosophy in a nonphilosophic way, not too dry for "gens du monde" but not too light for "savants." Roland Mortier notes that the dialogue retained its popularizing function through the eighteenth century; "Variations on the Dialogue in the French Enlightenment," *Studies in Eighteenth-Century Culture,* 16, O.M. Brack Jr., ed., Madison, WI, 1986, pp. 225–40.

89. See the discussion of Nicolas Faret's *L'honnête homme, ou l'art de plaire à la cour,* frequently reprinted between 1630 and 1682, in M. Gérard, "Art épistolaire et art de la conversation: les vertus de la familiarité," *Revue d'histoire littéraire de la France,* 78 (1978), pp. 958–74.

90. Félibien, *Entretiens,* I, p. 46.

91. Crow, *Painters and Public Life,* pp. 26–9.

92. De Piles, *Conversations,* pp. 7–10. On de Piles's theory of connoisseurship, also see C. Gibson-Wood, *Studies in the Theory of Connoisseurship from Vasari to Morelli* (Garland Dissertation), New York, 1988, Chap. 5.

93. See, for example, Charles Coypel's unpublished Academy lecture "Dissertation sur la nécessité de recevoir des avis," Sorbonne, MS 1009, p. 60. Also see C.-H. Watelet and P.-C. Levesque's article "Imitation" in their *Dictionnaire des arts de peinture, sculpture et gravure,* 5 vols., Paris, 1792, vol. III, pp. 137–8: "Remarque-t-on, dans les ouvrages d'un maître . . . la partie dans laquelle il se montre constamment supérieur à ses rivaux. . . . l'on étudiera, l'on imitera principalement [Raphael, Correggio, Titian, etc.] pour les parties dans laquelle chacun d'eux a excellé."

The doctrine of selective imitation was introduced into France by Du Fresnoy embodied in Annibale Carracci: "Le soigneux Annibale a pris de tous ces Grands Hommes [Raphael, Michelangelo, Romano, Correggio, Titian] ce qu'il en a trouvé de bon, dont il a fait comme un pressis qu'il a converti en sa propre substance"; *L'Art de peinture,* 2d ed., Paris, 1673, pp. 87–8. On Carracci's practice of imitation, see C. Dempsey, *Annibale Carracci and the Beginnings of Baroque Style,* Glückstadt, Germany, 1977.

More generally on imitation during the period, see G. W. Pigman, "Versions of Imitation in the Renaissance," *Renaissance Quarterly*, XXXIII (1980), pp. 1–32; E. Gombrich, "The Style *all'antica*: Imitation and Assimilation," *Norm and Form*, pp. 122–8; Cropper, *The Ideal of Painting*; J. M. Muller, "Rubens' Theory and Practice of the Imitation of Art," *Art Bulletin*, 64 (1982), pp. 229–47; and R. Wittkower, "Imitation, Eclecticism, and Genius," in *Aspects of the Eighteenth Century*, E. Wasserman, ed., Baltimore, MD, 1965, pp. 143–61.

94. The reconstruction is based on the catalogue by J.-B. de la Curne de Sainte-Palaye, *Catalogue des tableaux du cabinet de M. Crozat, Baron de Thiers*, Paris, 1755 (Geneva, Minkoff reprint, 1972), pp. 5–6. Thiers was Pierre Crozat's nephew; he inherited the picture collection in 1750 by way of his elder brother, L.-F. Crozat, Marquis de Châtel. Thiers rearranged the collection after 1750 but without altering fundamentally its purpose. See M. Stuffmann, "Les tableaux de la collection de Pierre Crozat," *Gazette des Beaux-Arts*, LXXII (1968), pp. 1–144.

95. A. Antonini, *Memorial de Paris et de ses environs*, 2 vols., Paris, 1749, I, pp. 293–320. Interestingly, L.-F. Dubois de Saint-Gelais's well-known catalogue of the Orléans collection, *Description des tableaux du Palais Royal*, Paris, 1727, is of no use to us in reconstructing the hang because it lists paintings by artist in alphabetical order (by first name!). This "rational" classification calls attention to the absence of a similar classification in the collection itself. The list of each painter's works is preceded by a brief biography summarizing his strengths and weaknesses in the parts of painting.

96. Stuffmann, "Les tableaux . . . de Pierre Crozat," p. 16ff.

97. See Crow, *Painters and Public Life*, pp. 39–41.

98. P.-J. Mariette, *Description sommaire des dessins des grands maîtres d'Italie, des Pays-Bas et de France au cabinet de feu M. Crozat*, Paris, 1741, p. ix (translation from Crow, *Painters and Public Life*, p. 40). The Comte de Caylus felt similarly indebted to the Crozat reunions; see Stuffmann, "Les tableaux . . . de Pierre Crozat," pp. 22–3.

99. Stuffmann, "Les tableaux . . . de Pierre Crozat," p. 18; and *CDD*, III, pp. 362–90.

100. Dubois de Saint-Gelais, *Description des tableaux*, p. v. In the preface to his *Discours prononcez dans l'Académie royale de peinture et sculpture*, Paris, 1721, Antoine Coypel described his relationship with de Piles as "une amitié tres-étroite dès ma jeunesse. . . . j'étois toujours le confident de ses Ouvrages à mesure qu'ils les produisoit."

101. Coypel, *Discours*, p. 99.

102. Ibid., Preface.

103. Dubois de Saint-Gelais, *Description des tableaux*, p. vi.

104. Anonymous, *Lettre sur les tableaux tirés du cabinet du roi et exposés au Luxembourg depuis le 24 octobre 1750*, 1751 (Deloynes, p. 1427).

105. *Lettre de M. le Chevalier de Tincourt à Madame la Marquise de *** sur les Tableaux et Dessins du Cabinet du Roi*, Paris, 1751 [Deloynes, p. 1430], p. 6.

106. Ibid., p. 7.

107. Ibid., p. 20.

108. Ibid., p. 22.

109. Ibid., pp. 44–8: "Vous seriez agréablement surpris de trouver dans leur comparaison le goût & le contraste de trois Ecoles differentes; le morceau du Poussin tire sur Raphael, celui de Lebrun sent beaucoup les Carraches, le Tableau de Le Moine a toutes les graces & les finesses de l'Ecole Vénitienne."

110. Ibid., pp. 72–6.

111. Ibid., pp. 79 (nos. 62, 95), 88–90 (nos. 96, 85, 60, 61, 81, 82), 93–5 (nos. 91, 93, 72).

112. Louis Marin discusses the way that written guidebooks supply the distant reader with information about a given place at the same time that they establish an itinerary for the actual visitor to that place; *Portrait of the King*, Minneapolis, MN, 1988, pp. 185–7.

113. See, for example, Coypel, *Discours sur la peinture*, Paris, 1732. This was the published version of a lecture entitled "Dialogue sur la connoissance de la peinture" (the original is at the Bibliothèque Doucet, Paris, MS 510) that Coypel read to the Academy on numerous occasions from 1723, the year after his father's death.

Coypel's expert, Alcipe, says to his friend, Damon:

> Les beaux arts sont faits pout toutes les personnes de bons sens & d'esprit. . . . Croïez qu'il y a tel homme d'esprit, qui sera plus capable de sentir les grandes beautez d'un tableau, que quantité de prétendus connoisseurs, qui vous imposent par leur jargon; de ces gens qui ont passé leur vie à étudier les differentes manieres de tels & tels, sans s'appliquer à connoître quelle partie a rendu celui-ci fameux que cet autre.

P. 22. Elsewhere Alcipe is outraged by those who concern themselves with "rarity" rather than "excellence": "Ces gens en un mot qui ne connoissent (si j'ose hazarder cette expression) que le caractere d'écriture de Raphael, du Correge, du Titien, & de tant d'autres; & qui n'ont jamais sçu reflechir sur la beauté de leur stile" (p. 26). Another lecture, "De la nécessité de recevoir des avis," first delivered in 1730, reiterates his father's belief in selective imitation.

114. Arsenal, MS 4041, ff.427–8. Significantly, Bachaumont recommended the works of Du Fresnoy, Félibien, de Piles, Antoine Coypel, and Du Bos to those who sought his advice; "Catalogue des meilleurs livres françois sur la peinture . . . " (f.391). His list was probably drawn up by Mariette, who recommended the same authors to the Academy in October 1747; Arch. Nat., O1 1922a (Mariette), f.1.

115. Sorbonne, MS 1155: "De la nécessité des conférences," 1746, pp. 86–7. Elected amateur at the Academy in 1731, Caylus became actively involved in its affairs only from Lenormand's appointment to the Bâtiments. In addition to reviving the conférence, he sponsored the tête d'expression prize and contributed to Lépicié's project to write a comprehensive lives of the first painters of the king. See S. Rocheblave, Essai sur le Comte du Caylus, Paris, 1889, pp. 165–98; also see Locquin, La peinture d'histoire, pp. 10–13, 92–5; and Crow, Painters and Public Life, pp. 26–33.

116. PVAR, VI, pp. 240–1.

117. A. Tuetey and J. Guiffrey, La Commission du Muséum et la création du musée du Louvre, Paris, 1910, p. 187. To judge by Watelet and Levesque's Dictionnaire des arts, comparative viewing and de Pilesian values retained currency into the 1790s. To become an amateur, wrote Watelet in the article "Amateur," one must first read the standard texts by Du Fresnoy, de Piles, Vasari, Giovanni Lomazzo, and so on, and back this up with a "course of reasoned observations."

> Ce cours ne peut faire qu'en voyant & revoyant plusieurs fois les collections qui rassemblent les ouvrages capitaux des grands Maîtres. Arretez-vous sur les Ecoles célèbres, premièrement sans les mêler, ensuite en les comparant. Appliquez l'examen des plus beaux tableaux tour-à-tour aux principales parties de l'Art; reservez pour les derniers objets d'instruction ce qu'on place plus souvent mal-à-propos à la tête, je veux dire, l'aptitude à distinguer les maîtres.

Vol. I, pp. 64–5. In their article "Cabinet" they state: "Rien n'est plus capable de donner des idées des genres, des manières, du mérite des différens Maîtres, & par consequent de l'Art en lui-même, que de pouvoir, sans sortir du même lieu, comparer un grand nombre de chefs-d'oeuvres" brought together "avec une sorte de méthode" (vol. I, pp. 285–6).

118. Courajod, L'Ecole royale ; also see Locquin, La peinture d'histoire, pp. 10–11, 88–92.

119. Ibid., p. 13. N. Pevsner, Academies of Art Past and Present, Cambridge, 1940, p. 177, rightly emphasized the role of practice at the Ecole royale: "Their main task . . . was to work at oil painting. . . . The copying of pictures was taught . . . and also composition, history and mythology, perspective and anatomy."

120. PVAR, VI, p. 148; also see Courajod, Ecole royale, p. 14.

121. Courajod, Ecole royale, p. 118.

122. J. H. Rubin remarked the Ecole royale's initiative: "The founding of an additional school . . . was surely related to the increased importance of color and painterly handling in the style of mid-century." Eighteenth-Century French Life-Drawing, Princeton, NJ, 1977, p. 21.

123. See, for example, M.-F. Dandré-Bardon, *Vie de Carle Vanloo*, Paris, 1765, p. 51: "A l'égard de la pratique du pinceau, de la pâte, de la fonte, de la couleur, peu de gens l'ont mieux connue: bien peindre étoit un jeu pour lui. Il avoit un soin extrême de bien arrondir, de terminer, de rendre tous les détails de ses ouvrages et d'y rechercher toutes les finesses de la Nature." Also see L. Réau, "Carle Vanloo," *NAAF* (1938), pp. 9–96; P. Rosenberg and M.-C. Sahut, *Carle Vanloo,* exhibition catalogue, Musée Chéret, Nice, 1977; and Bailey, *The First Painters of the King,* pp. 91–100.

124. In 1753 Van Loo borrowed a Rubens and a Poussin from the Luxembourg; presumably other loans were made; Arch. Nat., O1 1908 (53), f.26. In the following year, Marigny gave permission to one Mlle. Delandes to "aller etudier et peindre d'après les tableaux qui sont au Luxembourg," but later withdrew it after complaints from Bailly; O1 1908 (54), ff.2, 4. For further references to copying practice, see Chapter 2.

125. Arch. Nat., O1 1685, f.134; also see A. Hustin, *Le Luxembourg,* 2 vols., Paris, 1910–11, II, p. 78.

126. See N. Bryson, *Tradition and Desire: From David to Delacroix,* Cambridge, 1984.

127. La Font, *Réflexions,* p. 44.

128. *Lettre sur l'exposition des tableaux au Palais du Luxembourg,* Deloynes, LII, 1429.

129. Anonymous, *Lettre sur les tableaux tirés du cabinet du roi et exposés au Luxembourg,* Deloynes, LII, 1428.

130. See *Lettre sur les tableaux tirés du cabinet,* p. 2. The author of "Lettre au P.B.J. sur les Tableaux exposés au Luxembourg" dubbed the Gallery "le Salon des Anciens," pp. 106–7. The Luxembourg opened on October 14; the Salon usually closed in early October.

131. See de Piles, *Cours de Peinture,* p. 322; also Coypel, *Discours,* p. 22; A.-J. Dezallier d'Argenville, "Lettre sur le choix et l'arrangement d'un cabinet curieux," *Mercure de France* (June 1727), pp. 1294–1330; and La Font, *Réflexions,* pp. 30–1.

132. *Catalogue des Tableaux,* 7th ed., Paris, 1759, p. 16 (no. 57). De Troy died in 1752,

and it is likely that it was only after his death that his paintings became eligible for public display in the gallery. The *Diana* was added sometime after 1754, when it was lent to the collector Etienne Bouret from Versailles (along with Le Moyne's *Scipio*) to enhance his collection of Le Moynes displayed at his hôtel on the rue Grange Batelière; see Arch. Nat., O1 1908 (54), ff.56–8. Four new history paintings by Noel Coypel (nos.45–8) had also been added to the Throne Room by 1759. On the d'Antin competition of 1727, see note 7 above.

133. Arch. Nat., O1 1914 (77), ff.146, 148. The Emperor traveled incognito as the Comte du Falkenstein. In 1758 a plan to house the Vernets in the former apartments of the Maréchal de Lowendal next to the Rubens gallery was approved by the king; Arch. Nat., O1 1684, ff.325–6, 329–30. On the ports themselves, see P. Conisbee, *Claude-Joseph Vernet,* exhibition catalogue, Kenwood House, London, 1976.

134. On the collecting of French painting during the period, see C. B. Bailey, *Aspects of the Patronage and Collecting of French Painting in France,* D.Phil. dissertation, Oxford University, 1985.

135. F.-B. Lépicié, *Vies des premiers Peintres, depuis Lebrun jusqu'à présent,* 2 vols., Paris, 1752. Lépicié's lives, originally presented to the Academy in lecture form, was inspired by an earlier pro-French manifesto, Abbé Mazière de Monville's *La vie de Pierre Mignard,* Paris, 1730. On the first painters, see Bailey, *The First Painters of the King.*

136. Marquis J.-B. d'Argens, *Réflexions critiques sur les différentes écoles de peinture,* Paris, 1752. Elie Fréron, in his review of this book, concurred that the only way to demonstrate the equality of French artists was to "comparer Peintre à Peintre, tableaux à tableaux." *Lettre sur quelques écrits,* VII, 1753, Letter XIV, p. 320.

137. Ibid., pp. 141–2.

138. Perrault, *Parallèle,* p. 221. In the 1670s the two were hung together in the Grand Cabinet at the Tuileries; see Félibien, *Entretiens,* II, p. 2. Also see A. Brejon de Lavergnée, *L'inventaire Le Brun de 1683,* Paris, 1987, 25–9.

139. J.-A. Piganiol de la Force, *Nouvelle description des Chasteaux et Parcs de Versailles,* Paris, 1701, pp. 43–5. They were used as a pair in Watelet and Levesque's *Dictionnaire,* II, p. 15.

140. On Louis XVI's pictures at the Tuileries in 1791, see Arch. Nat., F17 1059 (16); for the Louvre, *Catalogue des objets contenus dans la galerie du Muséum français,* Paris, 1793, pp. 34, 36 (nos. 159, 173).

141. *L'Encyclopédie,* V, p. 321, article "École." As early as 1667 in a lecture to the Academy, the painter J. Nocret used Veronese's *Pilgrims* to remind artists that they could hope to excel in only certain parts; see Teyssèdre, *Roger de Piles,* p. 156.

142. Petit de Bachaumont, *Essai sur la peinture,* p. 24.

CHAPTER 2: D'ANGIVILLER'S LOUVRE PROJECT

1. It was known in the early 1770s that upon the accession of Louis XVI the Luxembourg would be given to the Comte de Provence; see Arch. Nat., O1 1684, ffs.217, 266, 354, 411, 436. Also see J. L. Connelly, *The Movement to Create a National Gallery in France,* Ph.D. dissertation, University of Kansas, 1962, Chap. 4. The Luxembourg was formally given to the Comte de Provence in December 1778; the Gallery closed in the following summer.

2. *NAAF,* 1905 (1906), p. 109.

3. According to Henri Sauval, *Histoire et recherches des antiquités de la ville de Paris,* 3 vols., Paris, 1724, II, pp. 43–4, Poussin planned to use casts from the Column of Trajan and the Arch of Constantine. Also see Forte, *Political Ideology and Artistic Theory,* especially p. 94ff; and A. Blunt, "Poussin Studies IV: Poussin's Decoration of the Long Gallery of the Louvre," *BM,* 93 (1951), p. 369ff; 94 (1952), p. 31ff.

4. Bernini's observations on the Louvre, sent from Rome, included the following:

Il seroit bien à propos d'y observer un appartement propre pour y mettre les tableaux de Sa Majesté, où les jours fussent bien disposés, et un autre appartement à orner de statues et bustes; et penser, dès à présent, aux ornemens à ces deux appartemens, de

sorte qu'ils servissent à relever la beauté desdits tableaux, statues et bustes. See P. Clément, *Lettres, instructions et mémoires de Colbert,* 7 vols., Paris, 1861–9, V (1868), pp. 256–7.

5. For a brief history of the movements of the royal collection in the seventeenth century, see Brejon de Lavergnée, *L'inventaire Le Brun de 1683,* p. 17ff. The bulk of the royal collection had been moved to Versailles by 1683.

6. See, for example, La Font, *Réflexions,* 1747, p. 31ff. The idea was also taken up in connection with the place Louis XV project; see Contant d'Ivry's suggestion in P. Patte, *Monumens érigés en France à la gloire de Louis XV,* Paris, 1767, p. 201; and Germain Boffrand's plan, discussed by Connelly, *The Move to Create a National Gallery,* II, pp. 180–2.

7. See Gordon, *The Marquis de Marigny,* p. 53ff.

8. Reboul, *Essai sur les moeurs du tems,* Paris, 1768, p. 186.

9. *Encyclopédie,* IX, 1765, pp. 706–7. See also Maille Dussausoy, *Le Citoyen désintéressé, ou diverses idées patriotiques, concernant quelques établissemens utiles à la ville de Paris,* Paris, 1767, p. 140ff. Dussausoy envisioned a "gallery" attached to each of the academies seated in the Louvre. The wing of the palace facing the river was to be a "Galerie des Hommes Illustres," in which the picture collection was displayed. The Grand Gallery, meanwhile, was to be given over to the king's library and the "Cabinet des Estampes, Dessins, Médailles, et Pierres Gravées."

10. See Gordon, *The Marquis de Marigny,* p. 73.

11. Arch. Nat., O1 1670, f.103; letter dated March 2, 1773. Soufflot first informed Marigny of the need to repair the roof in 1769. The estimated cost was put at 23,000 *livres,* which the director general confessed he could not afford (ff.95–7).

12. Cochin tells us that an appeal by the editor of the journal *L'Avant coureur,* Jacques Lacombe (who had made a similar appeal to Marigny thirteen years earlier), left a particularly deep impression. Lacombe wrote to Terray on August 8, 1774: "Les tableaux empilés à Versailles orneraient Paris & y feraient un nouveau spectacle. Je propose ce

noble projet en 1760 à M. le Marquis de Marigny. Il le renvoya après la paix." Arch. Nat., O1 1912 (73), f.82. For its effect on Terray, see Locquin, *La Peinture d'histoire,* p. 65. Another public appeal for a gallery in the Louvre was made in the *Mercure de France* (November 1773), pp. 182–5. On Terray, see Bailey, *Aspects of the Patronage and Collecting of French Painting,* Chap. 2. Also see [J.-B.-L. Coquereau], *Mémoires de l'Abbé Terrai,* 2 vols., n.p., 1776, I, pp. 272–3

13. The precise sequence of events is unclear though much documentation survives; Arch. Nat., O1 1912 (73), ff.83, 99, 101–2, some of which is published in *NAAF,* 1905 (1906), pp. 2–9. Perhaps it was a memoir [O1 1912 (73), f.102], sent to Terray's secretary Montucla on August 13, by the painter Etienne Jeurat, *garde des tableaux* at Versailles, that prompted high-level discussion within the Bâtiments. The opening paragraph is worth reproducing to demonstrate how widespread the perception of the political worth of the king's pictures was in the eighteenth century:

> Un des plus grands avantages que le Roy puisse et doive retirer de sa precieuse collection des tableaux, c'est sans contredit celuy de mettre encore plus sous les yeux des Etrangers que sous ceux des nationaux, les richesses sans nombre que Sa Majesté possede dans tous les genres de Peinture de meilleurs Maitres des differentes Ecoles. Le desir de connoître de toutes parts les amateurs et connoisseurs de tout sexe et de toute qualité, et c'est travailler certainement à la gloire de l'Etat que de s'occuper du soin de faire valoir ce qui peut contribuer à faire connoître la superiorité de la nation françoise dans ce qui est relatif aux arts.

A note, probably by Montucla, added to the bottom of Jeurat's memoir reads: "Monsieur le controleur general a pris des arrangemens avec M. de Monteynard pour placer un jour les tableaux dans la gallerie des plans." A second memoir, also presumably by Montucla [O1 1912 (73), f.83; reproduced in *NAAF,* 1905, p. 2], may represent the first suggestion to use the Grand Gallery. Years later the painter Joseph-Siffred Duplessis recalled that it

was Charles-Marie de la Condamine who suggested the idea of a gallery in the Louvre at this time; see his *Lettre à M. Barrère de Vieusac,* Paris, 1791. Duplessis added: "Si M. d'Angiviller n'est pas l'inventeur, il a au moins le mérite de l'avoir adopté & d'avoir commencé son exécution" (p. 2).

14. Three hundred workers were ready to begin on April 1, according to the *Mémoires secrets,* 27 (March 31, 1774), p. 190.

15. On d'Angiviller, see J. Silvestre de Sacy, *Le comte d'Angiviller, dernier directeur général des Bâtiments du Roi,* Paris, 1953; also his own memoirs, *Mémoires de Charles-Claude Flahaut. Comte de la Billarderie d'Angiviller. Notes sur les Mémoires de Marmontel,* L. Bobé, ed., Copenhagen, 1933.

16. Arch. Nat., O1 1912 (74), f.153. In a letter to the *garde des tableaux* and future mayor of Paris, J.-S. Bailly, dated December 29, 1774, d'Angiviller wrote: "J'ai esperance d'avoir avant qu'il soit peu la gallerie des plans pour y exposer la plus grands partie des tableaux du Roy."

17. Arch. Nat., O1 1912 (74), f.110.

18. On the collection and its removal to the Ecole Militaire, see R. Baillargeat, *Les Invalides, trois siècles d'histoire,* Paris, 1974, pp. 312–16. Some of the models were so large that a hole in the roof of the gallery had to be made in order to transport them intact.

19. In November 1773, the *Mercure de France,* p. 183, argued: "Le vraie place de ce dépôt seroit l'Ecole Militaire, où il serviroit à l'instruction des jeunes élèves, qui, sans sortir de l'enceinte de cet Hôtel, pourroient se transporter, pour ainsi dire, dans toutes les Places fortifiées qu'ils seront peut être un jour dans le cas de défendre."

20. Arch. Nat., O1 1670, f.105; letter dated October 1, 1776. The Comte de Saint-Germain promised to begin clearing the models in a letter to d'Angiviller dated October 26, (f.108). Good summaries of the architecture of the museum are given by J. L. Connelly, "The Grand Gallery of the Louvre and the Museum Project: Architectural Problems," *Journal of the Society of Architectural Historians,* 31 (May 1972), pp. 120–32; and M.-C. Sahut, *Le Louvre de Hubert Robert,* Réunion des musées nationaux, Paris, 1979.

21. Arch. Nat., O1 1670, f.109; report dated October 29.
22. See PVARA, IX, pp. 358–62. Also see C.-A. Guillaumot, *Mémoire sur la manière d'éclairer la galerie du Louvre, pour y placer le plus favorablement possible les peintures et sculptures, destinées à former le musée national des arts* [Paris, an V (1797)], p. 40. The interest generated by the quest for the ideal museum is reflected in the subject of the Academy of Architecture's Prix de Rome in 1779, won by Guy de Gisors and J.-F. Delannoy.
23. See Brébion's report, Arch. Nat., O1 1670, f.125. The idea may have been suggested by Comte d'Affry; see f.118.
24. Guillaumot, *Mémoire*, pp. 21–2. Guillaumot published the entire history of the gallery debate in 1797 when the question of lighting was again raised. It should be said that not everyone was in favor of leaving the space as it was. Brébion thought the gallery should be divided into four or five units, whereas Antoine Duchesne, the former *prévôt des Bâtiments du Roi,* proposed the creation of a suite of fourteen triangular cabinets; see Arch. Nat., O1 1670, ff.129, 130.
25. On Robert's views of the Louvre, see Sahut, *Le Louvre de Hubert Robert.*
26. See d'Angiviller's report of April 1, 1778; Arch. Nat., O1 1670, f.134.
27. In 1783 d'Angiviller instructed Brébion to keep interior decoration "purement simple et noble . . . pour donner plus d'éclat encore aux richesses qui doivent attirer tous les regards." Arch. Nat., O1 1176, f.462. According to Guillaumot, *Mémoire,* pp. 16–17, decoration was to be restricted to the cornice, vault, and end doors. Walls were to have been painted green, as they were at the Luxembourg and at the Salon.
28. On the frames made by F.-C. Butteux, see G. Bazin, *The Museum Age,* New York, c. 1965, p. 154; and B. Pons, "Les cadres français du XVIIIe siècle et leurs ornements," *Revue de l'art,* 76 (1987), pp. 41–50.
29. Arch. Nat., O1 1670, f.247
30. See Brébion's report of May 27, 1778, Arch. Nat., O1 1670, f.137; and Connelly. "The Grand Gallery," p. 125.

31. Arch. Nat., ff.119–30; also Connelly, "The Grand Gallery"; and Sahut, *Le Louvre de Hubert Robert,* pp. 17–19.
32. Arch. Nat., O1 1670, f.137; dated May 27, 1778.
33. Arch. Nat., O1 1670, ff.227–9; the staircase, executed by Brébion after Soufflot's death in 1780, had the advantage of not intruding directly into the Salon. Also see A. Babeau, *Le Louvre et son histoire,* Paris [1899?], p. 239; and Connelly, "The Grand Gallery," p. 125. It is a mark of the importance of the museum project that d'Angiviller was given any money at all during the war; annual expenditure on the Louvre in the early 1780s averaged just over 100,000 *livres;* see Arch. Nat., O1 1172, f.213; 1174, f.31; 1175, f.1148.
34. On the Palais Royal, see F. Kimball, *The Creation of the Rococo,* Philadelphia, PA, 1943, p. 116. La Font had praised the lighting at the Palais Royal, *Réflexions,* p. 39. On the Octagon Room, see, F. J. B. Watson, *The Choiseul Box,* Oxford, 1963, pp. 11–12.
35. Arch. Nat., O1 1244, f.46.
36. See Guillaumot, *Mémoire.* Le Pelletier de Mortefontaine built a top-lighted gallery for his collection; see Bailey, *Aspects of the Patronage and Collecting of French Painting,* p. 61; also see the anonymous response to *État actuel des arts en France et de celui à qui leur administration est confiée* [1777], Deloynes, X, no. 171. By the end of the decade, Watelet and Levesque could insist on the absolute necessity of top lighting in pictures, galleries; *Dictionnaire des arts,* I, p. 326.
37. Arch. Nat., O1 1670, f.231; letter dated August 26, 1780.
38. See Sacy, *Le comte d'Angiviller,* p. 139; and Connelly, "The Grand Gallery," pp. 125–6.
39. See his letter to the Academy of Architecture, PVARA, IX, pp. 358–62.
40. Arch. Nat., O1 1670, f.247.
41. PVARA, IX, p. 361.
42. See Connelly, "The Grand Gallery," p. 126; Renard, son-in-law of the architect Guillaumot, held the post of inspector in the Paris department of Superintendance.
43. See Sahut, *Le Louvre de Hubert Robert,* p. 18; and PVARA, IX, pp. 358–62.

44. Arch. Nat., O1 1932 (8), f.74.
45. Guillaumot, *Mémoire*, pp. 6–7; also Sahut, *Le Louvre de Hubert Robert*, p. 18.
46. Arch. Nat., O1 1670, f.161. D'Angiviller's instructed the nine architects to ignore Renard's lantern scheme because, despite its "véritable caractère de génie," it would ruin the external appearance of the gallery, produce uncertain light effects inside, and would be too difficult to maintain year-round. He informed them: "Vos études doivent s'appliquer singulièrement aux moyens d'éclairer par les flancs et dans les points les plus avantageux."
47. Guillaumot, *Mémoire*, p. 24 and passim; also Connelly, "The Grand Gallery," pp. 129–30.
48. Arch. Nat., O1 1670, f.247; report by Mique, Hazon, and Guillaumot, dated November 16, 1789.
49. See Sacy, *Le comte d'Angiviller*, especially Chaps. XI and XIII.
50. Ibid., p. 172.
51. Arch. Nat., O1 1182, f.187.
52. Arch. Nat., O1 1670, f.247. Vien also reported the lantern was a great success; O1 1920 (89), f.115. According to Sahut, *Le Louvre de Hubert Robert*, p. 59, n. 110, Renard was the author of the project. The lantern was constructed by J.-A. Raguin, who had already built several similar lanterns in Paris, including one at the Hôtel de Bullion, presumably for the dealer A.-J. Paillet; see O1 1670, f.170. Brébion's complaints were vindicated in December when a storm damaged the lead covering on the roof and broke twenty-four panes of glass in the lantern; see Connelly, "The Grand Gallery," p. 131.
53. This figure is based on three documents giving totals for money spent on art from 1775 to 1787: Arch. Nat., O1 1915 (79), f.5: 1775–8, 191,878 *livres*; O1 1919 (86), f.109: 1779–85, 627,701 *livres*; O1 1920 (88), f.15: 1786–7, 144,102 *livres*. If we add the 30,000 given to the Carthusians in exchange for Le Sueur's Saint Bruno pictures and 50,000 *livres* paid for the Le Sueurs from the Hôtel Lambert, the total is 1,043,681 *livres*. These totals may well leave certain works of art unaccounted for.
54. The Sèvres vases were referred to in a letter from Baron d'Hancarville to d'Angiviller, dated August 29, 1786; Arch. Nat., O1 1919 (86), f.265.
55. The *Grands Hommes* commissions were worth 10,000 *livres* each; four paintings were commissioned at 6,000 *livres;* two at 4,000; and a further two at 3,000. The total for each salon was 78,000 *livres*. Over seven years this amounted to 546,000 *livres*. On the commissions (painting), see B. Jobert, "The *travaux d'encouragement:* An Aspect of Official Arts Policy in France under Louis XVI," *Oxford Art Journal*, 10 (1987), pp. 3–14; also Locquin, *La Peinture d'histoire*.
56. Arch. Nat., O1 1912 (73), f.54; The tax farmer, Favereau, had two pictures, one attributed to Poussin, the other a copy after Carracci.
57. The essential source of information about d'Angiviller's acquisitions is Fernand Engerand, *Inventaire des tableaux commandés et achetés par la direction des Bâtiments du Roi (1709–1792)*, Paris, 1901.
58. The existence of copies and fakes on the market had been a recognized problem since the early seventeenth century; see Bazin, *The Museum Age*, pp. 85–6. Also see the memoir of March 1782 by d'Angiviller's secretary, Montucla, Arch. Nat., O1 1916 (82), f.88; and A. McClellan, "The Politics and Aesthetics of Display: Museums in Paris, 1750–1800," *Art History*, 7 (1984), p. 452.
59. Arch. Nat., O1 1917 (84), ff.402–3. D'Angiviller spent a total of 239,641 *livres* at the sale. On Vaudreuil as a collector, see C.B. Bailey, "The Comte de Vaudreuil: Aristocratic Collecting on the Eve of the Revolution," *Apollo*, CXXX (July 1989), pp. 19–26.
60. Arch. Nat., O1 1917 (83), f.312. Before attending the Locquet sale in Holland on September 22, 1783, Paillet was instructed to ignore artists the king already owned except in the case of works of beauty ("prendre s'il est beau"). In 1785 d'Angiviller justified to the king a recent spending spree in Belgium in the following way: "J'ai fait acheter en Flandres 3 ou 4 tableaux de Maîtres qui manquoient à la collection de votre Majesté"; O1 1918 (85),

f.386. Also in 1785, by which time funds for pictures were running low, d'Angiviller responded to the dealer Lebrun's offer to buy on behalf of the king at the Slinglandt sale in Holland by saying: "Le catalogue de la vente de Slingland m'a indiqué des maîtres très celebres mais qui sont déjà classés par leurs oeuvres dans la collection du Roy." Nevertheless, he did end up buying works by Jan Both, Gerard Terborch, Rembrandt, Albert Cuyp, and Godfried Schalken from Lebrun; O1 1178, ff.524–6, 537–8.

61. Arch. Nat., O1 1917 (84), f.399. A Guido Reni was also bought for 8650 *livres*. For Italian paintings bought after 1775, see Engerand, *Inventaire*, p. 540ff.

62. Arch. Nat., O1 1918 (85), f.246.

63. Arch. Nat., O1 1918 (85), ff.385, 437.

64. Arch. Nat., O1 1915 (79), f.155.

65. Arch. Nat., O1 1913 (76), f.196; O1 1914 (77), ff.99, 442; O1 1914 (78), ff.40, 50, 120; O1 1919 (86), ff.265–6; and see other references below. Most but not all offers were motivated by a desire for financial gain.

66. Arch. Nat., O1 1917 (84), f.361.

67. Arch. Nat., O1 1918 (85), f.190.

68. Arch. Nat., O1 1915 (80), f.286. Also O1 1917 (82), f.88 concerning a set of Le Sueurs belonging to the Marquis de Turgot that were turned down because they belonged to the artist's early style, by then well represented in the royal collection.

69. On dealing in the eighteenth century, see Pomian, *Collectionnneurs, amateurs et curieux*, pp. 163–94. For England, see I. Pears, *The Discovery of Painting. The Growth of Interest in the Arts in England 1680–1768*, New Haven, CT, 1988; and L. Lippincott, *Selling Art in Georgian London. The Rise of Arthur Pond*, New Haven, CT, 1988.

70. See JoLynn Edwards, *Alexandre-Joseph Paillet (1743–1813): A Study of a Parisian Art Dealer*, Ph.D. dissertation, University of Washington, 1982, pp. 104–5.

71. Ibid., p. 105; also Arch. Nat., O1 1914 (77), f.118. D'Angiviller sent Pierre a marked copy of the catalogue and said of the Le Nain (and two others) that he would be annoyed to let them go "même au dessus du prix marqué." It was perhaps at this

point that D'Angiviller realized that he needed a professional working for him.

72. Engerand, *Inventaire*, p. 571. Also see Arch. Nat., O1 1917 (83), f.408.

73. There are numerous instances of Paillet and Pierre passing judgment on pictures on the market or offered to the king: Arch. Nat., O1 1914 (77), f.110; O1 1915 (79), f.177; O1 1917 (84), f.253; *NAAF* 1905 (1906), p. 49.

74. Arch. Nat., O1 1917 (84), with reference to the collections of Montriblond and the Comte de Merle.

75. Arch. Nat., O1 1914 (77), ff.12, 14, 138, 145, 158, 183, 193. Pierre spent 28,660 of the 120,000 *livres* (f.193) on three paintings: *Le martyre de saint Liévens* by Rubens, a *Visitation of the Virgin* by Jan Lievens, and Jan Cossiers's *Adoration de Mages*; see Sacy, *Le comte d'Angiviller*, p. 131.

76. Arch. Nat., O1 1914 (77), ff.248–9. Local authorities complained about the removal, necessitating the intervention of the French foreign minister and d'Angiviller's close friend, the Comte de Vergennes. A copy was made for the altar.

77. On Sauvage and Bosschaert, see Arch. Nat., O1 1918 (85), ff.297, 373, 437, 449, 479; O1 1178, ff.501–3; also J. Guiffrey, "Correspondance du comte d'Angiviller avec Bosschaert," *NAAF* 1880–1, pp. 93–130. D'Angiviller was particularly interested in the Elector's two dozen works by Adriaen van der Werff, whose jewel-like finish was highly appreciated in the eighteenth century. Bosschaert was a personal friend of the architect de Wailly. D'Angiviller bought from Lebrun in 1785 [O1 1918 (85), f.419; O1 1178, ff.524, 537–8] and negotiated with him, with unclear results, to buy Le Sueur drawings from the Prince de Soubise in 1789; see O1 1182, f.85; and *NAAF*, 1877, pp. 354–8.

78. Arch. Nat., O1 1177, f.24. Paillet complained to d'Angiviller about Lebrun's tactics at a recent auction when he publicly refuted the authenticity of pictures up for sale; O1 1916 (83), f.398.

79. Arch. Nat., O1 1919 (86), f.57. Lebrun wrote to d'Angiviller in March 1786:

La protection dont vous l'honorez [Paillet] me devient de jour en jour plus préju-

diciable. . . . Vous avez su, Monsieur le Comte, que c'était moi que l'on avait chargé de la vente des Tableaux de feu M. Aubert et que sur le désir que vous avez montré que je la fisse la moitié avec M. Paillet, je n'ai pas hesité à m'y soumettre, et même à me desister entièrement de mes prétentions à ce travail. On the Watelet sale, and Lebrun's belief that d'Angiviller influenced the decision of the Chambre des comptes to give it to Paillet, see O1 1179, ff.142–3. (The Crown spent 18,477 *livres* at this sale, mostly on French paintings and drawings [O1 1919 (87), f.61.]

80. Paillet refused to accept a commission for buying for the king at the Blondel d'Azincourt sale in 1783; see d'Angiviller's letter to Blondel d'Azincourt dated May 4, 1783; Arch. Nat., O1 1176, f.222. It was normal, it seems, for the dealer to take a 10 percent commission from the buyer, as Rémy had done in the Conti sale of 1777; O1 1914 (77), f.225.

81. In August 1788, for example, Paillet planned an expedition to Holland and asked d'Angiviller for a passport and a letter of recommendation to the French ambassador; Arch. Nat., O1 1920 (88), f.174.

82. Arch. Nat., O1 1920 (90), f.86. The entire collection was valued by Hubert Robert and Lebrun at 960,000 *livres*. On the fate of the Orléans collection, see F. Haskell, *Rediscoveries in Art*, Oxford, 1980, pp. 39–44 and passim.

83. One thousand drawings, by Pierre Puget, Watteau, Poussin, Charles Parrocel, and Bouchardon, among French artists, were bought at the Mariette sale for 58,000 *livres;* see Arch. Nat., O1 1913 (75), ff.359–60. Pierre wrote to d'Angiviller with the Mariette collection in mind: "Le cabinet des dessins du Roy est riche en maîtres rares mais en même tems ne possede rien des artistes celebre du second age. Quant aux modernes *rien*, excepté des Le Brun. *Ecole à former*" (f.349). The prices paid for French drawings equaled those for Italian artists; one drawing by Poussin fetched 2,900 *livres*. Eleven Pierre Peyron drawings were among those bought at the Baudouin sale in 1786; O1 1919 (86), f.69;

Bouchardon drawings, along with paintings by P.-C. Trémolières and Boucher, were bought at the Watelet sale in 1787. These purchases attest to the heightened appreciation for drawings in the eighteenth century.

84. *NAAF,* 1905 (1906), p. 37. Also see Arch. Nat., O1 1913 (75), ff.39–41; and A. Schnapper, *Jean Jouvenet,* Paris, 1974, pp. 67–8. Hacquin paid Chabanais 2,600 *livres* for the Jouvenet and sold it to Pierre for twice that amount.

85. For the transaction, see Arch. Nat., O1 1913 (76), ff.256–71; also J. Guiffrey, "Lettres et documents sur l'acquisition des tableaux d'Eustache Le Sueur," *NAAF* (1877), pp. 274–362. In return for the paintings, the king gave the order 30,000 *livres* toward the cost of a new roof. For contemporary descriptions of the cycle, see G. Brice, *Description,* 6th ed., 1713, II, p. 406; J.-B. de La Curne de Sainte Palaye, *Lettre à M. de B*** sur le bon goût dans les arts et dans les lettres,* Paris, 1751; "Description des tableaux du petit cloître des chartreux peints par Le Sueur," Deloynes, LII, p. 1435. De Piles thought the Saint Bruno cycle his best works; *Abrégé de la vie des peintres,* p. 479. He was compared to Raphael by d'Argens in his *Réflexions critiques,* G. Rouchès, *Eustache Le Sueur,* Paris, 1923, pp. 77–92.

86. For Walpole, see *The Yale Edition of Horace Walpole's Correspondence,* W. S. Lewis, ed., XXXV, p. 126; for Ramdohr, see Arch. Nat., O1 1916 (83), f.305. A special display of unspecified Le Sueur paintings was arranged in the Galerie d'Apollon for Catherine II's son, Grand Duke Paul Petrovich, who visited Paris in 1782; see O1 1922 (Hacquin), f.11.

87. Arch. Nat., O1 1913 (76), f.261; also Comte de Maurepas's letter to Père Robinet, prior of the order, in which the paintings are described as "un monument précieux de l'Ecole Françoise," O1 1913 (76), f.262. Preparatory drawings for the cycle were bought by the Crown in 1777; O1 1914 (77), f.83.

88. Arch. Nat., O1 1913 (76), f.181: "J'ai cru devoir profiter de cette occasion, vraiment unique, d'enrichir les collections de Votre Majesté d'une partie qui y manque, et qui

est d'autant plus nécessaire, qu'elle est la plus brillante peut être de l'Ecole Françoise." Pierre recommended a price of 50,000 *livres* for the lot (though he thought certain were not worth removing from *situ*), and he pointed out that recently 60,000 *livres* had been offered for them; O1 1913 (76), ff.170–2. Also see *Le Cabinet de l'Amour de l'Hôtel Lambert*, Réunion des musées nationaux, Paris, 1972.

89. The Marquise de Roncée (?) was prompted by the news to leave a painting by Le Sueur of *Saint Bruno Distributing Alms* to the king instead of to the Carthusians, as she had originally intended; see Arch. Nat., O1 1915 (78), f.295. In 1779 the curate of Saint Sulpice offered d'Angiviller two paintings attributed to Le Sueur, "dont on m'a assure que vous faites la collection des ouvrages au Louvre"; O1 1915 (79), f.189. Two years earlier, Comte Malet-Graville de Largillière proposed an exchange of decorative paintings by Mignard, Lebrun, Coypel, and Monnoyer from the Hôtel Sagonne (built for J.-H. Mansart) for land. As an incentive he offered "de les faire lever de dessus le plâtre, n'y en ayant qu'un seul qui représente la Parnasse, qui soit sur toile"; O1 1914 (77), f.261. (These pictures were later offered for sale by the restorer Dubuquay in the *Journal de Paris*, 221, August 9, 1779, p. 899.)

90. Mazière de Monville, *La Vie de Pierre Mignard*, pp. 130–1. The ceiling was at Versailles: "Le plat-fond a été gravé par Gerard Audran, & l'estampe peut servir à consoler en quelque sorte les curieux de la perte du tableau" (p. 131). On engraving as a means of transmitting paintings to posterity, see, for example, A. Félibien, *Tableaux du Cabinet du Roy*, Paris, 1677, and J.-B. Massé, *La Grande Galerie de Versailles*, Paris, 1752.

91. In his address to the Academy of Architecture of 1785, d'Angiviller urged the architects to consider carefully the issue of safety "qu'exige le dépôt inestimable [the royal collection]" that the Grand Gallery "doit conserver à jamais." *PVARA*, IX, p. 360.

92. Arch. Nat., O1 1925b (83), letter from Lagrenée to d'Angiviller, dated July 5, 1783. The painting was exhibited at the Salon of that year. Also see E. Pommier, *Le problème du musée à la veille de la Révolution*, Cahiers du Musée Girodet, Montargis, 1989, pp. 7, 24.

93. For Mengs and the Pio-Clementine museum, see C. Springer, *The Marble Wilderness: Ruins and Representation in Italian Romanticism, 1775–1850*, Cambridge, 1987, especially Chap. 2.

94. See C.-N. Cochin, *Lettre sur les peintures d'Herculaneum, aujourd'hui Portici*, Paris, 1751. Cochin remarked, "On ne peut même attribuer au tems, aucune altération dans leur conservation, d'autant que l'espece de vernis qu'on y a appliqué paroît leur avoir rendu leur premier feu, sans leur avoir fait aucun fort" (p. 10). Also see Gautier d'Agoty, *Observations sur la peinture*, I, 1753, p. 22; and the Chevalier de Jaucourt's article "Peinture" in the *Encyclopédie*, 12 (1765), p. 218.

95. *CDD*, X, p. 212 and passim.

96. See Arch. Nat., O1 1919 (86), f.139; also "Projet tendant à l'établissement des mosaïcistes en France," Deloynes, LXIII (pièces 2034–6). For references to the Rome mosaics, see Marquis d'Argens, *Réflexions critiques*, pp. 41–2; Abbé Leblanc, *Observations sur les ouvrages de MM. de l'Académie*, Paris, 1753, pp. 141–2; and C. de Brosses, *Lettres du Président du Brosses*, II, pp. 241–3. Also see F. di Federico, *The Mosaics of Saint Peter's*, University Park, PA, 1983. For the revival of mosaic and posterity, see also Watelet and Levesque, *Dictionnaire*, III, p. 492ff; *Notice de deux tableaux de Mosaïque, par J. Rinaldi, artiste romain*, Paris, 1808; and J. Guillerme, *L'Atelier du temps*, Paris, 1964, pp. 118–22.

97. See D. Rice, *The Fire of the Ancients: The Encaustic Painting Revival, 1755–1812*, Ph.D dissertation, Yale University, 1979. Also see R. Rosenblum, *Transformations in Late Eighteenth Century Art*, Princeton, NJ, 1967, pp. 185–6.

98. The name of Arnauld-Vincent de Montpetit deserves mention in this regard. Much of his life was devoted to the discovery of new paints and techniques for preserving art. See his *Note interéssante sur les moyens de conserver les Portraits peints à l'huile, et de les faire passer à la postérité*, Paris, 1775. This method involved fixing glass to the paint

surface to prevent contact with air. Montpetit tried many times to interest d'Angiviller in his schemes; see Arch. Nat., O1 1913 (76), f.25; O1 1916 (82), f.241; O1 1917 (84), f.1. Also see Montpetit's obituary, *La Décade philosophique*, 23, 20 floréal an 8, pp. 309–11; and Guillerme, *L'Atelier du temps*, pp. 183–4. For further correspondence dealing with conservation techniques submitted to the Bâtiments, see O1 1915 (80), f.50; O1 1919 (87), ff.252, 256; and the letter of the would-be restorer Gault de Saint-Germain, O1 1920 (89), ff.62–3. It is worth noting that a number of artists and restorers claimed to have studied the chemistry of paints and varnishes with the distinguished chemist Jean Darcet; see O1 1920 (89), f.61. Also see J.-S. Duplessis, "Mémoire sur les lacques," in a collection of technical essays, Doucet, MS 1023a, pp. 49–57.

99. Arch. Nat., O1 1913 (75), f.273: "Note sur la survivance de Mme. Godefroid," written by either Montucla or Cuvillier. On these two, see Sacy, *Le comte d'Angiviller*, pp. 58–9. Following Mme Godefroid's death, the Bâtiments employed her son and one Hooghstoel on a free-lance basis [O1 1913 (75), ff.274, 276, 279; O1 1919 (87), f.221]; upon his death in 1788, Godefroid *fils*'s place was taken by Martin de La Porte, who was one of a number of artists who had studied paint chemistry with Jean Darcet; O1 1920 (89), f.61.

100. See Arch. Nat., O1 1913 (76), ff.70–8, 104, 115; O1 1914 (77), f.89. Hacquin was later given a pension of 600 *livres*, O1 1914 (78), f.152. On his death in 1783, Hacquin was succeeded by his son François-Toussaint (b. 1758).

101. See the fascinating discussion of the paintings in Boffrand's Communion Chapel at St. Merri; Guillaumot, *Mémoire*, pp. 18–20. In 1784, when the opening of the museum seemed imminent, d'Angiviller ordered a review of all paintings in need of restoration; Arch. Nat., O1 1917 (84), f.317; *NAAF* 1906, p. 56. The corollary of viewing pictures in good light was the fashion for viewing sculptures by lamp or candlelight, in which the minutiae of technique and the subtlety of contour could be better appreciated; see J. Whiteley, "Light and Dark in Neo-Classical Art," *BM*, CXVII (1975), pp. 768–73.

102. Arch. Nat., O1 1914 (76), ff. 396, 401. One Auguste Margu was also told to have his pictures cleaned (d'Angiviller recommended Paillet) before he submitted them for consideration; O1 1915 (79), f.177. Also see O1 1915 (80), f.286.

103. Arch. Nat., O1 1915 (79), f.285. Numerous offers were rejected because of poor condition, due especially to incompetent repaints by earlier restorers; *NAAF*, 1905, p. 49; *NAAF*, 1906, p. 63; O1 1914 (78), f.17; O1 1915 (79), f.155. Also see O1 1918 (85), f.191. Standards of restoration were clearly lower in the provinces. One Fruissant from Vitry explained in a letter accompanying a picture "dans la manière du Poussin" that

l'espece de gaizis que vous verrez derriere le tableau est un prétendu secret que j'ai trouvé dans un livre, pour faire revivre et conserver les couleurs: c'est une composition de graise de boeuf, l'huile de noix, de ceruse et de terre jaune qui n'a fait, je crois, ni bien ni mal. Vous trouverez que le tableau, pour avoir tout son éclat, a besoin d'être nétoyé, je n'ai pas voulu le confier a nos ouvriers de province.

O1 1913 (76), f.217. The picture was finally judged to be "mauvais."

104. Comte de Caylus, *Reccuil d'antiquités egyptiennes, etrusques, grecques et romaines*, 7 vols., Paris, 1752–67. The Preface to volume III (1759) is especially interesting on the methodology of the antiquarian: Caylus stresses the importance of empirical study of objects, "l'attention . . . aux différens dégrés d'exécution, de finesse," leading to an understanding of style. On Mengs and Winckelmann, see A. D. Potts, "Greek Sculpture and Roman Copies. I: Anton Raphael Mengs and the Eighteenth Century," *JWCI*, 43 (1980), pp. 150–73. Also see Pomian, *Collectionneurs, amateurs et curieux*, pp. 143–62.

105. See G. Martin, *Avis à la nation*, Paris, 1793, pp. 5–6. Martin also includes an anecdote about how cleaning increased the sale value of a picture; pp. 43–4. With respect to a "discovered" Le Sueur of Saint Peter from the church of Saint-Etienne

Dumont, which was sold to a dealer to pay for structural repairs, a report to d'Angiviller stated, "Il n'y a pas plus de 15 jours que ce bel ouvrage etoit encore exposé en vente bien nettoyé, et enrichi d'une assés belle bordure dont il l'a decoré"; Arch. Nat., O1 1913 (76), f.202. The "Brocanteur" was described by Watelet and Levesque, I, p. 270, as an "expert dans tous les moyens de sa profession, [qui] fait retoucher, repeindre, donner à propos au tableau le caratère respectable de l'ancienneté, ou la fraicheur & l'éclat d'un âge moins imposant."

106. Arch. Nat., O1 1916 (80), f.362.

107. Marquis d'Argens, *Examen critique des différentes écoles de peinture*, Berlin, 1768, p. 83. Also see the interesting case of Luca Penni's *Justice d'Othon*, which was transferred from wood to canvas before the Calvière sale of 1779 and then relined prior to the Calonne sale of 1788; G. Emile-Mâle, "Restauration de *La Justice d'Othon* de Luca Penni," *Revue du Louvre*, XXV (1975), pp. 366–67.

108. The painter/dealer/restorer G. Martin wrote in the early 1790s: "Depuis vingt ans, on s'est fort occupé de restaurer les tableaux de Versailles, ceux des églises et des ci-devant hôtels de Paris"; *Avis à la nation*, p. 24. For the restoration of pictures at the Dominican church on rue Saint-Jacques, and at Saint André-des-Arts, see the interesting letters in the *Journal de Paris*, 221 (August 9, 1779), pp. 898–9; 224 (August 12, 1779), pp. 894–5; 232 (August 20, 1779); 240 (August 28, 1779), pp. 978–9; 364 (December 10, 1778), pp. 1467–8; for Saint Roch (1772), see Arch. Nat., AP 392, II, f.209; for the Van Loos at Notre-Dame des Victoires (1786), O1 1919 (86); for Saint Sulpice, see *NAAF*, 1873, p. 409. The Bibliothèque de Sainte Geneviève and the Hôpital des Quinze-vingts also had pictures cleaned after 1775; see Emile-Mâle, "Jean-Baptiste-Pierre Lebrun."

109. F.-C.-C. Pahin de La Blancherie, *Nouvelles de la République des lettres et des arts*, 7 vols., Paris, 1779–87, VI (1783), p. 18.

110. *Description historique des Tableaux de l'église de Paris*, 1781. The author of the this pamphlet is identified by L.-V. Thiéry,

Guide des amateurs, II, p. 90. Godefroid remarks that the collection represented the "plus belles époques de la Peinture en France." For his discussion of the relationship between practice and viewing, see pp. 46–8. The May pictures had been cleaned and rearranged in 1732; see *Mercure de France* (June 1732), pp. 1400–5.

111. See, for example, "Lettre d'un amateur de la peinture à monsieur Dupont élève de monsieur Nattier concernant la manière d'étudier en peinture" (1759), which distinguishes between the treatment of nature in easel pictures and ceilings:

> Dans les plafons . . . dans les voutes d'eglises, il faut necessairement a raison de l'eloignement des yeaux ou les objets qu'on peint sont placés, outrer la nature pour en rendre la representation plus agreable a la grande distance qui adoucit pour lors et lui rend agreable ce qui, consideré de prés, choquerait les yeux et leur paraitrait insupportable.

Deloynes, LXIII, no. 2060. Very similar remarks were made by J.-B.-P. Lebrun:

> Le tableau de chevalet et le tableau de place, chacun isie a son genie particullier, selui qui se livres enthierement au tableau de place parais moins pray de perfection par ce que son genie se porte enthierement au point se vu ou il destinne son ouvrages au masse qui doive lentourré et a leffet imposan de tout quils doit produire. La peinture de chevalet au contraire devant être vu de plus pray exige une perfection plus sage plus reflechie plus vray plus epuré et plus pray de la comparaison de la nature alors le spectateur se trouve en partie lié avec louvrage de l'artiste.

BN, MS Français, 20157, f.219. Also see the interesting remarks about Charles Lebrun's decorative paintings at Versailles, "La Grande Galerie de Versailles," Deloynes, XLVII, no. 1244.

Perhaps most illuminating of all were the observations of Friedrich von Schlegel (1772–1829), prompted, significantly, by a visit to the Louvre in 1802–3:

> The place for which a picture is destined is a point of the highest importance. . . . Every good picture should be designed

for some particular spot, and most of the old paintings were thus appropriately conceived. . . . It is easy in the works of the really good masters, to trace their destination. . . . There is, indeed, no image . . . which can be universally appropriate; and every work of imitative art ought to be confined to some particular destination. *The Aesthetic and Miscellaneous Works of F. von Schlegel,* E. Millington, trans., London, 1849, pp. 102–3.

112. De Piles, *Conversations,* pp. 300–1.

113. Watelet and Levesque, *Dictionnaire,* II, p. 219. Again a distinction was made between between inset decorative works and easel pictures, the latter requiring a treatment that can accommodate "toute exposition raisonnable."

114. M. Baxandall, *Patterns of Intention,* New Haven, CT, 1985, Chap. 2; on the Academy's discussion of viewing distance, see *PVARA,* III, pp. 174–5.

115. The beholder's need to stand back against the opposite wall in order to view the largest pictures was a prime argument in favor of skylights and against lunettes above the cornice; see Guillaumot, *Mémoire,* pp. 25–6

116. In 1778 Pierre sent the director general a set of calculations proving that there were enough paintings to fill the gallery. Many he mentioned, like Lebrun's *Darius* and Veronese's *Pilgrims of Emmaus,* were at Versailles – can we assume the king had agreed to let them go to Paris? See *NAAF,* 1905, pp. 184–5: letter dated March 9, 1778.

117. Arch. Nat., O1 1917 (84), f.254. The Saint Bruno cycle was sent to the Musée spéciale de l'Ecole française during the Revolution but returned to the Louvre during the Restoration. In 1786 Paillet supplied d'Angiviller with a small painting by Veronese, "digne de remplir vos vues dans la place des tableaux de grands maîtres en petit"; O1 1919 (86), f.297.

118. See B. Jobert, "The *Travaux d'encouragement.*" Also C.-F. Jollain, *Réflexions sur la peinture et la gravure,* Paris, 1786, p. 21. Artists were made aware of this destination from the start; in 1779 Pierre wrote to Vien

in Rome reminding him to make both of his pictures for the king the same size "parce qu'ils sont destinés à faire pendant dans la Gallerie"; Arch. Nat., AP 392, III, f.44.

119. Arch. Nat., O1 1925 (76); list of paintings for the 1777 Salon.

120. J. David, *Le Peintre Louis David 1748–1825,* Paris, 1880, pp. 571–2; cited by Roberts, *Jacques-Louis David,* p. 197. On David's manipulation of his audience, also see E. Lajer-Burcharth, "Les oeuvres de David en prison: art engagé après Thermidor," *La Revue du Louvre,* 5/6 (1989), pp. 310–21; and idem, "David's *Sabine Women:* Body, Gender and Republican Culture under the Directory," *Art History,* 14 (1991), especially pp. 405–7. It is also worth noting that in preparation for work on his *Oath of the Tennis Court* David ordered a backdrop of green cloth to be set up in his studio in anticipation of the painting's eventual display at the National Assembly; see P. Bordes, *Le Serment du Jeu de Paume de Jacques-Louis David,* Paris, 1983, p. 54.

121. N. Bryson, *Tradition and Desire,* Cambridge, 1984, Chaps. 1–3. Also Crow "The *Oath of the Horatii* in 1785: Painting and Pre-Revolutionary Radicalism in France," *Art History* 1 (1978). On David's innovative use of gesture, see D. Johnson, "Corporality and Communication: The Gestural Revolution of Diderot, David and the Oath of the Horatii," *Art Bulletin,* LXXI (1989), pp. 92–113.

122. David wrote directly to d'Angiviller on the subject and also appealed to the Marquis de Bièvre; see D. and G. Wildenstein, *Documents complémentaires au catalogue de l'oeuvre de Louis David,* Paris, 1973, p. 17ff. Bièvre was a personal friend of the director general; see *The Memoirs of Elizabeth Louise Vigée-le-Brun, 1755–1789,* G. Shelley, trans., New York, n.d., p. 188.

123. Arch. Nat., O1 1918 (85), f.268.

124. A rough division of schools was implemented at Dusseldorf during the 1750s, and the works of Rubens and van der Werff were hung together in their own rooms; see Nicolas de Pigage, *La Galerie Electorale de Dusseldorf,* Basel, 1778, especially pp. x-xi. The manuscript and engravings were sent to

the Academy in Paris for its approval in 1776; two years later d'Angiviller was sent a complimentary copy of the book; Arch. Nat., O1 1914 (78), ff.115–17.

125. Chrétien de Mechel, *Catalogue des tableaux de la Galerie Impériale et Royale de Vienne*, Basel, 1784, pp. xiv–xv. Also see Meijers, *Kunst als natuur*. Meijers points out that Mechel's predecessor, Rosa, had reordered the Imperial collection by schools in about 1776. Mechel added chronology; pp. 46–7. Mechel was friendly with many prominent European amateurs, including Mariette and Winckelmann.

126. See A. Potts, "Winckelmann's Construction of History," *Art History*, 5 (1982), pp. 377–407; and idem, *Winckelmann's History of Ancient Art in Its Eighteenth-Century Context*, Ph.D. dissertation, University of London, 1978.

127. On Linnaeus, see H. Daudin, *De Linné à Lamarck. Méthodes de la classification et idée de série en botanique et en zoologie (1740–1790)*, Paris, 1926–7; and W. T. Stearns, "The Background of Linnaeus's Contributions to the Nomenclature and Methods of Systematic Biology," *Systematic Biology*, 8 (1958), pp. 4–24.

128. *Histoire naturelle, générale et particulière avec la description du cabinet du roi . . .*, vol. III, Paris, 1749, pp. 1–12; cited by Y. Laissus, "Les cabinets d'histoire naturelle," in *Enseignement et diffusion des sciences en France au XVIIIe siècle*, R. Taton, ed., Paris, 1964, pp. 659–711.

129. *Encyclopédie*, II (1751), p. 490; article "Cabinet." The same article insisted on a methodical order "most conducive to study" and that the "science of natural history will progress in proportion to the spread of finished collections."

The fields of art and natural history intersect in the person of A.-J. Dézallier d'Argenville, who wrote with equal authority on both. Best known to art historians as the author of the popular *Abrégé de la vie des plus fameux peintres*, 4 vols., Paris, 1762, he wrote an earlier treatise on minerals and shells in which he distinguished serious collectors from *curieux* according to the arrangement of their collections. Whereas the former thinks in terms of "classes" and "families" ("without doubt the best way and most methodical"), the latter gives all

to "the pleasures of the eye, sacrificing methodical order to form compartments varied with respect to shape and color." *L'Histoire naturelle éclaircie dans deux de ses parties principales, la lithologie et la conchyliologie*, Paris, 1742, p. 195. On Dézallier, see Gibson-Wood, *Theories of Connoisseurship*, pp. 71–94.

130. Significantly, the natural history collections at Vienna were reorganized at exactly the same time that Mechel was rehanging the picture galleries; see Meijers, *Kunst als natuur*, p. 94ff.

131. On the universal versus the local in eighteenth-century history painting, see J. Barrell, "Sir Joshua Reynolds and the Englishness of English Art," in *Nation and Narration*, H. K. Bhabha, ed., London, 1990, pp. 154–76. D'Angiviller explicitly privileged ancient history over modern subjects in a private note dated March 20, 1776: "Il a été trouvé convenable pour maintenir le grand style de donner la préférence au sujets de l'histoire ancienne quant au nombre sur ceux de l'histoire moderne"; Arch. Nat., O1 1925b1.

132. See Jobert, "The *Travaux d'encouragement*."

133. *PVAR*, VIII, pp. 176–8. See the list drawn up on March 20,1776, Arch. Nat., O1 1925 (76). Discussed by Locquin, *La Peinture d'histoire*, pp. 48–53; and Crow, *Painters and Public Life*, p. 189ff. Also see Rosenblum, *Transformations*, Chap. 2.

134. For a fuller treatment of the following material, see my article "D'Angiviller's 'Great Men' of France and the Politics of the Parlements," *Art History*, 13 (1990), pp. 175–92.

135. On the *Parnasse François* and other eighteenth-century projects, see J. Colton, *The Parnasse François and the Origins of the Monument to Genius*, New Haven, CT, 1979; and idem, *Monuments to Men of Genius: A Study of Eighteenth-Century English and French Sculptural Works*, Ph.D. dissertation, New York University, 1974. On the Ecole Militaire, see M. Gagne, "Quelques documents sur les statues de grands hommes," *Revue de l'art ancien et moderne*, 59 (1931), pp. 139–44.

136. Arch. Nat., O1 1913 (76), f.199; dated August 12, 1776.

137. *Journal de Paris*, March 30, 1777, p. 2.

138. For a good introduction to the Parlements in eighteenth-century France, see W. Doyle, "The Parlements," in *The French Revolution and the Creation of Modern Political Culture*, K. Baker, ed., 2 vols., Oxford, 1987, I, pp. 157–68. Also, B. Stone, *The Parlement of Paris, 1774–1789*, Chapel Hill, NC, 1981.

139. As Doyle, "The Parlements" (p. 158) noted, remonstrances had already evolved into a "vehicle for opposing royal will in the name of the law" by the sixteenth century. It was precisely to check this unwelcome development that Louis XIV silenced the Parlements in 1673 by removing their privilege of remonstrance before the registration of edicts. This policy was overturned by the regent in 1715. On the running disputes between the Parlements and the Crown, see J. Egret, *Louis XV et l'opposition parlementaire*, Paris, 1970; and W. Doyle, "The Parlements of France and the Breakdown of the Old Regime, 1770–1788," *French Historical Studies*, 6 (1970), pp. 415–58.

140. On the idea of political representation and the Parlementary crisis in eighteenth-century France, see Baker, *Inventing the French Revolution*, pp. 31–58, 224–51, and passim.

141. See D. C. Hudson, "In Defence of Reform: French Government Propaganda during the Maupeou Crisis," *French Historical Studies*, 8 (1973), pp. 51–76. Also see the interesting article on the anti-Maupeou pamphleteers, P. Dupieux, "L'Agitation parisienne et les prisonniers de la Bastille," *Bulletin de la Société de l'histoire de Paris*, 58 (1931), pp. 45–57.

142. See the two collections, *Les Efforts de la liberté & du patriotisme du Sr Maupeou . . . ou receuil des écrits patriotiques pour maintenir l'ancien gouvernement français*, 3 vols., London, 1775; and *Maupeouana, ou receuil complet des écrits patriotiques publiés pendant le règne du Chancelier Maupeou, pour démontrer l'absurdité du despotisme qu'il voulait établir & pour maintenir dans toute sa splendeur la monarchie française*, M.-F. Pidansat de Mairobert, ed., Paris, 1775.

143. See the collection of Parlementary documents, *Receuil des réclamations, remonstrances . . . des Parlemens . . . au sujet de l'édit de décembre 1770*, 2 vols., London, 1773, II, pp. 192, 230, 254, and passim.

144. See Hudson, "In Defence of Reform."

145. Anonymous, *Tableaux des différens âges de la monarchie française* in *Les Efforts de la liberté*, II, p. 43. On the use of history by the two sides in the debate, see Baker, *Inventing the French Revolution*, especially pp. 31–85.

146. Egret, *Louis XV et l'opposition parlementaire*, p. 218.

147. Abbé Joseph Rémy, ed., *Le Code des françois, ou receuil de toutes les pièces intéressantes publiées en France, relativement aux troubles des Parlemens*, 2 vols., Brussels, 1771, I, pp. 109, 138–9, 140, and passim. Cited by Hudson, "In Defence of Reform," p. 62. L'Hôpital continued to be regarded by Parlementarians as the ideal magistrate; see, for example, Président Hénault, *Nouvel abrégé chronologique de l'histoire de France*, 3 vols., Paris, 1775 ed. (first published 1744), II, p. 538, where he is described as "un magistrat au-dessus de tout éloge."

148. Egret, *Louis XV et l'opposition parlementaire*, Chap. 6. According to Besenval (*Mémoires*, I, p. 384), the king's principal adviser, the Comte de Maurepas, "était soucieux de débuter par un coup d'éclat qu'il savait bien devoir plaire au plus grand nombre." Cited by Egret, pp. 224–5. Also see Doyle, "The Parlements of France and the Breakdown of the Old Regime," and Stone, *The Parlement of Paris*, p. 35ff. D'Angiviller's close friend and ministerial colleague, Turgot, was also in favor of recalling the Parlements; see H. Carré, "Turgot et le rappel des Parlements (1774)," *La Révolution française*, 43 (1902), pp. 193–208.

149. The list of *Grands Hommes* is the first document filed for 1775 in the Bâtiments archives; Arch. Nat., O1 1913 (75), f.1. D'Angiviller took personal responsibility for the choice of Great Men; see McClellan, "D'Angiviller's 'Great Men.'"

150. Mercier, *Tableau de Paris*, 8, p. 27ff.

151. See McClellan, "D'Angiviller's 'Great Men,'" especially pp. 177–8.

152. The connection is discussed at length in F. H. Dowley, *A Series of Statues of "Grands Hommes" ordered by the Académie Royale*

de Peinture et de Sculpture, Ph.D. dissertation, University of Chicago, 1953.

153. See d'Angiviller, Mémoires, p. 20; also see Dowley, A Series of Statues, pp. 85–7; and A. Deleyre, Essai sur la vie et les ouvrages de Thomas, Paris, 1792, pp. 33–4. In 1775 d'Angiviller secured for Thomas the post of historiographer to the Bâtiments; see M. Henriet, "L'Académicien Thomas," Bulletin du bibliophile, 9 (1917), p. 291.

154. Mémoires secrets, 11, p. 40.

155. See, for example, E.-M. Falconet, "Réflexions sur la sculpture," in Oeuvres complètes, Lausanne, 1771, vol. 1, p. 2: "La sculpture, après l'histoire, est le dépôt le plus durable des vertus des hommes . . . le but digne de la sculpture est donc de perpétuer le mémoire des hommes illustres & de donner des modèles de vertus."

156. For Thomas's reference to Pigalle's tomb, see Oeuvres, Paris, 1773, vol. 3, pp. 1–3. Also see his Essai sur les éloges, in Choix d'éloges couronnés par l'Académie française, Paris, 1812, vol. 1, pp. 530–2; and his Eloge d'Aguesseau, Paris, 1760, pp. 138–9.

157. Abbé J.-H. Rémy, Eloge de Michel de l'Hôpital, Paris, 1777. Addressing the "magistrat prévaricateur," he wrote:

Vous fûtes tour-à-tour les objets de la sollicitude de l'Hôpital, vous qui destinés à faire regner les Lois, ne craigniez pas alors de les violer, soit pour assouvir vos vengeances, soit pour seconder un zèle aveugle, soit pour défendre des intérêts incompatible avec la constitution Monarchique. Le Chancelier veut que le Magistrat soit subordonné au Monarque. (p. 35)

158. Arch Nat., O1 1914 (77), ff.333–4. The note accompanying Rémy's eulogy read: "C'est à vous que je dois le morceau de mon ouvrage qui a le mieux reussi devant le public, et devant l'Académie. Permettez-moi de vous offrir un exemplaire de l'éloge . . . comme un hommage de ma reconnoissance." The "morceau" of which he speaks was probably the mention he makes at the start of the eulogy (p. 3) of D'Angiviller's statue and the joint celebration of the academies. On September 3, d'Angiviller replied: "C'est un vrai plaisir que j'apprens avoir contribué par la en quelque chose au succez de votre ouvrage." There is no evi-

dence to suggest the competition was fixed in Rémy's favor, but it is noteworthy that the two most celebrated eulogists of the day – Jean-François de La Harpe (winner of the prize in 1767, 1771, 1775) and Garat (1779, 1781, 1784) – did not compete that year.

159. Predictably, the Parlements were bitterly upset by the éloge and tried (it seems unsuccessfully) to have it withdrawn from circulation; see Mémoires secrets, 10, pp. 223, 229. Further readings of l'Hôpital, including an important subversive one by F.-A. de Guibert, were given in other eulogies published at the time; see McClellan, "D'Angiviller's 'Great Men.'"

160. [François-Apolline de Guibert], Eloge de l'Hôpital, n.p., 1777, pp. 55–56. The author of this eulogy is usually incorrectly identified as Jacques-Antoine Hippolyte de Guibert. F.-A. de Guibert, best known for his controversial but influential book on military tactics, Essai général de tactique (1770), had ties to both the court and the philosophes. He rose to the rank of field marshal and was elected to the Académie Française in 1786; see Dictionnaire de biographie française, fascicule xcvii, 1986, pp. 48–50.

Guibert's Eloge was distributed illegally. Its reception (as well as that of Rémy) was reported with great interest by the Mémoires secrets, 10, pp. 209, 223, 229–30, 232–3.

161. Ibid., p. 56. M.-F. Pidansat de Mairobert reprinted the most biting passages of the Eloge with commentary in his L'Espion anglois, ou correspondance secrete entre Mylord All'eye et Mylord All'ear, 10 vols., London, 1783, VIII, Letter IV. Interestingly, Mairobert noted: "Il est . . . frappant, que l'auteur oppose aux Magistrats ce même l'Hôpital dont ils se sont prévalus si souvent dans leurs remonstrances & leurs autres écrits" (p. 95).

162. Baker, Inventing the French Revolution, p. 172.

163. Montesquieu is, of course, best known for De l'esprit des lois of 1748. Henri-François d'Aguesseau, like Montesquieu, came from a distinguished robe family. Some of his speeches, such as "L'homme public" (1706) or "L'amour de la patrie" (1715), are particularly interesting in light of later Par-

lementary discourse; see *Discours et oeu-vres mêlées de M. le Chancelier d'Aguesseau,* 2 vols., Paris, 1771.

164. P.-P.-N. Henrion de Pancé, *Discours prononcé à la rentrée de la conférence publique de messieurs les avocats au parlement de Paris* [13 January 1775], Lausanne, 1775, p. 8.

165. J. Egret, *The French Prerevolution, 1787–1788,* Chicago, 1987, p. 187 and passim; also Doyle, *Origins of the French Revolution,* Chap. 5.

166. *NAAF* 1906 (1907), p. 2664.

167. Arch. Nat., O1 1925b (17). The statues, still on the books in May 1792, were never executed. According to M. Furcy-Raynaud, *Inventaire des sculptures exécutées au XVIIIe siècle pour la Direction des Bâtiments du Roi,* Paris, 1927, there is no record of their ever being commissioned.

168. On David's pre-Revolutionary politics, see especially Crow, "The *Oath of the Horatii* in 1785," pp. 424–71; A. Boime, "Marmontel's *Bélisaire* and the Pre-Revolutionary Progressivism of David," *Art History* 3 (1980), pp. 81–101; and R. L. Herbert, *David: Brutus,* London, 1972.

CHAPTER 3. THE REVOLUTIONARY LOUVRE

1. Arch. Nat., O1 1670, ff.217, 213, 247. The problem was first brought to d'Angiviller's attention in 1784.

2. A. Tuetey and J. Guiffrey, *La Commission du Muséum et la création du Musée du Louvre,* Paris, 1910, p. 23.

3. *Le Moniteur,* vol. 14, p. 263. On Roland and the early Revolutionary Louvre, see E. Pommier, *Jean-Baptiste-Pierre Lebrun, Reflexions sur le Museum national,* Paris, 1992. Pommier's excellent essay came to my attention only after my book had gone to press.

4. E. Pommier, "Idéologie et musée à l'époque révolutionnaire," in *Les Images de la Revolution française,* M. Vovelle, ed., Paris, 1988, pp. 57–78.

5. *PVCM,* I, p. 266. Independently of the Commission, F.-M. Puthod de Maison Rouge had a similar vision: "O quelle collection précieuse ne feroit-on dans nos principales villes, comme Paris, Nantes, Lyon, Bordeaux! O quels superbes museums on y pourroit élever des dépouilles de nos églises et monastères supprimés!" *Les monuments*

ou le pélerinage historique, Paris, 1790, pp. 2–3, cited by Pommier, "Idéologie et musée," p. 58.

6. M.-J. Mavidal and M.-E. Laurent, eds., *Archives parlementaires de 1787 à 1860,* 139 vols., Paris, 1867–96, 26, p. 469.

7. A.-G. Kersaint, *Discours sur les monuments publics,* Paris, 1792, pp. 41–2. Also see an earlier recommendation along similar lines by B. Poyet, *Mémoire sur la nécessité d'entreprendre de grands travaux publics,* Paris, 1790.

8. Ibid., p. 45.

9. Tuetey and Guiffrey, *La Commission du Muséum,* p. 26. Roland's commission succeeded a first museum commission appointed in haste by the Legislative Assembly in the aftermath of August 10. The composition and activities of this commission are unclear, though there is evidence that it undertook work on the Grand Gallery; pp. 1–3; and *PVCM,* vol. I, pp. 142–4. On Roland and his campaign to bring control of the museum and all national property under the jurisdiction of the ministry of the interior, see E. Bernardin, *Jean-Marie Roland et le Ministre de l'Intérieur (1792–1793),* Paris, 1964, pp. 435–8.

10. See Kersaint, *Discours,* p. 46. It was this experiment that prompted the author to come up with a new, more spacious museum plan complete with top lighting.

11. Tuetey and Guiffrey, *La Commission du Muséum,* pp. 123–4.

12. *PVCM,* I, p. 247.

13. Arch. Nat., F17 1059 (15); letter dated July 4, 1793.

14. D. J. Garat, *Mémoires sur la révolution,* Paris, an III, p. 3.

15. On anti-Revolutionary propaganda, see D. Bindman, *The Shadow of the Guillotine. Britain and the French Revolution,* British Museum, London, 1989.

16. See the Commission's "Considérations sur les arts et sur le Muséum national" of June 1793, in Tuetey and Guiffrey, *La Commission du Muséum,* p. 183ff.

17. *PVCM,* I, pp. 122, 157.

18. *PVCM,* I, pp. 247, 251. For the difficulties between the two commissions, see Tuetey and Guiffrey, *La Commission du Muséum,* pp. 32, 42–3, 53, and passim; and *PVCM,* I, pp. 211–12. Cossard and Pasquier were members of both the Museum Commission

and the Commission des monuments, but they were unable to smooth relations between the two.

19. *Catalogue des objets contenus dans la galerie du Muséum Français*, Paris, 1793.
20. F.-A. de Boissy d'Anglas, *Essai sur les fêtes nationales suivi de quelques idées sur les arts*, Paris, an II, p. 5. In year II the radical Société populaire et républicaine said of civic festivals: "nous les avons considérés comme essentiellement liées à l'instruction publique." A. Détournelle, *Aux Armes et aux arts! Journal de la Société populaire et républicaine des arts*, Paris, n.d., p. 155.
21. The idea of molding or educating the citizenry, while retaining the semblance of liberty, owed much to Jean-Jacques Rousseau; see C. Blum, *Jean-Jacques Rousseau and the Republic of Virtue*, Ithaca, NY, 1986, Chap. 3, especially pp. 66–8.
22. Boissy d'Anglas, *Essai sur les fêtes*, p. 7.
23. L. Hunt, *Politics, Culture, and Class in the French Revolution*, Berkeley, CA, 1984, p. 55.
24. J.-L. David, *Rapport et décret sur la fête de la Réunion republicaine du 10 Août*, Paris, 1793, p. 4. For good accounts of the festival, see *Procès-verbal des monumens, de la marche, et des discours de la fête consacrée à l'inauguration de la Constitution de la République française, le 10 août 1793*, Paris, 1793; *Détail de la fête de l'unité et de l'indivisibilité de la république*, Paris, 1793.
25. M. Ozouf, *La fête révolutionnaire 1789–1799*, Paris, 1976, p. 100. It should be said that Ozouf questions both the success and the sincerity of the festival.
26. See D. L. Dowd, *Pageant-Master of the Republic. Jacques-Louis David and the French Revolution*, Lincoln, NB, 1948, Chap. 5.
27. See Hunt, *Politics, Culture, and Class*, Chaps. 3 and 4; and M. Agulhon, *Marianne au combat: L'Imagerie et la symbolique républicaines de 1789 à 1880*, Paris, 1979.
28. Ozouf, *La fête révolutionnaire*, p. 149.
29. The inaccessibility of the Grand Gallery prior to the removal of the relief models is mentioned by Pierre in a letter of 1779; Arch. Nat., O1 1171, ff.207–8.
30. Abbé H. Grégoire, *Rapport sur les destructions opérées par le vandalisme*, Paris, an II, p. 21.
31. Corps Législatif, *Rapport fait au Conseil des Cinq-Cents, sur les sceaux de la République, par Grégoire: Séance du 11 pluviôse an IV* (January 31, 1796); quoted by Hunt, *Politics, Culture, and Class*, p. 92.
32. Tuetey and Guiffrey, *La Commission du Muséum*, p. 213.
33. Ibid., pp. 244, 289–91. Also see the catalogue Lenoir had printed for the occasion, *Notice succincte des objets de sculpture et architecture réunis au Dépôt provisoire national* [Paris], 1793.
34. *La Décade philosophique*, 10 pluviôse an III, p. 213.
35. See Crow, *Painters and Public Life*; and Dowd, *Pageant Master*, Chap. 2.
36. S.-C. Miger, *Lettre à M. Vien*, Paris, 1789, p. 1. By year II demands had intensified; witness *La Décade philosophique* for 10 floréal: "Si, dans ce pays où les arts marchent ainsi chargés de chaînes, la liberté vient à sourire; si la cour est détruite, le trône abattu, la couronne réduite en poudre . . . les académies et toutes les autres institutions monarchiques sont pulvérisées comme le sceptre" (vol. 1, pp. 8–9).
37. *Adresse, mémoire et observations présentés à l'Assemblée Nationale, par la Commune des arts*, Paris, 1791, p. 8.
38. Ibid., p. 26; also see pp. 28, 48.
39. See, for example, *La Décade philosophique*, 10 floréal an II, p. 8ff; J.-B.-P. Lebrun, *Essai sur les moyens d'encourager la peinture*, Paris, an III, pp. 21–2. For earlier references, see Dufresnoy, *De arte graphica*, p. 254; de Piles, *Cours de peinture*, p. 412; and the *Encyclopédie*, vol. 5, p. 333. And see Sir Joshua Reynolds, *Discourses on Art*, R. R. Wark, ed., New Haven, CT, 1975, pp. 26, 41 (Discourses II and III).
40. Quoted by D. Poulot, "La Naissance du musée," in P. Bordes and R. Michel, eds., *Aux Armes et Aux Arts! Les Arts de la Révolution, 1789–1799*, Paris, 1988, p. 215.
41. G.-F. Romme, *Rapport . . . sur la suppression de la place de directeur de l'Académie de France à Rome*, Paris, 1792, p. 3.
42. In the early 1770s, Jeurat remarked: "Si la galerie du Luxembourg et les tableaux du Roi . . . sont exposés aux curieux deux fois la semaine, il est bon de rappeler que l'étude de la jeunesse entra pour beaucoup lors de cet arrangement"; *NAAF* 1905 (1906), p. 7;

also *NAAF* 1903 (1904), p. 164; *NAAF* 1904 (1905), p. 128. For copying policy under Terray and d'Angiviller, see Arch. Nat., O1 1913 (75), f.118; O1 1914 (77), f.136.

43. Tuetey and Guiffrey, *La Commission du Muséum*, p. 335.

44. Cantarel-Besson, *La naissance du musée*, II, p. 68; also p. 235. For a brief period during the Terror there were virtually no restrictions on artists wishing to copy. In March 1794, the museum administration announced that "Toutes les facilités seront accordées tous les jours, à toutes les heures, dans toutes les saisons, aux artistes qui désirent étudier et copier"; *Les Conservateurs du Muséum national des arts à leurs concitoyens*, Paris, an II, p. 4. Also see Détournelle, *Aux armes*, p. 293.

45. Poulot, "La naissance du musée," p. 218.

46. Arch. Nat., F21 569 (1), f.19.

47. Ibid., F21 569 (5), f.102.

48. For David's political career, see D. L. Dowd, "Jacques-Louis David, Artist Member of the Committee of General Security," *American Historical Review*, LVII (1952), pp. 871–92; idem, "Jacobinism and the Fine Arts: The Revolutionary Careers of Bouquier, Sergent and David," *Art Quarterly*, XVI (1953), pp. 195–214. For a recent summary, see W. Roberts, *Jacques-Louis David, Revolutionary Artist*, Chapel Hill, NC, 1989, Chap. 2.

49. *PVSPRA*, Introduction.

50. Mavidal and Laurent, *Archives Parlementaires*, vol. 70, pp. 519–24.

51. *PVSPRA*, pp. 198–9; David had J.-B. Regnault thrown out of the Society on grounds of dubious patriotism; to qualify for readmission he was obliged to acquire "un certificat de civisme du Comité révolutionnaire de sa section." In an article, "Influence de la liberté. Suppression des Académies," in *La Décade philosophique*, it was stated of the SPRA: "Les artistes et citoyens, doivent être d'un patriotisme reconnu. L'épuration la plus scrupuleuse a purgé la société de tout vieux levain aristocratique" vol. 1, p. 9.

52. For a powerful statement of the importance of art to the Revolution, see J.-L. David, *Rapport . . . sur la nomination des cinquante Membres du Jury qui doit juger le Concours des Prix de Peinture, Sculpture*

& *Architecture*, Paris, 1793, pp. 2–3. Also see Détournelle, *Aux Armes*, p. 291; and J. Leith, *The Idea of Art as Propaganda*, Toronto, 1965, Chap. 5; Hunt, *Politics, Culture, and Class*, passim. As early as 1789, the *Revolutions de Paris* stated: "We should not forget in this revolution the powerful effect of the language of signs," vol. I, September 5–12, p. 26; quoted by Herbert, *J.-L. David*, p. 147.

53. G.-F. Bouquier, *Rapport et projet de décret relatifs à la restauration des Tableaux et autres monumens des arts, formant la collection du Muséum national*, Paris, 1794, p. 2. Before his election as a deputy to the National Convention, Bouquier (1739–1810) had been a painter of seascapes and ruins and had also dabbled in art criticism; see F. Soubeyron and J. Vilain, "Gabriel Bouquier, critique du Salon de 1775," *La Revue du Louvre*, 25 (1975), pp. 95–104. On the gendering of Revolutionary discourse, see J. B. Landes, *Women and the Public Sphere in the Age of the French Revolution*, Ithaca, NY, 1988.

54. The "projet de decret" of the 1791 *Adresse, mémoire et observations* stated under article IX (p. 48):

Tous les tableaux, statues tant en marbre qu'en plâtre, dessins, estampes & autres objets des arts, formant les collections ci-devant dites du cabinet du roi, ensemble celles qui renferment les salles des académies de peinture, sculpture & architecture, seront réunies dans de lieux convenable & éclairés d'une manière avantageuse, & sous l'inspection de la commune des arts.

55. *PVCTA*, Introduction. This commission was dissolved in 1795. M.-L. Chenier referred to its members (after Thermidor) as the "créatures de David," p. xxx.

56. Ibid., pp. x–xi.

57. J.-B.-C. Mathieu, *Rapport . . . fait au nom du Comité d'instruction publique . . . ,* Paris, 1793, pp. 4–5. Mathieu (1754–1833) was also a member of the CIP and the Commitee of Public Safety. The *Journal de Paris* reported the Commission's dissolution the day after Mathieu's speech; see *PVCM*, II, p. 119. The Commission had been denounced, though not unreservedly, by the Commune in September; see *PVSPRA*, pp.

86–8. The Commission did, in fact, issue an ineffective defense of its work, *Compte rendu à la Convention nationale par le rapport du Comité d'instruction publique*, Paris, 1794.
58. J.-L. David, *Rapport sur la suppression de la commission de muséum*, Paris, 1793.
59. Idem, *Second rapport sur la nécessité de la suppression de la commission du muséum*, Paris, 1794.
60. Grégoire, *Rapport sur . . . le vandalisme*, p. 27. A slightly earlier pamphlet of vendemiaire year II had said of vandalism: "Elle déshonoreroit la France et souillerait la révolution; elle porteroit le coup funeste à la république naissante en la rendant l'objet du mépris des autres peuples de la terre." A. A. Renouard, Chardin, Charlemagne fils, *Observations de quelques patriotes sur la nécessité de conserver les monumens de la littérature et des arts*, Paris, an II.
61. David, *Second rapport*, pp. 5–6.
62. Arch. Nat., F17 1059 (6); letter to Roland, dated October 23. On Lebrun's Revolutionary career, see G. Emile-Mâle, "Jean-Baptiste-Pierre Lebrun, son rôle dans l'histoire de la restauration des tableaux du Louvre," *Bulletin de la Fédération des Sociétés historiques et archéologique de Paris et de l'Ile de France*, VII (1956), pp. 371–417.
63. Arch. Nat., F17 1059 (13); also see the letter from David to Roland, dated November 15, 1792, F17 1059 (16).On Lebrun and his dealings with Roland, see Pommier, *Jean-Baptiste-Pierre Lebrun, Reflexions sur le Museum national*.
64. Arch. Nat., F17 1059 (13); Roland's letter dated January 16, 1793.
65. For an account of this affair, see *Les commissaires du Muséum Français aux membres du Comité d'instruction publique*, Paris, 1793.
66. *Supplement de la Chronique de Paris*, March 6, 1793, p. 2; reprinted in Tuetey and Guiffrey, *La Commission du Muséum*, pp. 98–101. Lebrun also wrote to Garat demanding the suspension of restoration, Arch. Nat., F17 1059 (13).
67. Picault's *Observations* was a version of a memoir originally sent to d'Angiviller in 1789 appealing for a chance to prove himself; Arch. Nat., O1 1920 (89), f.67. The

Observations was reprinted in the *Revue Universelle des Arts*, IX (1859), pp. 505–24; X, pp. 38–48. It is significant that Picault was using Lebrun as a referee in 1789; O1 1920 (89), f.86.
68. See, for example, Arch. Nat., F21 570 (2), f.55; and the accounts of Louvre expenses during the Empire, O2 835–6. Hacquin published an angry rebuttal to Picault's *Observations*; see *Un mot au citoyen Picault*, Paris, 1793.
69. Tuetey and Guiffrey, *La Commission du Muséum*, p. 185. The Commission, in fact, described the museum as an "encyclopédie matérielle et physique des beaux-arts." Also see *Aux Membres du Comité d'Instruction publique de la Convention National: Les Commissaires du Muséum Français*, Paris, 1793, p. 6: "Le Muséum ne doit pas contenir seulement les chef-d'oeuvres en peinture, sculpture, dessins, gravures, etc., mais encore des machines ingénieuses & utiles, des instrumens de physique, d'astronomie, d'optique, etc."
70. David, *Second rapport*, p. 4. Interestingly, Lebrun's early *Réflexions* contains a description of the ideal museum complete with luxury goods – "vases et colonnes de toute sorte de matières . . . pierres gravées, médailles, émaux, vases et coupes d'agathe, jade, etc." (pp. 5–6). In the subsequent *Observations* he limited himself to a discussion of issues peculiar to the fine arts.
71. Idem, *Rapport sur la suppression*, pp. 4–5. The same sentiment is expressed by Pierre Chaussard, *Essai sur la dignité des arts*, Paris, an VI, p. 14.
72. See J.-B.-P. Lebrun, *Réflexions sur le Muséum national*, Paris, 1793; idem, *Observations sur le Muséum national . . . pour servir de suite aux réflexions qu'il a déjà publiées sur le même objet*, Paris, 1793; and Picault, *Observations*.
73. Arch. Nat., F17 1059 (1): "Considerations sur les arts et sur le Muséum national," reprinted in Tuetey and Guiffrey, *La Commission du Muséum*, p. 187.
74. See L. Courajod, *Alexandre Lenoir, son journal et le Musée des monuments français*, 3 vols., Paris, 1878–87, I, p. clxxii.
75. The principal advocate of the school-chronology system was Lebrun, who, as the

leading connoisseur of the day, stood to benefit most from its introduction. It is interesting to note how his argument changes in the course of 1793. In a letter to Garat of April 1, he claims it is the amateur who requires such an arrangement [Arch. Nat., F17 1059 (14)]; but in the later *Observations,* published after the abolition of the Academy, it is the needs of students that are paramount.

76. Bouquier, *Rapport,* p. 2. Watelet, in his article "Galerie" in the *Dictionnaire des arts,* II, p. 390, ridiculed the ostentation of many Parisian collections and the vanity of their owners.

77. In an Academy lecture of 1698, Noel Coypel stated that a *cabinet de tableaux* should offer the variety of "un parterre orné de toutes sortes de Fleurs, qui ont chacune leur agrément, et des odeurs différentes." Cited by Teyssèdre, *Roger de Piles,* p. 455. Significantly, Roland also likened the museum to "un parterre qu'il faut émailler des plus brillantes couleurs." Courajod, *Alexandre Lenoir,* I, p. clxxii.

78. The Convention decree suppressing the Museum Commission and authorizing the Conservatoire was dated 27 nivôse an II. The Conservatoire was under the direction of the minister of the interior and the surveillance of the CIP; see Arch. Nat., F21 569 (1).

79. Restoration had been halted in February shortly after the Conservatoire took office. The competition was discussed by the Conservatoire and CIP in April and May; see Cantarel-Besson, *La Naissance du musée,* I, p. 49; II, pp. 182 (n. 142), 225. Later in the year, alternative ideas for a competition were put forward by Lebrun, *Quelques idées sur la disposition . . . du muséum national,* Paris, an III, p. 17ff; and Martin, *Avis à la nation.*

80. Cantarel-Besson, *La Naissance du musée,* I, pp. 63–5; a register was opened for a fortnight beginning July 2, and an announcement to this effect was posted on the museum door; but a week later it was discovered that "très peu de citoyens se sont fait inscrire."

81. Ibid., I, p. 89. Also see Arch. Nat., F17 1220 (1), 24 fructidor an II.

82. It was reported of the Belgian pictures upon arrival, "La plupart ont besoin d'être mis en chassis, rentoilés et restaurés." Arch. Nat., F21 570 (4), f.53. Lebrun was put in charge of inspecting these pictures.

83. Arch. Nat., F21 570(3), f.19. Mérimée worked at the Musée central in the late 1790s on matters connnected with restoration. He was the author of the interesting treatise *De la peinture en huile,* Paris, 1830, as well as the father of the writer and conservationist, Prosper Mérimée.

84. Martin, *Avis à la nation,* p. 24: "Restaurer un tableau est aujourd'hui une des plus précieuses branches de la peinture, puisqu'on lui restitue sa première existence; c'est le réintégrer dans ses qualités élémentaires qui constituent son mérite et son prix." Martin was a journeyman restorer employed occasionally by the Bâtiments in the 1780s. His pamphlet is the most useful source of attitudes toward restoration in the 1790s. He included in his pamphlet a "Manuel pour servir d'instruction à faire connoître les écoles, les maîtres et le restauration des tableaux." See also Lebrun, *Quelques idées,* pp. 20–2. See also the passage in the *Instruction sur la manière d'inventorier,* quoted by Tuetey in *PVCTA,* p. xviii. A good idea of the standards expected of restorers at the start of the nineteenth century is provided by A. Giroux, *Notice de plusieurs tableaux,* Paris, 1809.

85. Cantarel-Besson, *La Naissance du musée,* I, pp. 18–19.

86. Ibid., I, pp. 47, 69.

87. Ibid., I, p. 19:

Dans le déplacement qui a eu lieu ce matin [February 25, 1794] des objets médiocres de la gallerie du Muséum, un des vases du Japon, dont le pendant existe sous le no 65, a été cassé au moment de l'enlèvement; il est facile de se convaincre par le pendant que les arts n'ont rien perdu de l'anéantissement de cette production japonaise.

Also see *La Décade philosophique,* vol. 2, pp. 22–3.

88. Armorial bearings were removed from the Louvre prior to the opening of the museum; Arch. Nat., F17 1059 (17); *PVCM,* p. xx. The suppression of feudal insignia was

authorized by decrees of August 14, 1792 and July 4, 1793.

89. Cantarel-Besson, *La Naissance du musée*, I, p. 82. In August 1793 the Commune concluded that the series should not be destroyed but merely removed from public view; *PVSPRA*, p. 11.

90. Ibid., I, pp. 82–3.

91. Détournelle, *Aux armes*, p. 321.

92. Ibid., pp. 267–8; *PVSPRA*, pp. 273–4; and Poulot, "La naissance du musée," pp. 218–19.

93. Cantarel-Besson, *La Naissance du musée*, I, pp. 41–2. List dated 4 floréal an II (April 24, 1794).

94. The Conservatoire's ambivalence over religious paintings is revealed in two meetings of March 1794, where, in one, it was agreed to remove Crayer's *Saint Jerome in the Desert* for fear that it would "entretenir le fanaticisme," whereas, in the other, it was decided that no effort should be spared to ensure that Le Sueur's *Saint Gervais and Protais Brought Before Astasias* "soit le plus promptement possible en état d'être placé au Muséum." Cantarel-Besson, *La Naissance du musée*, I, pp. 32–3, 24, respectively.

95. *La Décade philosophique*, 20 brumaire an III, p. 287. This criticism appeared in a review of Georg Forster's *Voyage philosophique et pittoresque sur les rives du Rhin*, 2 vols., Paris, an III.

96. The issue of what was and was not ideologically safe to display is analogous to the larger Revolutionary problem of drawing a line between the destruction of feudal signs and the preservation of that which was considered culturally and historically significant. As is well known, a great many art objects fell too easily into the latter category and were destroyed by vandals. Those that were spared were protected not only by their perceived quality but by their identity as appropriated and therefore "revolutionized" property. They entered the museum as transcendant products of human civilization and emblems of triumph over despotism. See Pommier, "Idéologie et musée," passim.

97. A remark appearing in the *Annales Patriotiques* quoted by Lynn Hunt is of interest in

this regard: "The metaphysical principles of Locke and Condillac should become popular, and the people should be accustomed to see in a statue only stone and in an image only canvas and colors." *Politics, Culture, and Class*, p. 91.

98. See S. Idzerda, "Iconoclasm during the French Revolution," *American Historical Review*, LX (1956), p. 24.

99. C. Varon, *Rapport du Conservatoire du Muséum national des arts*, Paris, an II; reprinted in Cantarel-Besson, *La Naissance du musée*, II, pp. 226–9.

100. Ibid., II, p. 228; my emphasis.

101. Mathieu, *Rapport fait à la Convention*, p. 16.

102. Cantarel-Besson, *La Naissance du musée*, II, p. 227.

103. Ibid., I, pp. 106, 108, 112, 114, 128.

104. Ibid., II, p. 235; report of September 27, 1794.

105. See G. Brière, "Le Peintre J.-L. Barbier et les conquêtes artistiques en Belgique (1794)," *BSHAF* (1920), pp. 204–10; also M. Dreyfous, *Les Arts et les Artistes pendant la période révolutionnaire*, Paris, 1906, pp. 73–4. An excellent summary of French confiscation during the Revolution and Empire is provided by Cecil Gould, *Trophy of Conquest; The Musée Napoléon and the Creation of the Louvre*, London, 1965.

106. See Besson's letter to the CTA of 20 messidor an II, Arch. Nat., F17 1231 (4); also Gould, *Trophy*, p. 31. Besson had suggested confiscating the Elector's collection at Dusseldorf as early as January 1794.

107. The wording of these guidelines closely resembles that of the instructions on compiling inventories; see R. Devleeshouwer, *L'Arrondisement du Brabant sous l'occupation française, 1794–1795*, Brussels, 1964, p. 453.

108. Lebrun was often asked to advise on the contents of foreign collections, especially in northern Europe; see BN, MS Français 20157, ff.107, 153, 168–74; *PVCTA*, I, p. 519. In the late 1790s he claimed to have traveled outside France forty-three times. Also see Emile-Mâle, "Jean-Baptiste-Pierre Lebrun," p. 401; and *PVCTA*, I, p. 297.

109. Gould, *Trophy*, p. 34. On these paintings, see G. Emile-Mâle, "Le séjour à Paris de

1794 à 1815 de célèbres tableaux de Rubens," *Bulletin de l'Institut Royal du Patrimoine Artistique,* VII (1964), pp. 153–71

110. F. Aulard, *Recueil des actes du Comité se Salut Publique,* vol. XVI, p. 14. I am grateful to Sura Levine for this reference.

111. See the "Etat des objets d'arts envoyés aux divers musées français et conquis par les armées de la République" compiled by General F.-R.-J. de Pommereul, in F. Milizia, *De l'Art de voir dans les beaux-arts,* Paris, an VI.

112. Arch. Nat., F21 570 (4), f.54; also see Cantarel-Besson, *La Naissance du musée,* I, pp. 92–7; II, p. 238–9.

113. *Moniteur universelle,* 3 vendémiaire an III (September 24, 1794); réimpression, vol. XXII (1847), pp. 26–7.

114. Kersaint, *Discours sur les monuments publics,* p. 45.

115. F.-A. de Boissy d'Anglas, *Quelques idées sur les arts, sur la nécessité de les encourager, sur les institutions qui peuvent en assurer le perfectionnement, & sur divers établissemens nécessaires à l'enseignement public,* Paris, an II, pp. 28–9.

116. Grégoire, *Rapport sur . . . le vandalisme,* pp. 22–7.

117. On art confiscation in Italy, see E. Muntz, "Les annexations de collections d'art ou de bibliothèques et leur rôle dans les relations internationales principalement dans la Révolution française," *Revue d'histoire diplomatique,* 8 (1894), pp. 481–97; 9 (1895), pp. 375–93; 10 (1896), pp. 481–508. C. Saunier, *Les Conquêtes artistiques de la Révolution et de l'Empire,* Paris, 1902. M.-L. Blumer, "La Commission pour la recherche des objets de sciences et arts en Italie, 1796–1797," *Révolution française* (1934), pp. 62–88, 124–50, 222–59. A number of good summaries are available in English: Gould, *Trophy;* with reference to antique sculpture, F. Haskell and N. Penny, *Taste and the Antique,* New Haven, CT, 1981, Chap. 14; D. M. Quynn, "The Art Confiscations of the Napoleonic Wars," *American Historical Review,* 50 (1945), pp. 437–60; and M. L. Turner, "French Art Confiscations in the Roman Republic, 1798," *Proceedings of the Con-*

sortium on Revolutionary Europe, 1750–1850 (1980), vol. 2, pp. 43–51.

118. Gould, *Trophy,* p. 44.

119. Blumer, "La Commission," p. 69.

120. Ibid., pp. 70–1; also see *CDD,* 16, pp. 413–17.

121. See *Correspondance de Napoléon Ier, publiée par ordre de l'Empereur Napoléon III,* Paris, 1858, vol. I, pp. 527–30.

122. For Florence and Turin, see Gould, *Trophy,* pp. 59–62; and, with specific reference to Napoleon's pursuit of the *Venus de Medici,* see F. Boyer, "Un conquête de la diplomatique du premier consul," *Revue d'histoire diplomatique* (1957), p. 22ff. On the Borghese and Albani collections, see F. Boyer, "L'Achat des antiques Borghèse par Napoléon," *Académie des Inscriptions & Belles-Lettres. Comptes rendus des séances de l'année 1937* (1937), pp. 405–15; and, Haskell and Penny, *Taste and the Antique,* pp. 112–13.

123. See Blumer, "La Commission," p. 75ff.

124. *La Décade philosophique,* 10 frimaire an V, 428. Lebrun drew up the inventory upon arrival; Cantarel-Besson, *La Naissance du musée,* II, p. 142.

125. BN, MS Français 20157, f.109.

126. A. Thouin, *Voyage dans la Belgique, la Hollande et l'Italie,* 2 vols., Paris, 1841, II, p. 46. Haskell and Penny suggest Lalande's value judgments may have influenced the commissioners; *Taste and the Antique,* p. 109.

127. Arch. Nat., F17 1275a (2). On Maffei, see Pomian, *Collectionneurs, amateurs et curieux,* pp. 195–211.

128. Arch. Nat., F17 1275b (1), f.275.

129. See C.-G. Redon de Belleville, *Notes et correspondance,* 2 vols., Paris, 1892, II, pp. 224–42. The headings in the Louvre's list coincide exactly with chapters in volume 1 of the *Storia.* Lanzi's 1782 catalogue of the Uffizi collection was used at the same time to compile a list of antiquities in Florence that would be appropriate for the Louvre. On Lanzi, see Gibson-Wood, *Studies in the Theory of Connoisseurship,* pp. 140–51.

130. Haskell and Penny, *Taste and the Antique,* p. 109.

131. See the overview of Italian painting, based on the Louvre collection, given in *La Décade philosophique,* vol. 4, pp. 344–51,

407–15. The commissioners did hesitate momentarily over the choice of final objects from Rome. Correspondence with the Institut on the subject shows that they were at liberty to some extent to exercise their own judgment; see M. Bonnaire, *Procès-verbaux de l'Académie des Beaux-Arts,* 3 vols., Paris, 1937–43, II, pp. 23–4; and *Magasin Encyclopédique,* 4 (1796), pp. 275ff., 424ff. Guidance from Paris would have been more important in the case of towns like Perugia and paintings of less obvious stature than the few taken from Rome.

132. Louis-Antoine Lavallée's letter of year IX (1800–1) accompanying the list of Florentine artists emphasizes the need to form "une suite chronologique qui montre l'origine et les progrès de la peinture depuis sa renaissance sous Cimabue jusqu'à nos jours." To this end he recommends one painting by masters of the "première époque" (i.e., Cimabue to Leonardo) and at least two by those from Michelangelo to the mid-seventeenth century; see Redon de Belleville, *Notes et correspondance,* II, pp. 241–2. In his inventory of the second convoy from Italy, Lebrun was careful to note paintings by artists previously unrepresented in the Louvre; Arch. Nat., F21 570 (III), f.17.

133. *La Décade philosophique,* 20 messidor an V, pp. 84–8.

134. Ibid., 10 thermidor an V, p. 213.

135. Baltard, *Hommage d'un artiste, aux armées de la République,* n.p., n.d., p. 2.

136. *La Décade philosophique,* 20 floréal an V, p. 305.

137. Ibid., 20 germinal an VI, p. 154. In 1794, under the first Conservatoire, two large tricolors were hung in the Grand Gallery and above the entrance to the museum; Cantarel-Besson, *La Naissance du musée,* I, p. 71.

138. For an account of the dinner, see the *Moniteur universelle* for 2 and 4 nivôse an VI (December 22 and 24, 1797); and *Réimpression de l'ancien Moniteur,* vol. 29 (1847), pp. 102, 107–8.

139. For the Treaty of Tolentino, see *Correspondance de Napoléon Ier,* vol. 2, pp. 444–9. Funds for transportation were secured by Bonaparte; see Arch. Nat., F17 1275b, f.298.

140. *La Décade philosophique,* 10 thermidor an V, p. 214.

141. Arch. Nat., F17 1275a, f.382; letter from Thouin to the Directory, dated Marseilles, 6 vendemiaire an VI.

142. On the festival, see *La Décade philosophique,* 20 thermidor an VI, pp. 301–5; *La Clef du cabinet des souverains,* no. 552 (7 thermidor an VI), pp. 4816–19; for a recent interpretation, see P. Mainardi, "Assuring the Empire of the Future: The 1798 Fête de la Liberté," *Art Journal,* 48 (Summer 1989), pp. 155–63.

143. *La Clef du cabinet des souverains,* pp. 4816–19; translation by Mainardi, "Assuring the Empire," p. 158.

144. *La Décade philosophique,* 20 prairial an VI, p. 496.

145. The complete words of the song are given in *La Décade philosophique,* 10 thermidor an VI, pp. 230–2.

CHAPTER 4. THE MUSÉE CENTRAL DES ARTS

1. Doucet, MS 1089, II (4), 13 thermidor an VI; also *La Décade philosophique,* 20 thermidor an VI, p. 305.

2. *Archives des Musées nationaux,* 1 BB 3. Procès-verbal du Conseil, p. 1, note 1. Cited in *L'an V. Dessins des grands maîtres,* exhibition catalogue, Louvre Museum, Paris, 1988, p. 24, note 1.

3. On the personnel changes in the administration, see Cantarel-Besson, *La Naissance du musée,* Introduction; II, pp. 252–3.

4. *La Décade philosophique,* 10 pluviôse an III, p. 211.

5. *Le Conservatoire du Muséum national des arts au Comité d'Instruction Publique,* Paris, 1795.

6. Cantarel-Besson, *La Naissance du musée,* I, pp. 177–9.

7. Ibid., I, pp. 184, 234–5.

8. Ibid., I, pp. 257, 265, 267. The section of the gallery already in use measured 737 feet.

9. Ibid., II, p. 41; also Arch. Nat., O2 835 (5), f.8.

10. *Notice des tableaux des trois écoles, choisis dans la collection du Muséum des arts, rassemblés au Sallon d'exposition, pendant les travaux de la Gallerie,* Paris, an IV.

11. Ibid., pp. 41–2.

12. Cantarel-Besson, *La Naissance du musée,* II, pp. 135, 142, 153, 164, 247–52.

Cantarel-Besson has recently published a sequel to these two volumes covering the Louvre administration for 1797–8, *Musée du Louvre (janvier 1797–juin 1798). Procès verbaux du conseil d'administration du Musée central des arts*, Paris, 1992, which came to my attention only after my book had gone to press. The original documents were unavailable when I was in Paris, so I quote instead from copies in the Bibliothèque Doucet, Paris.

13. See *L'an V. Dessins des grands maîtres.* Morel d'Arleux was appointed keeper of drawings.
14. See the review in *La Décade philosophique*, 30 fructidor an V, pp. 559–61.
15. *L'An V. Dessins des grands maîtres*, p. 22. The exercise book was written by B.-J. Foubert, *Recueil de Principes Elémentaires de Peinture sur l'Expression des Passions, suivi d'un Abrégé sur la Physionomie et d'un Exposé du Système nommé Physiognomie extrait des oeuvres de Ch. Le Brun, Winckelmann, Mengs, Watelet, etc., à l'usage des jeunes artistes et destiné à faciliter leurs études au Musée Central des Arts principalement dans la galerie des Dessins.*
16. *La Décade philosophique*, 30 thermidor an V, p. 365.
17. Cantarel-Besson, *La Naissance du musée*, II, p. 62.
18. See Tuetey and Guiffrey, *La Commission du muséum*, pp. 2–20, for the list.
19. For a brief history, see the report of an XIII, Arch. Nat. O2 840; also *PVCTA*, I, pp. 382–3. And see A. Dutilleux, "Le Muséum national et le Musée spéciale de l'école française à Versailles (1792–1823)," *Réunion des sociétés des beaux-arts des Départements* (1886), pp. 101–36; M. Furcy-Raynaud, *Deux musées de sculpture française à l'époque de la révolution*, Paris, 1907.
20. See C. Varon, *Rapport fait au nom des commissaires envoyés dans le département de Seine & Oise*, Paris, 1794; also *PVCTA*, II, 674–8.
21. Arch. Nat., F21 569 (6), f.67; Versailles was officially informed in March, f.73. Also *Semaines critiques*, no. 9 (May 22, 1797), pp. 430–1.
22. For example, J.-B.-P. Lebrun, an important member of the jury, was asked in ventôse of year VI to advise on the arrangement of the

French school at the Louvre and then in prairial to help determine which pictures to send to Versailles; BN, MS Français 20157, ff.120–1. Other members of the jury were Vincent, Regnault, Fragonard, Moreau le jeune, Quatremère de Quincy, Chaudet, and A.-F. Peyre.

23. Arch. Nat., F21 569 (6). On the jury's activities, see Doucet, MS 1089, I (dossiers 4, 5, 8, 10, 11). The *Semaines critiques*, though welcoming the Musée spéciale, remarked "le Musée Central de Paris réunira tout ce que la peinture offre d'excellent dans les trois écoles," no. 9 (May 22, 1797), p. 430.
24. Benezech was explicit on this point, stressing to the Musée central administration that it should concern itself with quality rather than history; that too much attention to the latter would compromise standards. It was at Versailles "que l'on pourra composer sans lacune l'histoire chronologique de l'art en France." Arch. Nat., F21 569 (6), ff.83–4.
25. *La Clef du cabinet des souverains*, 542, 27 messidor an VI (July 15, 1798), p. 4743.
26. See Carl Christian Berkheim, *Lettres sur Paris*, Heidelberg, 1809, p. 380. Also see the fascinating article by Lauzun, one of the keepers at Versailles, "Sur le tableau de la Magdeleine, peint par Lebrun," *Journal du Département de Seine et Oise*, no. 31 (10 thermidor an VI), discussed in the conclusion. For the museum's contents, see *Notice des tableaux, statues, vases, bustes, etc. composant le Musée spéciale de l'école française*, Versailles, an X.
27. Doucet, MS 1089, I (dossiers 19 and 20); selection and restoration began in October 1797.
28. *Corps Legislatif: Conseil des Cinq-Cents. Motion d'ordre par Marin sur le Muséum central des arts.* Séance of 1 nivôse an VI (December 21, 1797).
29. Quoted by Emile-Mâle, "Le séjour à Paris de 1794 à 1815 de célèbres tableaux de Rubens," pp. 159–60. Lebrun's sentiments were repeated in the first article to appear in the *Décade* on the Belgian pictures, the aim of which was to publicize "l'état précis dans lequel ils nous sont arrivés." Vol. 3, an III, pp. 94–5. Also see the report on the convoy from Lombardy, Arch. Nat., F21 570 (3), f.17.
30. See the article from the *Journal des arts*,

Deloynes, XXV, p. 670. Also the self-defense published by the museum administration, *La Décade philosophique*, 10 nivôse an VI, pp. 42–5. Included in the latter was a report from the Italian commissioners that most of the pictures confiscated needed restoration; "il est très heureux pour l'Art," they wrote, "que ces chefs-d'oeuvres soient tirés d'un pays où ils étaient totalement négligés, et il ne faudra pas moins que la main habile de nos réparateurs pour les rendre aux vrais amateurs des Arts."

31. *La Décade philosophique*, 20 messidor an V, pp. 84–8; 10 thermidor an V, pp. 212–15.

32. D. Vivant-Denon, *Discours sur les monuments d'antiquité arrivés d'Italie*, Paris, an XII, p. 3.

33. *PVABA*, I, pp. 92–3.

34. *CDD*, 16, pp. 430–1; letter from Petracchi and Caselli to Delacroix, 7 thermidor an IV (July 25, 1796). *La Décade philosophique* (20 pluviôse an VI, pp. 301–2) reproached Marin for having gone public with his complaints: "Quand même les abus dont on se plaint eussent existé, il fallait chercher à y remédier *secrètement*, et ne annoncer à l'Europe que nous n'avions dépouillé les pays conquis, de leurs précieux monumens, que pour les laisser détruire dans la ville centrale, et sous les yeux mêmes de nos plus habiles Artistes."

35. Doucet, MS 1089 (25), 8 nivôse an VI (December 28, 1798). The affair was reported by *La Décade philosophique*, 10 nivôse an VI, pp. 42–5; 20 pluviôse an VI, p. 301–2.

36. Arch. Nat., F21 570 (3), f.14; (5), f.95ff.

37. The cumbersome title of the original report is *Musée Central des Arts. Pièces relatives à l'administration de cet établissement, imprimées par ordre du Directoire exécutif*, Paris, an VI. A more polished version of the same material was published by the museum secretary, Athanase Lavallée, as *Observations sur l'administration du Musée Central des Arts*, Paris, an VI. Marin published a reply, *Réponse du représentant du peuple Marin à un écrit intitulé Musée Central des Arts . . .* , but to no effect.

38. *Pièces relatives*, pp. 27–8. In brief, the other conclusions were: (1) After cleaning, paintings should be treated with a protective layer of varnish that would also lend them an attractive luster; (2) the different branches of restoration must be practiced by specialists trained in those areas; (3) paintings should be returned to their original dimension, meaning that, wherever possible, portions of canvas added to accommodate a picture in a setting for which it was not designed should be removed.

39. *Pièces relatives*, p. 3: "On a accusé les Administrateurs du Muséum des Arts, d'impéritie, même de malvaillance, et le Gouvernement, de la négligence la plus coupable."

40. Arch. Nat., F21 570 (5), f.114. Excerpts from Marin's report appeared in *Der neue teutsche Merkur*, I (February 1798), pp. 156–7; see the superb dissertation by Jane Van Nimmen, *Responses to Raphael's Paintings at the Louvre, 1798–1848*, Ph.D. dissertation, University of Maryland, 1986, p. 64ff. Goethe, anxious to verify those reports, asked his friend Wilhelm van Humboldt, who had recently moved to Paris, for a firsthand account. In addition to describing the state of the Grand Gallery, Humboldt had this to say about Marin's report:

"The most important question is this: whether or not the pictures which have arrived so far have suffered from the transport, the treatment here, and the restoration. To answer this fully, one would have to have known them well before. Some people, who are in that position, are now complaining bitterly about it. Yet how difficult it is to distinguish how much imagination and how much politics have to do with it. Also it is certainly a natural vanity to say that something is no longer what it used to be, when one knew it before. Before she was cleaned here, the St. Cecilia was obviously dirty, but she now has a certain red coloring. All damage is thus not to be denied. I believe it is, by far, not as much as many claim *(Goethe's Briefwechsel mit den Gebrüdern von Humboldt (1795–1832*, F. Th. Bratranek, ed., Leipzig, 1876, pp. 51–54; quoted and translated by Van Nimmen, p. 67.

Incidentally, Humboldt had heard that David was behind Marin's complaints. The

English press also kept close watch on events in France; see Van Nimmen, p. 5off.

41. "Rapport sur la restauration du tableau de Raphael," *Mémoires de l'Institut. Littérature et Beaux-Arts,* vol. V, an XII, pp. 444–5. So extensive was the description of the restoration process that Hacquin complained that his trade secrets had been given away. He consequently received an indemnity from the Louvre; see Van Nimmen, *Responses,* pp. 143–4.

42. *Notice des plusieurs précieux tableaux, recueillis à Venise, Florence, Turin et Foligno,* Paris, 1800, pp. 49–53. In retrospect the merits and demerits (forcefully argued at the time by English visitors to the Louvre) of the large amount of restoration executed by the French are impossible to judge due to the passage of time and intervening restorations. It should be noted, however, that a recent Vatican publication commended the work of French restorers at the Louvre during the Revolution and Empire; see F. Manicelli, *A Masterpiece Close-up: The Transfiguration by Raphael,* The Vatican, 1979.

43. *Notice des principaux tableaux recueillis dans la Lombardie,* Paris, an VI.

44. Ibid., p. vi.

45. See Conisbee, *Painting in Eighteenth-Century France,* pp. 62–3, 69.

46. *Notice des principaux tableaux recueillis dans la Lombardie,* p. 56.

47. Ibid., pp. 59, 61.

48. H. Belting, *The End of the History of Art?* C. S. Wood, trans., Chicago, 1987, p. 73.

49. J.-B.-P. Lebrun, *Examen historique et critique des tableaux exposés provisoirement venant des premiers & second envois de Milan, Crémone, Parme, Plaisance, Modéne, Cento & Bologne . . . ,* Paris, an VI. The museum administration was upset with Lebrun for having produced his *Examen,* fearing that it would diminish sales of its own catalogue. Lebrun was made to agree to wait until a month after the exhibition opened before offering his pamphlet for sale. Doucet, MS 1089 (25); 13 nivôse an VI.

50. J.-B.-P. Lebrun, *Galerie des Peintres Flamands, Hollandais et Allemands,* 3 vols., Paris, 1792–6, I, p. v. In March 1805, Lebrun wrote to a correspondent in Rouen with respect to his *Galerie:* "Je n'ai pas

scrupuleusement suivi l'ordre chronologique, ja'i prefere de classer les maitres par ecole. Ce systeme m'a paru convenable en ce qu'il rapprochait les eleves des maitres." BN, MS Français 20157, f.45.

51. Lebrun, *Examen,* p. 49. On Gennari's dependence on Guercino, also see Charles Landon, *Annales du musée,* 17 vols., Paris 1801–9, 12 (1806), pp. 13–14; 15 (1807), p. 56; 16 (1808), pp. 63, 121.

52. Ibid., p. 49. Lebrun borrowed the line "invent and you will flourish" from a line ("Invente: tu vivras") in A.-M. Lemierre's poem "La Peinture. Poëme en trois chants," Paris, 1769.

53. *La Décade philosophique,* 30 messidor an V, p. 367.

54. M. Rosenberg, "Raphael's *Transfiguration* and Napoleon's Cultural Politics," *Eighteenth-Century Studies,* 19 (Winter 1985/6), pp. 180–205. An excellent example of how Raphael's career was used by the French as a paradigm of academic instruction is provided by Mazière de Monville in his *Vie de Pierre Mignard,* pp. 8–9. In particular, Mignard's trip to Italy, during which he freed himself of his master Vouet's style, is likened to Raphael's exposure to Leonardo and Michelangelo.

55. See *Fêtes de la Liberté et entrée triomphale des objets de sciences et d'arts recueillis en Italie. Programme,* Paris, an VI, pp. 8–9.

56. *Notice des principaux tableaux recueillis en Italie,* Paris, an VII, p. 68. The *Moniteur universelle* for August 19, 1798, p. 1330, had already noted: "We have brought from Italy the first and the last art born from the brush of Raphael. The first is an Assumption of the Virgin, which keeps to the stiff, cold manner of Perugino, his master. The last is the Transfiguration. One will see in our Museum in what state he left it" (quoted by Van Nimmen, *Responses,* p. 102).

57. Ibid., p. 53. Also Landon, *Annales du musée,* vol. 2 (1802), p. 108: "Sa manière est assez pure, mais un peu sèche. Ce qui a le plus contribué à sa gloire, est d'avoir eu pour disciple le célèbre Raphael, dont les premiers ouvrages ont été souvent confondus avec ceux de son maître."

58. A mixture of ancient and modern sculpture seems to have been used at this point. Bouchardon's *Amour,* Coustou's copy of

Duquesnoy's *Saint Suzanna,* Giambologna's *Mercury,* and two antiques are on record as having been installed in the Gallery after November 1797; see Doucet, MS 1089 (20); séance 8 frimaire an VI; Sahut, *Le Louvre de Hubert Robert,* pp. 38, 59. Michelangelo's *Slaves* were placed at the entrance to the museum in 1794; Cantarel-Besson, *La Naissance du musée,* I, p. 83.

59. Doucet, MS 1089, I (32); séance 9 ventôse an VI: "Pour la commodité et l'instruction du plus grand nombre et pour établir un ordre invariable dans la collection nationale, il est plus convenable de classer les tableaux par écoles, quoique plusieurs raisons militent en faveur du système contraire que quelque membres jugent plus favorable à l'étude."; also see (35); 23 ventôse an VI.

60. *Notice des tableaux des écoles française et flamande,* Paris, an VII, p. ii.

61. One of the responsibilities of his post as "commissioner expert" at the museum from 1797 was to lend advice on the "le classement et le placement des objets dans le Musée Central et dans celui de l'école française à Versailles." BN, MS Français, 20157, 104. He was involved in the hanging of every exhibition and installation before Vivant-Denon's takeover; Ibid., ff.105, 118, 120; Doucet, MS 1089, I (liasses 29, 31, 37–8, 40–1).

62. Doucet, MS 1089, I; séance 28 messidor an V. Lebrun's system of classification had long been used in collections of engravings.

63. Ibid., 1087, II; séance 2 floréal an IX. The Eeckhout is perhaps *Anne présentant au grand-prêtre Eli son fils Samuel,* Inv. 1267.

64. Arch. Nat., F17 1060 (4): "Mémoire serruries pour le Muséum, an VI" by Blampignon.

65. Hanging of the French pictures began in February 1798, but it was not until April that the placement of "moyens tableaux" was determined, Doucet, MS 1089, I (31, 38). Blampignon's bill for hanging the third *travée* to the right, for example, records that Lebrun's *Family of Darius* was hung first, followed by three unidentified pictures on either side. Poussin's *Manna from Heaven* was hung directly beneath the *Darius* and itself framed by four unspecified

small pictures; Arch. Nat., F17 1060 (4), pp. 35–6.

66. *Notice des tableaux des écoles française et flamande . . . et des tableaux des écoles de Lombardie et de Bologne,* Paris, an IX, p. ii: "Dans la seconde partie de la Galerie . . . les Peintres . . . ont été rangés, ainsi que dans la première partie, suivant l'ordre chronologique de leur naissance."

67. Denon still awaits the biographer he deserves. For an introduction, see Gould, *Trophy,* Chap. 5. And J. Chatelain, *Dominique Vivant Denon et le Louvre de Napoléon,* Paris, 1973.

68. Gould, *Trophy of Conquest,* p. 90.

69. Arch. Nat., AF IV 1049 (2); quoted by Van Nimmen, *Responses,* p. 138.

70. Letter to Thomas Jefferson, February 25, 1802; quoted by Van Nimmen, *Responses,* p. 127, who provides an excellent account of Cosway and her fascinating project. The plates were published in France with text (in English and French) by Julius Griffiths as *Galerie du Louvre, représentée par des gravures à l'eau forte exécutées par Maria Cosway avec une description historique et critique par J. Griffiths,* Paris, 1802 (2d ed., 1806); and in England as *Triumph of Art Works, Musée Napoléon,* London, 1804.

71. *Moniteur universelle,* no.103 (13 nivôse, an XI), p. 415; quoted by Van Nimmen, *Responses,* p. 148, whose translation in places I have used.

72. Ibid., p. 415. It was said of the *Belle Jardinière*: "It is a work of the second epoch in which, after having seen Florence, Raphael absorbed all the graces of the brush reunited in a purity of forms."

73. Ibid., p. 415; translation by Van Nimmen, *Responses,* p. 149.

74. This edition, which appeared in the spring of 1803, was based on the 1759 Bottari edition; see Van Nimmen, *Responses,* pp. 150, 177.

75. On the stylistic transition from Perugino to Raphael, see the preface to Part Three of Vasari's *Lives.* Vasari's verdicts on the two masters are incorporated into Charles Landon's critiques of their works in his *Annales du musée*; see, for example, his discussion of Perugino's *La Vierge environnée d'une gloire et d'esprits célestes,* vol. 15 (1807),

pp. 36–8; Raphael's *Holy Family* of Francis I, vol. I (1803), pp. 64–6; and his *Belle Jardinière*, vol. 4 (1803), pp. 32–4.

76. See *La Décade philosophique*, 20 germinal, an VI, p. 159. A comprehensive list of desirable early Florentine Renaissance masters, "depuis Cimabué jusqu'à Léonard de Vinci," was drawn up by Lavallée in year IX (1800–1) using Lanzi; see Redon de Belleville, *Notes et correspondance*, I, p. 228ff. Also see *La Décade*, 30 pluviôse an III, p. 345.

77. On Vasari's conception of progress, see Belting, *The End of the History of Art?* part 2; also E. Gombrich, "The Renaissance Conception of Progress and Its Consequences," in *Norm and Form*, pp. 1–10.

78. See Belting, *The End of the History of Art?* p. 81ff; also S. Alpers, "Ekphrasis and Aesthetic Attitude in Vasari's *Lives*," *JWCI*, 23 (1960), pp. 190–215.

79. Vasari's concept of the cycle is clearly expressed in the preface to Part Two of the *Lives*. On the use of the biological model in Renaissance historiography, see P. Burke, "Tradition and Experience: The Idea of Decline from Bruni to Gibbon," *Daedalus*, 105 (Summer 1976), pp. 137–52.

80. See A. Potts, "Winckelmann's Construction of History," *Art History*, 5 (1982), pp. 382–3.

81. Bellori's brief comments on art historical development are incorporated into his famous address on the "Idea" delivered to the Accademia di S. Luca in 1664, which formed the introduction to his *Vite de' Pittori, Scultori et Architetti Moderni*, Rome, 1672. Interestingly, the lives themselves are less concerned with chronological development or structure than the exemplary qualities of a given artist's work. In this respect Bellori influenced de Piles. On Bellori, see Cropper, *The Ideal of Painting*, Chap. 4.

82. On Winckelmann and his place in the history of art, see Potts, *Winckelmann's Interpretation of the History of Ancient Art in its Eighteenth-Century Context*. On the parallels between ancient and modern art, see especially 158ff; also see Potts, "Winckelmann's Construction of History."

83. See A. Potts, "Political Attitudes and the Rise of Historicism in Art Theory," *Art History*, 1 (1978), pp. 191–213. Potts makes the important point that Quatremère's pessimistic outlook on modern art (shared by German theorists of the day) was in large part due to a negative political reaction to the French Revolution. He notes that Winckelmann's ideas on art historical development from the Renaissance were given currency in France through Watelet and Levesque's *Dictionnaire des arts*. On historical pessimism in the eighteenth century, see H. Vyverberg, *Historical Pessimism in the French Enlightenment*, Cambridge, MA, 1958.

84. A.-C. Quatremère de Quincy, *Seconde suite aux Considerations sur les arts des dessin*, Paris, 1791, p. 42

85. Ibid., p. 86. On Quatremère's art theory, also see E. Pommier, *Quatremère de Quincy, Lettres à Miranda sur le déplacement des monuments de l'art de l'Italie*, Paris, 1989.

86. See Potts on Vasari in "Winckelmann's Construction of History," p. 382.

87. See Belting, *The End of the History of Art?* p. 82ff; and Pevsner, *Academies of Art*, pp. 48, 296–304. As Pamela Jones has recently demonstrated, a study collection of Renaissance masters was central to the Ambrosian Academy in Milan established by Federico Borromeo in the early seventeenth century. Borromeo explicitly hoped that study of the Old Masters would reverse what he perceived as a recent decline in art; see P. M. Jones, *Federico Borromeo and the Ambrosiana. Art Patronage and Reform in Seventeenth-Century Milan*, Cambridge, 1993, Chap. 3.

88. It is significant, however, that prior to the Revolution, Denon had published an optimistic rebuttal (*Lettre de M. de Non en réponse à une lettre d'un étranger sur le Salon de 1787*, Paris, 1787) to the pessimistic overview of French art included in Count Potocki's review of the 1787 Salon; see M. E. Zoltowska, "La première critique d'art écrite par un polonais: *Lettre d'un étranger sur le Salon de 1787* de Stanislas Kostka Potocki," *Dix-huitième siècle*, 6 (1974), pp. 325–41. Denon's own collection of art, as well as his etchings after other artists, revealed a strong interest in seventeenth- and eighteenth-cen-

tury masters of all schools, not least the French (perhaps his most remarkable picture was Watteau's *Gilles*); see *Vente du cabinet de feu M. le Baron V. Denon*, Paris, 1826; and C.-A. Amaury-Duval, *Monuments des arts du dessin chez les peuples tant anciens que modernes recuelis par le Baron Vivant Denon . . . pour servir à l'histoire des arts*, Paris, 1829.

89. T.-B. Eméric-David, "Discours historique sur la peinture moderne," *Le Musée Français, recueil complet des tableaux, statues et bas-reliefs qui composent la collection nationale*, II, 1805, p. 89. He tells us (p. 2) that the purpose of the book was "à faire revivre la collection des tableaux la plus riche qui ait encore existé, soit par le nombre, soit par la beauté des chefs-d'oeuvres qu'elle renferme." The "Discours" was published separately as a book in the same year. See Van Nimmen, *Responses*, pp. 167–8, note 52. According to Paul Lacroix in his article on Eméric-David for *Biographie universelle*, XII (1854), pp. 431–6, Eméric-David was appointed to the *Le Musée Français* project on the recommendation of Vivant Denon (and the antiquarian G. B. Visconti).

90. J. Lebreton's official *Rapport sur les beaux-arts*, Paris, 1808, p. 29, describes the Louvre as "le plus vaste moyen d'instruction que le monde puisse offrir aux artistes." Also see Blanchard de la Musse, *De l'influence des arts sur le bonheur et sur la civilisation des hommes*, Paris, an X. Linda Nochlin's remark that "art historians are . . . reluctant to proceed in anything but the celebratory mode" (*The Politics of Vision*, New York, 1989, p. 56) seems especially true of museum curators, and Denon was no exception. What museum would characterize its collection in negative terms?

91. The petition in favor of conquest appeared in the *Moniteur universelle*, 12 (12 vendémiaire an V), pp. 45–6, and is reprinted in C. Saunier, *Les Conquêtes artistiques*, pp. 51–4. See also Van Nimmen, *Responses*, p. 42, whose translation I use. The petition was signed by Chaudet, Gérard, Regnault, J.-B. Isabey, and A. Lenoir, among others.

92. On Winckelmann's attitude to seventeenth-century art, see D. Mahon, *Studies in Seicento Art and Theory*, London, 1947, pp. 212–14.

93. J.-P. Rabaut de Saint-Etienne, *Rapport . . . sur l'établissement d'un Muséum national d'antiques*, Paris, an III, pp. 4–5; reprinted in the *Magasin encyclopédique*, 1795, vol. II, pp. 366–71.

94. See *PVCTA*, I, p. 92; II, pp. 168, 178; and Cantarel-Besson, *La Naissance du musée*, I, pp. 193–5.

95. Cantarel-Besson, *La Naissance du musée*, I, pp. 201, 272.

96. Grégoire, *Rapport sur . . . le vandalisme*, p. 27: "Certes, si nos armées victorieuses pénètrent en Italie, l'enlèvement de l'Apollon du Belvédere et de l'Hercule Farnèse seroit la plus brillante conquête."

97. See Haskell and Penny, *Taste and the Antique*, Chap. XIV.

98. Arch. Nat., F21 569 (5), ff.2, 5; Doucet, 1089 (19), 25 vendemiaire, an VI. The top light obtaining in most churches, though preferred for paintings, was thought to be disadvantageous for sculpture.

99. Arch. Nat., F21 569 (5), f.10.

100. Ibid., f.16.

101. See C. Aulanier, *Histoire du palais et du musée du Louvre*, 10 vols., Paris, 1947–68, 5, p. 65ff.

102. Ibid., p. 68ff.; and Duncan and Wallach, "The Universal Survey Museum."

103. For the decoration of the galleries, see the series of articles by Charles Landon, *La Décade philosophique*, 10 frimaire an IX, pp. 424–6; 20 frimaire an IX, pp. 490–3; 20 nivôse an IX, pp. 103–6; 30 ventôse an IX, pp. 549–51; also see Landon, *Annales du musée*, I, an IX.

104. See Whiteley, "Light and Shade in French Neo-Classicism."

105. For a brief history of museum finances, see Cantarel-Besson, *La Naissance du musée*, I, pp. xx–xxiii.

106. Cantarel-Besson, *La Naissance du musée*, II, p. 50.

107. Arch. Nat., F21 570 (5), f.42.

108. Doucet, MS 1089, séance 21 vendemaire an IX; letter from Laborde de Méréville to the administration.

109. The practice began under the Conserva-

toire; see Cantarel-Besson, *La Naissance du musée*, II, p. 119.

110. Arch. Nat., F 21 570 (2), ff. 13, 18, 29. The sale, mainly of church plate, realized 34,681 francs; the estimated cost of the antiques galleries was 30,000 francs. Also see F17 1055 (10), f.9.

111. Arch. Nat., F17 1059 (23); decree of 11 brumaire an VII.

112. *La Décade philosophique,* 10 prairial an VII, p. 436.

113. An interesting account of Visconti's arrangement of the Pio-Clementino, which notes the careful balance between the demands of visual symmetry and scholarship, is given in J. Labus's "Notice biographique" included in the second edition of Visconti's museum catalogue, *Oeuvres de Ennius Quirinus Visconti. Musée Pie-Clémentin,* 7 vols., Milan, 1818, I, pp. 34–5. The author further notes: "Ennio placa les monumens dans le Musée Français, suivant l'ordre qu'il avait déjà donné aux antiquités, pour en rendre la science facile" (p. 44). There was a rough correspondence between the arrangement of the Pio-Clementino and the layout of Visconti's magnificent catalogue, as he explains in the Preface; I, p. 17.

114. *PVCTA,* II, p. 117. The architect Hubert owned the Jansen edition as well as earlier French (Huber, 1781) and Italian translations; see J.-B.-P. Lebrun, *Catalogue d'une suite précieuse de livres sur les arts,* Paris, 1798.

115. When the Albani collection was confiscated it was hoped in certain quarters that it could be re-established in Paris as Winckelmann had left it. *La Décade philosophique* (30 vendemiaire an VII, p. 183) reported:
 Cette collection arrangée systematiquement par Winckelmann, excitatit plus qu'aucune autre la curiosité des étrangers et offrait une source féconde d'instruction. Nos commissaires en Italie ont fait dessiner très-exactement le plan de cette Villa. Ils ont aussi apposé des numéros sur chacun des objets qui en ont été enlevés, de sorte qu'on pourra dans les environs de Paris, reconstruire à-peu-près le Villa Albani, et y remettre tous les monumens antiques chacun à sa place.

Also see Thouin's description of the Borghese collection, *Voyage dans le Belgique,* II, p. 285.

116. See A. D. Potts, "Greek Sculpture and Roman Copies I: Anton Raphael Mengs and the Eighteenth Century," *JWCI,* 43 (1980), pp. 150–73.

117. *La Décade philosophique,* 30 thermidor an X, pp. 345–52; 10 fructidor an X, pp. 399–408.

118. Haskell and Penny, *Taste and the Antique,* pp. 149–51.

119. A day before the *Musée des antiques* opened on 18 brumaire year IX (November 9, 1800), first anniversary of Bonaparte's coup d'état, the minister of the interior, François de Neufchâteau, was due to inaugurate the statue by placing a commemorative plaque in its base. In the event, the honor went to Bonaparte instead. On a tour of the museum two days before the scheduled ceremony, he was asked (it seems spontaneously) by a group of artists on hand to lay the plaque. Naturally, he did not disappoint them. Doucet, MS 1087; séance 16 brumaire an IX; also L. de Lanzac de Laborie, *Paris sous Napoléon,* 8 vols., Paris, 1905–13, 8, p. 245. The plaque (now preserved at the Carnavalet Museum) read:
 La statue d'Apollon . . . trouvée à Antium sur la fin du XVe siècle, placée au Vatican par Jules II au commencement du XVIe siècle, conquise en l'an V de la République par l'armée d'Italie sous les ordres du général Bonaparte, a été fixée le 21 germinal an VIII, première année de son consulat.
 Quoted by F. Benoit, *L'Art français sous la Révolution et l'Empire,* Geneva, 1975, p. 118, n. 1.

CHAPTER 5. ALEXANDRE LENOIR AND THE MUSEUM OF FRENCH MONUMENTS

1. On Lenoir and his museum, and especially his controversial place in French history, see D. Poulot, "Alexandre Lenoir et les musées des monuments français," in *Les lieux de mémoire,* P. Nora, ed., 3 vols., Paris, 1986, II, pp. 497–531; B. Foucart, "La fortune critique d'Alexandre Lenoir et du premier musée des monuments français," *L'infor-*

mation de l'histoire de l'art, 5 (1969), pp. 223–32. Also *Le Gothique retrouvé*, exhibition catalogue, C.N.M.H.S., Paris, 1979. An informative though not wholly reliable account of the museum's formation is given by C. M. Green, "Alexandre Lenoir and the Musée des monuments français," *French Historical Studies*, 12 (1981), pp. 200–22.

2. See J.-L. David, *Discours prononcé par le citoyen David . . . 17 brumaire an II*, Paris, year II; *PVCIP*, II, pp. 801–7; *PVCTA*, p. 248.

3. For a brief introduction, see E. Kennedy, *A Cultural History of the French Revolution*, New Haven, CT, 1989, Chap. VIII.

4. In February 1794, for example, Lenoir was informed after the fact that the church of Saint-Germain-des Près had been converted into a powder magazine and that the Administration des poudres et salpêtres had already "fait démonter tous les marbres de l'église." The demolitioner, F.-L. Scellier, was sent to collect the pieces. See Courajod, *Alexandre Lenoir*, I, pp. 48–9. Also see *PVCM*, I, pp. 61, 272–4; and *MMF*, III, pp. 164–215. F. Jacquemart lists the churches that had to date been turned into soldiers' barracks; *Remarques historiques et critiques sur les abbayes, collégiales . . . de Paris*, Paris, 1792, p. 82.

5. A decree of April 13, reinforced by a second of June 6, condemned anyone caught defacing a public monument to two years in prison, see Kennedy, *A Cultural History*, p. 201; and *PVCM*, I, p.xvii; notices to this effect were posted in churches. For Lenoir's comments on the Paris Commune, see the archives of the Museum of French Monuments published in the *Inventaire général des richesses d'art de la France*, 3 vols., Paris, 1883–97 (hereafter *MMF*), II, pp. 414–15; III, p. 153.

6. *PVSPRA*, p. 33.

7. Cited by Kennedy, *A Cultural History*, p. 207

8. The Abbé Grégoire's famous three addresses to the Convention mark a turning of the tide against vandalism, though, as E. Pommier has pointed out, public outcry dates from midway through the Terror itself; see "La théorie des arts," in Bordes and Michel, *Aux armes et aux arts!* p. 182ff.

9. On the history of the convent, see S. Thouroude, "Le couvent des Petits-Augustins," *l'Information d'histoire de l'art*, 4 (1964), pp. 161–77. In 1816 the convent/museum became home to the Ecole des Beaux-Arts.

10. BN Cabinet des Estampes, NA 169 (1); he enrolled at the Academy in 1778. Also see C.-N. Allou, *Notice sur la vie et les travaux d'Alexandre Lenoir*, Paris, 1842, based on a manuscript by Lenoir. Lenoir's year of birth is often given as 1762, but in his letter of application to become a Freemason, dated December 1818, he states that he was born on December 26, 1761; BN, MS Français 2480, f.214.

11. The play is entitled *Les Amis du temps passé*, Paris, 1786; the anonymous Salon pamphlet, *L'Ombre de Rubens au Sallon*, "Athens," 1787 (Deloynes, XV, no. 371). For Cochin's reaction to the latter, see Arch. Nat., O1 1919 (87), f.242.

12. See H. Stein, *Le peintre G. F. Doyen et l'origine du musée des monuments français*, Paris, 1888. From September 1790, Doyen was responsible to the Municipality of Paris and the Bureau des biens nationaux for designating objects in Paris churches worthy of conservation on artistic grounds. He emigrated to Russia in 1791.

13. *MMF*, II, p. 6.

14. *MMF*, I, p. 1ff.

15. *MMF*, I, pp. 13–15.

16. On one famous occasion, Lenoir disguised a set of bronze statues by Sarrazin as plaster in order to spare them from the Arsenal foundry; *MMF*, III, p. 153. This act of daring seems to have been exceptional, however. Government agents paid regular visits to the depot in search of raw materials and rarely left empty-handed; see Courajod, *Alexandre Lenoir*, I, pp. 17, 18, 22, 27, 35, and *passim*. Also see Foucart, "La fortune critique."

17. See *MMF*, II, pp. 17, 38–9, 43–5; Tuetey and Guiffrey, *La Commission du muséum*, pp. 36–43, 53; and *PVCM*, I, pp. xlix-l, 158.

18. *MMF*, II, pp. 39–40. Regnault insinuated that Lenoir was inappropriate for the job since he owed it to an émigré (Doyen), whom Regnault had struck from Commission des monuments. Significantly, perhaps, Regnault soon found himself in trouble with the Société populaire et républicaine des arts; see *PVSPRA*, pp. 198–9.

19. See G. Huard, "Alexandre Lenoir et le muséum," *BSHAF* (1940), pp. 188–206.
20. *MMF*, II, p. 49.
21. Arch. Nat., F17 1063 (1); *MMF*, II, p. 75; Tuetey and Guiffrey, *La Commission du muséum*, pp. 244, 289; Huard, "Alexandre Lenoir," p. 198. The depot stayed open until the end of September.
22. Arch. Nat., F17 1036 (3), quoted by Huard, "Alexandre Lenoir," p. 198.
23. A. Lenoir, *Notice succincte des objets de sculpture et d'architecture réunis au Dépôt provisoire des Petits-Augustins*, Paris, 1793. Also see *MMF*, I, p. 24: "Je sollicitai la publicité du Dépôt . . . je l'obtins. Je publiai en même temps une notice succincte . . . que je fis imprimer à mes frais." Elsewhere (*MMF*, II, p. 59) he claimed the *Notice* was published in June and distributed free. A copy was sent to the Commission late in July; *PVCM*, I, pp. 247–8.
24. See Courajod, *Alexandre Lenoir*, I, p. 1ff.
25. Lenoir, *Notice succincte*, p. 12.
26. Courajod, *Alexandre Lenoir*, II, p.v.
27. *MMF*, II, p. 107; also Courajod, *Alexandre Lenoir*, I, pp. 24–5. After the Terror Lenoir was criticized for having turned his back on Leblond and the Commission des monuments; see *Journal des savants,* 30 ventôse an V, p. 201.
28. Courajod, *Alexandre Lenoir*, I, p. 20; *MMF*, II, pp. 90–1.
29. *MMF*, II, pp. 102–3, 148; Courajod, *Alexandre Lenoir*, I, pp. 18–19, 46. Lenoir made some effort to preserve portraits of the first rank; in an inventory of August 1795 he listed 133 "portraits précieux" still at the depot; *MMF*, II, p. 240; Courajod, I, pp. 197–210.
30. *MMF*, I, p. 16.
 Ils y formèrent . . . une montagne verdoyante et triomphante, allégorie à la "Montagne" de l'Assemblée; des cyprès, des pins, des lis, des sapins et des gazons furent plantés. La sein de cette montagne offre une grotte formée par les débris des tombeaux des rois de France; les marbres qui jadis ornaient les sépulcres y ont été apportés en grand nombre pour former les voûtes et les piliers de cette grotte patriotique. J'ai vu plusieurs figures de rois, sculp-

tées en pierre de liais, placés en travers des piliers pour servir de frontons; les matières les plus belles en ce genre ont été employées sans art par des mains libres. Ce monument bizarre érigé à la liberté est peut-être la leçon la plus philosophique qui puisse se donner en ce genre.
31. Arch. Nat., F17 1280A (3); the catalogue is filed with the letter; also see *PVCTA*, I, p. 328.
32. A. Lenoir, *Essai sur le Muséum de peinture*, Paris, an II (1794), pp. 7–8.
33. *PVCTA*, I, p. 346; also Arch. Nat., F17 1280A, "Rapport sur le catalogue des Petits-Augustins," by Varon, Picault, and Lebrun, dated 30 thermidor an II; and *MMF*, II, p. 202. It was Lebrun who argued most forcefully against the catalogue.
34. See Lenoir's "Rapport sur le dépôt des monumens . . . et sur la nécessité de rétablir les monumens des arts, pour leur conservation," dated brumaire an III, Arch. Nat., F17 1280A (5); also Courajod, *Alexandre Lenoir*, I, p. 69; and *MMF*, II, p. 217ff.
35. Courajod, *Alexandre Lenoir*, I, p. 73.
36. *MMF*, I, pp. 34, 22ff.; also Courajod, *Alexandre Lenoir*, I, p. 90.
37. Courajod, *Alexandre Lenoir*, I, p. 84. Lenoir announced the publication in fructidor an III; a printed copy was sent to the CIP at the start of vendemiaire an IV, three weeks before it approved the museum.
38. A. Babeau, *Lettres d'une voyageuse anglaise*, Paris, 1888, p. 114.
39. A. Lenoir, *Notice historique des monumens des arts, réunis au dépôt national . . .* , Paris, an IV.
40. *MMF*, II, pp. 305–6.
41. For the thermidorian reaction to iconoclasm during the Terror, see B. Baczko, *Comment sortir de la Terreur*, Paris, 1989, Chap. IV.
42. Ibid., p. 299. Also see Dominique Poulot's discussion of the Musée des monuments as a *lieu de mémoire*; "Alexandre Lenoir et les musées des monuments français"; and H. Honour, *Romanticism*, New York, 1979, pp. 162–3.
43. Lenoir, *Notice historique*, an IV, p. vi.
44. *MMF*, II, p. 304; dated 18 germinal an IV (April 7, 1796).

45. S. Mercier, "Sur le dépôt des Petits-Augustins, dit: Le Musée des Monumens Français," *Paris pendant l'année 1797*, V, CXXXIX, pp. 473–5.

46. Arch. Nat., F 17 1280A, report of 5 brumaire an III (October 27, 1794), reproduced in *MMF*, II, p. 217ff.

47. Arch. Nat., F 17 1280A, "Catalogue des objets"; also *Description historique*, an VIII, p. 118. In his first *Rapport* (p. 27) on vandalism, Grégoire wrote: "Les monumens du moyen âge formeront des suites intéresantes, sinon pour la beauté du travail, au moins pour l'histoire et la chronologie." Grégoire's report was made after the manuscript of Lenoir's catalogue was received by the CTA and CIP, and was therefore perhaps indebted to it to some degree.

48. Arch. Nat., O1 1913 (75), ff.215–17. Proposing to use Montfaucon as his primary guide, Cochin argued in a letter to d'Angiviller:
 Je crois que cecy entre d'autant mieux dans vos projets que vous avez parû determiné à demander, dans les tableaux que vous ordonnerés, des sujets de l'histoire de France. Il seroit avantageux pour eux [artists] qu'on leur epargnât la peine et les pertes de temps qu'exigent ces recherches.

49. *MMF*, I, p. 26.

50. Poulot, "Alexandre Lenoir," pp. 513–14.

51. *MMF*, II, p. 305.

52. Quoted by Poulot, "Alexandre Lenoir," p. 513. Also see D. Poulot, "Le reste dans les musées," *Traverses,* 12 (1978), pp. 100–16.

53. *MMF*, II, p. 240ff.

54. *MMF*, II, pp. 305–6.

55. Arch. Nat., F21 569, f.100; also *MMF*, I, pp. 83–4, II, p. 333. The jury included two enemies of Lenoir: J.-B.-P. Lebrun and Quatremère de Quincy.

56. Over the years Lenoir took little interest in religious sculpture, probably mostly because of the state's official position on Christianity. For a highly critical overview, see J. Vanuxem, "La sculpture religieuse au Musée des monuments français," *Ecole du Louvre. Positions des thèses soutenus par les anciens élèves de l'école du Louvre de 1911 à 1944*, Paris, 1956, pp. 200–3.

57. For a list of sculptures and columns transferred to the Louvre, see *MMF*, II, pp. 248–51.

58. Lenoir's interpretation of these altars was seemingly influenced by C.-C. Baudelot de Dairval's *Description des bas-reliefs anciens trouvés . . . dans l'église cathédral de Paris*, Paris, 1711. The sculptures are now displayed at the Musée de Cluny.

59. A. Lenoir, *Description historique et chronologique des monumens de sculpture réunis au Musée des monumens français*, Paris, an VIII, p. 79:
 C'est à ces peuples célebres [the Romans] que nous devons les notions que nous avons des arts; et les monumens de l'ancienne Gaule que je vais décrire, en sont une preuve incontestable, puisque leur exécution porte le vrai style romain tant dans le dessin que dans les formes, et que l'on y distingue parfaitement les mêmes principes dans le travail.
 Thanks to these altars Lenoir was able to claim: "Mon Musée . . . montre l'histoire en France, sans interruption, depuis le règne de Tibère jusqu'à nos jours"; *MMF*, III, p. 62.

60. Lenoir, *Description historique*, an VIII, p. 6.

61. Arch. Nat., F17 1059, 1060.

62. Arch. Nat., F13 1113; Lenoir to Chaptal, dated 21 pluviose an X. Also see Lenoir, *Description historique*, an VIII, p. 8 where he emphasized his responsibility for "le placement, la reconstruction et la restauration des monumens, l'arrangement des siècles, leur distribution, le style qui leur est propre, les couleurs à donner tant aux monumens qu'aux murailles, et en général tout ce qui peut contribuer à rendre mes portraits exacts."

63. S. Bann, *The Clothing of Clio*, Cambridge, 1984, Chap. 4. It should be said that many contemporary visitors found his museum highly illusionary and evocative.

64. Lenoir was interested in a history of customs and manners of the type pioneered earlier in the century by Voltaire. Lenoir's sculptures in their fabricated environments were useful to the historian in the way that Jean Chapelain argued medieval romances could be in his *De la lecture des vieux romans*, published in 1728; see C.

Ginzburg, "Fiction as Historical Evidence: A Dialogue in Paris, 1646," *The Yale Journal of Criticism*, 5 (1992), pp. 165–78.

65. Arch. Nat., F13 871; letter of Peyre and Lenoir, dated messidor an IV; see also bills filed under F17 1259.

66. *MMF*, II, pp. 396–7; Courajod, *Alexandre Lenoir*, I, p. 106.

67. For the stained glass in the museum, see Lenoir, *Description historique,* an VIII, pp. 368–70, 373–92.

68. *MMF*, I, pp. 69–70: According to Peyre the museum contained "les images ou les monuments élevés à la gloire des grands hommes." Also see J. Lavallée's article in *Semaines critiques, ou gestes de l'an cinq,* 13, 1 messidor an V (June 19, 1796), p. 161.

69. Ibid., I, pp. 322–3.

70. See Poulot, "Alexandre Lenoir," p. 505ff.

71. *MMF*, I, p. 140; also see A. Lenoir, *Description historique et chronologique des monumens de sculpture réunis au Musée des monumens français,* Paris, an X, pp. 338–41.

72. Some known views of the garden are listed by L. Réau, "Le jardin Elysée du Musée des monuments français," *Beaux-arts* (January 1924), p. 1ff.

73. *Description historique,* an VIII, pp. 337–41.

74. See G. Huard, "La salle du XIIIe siècle au Musée des monuments français à l'Ecole des beaux-arts," *Revue de l'art ancien et moderne,* 47 (1925), pp. 113–26. Also see Thouroude, "Le couvent des Petits-Augustins."

75. Lenoir, *Description historique,* an VIII, p. 139.

76. On the publication and reception of Winckelmann's ideas in France, see E. Pommier, "Winckelmann et la vision de l'Antiquité classique dans la France des Lumières et de la Révolution," *Revue de l'art,* 83 (1989), pp. 9–20.

77. Lenoir, *Description historique,* an VIII, p. 351. The monument consisted of a bust of Winckelmann commissioned from Michallon atop a pedestal in which Lenoir placed "un bas-reliefs qu'il a publiés dans ses ouvrages."

78. Ibid., p. 25. The quotation from Rousseau comes from Book IV, Chapter 4 of The

Social Contract: "Experience teaches us daily the causes of revolutions in empires."

79. A. Lenoir, *Musée des monuments français, recueil de portraits inédits,* Paris, 1809, p. 17.

80. *Description historique,* an VIII, p. 35ff. Also see Lenoir's appreciation of Francis I's patronage in his *Rapport historique sur le château d'Anet,* Paris, an VIII.

81. J.-B. Réville and Lavallée, *Vues pittoresques et perspectives des salles du Musée des monuments français,* Paris, 1816, p. 34.

82. Lenoir, *Recueil de portraits,* p. xiii. Foreign visitors noted the graduated lighting; see W. Shepherd, *Paris in 1802 and 1814,* London, 1814, p. 84; and J. F. Reichardt, *Un hiver à Paris sous le Consulat,* 1803, p. 183.

83. Idem, *Musée des monumens français,* 5 vols., Paris, 1800–6, I, pp. 14–15.

84. *Description historique,* an VIII, p. 161. Lenoir's theories about the origins of Gothic architecture were rejected by many of his contemporaries; see, for example, J.-C. Huet, *Parallèle des temples anciens, gothiques et modernes,* Paris, 1809, pp. 41–2. Also see Foucart, "La fortune critique"; and J. Vanuxem, "Aperçus sur quelques tableaux représentant le Musée des monuments français," *BSHAF* (1971), pp. 141–51.

85. See *Le Gothic retrouvé,* p. 83.

86. Lenoir had problems with the architecture of this room, see Thouroude, "Le couvent des Petits-Augustins," p. 170.

87. *MMF,* I, p. 231.

88. BN, Cabinet des Estampes, MS Ya2 151 (II), p. 21.

89. Lenoir, *Musée des monuments français,* II, p. 100.

90. *MMF*, III, p. 277; article in the *Moniteur universelle* for June 7, 1819. A well-documented example is presented by G. Huard, "Le tombeau de Gabrielle d'Estrées au Musée des monuments français," *BSHAF* (1932), pp. 166–74. Complaints about Lenoir's restorations date from the Consulate; see L.-P. Deseine, *Opinion sur les musées,* Paris, 1802.

91. See the description in Thiery, *Guide des amateurs,* I, pp. 667–8.

92. See Lamotte's account in *MMF*, II, p. 367, and compare it to Lenoir's description in

his *Musée des monuments français*, II, p. 105.

93. Lenoir, *Description historique*, an X, p. 240.

94. L.-P. Deseine, *Opinion sur les musées*, p. 367 of the general edition of his writings, *Notices historiques . . . suivies de deux écrits*, Paris, 1814; also see Lenoir, *Description historique*, an VIII, pp. 242–5; *MMF*, III, p. 203; and Lenoir, *Musée des monumens français*, IV, pp. 77–85.

95. See the account accompanying the sketch by J.-A. Guibert, dated floréal an II; Arch. Nat., F17 1043 (1). The sculptor L.-S. Boizot supervised the clearance of Saint-Sulpice on behalf of the Commission des monuments; *PVCM*, II, pp. 215–19. For an account of the dismantling of Turenne's tomb at Saint-Denis, see F17 1059 (5).

96. Hans Belting observes that Vasari omits Gothic and Byzantine art from his art historical schema because the "maniera tedesca . . . seems to lack order, because it doesn't speak the language of antiquity. It is so to speak ungrammatical: there is only *antique* grammar." *The End of the History of Art?* p. 73.

97. In 1802 the minister of the interior, Chaptal, reassured Lenoir: "Ce qui concerne la restauration des monumens n'appartient qu'à vous seul . . . et jamais il n'a été dans mon intention de vous retirer cette partie essentielle de vos attributions." *MMF*, III, p. 54.

98. See *MMF*, I, pp. 151–2.

99. The contents as of 1816 are listed in Reville and Lavallée, *Vues pittoresques*, and in J.-E. Biet and J.-P. Brès, *Souvenirs du Musée des monumens français*, Paris, 1821. Also see M. Gallet, "Une vue de l'ancien Musée des monuments français," *Bulletin du Musée Carnavalet* (June 1969), pp. 17–19.

100. The most interesting example is the Blanche de Castille monument, "entièrement refait" by Lenoir using various architectural fragments, sculpted arabesques, and mosaic pieces from Saint-Denis. Reconfigured according to his specifications, the monument could then serve as an "autorité pour constater ce que j'ai avancé . . . sur l'architecture arabe, improprement dit gothique."

Lenoir, *Musée des monumens français*, V, p. 232; also see *MMF*, !II, p. 199.

101. See A. Lenoir, *Rapport historique sur le château d'Anet*; idem, *Suite de rapport sur le château d'Anet*, Paris, an VIII; Courajod, *Alexandre Lenoir*, I, pp. 103, 128, 132; *MMF*, I, pp. 92–3, 153–5, 271–2; and M. Mayer, *Le Château d'Anet*, 1952.

102. The lack of a dignified entrance was a source of complaint (see the report of Petit-Radel to the Conseil des bâtiments civils of floréal an VIII, Arch. Nat., F13 507); at one point there was talk of Peyre building a façade in the form of "une pyramide Egyptienne" (F13 871; vendemiaire an VI).

103. *MMF*, I, p. 232. A plan by Lenoir at the Louvre (Album Lenoir, Cabinet des Dessins, vol. I) shows how the three courtyards would have been arranged. From the entrance, incorporated into the sixteenth-century courtyard, the visitor would walk due west, away from what is now the rue des Beaux-Arts, into the fifteenth-century courtyard and then into the "cour Gothique."

104. On Gaillon, see Courajod, *Alexandre Lenoir*, II, p. 74ff; also *Description historique*, an X, p. 180. On the acquisition of the château, see *MMF*, I, p. 246; III, pp. 58–60. In his letter to Bonaparte of March 1801, Lenoir noted that the fifteenth- and sixteenth-century courtyards were complete and that "la troisième cour sera ornée d'ogives que je puis obtenir de la démolition projetée d'un édifice du quatorzième siècle; elle formera le complément des trois époques de l'architecture en France"; *MMF*, I, p. 233.

105. Petit de Bachaumont was among the first to single out Goujon's *Fontaine des Innocents* for praise; *Essai sur la peinture*, p. 62. Also see A.-N. Dezallier d'Argenville, *Vies des fameux sculpteurs*, Paris, 1787, pp. 109–15; Thiéry, *Guide des amateurs*, I, p. 498; and P. Chaussard, *Le Pausanias françois: Le Salon de 1806*, Paris, 1806, p. 30; idem, *Sur le tableau des Sabines par David*, an VI, p. 40.

106. On Pajou's restoration of the fountain, see *NAAF* (1906), p. 215; letter from d'Angiviller to Pierre, dated November 14, 1787; and J.-G. Legrand and C.-P. Landon, *Description de Paris*, Paris, 1808, II, pp. 71–4. A copy of Pilon's *Three Graces*

adorned a fountain in the top-lighted stair-well of the house Charles de Wailly built for himself in the 1780s; see A. Braham, *The Architecture of the French Enlighten-ment,* London, 1980, p. 104. Goujon's cariatides in what was then the Salle des antiques of the Louvre form the backdrop to David's painting of *Paris and Helen* of 1788.

107. See N. R. Johnson, *Louis XIV and the Age of the Enlightenment: The Myth of the Sun King from 1715 to 1789, Studies on Voltaire and the Eighteenth Century,* vol. 172, Oxford, 1978. Petit de Bachaumont opined at midcentury that Francis I's efforts to stimulate art had been "peu heureux." Arsenal, MS 4041, f.367.

108. Quoted by Johnson, *Louis XIV,* p. 190.

109. Lenoir, *Description historique,* an VIII, p. 259.

110. P. Chaussard, *Essai philosophique sur la dignité des arts,* Paris, an VI, p. 12.

111. Deloynes, LVII, no. 1817.

112. J. Lavallée, *Tableau philosophique du règne de Louis XIV, ou Louis XIV jugé par un François libre,* Strasbourg, 1791, pp. 287–8.

113. Revolutionary criticism of the Academy dates from 1789. See the speech made in the Academy by J.-B. Restout on December 19, 1789, published as *Discours prononcé dans l'Académie royale de peinture,* Paris, 1790; cited by Leith, *The Idea of Art as Propaganda,* p. 142. Lenoir describes him-self as a "victim" in his *Description his-torique* of an VIII, p. 316. He continued to criticize the Academy after its return in 1795 under the guise of the Institut; see, for example, Lenoir, *Musée des monumens,* I, pp. 51–2; Lenoir, *Description historique,* an X, p. 32ff. Lenoir's monument to J.-G. Drouais should be interpreted as a form of compensation for the Academy's controver-sial refusal to award the young painter posthumous admission to its ranks follow-ing his death in 1788; see Lenoir, *Descrip-tion historique,* an VIII, pp. 337–41.

114. *La Décade philosophique,* 20 germinal an VI, pp. 155–6.

115. Lenoir, *Description historique,* an X, p. 32. Chaussard also held Lebrun to blame, call-ing him an "esclave à la cour, tyran dans

l'école"; *Essai philosophique,* p. 11. The anonymous critic for the *La Clef du cabinet des souverains,* 84, 24 germinal an V (April 13, 1797), p. 837, however, thought Lenoir's attack on Lebrun exaggerated and insisted that he was after all a great painter. Also see R. Wrigley, "The Afterlife of an Academician," in *Courage and Cruelty: Lebrun's Massacre of the Innocents and Horatio Cocles in Context,* exhibition cata-logue, Dulwich Picture Gallery, London, 1990.

116. Lenoir, *Description historique,* an VIII, nos. 174, 190, 197.

117. On Le Sueur, Lenoir (quoting Qua-tremère) remarked that he disdained Lebrun's academy, preferring the "égalité" of the rival Academy of Saint-Luc. He added gratuitously that the latter was destroyed by Pierre, "artiste aussi médiocre qu'il était hautain." Lenoir, *Description historique,* an VIII, p. 39. The intrigues against Poussin are also reported in the catalogue, p. 37. According to Lenoir, Sarrazin was "un des créateurs de la société d'artistes libres qui ne voulurent pas s'astreindre à acheter une maîtrise pour faire valoir leurs talents." *MMF,* II, p. 186. Puget's refusal to work for Lebrun was well known by the late eighteenth century; see Chaussard, *Essai philosophique,* p. 11; J. Lebreton, *Notice historique sur la vie et les ouvrages de Pierre Julien,* Paris, an XIV, pp. 16–17.

118. On Vasari's use of his prefaces, see Alpers, "Ekphrasis and Aesthetic Attitudes in Vasari's *Lives.*"

119. One anonymous visitor wrote in an IV: "Il faut avoir à la main ce catalogue raisonné." Deloynes, LVII, no. 1815. Copies of the catalogue are held by many visitors in con-temporary views of the museum. Signifi-cantly, pieces of Lenoir's text figured in translation in foreign guidebooks to Paris; see, for example, H. R. Yorke, *Letters from France,* 2 vols., London, 1814, II, pp. 108–33; and J.-G. Lemaistre, *A Rough Sketch of Modern Paris* (1802), p. 240. The first volume of Lenoir's *Musée des monu-mens français* was translated into English by Julius Griffiths (who also published Cosway's plates in England) in 1803 and

was printed and sold in both Paris and London.

120. *La Clef du cabinet des souverains*, 84, 24 germinal an V (April 13, 1797), p. 836.

121. Ibid., p. 837.

122. *Description historique*, an VIII, pp. 259–61, 292, and passim. Also see, for example, his negative characterizations of works by Girardon, *MMF*, III, p. 61, and the monument to Charles de Créqui, *MMF*, I, pp. 76–9, 99–106; Lenoir, *Musée des monumens français*, V, pp. 130–1.

123. L.-P. Deseine, *Lettre sur la sculpture destinée à orner les temples consacrés au culte catholique* [Paris, 1802], p. 13. The monument was eventually returned to Saint-Sulpice in 1821–2; see F. Souchal, *Les Slodtz*, Paris, 1967, pp. 679–81.

124. Although an eighteenth-century gallery proper was never built, Lenoir did include a full chapter in his catalogue on eighteenth-century monuments. The introduction to the chapter began by once more assailing Lebrun and blaming him for the decadence seen in the work of the Coypels, Van Loos, and Boucher. It ended by praising Vien for "raising art from the dust." Lenoir then reproduces an epistle to Vien by Ducis, read at the Institut in an VII, in which the venerable painter is celebrated as the "fortunate restorer" of the French school. Lenoir, *Description historique*, an VIII, pp. 315–24.

125. See F. Furet, *Penser la Révolution*, Paris, 1979.

126. *MMF*, I, p. 391.

127. Lenoir, *Musée royal des monumens français*, Paris, 1815, p. 45. Courajod provides a concise and amusing overview of Lenoir's repositioning in 1814–15; *Alexandre Lenoir*, II, pp. 210–13.

128. From an article in the *Annales archéologiques* of 1852, quoted by Courajod, *Alexandre Lenoir*, II, p. 207.

129. The fourteenth-century room wasn't completed until 1805 (*MMF*, III, p. 90) whereas the floor of the Salle d'introduction was laid only a year later (III, p. 95), but no major construction was undertaken after 1802, as is clear from a report published by Lenoir's secretary in 1809; E. Johanneau, *Coup-d'oeil sur l'état actuel et futur du Musée des monuments français*, Paris, 1809. In the same year the museum's operating budget was cut by 25 percent, ending hopes of further expansion; see *MMF*, I, p. 384.

130. A.-C. Quatremère de Quincy, *Rapport fait au Conseil général . . . le 15 thermidor an VIII, sur l'Instruction publique, la restitution des tombeaux, mausolées, etc*, Paris, an VIII. Also see R. Schneider, "Un ennemi du Musée des monuments français," *GBA* (1909), p. 356 and passim.

131. Deseine, *Lettre sur la sculpture*, p. 221 of the general edition of Deseine's writings, *Notices historiques . . . suivis de deux écrits*, Paris, 1814. On Deseine, see W. Szambien, "Les musées tueront-ils l'art? A propos de quelques animadversions de Deseine." In J. Guillerme, ed., *Les Collections: Fables et programmes*, Paris, 1993, pp. 335–40.

132. *MMF*, I, p. 64.

133. Deseine first became involved in restitution in 1797 when he sent a memoir to the director general of public instruction (see *Lettre sur la sculpture*, p. 221) and negotiated the return of sculptures from the Petits-Augustins to Saint-Roch and Saint-Sulpice; see Arch. Nat., F17 1241 (Dossier Deseine), report of 5 fructidor an V. At this time it seems the government was not opposed to the restitution of certain objects provided the church paid the bills.

134. Deseine, *Opinion sur les musées*, pp. 241–2.

135. Quatremère, *Rapport . . . sur . . . la restitution des tombeaux*, pp. 37–8. The same passage recurs almost verbatim in Quatremère's *Considérations morales sur la destination des ouvrages de l'art*, Paris, 1815, pp. 56–7. This text was read to the classe des Beaux-Arts of the Institut in 1806; a summary was published in the *Magasin encyclopédique*, VI (1806). Also see the *Moniteur* for February 22, 1806.

136. See D. Poulot, "Un regard britannique sur l'héritage de la civilisation: le témoinage des récits de visites de musées au XVIIIème siècle," *Enlightenment – Revue des études dix-huitièmistes*, 1 (1988), pp. 11–52.

137. See *MMF*, I, p. 279ff; and III, pp. 127–30.

138. See, for example, *Journal de Paris*, 26 pluviôse an X, pp. 876–7, criticizing his restoration work, followed by a second article on the same subject in the *Journal des*

bâtiments civils for 29 pluviôse, pp. 278–9; also see *Journal des arts,* 30 floréal an X, pp. 265–70.

139. In 1801 the prefect of the Seine-Inférieure, Beugnot, drew heavily on Quatremère and Deseine's writings (he was a friend of the former) to prevent Lenoir from removing the tombs of Henri de Guise and the Princesse de Clèves from the town of Eu. See *MMF,* III, pp. 16–20.

140. *MMF,* I, p. 361; letter from J.-V.-B. Neuville to Champagny, minister of the interior, dated 1807.

141. *MMF,* III, pp. 71, 89–90.

142. Lanzac de Laborie, *Paris sous Napoléon,* 8, p. 351.

143. *MMF,* III, pp. 316–27; also L. Courajod, *Les débris du Musée des monuments français à l'Ecole des beaux-arts,* Caen, 1885 (extract from the *Bulletin monumental,* vol. 51).

144. As mentioned already, Lenoir renamed the prospective nineteenth-century gallery the Salle des faits héroiques de l'Empéreur Napoléon le Grand, *MMF,* I, p. 391. Josephine was treated to a candlelighted tour of the museum in 1807, and Lenoir put on a similar spectacle in honor of Napoleon's 1810 wedding to Marie-Louise; see Lanzac de Laborie, *Paris sous Napoléon,* 8, p. 352; *MMF,* III, pp. 132–4.

145. *Journal des arts,* 30 floréal an X, p. 269. The parallels between the two museums and the equal applicability of Quatremère's argument to both were noted in an article in the *Journal de Paris,* 10 frimaire an X, pp. 428–9. Also see Lanzac de Laborie, *Paris sous Napoléon,* 8, p. 308.
In his own defense, Lenoir shrewdly made an analogy between his own triumph over "barbarism" resulting in the Musée des monuments and Bonaparte's confiscation of art in conquered lands; *MMF,* I, p. 232, "Rapport au Premier Consul sur le Musée des Monuments français," dated March 1801.
After 1815 Louis XVIII proved equally reluctant to return émigré property fearing the loss of luxury goods that decorated his palaces! See F. Boyer, "Louis XVIII et la restitution des oeuvres d'art confisquées

sous le révolution et l'empire," *BSHAF* (1965), p. 204.

146. *MMF,* I, p. 287.

147. Various proposals to move the museum to another location – the Pantheon, Monceau, Saint-Denis – came to nothing. See Allou, *Notice,* p. 9; *Le Moniteur universelle,* February 22, 1806, p. 209; Schneider, "Un ennemi du Musée des monuments," p. 362.; and Arch. Nat., F17 1280A (7); Lenoir to the minister of the interior, August 8, 1811.

148. *MMF,* I, pp. 438–9; also Poulot, "Alexandre Lenoir et les musées des monuments français," p. 505.

149. Arch. Nat., F21 567, "Supplique d'Alexandre Lenoir," dated 1816.

150. *MMF,* III, pp. 316–27; and Courajod, *Les débris du Musée des monuments français à l'Ecole des beaux-arts.*

151. *MMF,* III, p. 143.

CONCLUSION

1. The British plenipotentiary in Paris reckoned that 5,000 Britons alone made the journey to Paris in 1802; see Sir John Deal Paul, *Journal d'un voyage à Paris au mois d'août 1802,* Paris, 1913. Also Poulot, "Un regard brittanique." Selected German responses are discussed by Van Nimmen, *Responses.*

2. T. Jessop, *Journal d'un voyage à Paris en Septembre–Octobre 1820,* Paris, 1928, p. 57. An anonymous review of William Shepherd's *Paris in 1802 and 1814,* London, 1814, remarked: "He seems . . . to have experienced, as we believe every visitor of the Louvre does, a sort of distraction in his first visit, which does not allow a minute inspection"; *The Edinburgh Review,* September 1814, p. 470.

3. Quoted by Gould, *Trophy of Conquest,* p. 84.

4. J. Griffiths and M. Cosway, *Gallery of the Louvre,* Paris, 1802, p.i.

5. See Gould, *Trophy of Conquest,* p. 91ff.

6. See Lanzac de Laborie, *Paris sous Napoléon,* 8, pp. 274–5, 282.

7. Ibid., p. 300–1; also Gould, *Trophy of Conquest,* pp. 109–13. Denon's "primitives" made their debut at the Salon in 1814. The

catalogue reveals the clear influence of Vasari in recommending that amateurs "suivre les artistes dans la carrière ouverte depuis l'an 1240, époque de la naissance de Cimabué . . . jusqu'à l'année 1520, époque de la mort de Raphael. . . . Ils se plairont à distribuer à chacun d'eux le degré d'estime ou de blâme qu'ils méritent, pour avoir avancé les progrès de l'art par quelque découverte, ou l'avoir laissé rétrograder en s'attachant plus aux exemples des anciens, qu'aux efforts de leurs contemporains qui les ont surpassés." *Notice des tableaux des écoles primitives de l'Italie, de l'Allemagne . . .*, Paris, 1814, p. ii.

8. See Aulanier, *Histoire du palais,* I, pp. 21–3; and Sahut, *Le Louvre d'Hubert Robert,* p. 19.

9. On Zix's drawings, see G. Brière, "Vues de la Grande Galerie du Musée Napoléon," *BSHAF* (1920), pp. 256–63.

10. See Boyer, "Louis XVIII et la restitution des oeuvres d'art," p. 202. On the process of restitution, see Gould, *Trophy of Conquest,* Chap. 7.

11. See Gould, *Trophy of Conquest,* pp. 134–5.

12. Ibid., p. 128. For a list of works remaining in the Louvre, see F. Boyer, "Le Musée du Louvre après les restitutions d'oeuvres d'art de l'étranger et les musées des départements," *BSHAF* (1969), pp. 80–3. Some indignation may still be felt in the series of articles by Eugène Muntz, "Les invasions de 1814–1815 et la spoliation de nos musées," in the *Nouvelle Revue* for April 15, May 15, and August 15, 1897.

13. See E. Pommier, "Naissance des musées de province," in *Les lieux de mémoire. La Nation,* Paris, 1986, pp. 451–95; idem, "La création des musées de province: Les ratures de l'arrêté de l'an IX," *La Revue de l'art,* 85 (1989), pp. 328–35; and D. J. Sherman, *Worthy Monuments,* Cambridge, MA, 1989.

14. H. Milton, *Letters on the Fine Arts, written from Paris in the Year 1815,* London, 1816, p. 92.

15. F. Boyer, "Trois rapports sur la réorganisation du Musée du Louvre," *BSHAF* (1965), pp. 259–63. The sets by Le Sueur, Rubens, and Vernet had been displayed at the Luxembourg Palace since 1803; it was Qua-tremère, no less, who suggested they be returned to the Louvre.

16. As the press noted at the time, "C'est une institution depuis longtemps solicitée." See G. Lacambre, *Le Musée du Luxembourg en 1875,* exhibition catalogue, Grand Palais, Paris, 1974, p. 7.

17. See R. Krauss, "Photography's Discursive Spaces," in *The Contest of Meaning,* Richard Bolton, ed., Cambridge, 1990, pp. 287–302; and F. Haskell, "The Artist and the Museum," *New York Review of Books,* 34 (December 3, 1987), pp. 38–42.

18. This point is made by Van Nimmen, *Responses,* p. 233.

19. Ludwig I of Bavaria, *Briefwechsel zwishen Ludwig I. von Bayern und Georg von Dillis,* R. Messerer, ed., Munich, 1966, p. xvii; quoted by Van Nimmen, *Responses,* p. 234. Dillis visited the Louvre in 1806 and again in 1815 to collect paintings reclaimed by Munich.

20. Duncan and Wallach, "The Universal Survey Museum," p. 457ff.

21. A brief history of the Vatican museums is given in *The Vatican Collections: The Papacy and Art,* Metropolitan Museum of Art, New York, 1982. Also Springer, *The Marble Wilderness.*

22. This is perhaps particularly true of Caravaggio's *Deposition* in view of its original relationship with the altar beneath it; see G. Wright, "Caravaggio's Entombment Considered *in situ,*" *Art Bulletin,* LX (1978), pp. 35–42.

23. The literature on museums and their effect on art objects is extensive and growing rapidly; see, for a start, F. Haskell, "Les musées et leurs ennemis," *Actes de la recherche en sciences sociales,* 43 (1983), pp. 103–6; and D. Crimp, "The End of Art and the Origin of the Museum," *Art Journal,* 46 (1987), pp. 261–6.

24. This argument is pursued in articles by S. Greenblatt, "Resonance and Wonder," and S. Alpers, "The Museum as a Way of Seeing," in Karp and Lavine, *Exhibiting Cultures,* pp. 42–56, 25–32 respectively.

25. Abbé J.-B. Dubos, *Réflexions critiques,* Paris, 1719, I, p. 470.

26. See Poulot, "Alexandre Lenoir et les musées des monuments français" and "Un regard

britannique sur l'héritage de la civilization."
Also see Haskell, "Les musées et leurs enne-
mis."

27. F. von Schlegel, *The Aesthetic and Miscella-
neous Works of Friedrich von Schlegel,* E.
Millington, trans., London, 1849, p. 102–3
and passim.

28. See Pommier, *Lettres à Miranda,* p. 38.

29. It would be worth considering if the unease
of much baroque art in a museum setting is
rooted in what Martin Jay and others have
identified as the idiosyncratic representa-
tional aims and techniques of baroque
artists. See M. Jay, "Scopic Regimes of
Modernity," in *Vision and Visuality,* H.
Foster, ed., Seattle, WA, 1988, pp. 2–23.

30. See *Charles Le Brun, peintre et dessinateur,*
exhibition catalogue, Versailles, Musée
national du Château, 1963, p. 67; *L'Art du
XVIIe siècle dans les Carmels de France,*
exhibition catalogue, Paris, Musée du Petit-
Palais, 1982–3, p. 158. For a description of
the chapel, see G. Brice, *Description de la
ville de Paris,* Paris, 1713, II, pp. 372–3;
and J.-B. Eriau, *L'Ancien Carmel du
Faubourg Saint-Jacques, 1604–1792,* Paris,
1929. The woodwork of the chapel was
decorated with scenes from the Magdalen's
life executed by Lebrun's pupils.

31. See the interesting correspondence on the
Lebrun and the other paintings at the
church between Cochin and Marigny in
1763; *NAAF,* (1903), p. 258. Dezallier
d'Argenville, in his *Voyage pittoresque de
Paris* (6th ed., 1778, p. 287), described the
Magdalen as "le chef-d'oeuvre de Le Brun."

32. Lauzan, *Lettres sur plusieurs monumens
des arts . . . extraits du Journal du Départe-
ment de Seine et Oise,* Versailles, an VI, p.
12, translation by Wrigley, "The Afterlife of
an Academician," p. 33. F. Lauzan's first
two letters were devoted to Puget's *Milo of
Crotona* and *Alexander and Diogenes,*
respectively. Also see my article "Mobilité
et fortune critique. La Mort de Charles
Lebrun dans les galeries de la Révolution."
In *Les Collections: Fables et programmes,*
pp. 341–9.

33. *Notice des tableaux des trois écoles . . . ,*
Paris, an IV (1796), pp. 41–2. The entry
reads: "Le portrait de madame de la Val-
ière, maîtresse de Louis XIV. Les charmes,
les douloureux sacrifices de cette femme
crue sensible, ont ajouté au mérite réel du
tableau un tel intérêt, qu'il en perdrait une
partie, si l'on détruisait ces illusions."

34. Lauzan, "Trois lettres," pp. 14–15.

35. A.-C. Quatremère de Quincy, *The Destina-
tion of Works of Art,* Henry Thomson,
trans., London, 1821, p. 115. I have
adapted very slightly Thomson's transla-
tion.

36. Quatremère was added to the committee on
February 24, 1797 (5 ventôse an V); the
Magdalen was consigned to Versailles on
May 15 of that year (25 floréal); see
Doucet, MS 1089: "Registre du procès-ver
baux du Conseil d'administration du Musée
Central des Arts," vol. 1.

BIBLIOGRAPHY

Adresse, mémoire et observations présentés à l'Assemblée Nationale, par la Commune des arts. Paris, 1791.

Algarotti, Count F. Essai sur la peinture. Paris, 1769.

Allou, C.-N. Notice sur la vie et les travaux d'Alexandre Lenoir. Paris, 1842.

Angiviller, Charles-Claude Flahaut. Comte de la Billarderie d'. Mémoires de Charles-Claude Flahaut. Comte de la Billarderie d'Angiviller. Notes sur les Mémoires de Marmontel. L. Bobé, ed. Copenhagen, 1933.

Anglas, F.-A. de Boissy d'. Essai sur les fêtes nationales suivi de quelques idées sur les arts. Paris, an II.

_____. Quelques idées sur les arts, sur la nécessité de les encourager, sur les institutions qui peuvent en assurer le perfectionnement, & sur divers établissemens nécessaires à l'enseignement public. Paris, an II.

Antonini, A. Memorial de Paris et de ses environs. 2 vols., Paris, 1749.

Argens, Marquis Jean-Baptiste d'. Réflexions critiques sur les différentes écoles de peinture. Paris, 1752.

Aulanier, C. Histoire du palais et du musée du Louvre. 10 vols., Paris, 1947–68.

[Bachaumont, Louis Petit de]. Essai sur la Peinture, la Sculpture et l'Architecture. Paris, 1751.

Baczko, Bronislaw. Comment sortir de la Terreur. Paris, 1989.

Bailey, Colin B. Aspects of the Patronage and

Collecting of Franch Painting in France. D. Phil. dissertation, Oxford University, 1985.

_____. First Painters of the King. New York, 1985.

_____. "Conventions of the Eighteenth-Century Cabinet de tableaux: Blondel d'Azincourt's La première idée de la curiosité." Art Bulletin, LXIX (1987), 431–46.

Bailly, Jacques. Catalogue des tableaux du cabinet du Roy. Paris, 1750.

Baker, Keith M. Inventing the French Revolution. New York, 1990.

Bann, Stephen. The Clothing of Clio. Cambridge, 1984.

Bazin, Germain. The Museum Age. New York, 1967.

Belting, Hans. The End of the History of Art? Chicago, 1987.

Benoit, F. L'Art français sous la Révolution et l'Empire. Paris, 1897.

Biet, J.-E., and Jean-Pierre Brès. Souvenirs du Musée des monumens français. Paris, 1821.

Blumer, Marie L. "La Commission pour la recherche des objets de sciences et arts en Italie, 1796–1797." Révolution français, (1934), 62–88, 124–50, 222–59.

Bonnaire, Marcel. Procès-verbaux de l'Académie des beaux-arts. 3 vols., Paris, 1937–43.

Bordes, Philippe, and Régis Michel. Aux Armes et Aux Arts! Les Arts de la Révolution, 1788–1799. Paris, 1988.

Bouquier, Gabriel. Rapport et projet de décret, relatifs à la restauration des tableaux et

autres monumens des arts, formant la collection du muséum national. Paris, an II.

Boyer, Ferdinand. "Louis XVIII et la restitution des oeuvres d'art confisquées sous le révolution et l'empire." *BSHAF* (1965), 201–7.

_____. "Trois rapports sur la réorganisation du Musée du Louvre." *BSHAF* (1965), 259–63.

_____. *Le Monde des arts en Italie et la France de la Révolution et de l'Empire.* Turin, 1969.

_____. "Le Musée du Louvre après les restitutions d'oeuvres d'art de l'étranger et les musées des départements." *BSHAF* (1969), 80–3.

Brejon de Lavergnée, Arnauld. *L'inventaire Le Brun de 1683.* Paris, 1987.

Brière, Gaston. "Le Peintre J.-L. Barbier et les conquêtes artistiques en Belgigue (1794)." *BSHAF* (1920), 204–10.

_____. "Vues de la Grande Galerie du Musée Napoléon." *BSHAF* (1920), 256–63.

Bryson, Norman. *Word and Image: French Painting of the Ancien Régime.* Cambridge, 1981.

_____. *Tradition and Desire: From David to Delacroix.* Cambridge, 1984.

Burke, Peter. "Tradition and Experience: The Idea of Decline from Bruni to Gibbon." *Daedalus,* 105 (Summer 1976), 137–52.

Cantarel-Besson, Yveline., ed. *La Naissance du Musée du Louvre.* 2 vols., Paris, 1981.

Catalogue des objets contenus dans la galerie du Muséum Français. Paris, 1793.

Chaussard, Pierre. *Essai philosophique sur la dignité des arts.* Paris, an VI.

Colton, Judith. *The Parnasse François and the Origins of the Monument to Genius.* New Haven, CT, 1979.

Conisbee, Philip. *Painting in Eighteenth-Century France.* Oxford, 1981.

Connelly, James L. *The Movement to Create a National Gallery in France.* Ph.D. dissertation, University of Kansas, 1962.

_____. "Forerunner of the Louvre." *Apollo,* XCV (1972), 382–9.

_____. "The Grand Gallery of the Louvre and the Museum Project: Architectural Problems." *Journal of the Society of Architectural Historians,* 31 (1972), 120–32.

Corps Legislatif: Conseil des Cinq-Cents. Motion d'ordre par Marin sur le Muséum central des arts. Paris, 1 nivôse an VI (December 21, 1797).

Courajod, Louis. ed. *Livre-Journal de Lazare Duvaux.* 2 vols., Paris, 1873.

_____. *L'Ecole royale des élèves protégés.* Paris, 1874.

_____. *Alexandre Lenoir, son journal et le Musée des monuments français.* 3 vols., Paris, 1878–87.

Coypel, Antoine. *Discours prononcez dans l'Académie royale de peinture et sculpture.* Paris, 1721.

Coypel, Charles-Antoine. *Discours sur la peinture.* Paris, 1732.

_____. "Dialogue entre Dorsicour et Céligny." *Mercure de France* (November 1751), 59–73.

Crimp, Douglas. "The End of Art and the Origins of the Museum." *Art Journal,* 46 (1987), 261–6.

Crow, Thomas E. "The *Oath of the Horatii* in 1785: Painting and Pre-Revolutionary Radicalism in France." *Art History,* 1 (1978), 428–71.

_____. *Painters and Public Life in Eighteenth-Century Paris.* New Haven, CT, 1985.

Daudin, Henri. *De Linné à Lamarck. Méthodes de la classification et idée de série en botanique et en zoologie (1740–1790).* Paris, 1926–7.

David, Jacques-L. *Discours prononcé par le citoyen David . . . 17 brumaire an II.* Paris, year II.

_____. *Rapport et décret sur la fête de la Réunion républicaine du 10 août.* Paris, 1793.

_____. *Rapport sur la suppression de la commission de muséum.* Paris, 1793.

_____. *Second rapport sur la nécessité de la suppression de la commission du muséum.* Paris, 1794.

Denon, Dominique Vivant. *Discours sur les monuments d'antiquité arrivés d'Italie.* Paris, an XII.

Descourtieux, Patrick. *Les théoriciens de l'art au XVIIIe siècle: La Font de Saint-Yenne.* Mémoire de maîtrise, Université de Paris-Sorbonne, 1977–8.

Deseine, Louis-Pierre. *Lettre sur la sculpture destinée à orner les temples consacrès au culte*

catholique, et particulièrement sur les tombeaux. Paris, 1802.

_____. Opinion sur les musées. Paris, an XI.

_____. Notices historiques . . . suivis de deux écrits. Paris, 1814.

Détournelle, Athanase. Aux armes et aux arts! Journal de la Société républicaine des arts. Paris, an II.

Dezallier d'Argenville, A.-J. "Lettre sur le choix et l'arrangement d'un cabinet curieux." Mercure de France (June 1727), 1294–1330.

Dowd, David L. Pageant-Master of the Republic. Jacques-Louis David and the French Revolution. Lincoln, NB, 1948.

Dowley, Francis H. A Series of Statues of "Grands Hommes" ordered by the Académie Royale de Peinture et de Sculpture. Ph.D. dissertation, University of Chicago, 1953.

Doyle, W. "The Parlements of France and the Breakdown of the Old Regime, 1770–1788." French Historical Studies, 6 (1970), 415–58.

Dubois de Saint-Gelais, L.-F. Description des tableaux du Palais Royal. Paris, 1727.

Duncan, Carol, and Alan Wallach. "The Universal Survey Museum." Art History, 3 (1980), 448–69.

Durand, Yves. Finance et mécenat: les fermiers généraux au XVIIIe siècle. Paris, 1976.

Dussausoy, Maille. Le Citoyen désintéressé, ou diverses idées patriotiques, concernant quelques établissemens utiles à la ville de Paris. Paris, 1767.

Dutilleux, A. "Le Muséum national et le Musée spécial de l'école française à Versailles (1792–1823)." Réunion des sociétés des beaux-arts des Départements (1886), 101–36.

Edwards, JoLynn. Alexandre-Joseph Paillet (1743–1813): A Study of a Parisian Art Dealer. Ph.D. dissertation, University of Washington, 1982.

Egret, J. Louis XV et l'opposition parlementaire. Paris, 1970.

_____. The French Prerevolution, 1787–1788. Chicago, 1987.

Eméric-David, T.-B., E. Q. Visconti, and S.-C. Croze-Magnan. Le Musée français, receuil complet des tableaux, statues et bas-reliefs qui composent la collection nationale. 4 vols., Paris, 1803–9.

Emile-Mâle, Gilberte. "Jean-Baptiste-Pierre Lebrun, son rôle dans l'histoire de la restauration des tableaux du Louvre." Bulletin de la Fédération des Sociétés historiques et archéologiques de Paris et de l'Ile de France, VII (1956), 371–417.

_____. "Le séjour à Paris de 1794 à 1815 de célèbres tableaux de Rubens." Bulletin de l'Institut Royal du Patrimoine Artistique, VII (1964), 153–71.

_____. "La première transposition au Louvre en 1750: La Charité d'Andrea del Sarto." Revue du Louvre, 32 (1982), 223–30.

Engerand, Fernand. Inventaire des Tableaux du Roy rédigé en 1709 et 1710. Paris, 1899.

_____. Inventaire des tableaux commandés et achetés par la direction des Bâtiments du Roi (1709–1792). Paris, 1901.

Félibien, André. Conférences de l'Académie royale de peinture et sculpture. Paris, 1669.

_____. Entretiens sur les vies et sur les ouvrages des plus excellens peintres, 2d ed. 2 vols., Paris, 1685–90.

_____. Entretiens sur les vies et sur les ouvrages des plus excellens peintres anciens et modernes. R. Démoris, ed., Paris, 1987.

Fêtes de la Liberté et entrée triomphale des objets de sciences et d'arts recueillis en Italie. Programme. Paris, an VI.

Fontaine, A. Les doctrines d'art en France. Peintres, amateurs, critiques, de Poussin à Diderot. Paris, 1909.

Foucart, Bruno. "La fortune critique d'Alexandre Lenoir et du premier Musée des monuments français." L'information de l'histoire de l'art, 5 (1969), 223–32.

Foucault, Michel. The Order of Things. New York, 1973.

Furet, François. Penser la Révolution. Paris, 1979.

Gallet, Michel. "Une vue de l'ancien Musée des monuments français." Bulletin du Musée Carnavalet (June 1969), 17–19.

Garnot, N. Sainte-Fare. "La Galerie des Ambassadeurs au Palais des Tuileries (1666–1671)." BSHAF, année 1978 (1980), 119–26.

Gibson-Wood, Carol. Studies in the Theory of Connoisseurship from Vasari to Morelli. New York, 1988.

Gordon, Alden R. The Marquis de Marigny, Directeur-Général des Bâtiments du Roi to Louis XV, 1751–1773: A Study in French

Royal Patronage. Ph.D. dissertation, Harvard University, 1978.

Gossman, Lionel. *Medievalism and the Ideologies of the Enlightenment: The World of La Curne de Saint-Palaye.* Baltimore, MD, 1968.

La Gothique retrouvé. Exhibition catalogue, Paris, C.N.M.H.S., 1979.

Gould, Cecil. *Trophy of Conquest; The Musée Napoléon and the Creation of the Louvre.* London, 1965.

Green, Christopher M. "Alexandre Lenoir and the Musée des monuments français during the French Revolution." *French Historical Studies,* XII (1981), 200–22.

Grégoire, Abbé Henri. *Rapport sur les destructions opérées par le vandalisme et sur les moyens de le réprimer.* Paris, 14 fructidor an II (August 31, 1794).

———. *Second rapport sur le vandalisme.* Paris, 8 brumaire an II (October 21, 1794).

———. *Troisième rapport sur le vandalisme.* Paris, 24 frimaire an II (December 14, 1794).

Griffiths, Julius. *Galerie du Louvre, représentée par des gravures à l'eau forte exécutées par Maria Cosway avec une description historique et critique par J. Griffiths.* Paris, 1802 (2d ed. 1806).

Guibert, François-A. de]. *Eloge de l'Hôpital.* 1777

Guiffrey, J.-J. "Lettres et documents sur l'acquisition des tableaux d'Eustache Le Sueur." *NAAF* (1877), 274–360.

———. "Correspondance du comte d'Angiviller avec Bosschaert." *NAAF* (1880–1), 93–130.

Guillaumot, Charles-Axel. *Mémoire sur la manière d'éclairer la galerie du Louvre, pour y placer le plus favorablement possible les peintures et sculptures, destinées à former le musée national des arts.* Paris, 1797.

Guillerme, Jacques. *L'Atelier du temps.* Paris, 1964.

———, ed. *Les Collections: Fables et programmes.* Paris, 1993.

Haskell, Francis. *Rediscoveries in Art.* Oxford, 1980.

———. "Les musées et leurs ennemis." *Actes de la recherche en sciences sociales,* 43 (1983), 103–6.

———. "The Artist and the Museum." *The New York Review of Books* (December 3, 1987), 38–42.

Haskell, F., and N. Penny. *Taste and the Antique.* New Haven, CT, 1981.

Huard, G. "Alexandre Lenoir et le muséum." *BSHAF* (1940), 188–206.

———. "La salle du XIIIe siècle au Musée des monuments français à l'Ecole des beaux-arts." *Revue de l'art ancien et moderne,* 47 (1925), 113–26.

Hudson, D. C. "In Defence of Reform: French Government Propaganda during the Maupeou Crisis." *French Historical Studies,* 8 (1973), 51–76.

Hunt, Lynn. *Politics, Culture, and Class in the French Revolution.* Berkeley, CA, 1984.

Ingrams, Rosalind. "Bachaumont: A Parisian Connoisseur of the Eighteenth Century." *Gazette des Beaux-Arts,* LXXV (January 1970), 11–28.

Inventaire général des richesses d'art de la France. Archives du Musée des monuments français. 3 vols., Paris, 1883–97.

Izerda, Stanley J. "Iconoclasm during the French Revolution." *American Historical Review,* 55 (1954), 13–26.

Jobert, Barthélemy. "The *travaux d'encouragement*: An Aspect of Official Arts Policy in France under Louis XVI." *Oxford Art Journal,* 10 (1987), 3–14.

Johnson, N. R. *Louis XIV and the Age of the Enlightenment: The Myth of the Sun King from 1715 to 1789. Studies on Voltaire and the Eighteenth Century,* 172 (1978),

Jouin, Henri. *Conférences de l'Académie royale de peinture et sculpture.* Paris, 1883.

Karp, Ivan, and Stephen D. Lavine, eds. *Exhibiting Cultures. The Poetics and Politics of Museum Display.* Washington, DC, 1991.

Kennedy, Emmet. *A Cultural History of the French Revolution.* New Haven, CT, 1989.

Kersaint, Armand-Guy. *Discours sur les monuments publics.* Paris, 1792.

Lacroix, Paul., ed. "Conseils d'un ami des arts [Bachaumont] à Frédéréric II." *Revue Universelle des Arts,* 3 (1856), 351–7.

———. "Jugement de Bachaumont sur les meilleurs artistes de son temps." *Revue Universelle des Arts,* 5 (1857), 418–27.

La Curne de Sainte-Palaye, J.-B. de. *Catalogue des tableaux du cabinet de M. Crozat,*

Baron de Thiers. Paris, 1755 (Minkoff reprint, 1972).

[La Font de Saint-Yenne, Etienne]. *Réflexions sur quelques causes de l'état de peinture en France avec un examen des principaux ouvrages exposés au Louvre le mois d'aoust 1746.* The Hague, 1747.

_____. *L'Ombre du grand Colbert.* 1st ed. The Hague, 1749.

_____. *Le génie du Louvre aux Champs-Elysées.* 1756.

Laissus, Yves. "Les cabinets d'histoire naturelle," in *Enseignement et diffusion des sciences en France au XVIIIe siècle.* R. Taton, ed., Paris, 1964, 659–711.

L'an V. Dessins des grands maîtres. Exhibition catalogue, Paris, Réunion des musées nationaux, 1988.

Lanzac de Laborie, L. de. *Paris sous Napoléon.* 8 vols., Paris, 1905–13.

Lapauze, Henri. *Procès-verbaux de la Commune générale des arts et de la Société populaire et républicaine des arts.* Paris, 1903.

Laran, Jean. "L'Exposition des tableaux du Roi au Luxembourg." *BSHAF* (1909), 154–202.

Lauzan, François. *Lettres sur plusieurs monumens des arts . . . extraits du Journal du Département de Seine et Oise.* Versailles, an VI.

Lavallée, Athanèse. *Observations sur l'administration du Musée Central des Arts.* Paris, an VI.

Lavallée, J. (de). *Tableau philosophique du règne de Louis XIV, ou Louis XIV jugé par un François libre.* Strasbourg, 1791.

Lebrun, J.-B.-P. *Galerie des Peintres Flamands, Hollandais et Allemands.* 3 vols., Paris, 1792–6.

_____. *Réflexions sur le Muséum national.* Paris, 1793.

_____. *Observations sur le Muséum national . . . pour servir de suite aux réflexions qu'il a déjà publiées sur le même objet.* Paris, 1793.

_____. *Quelques idées sur la disposition . . . du muséum national.* Paris, an III.

_____. *Examen historique et critique des tableaux exposés provisoirement venant des premiers & second envois de Milan, Crémone, Parme, Plaisance, Modéne, Cento & Bologne. . . .* Paris, an VI.

Leith, James. *The Idea of Art as Propaganda in France, 1750–1799.* Toronto, 1965.

Lemonnier, H., ed. *Procès-verbaux de l'Académie royale d'architecture, 1671–1793.* 9 vols., Paris, 1911–26.

Lenoir, Alexandre. *Notice succincte des objets de sculpture et d'architecture réunis au Dépôt provisoire des Petits-Augustins.* Paris, 1793.

_____. *Essai sur le Muséum de peinture.* Paris, an II.

_____. *Notice historique des monumens des arts, réunis au dépôt national. . . .* Paris, an IV.

_____. *Description historique et chronologique des monumens de sculpture réunis au Musée des monumens français.* Paris, an VIII.

_____. *Rapport historique sur le château d'Anet.* Paris, an VIII.

_____. *Musée des monumens français, ou description historique et chronologique des statues. . . .* 5 vols., Paris, 1800–6.

Lépicié, F.-B. *Catalogue raisonné des tableaux du Roy.* 2 vols., Paris, 1752–4.

_____. *Vies des Premiers peintres, depuis Lebrun jusqu'à présent.* 2 vols., Paris, 1752.

Les commissaires du Muséum Français aux membres du Comité d'instruction publique. Paris, 1793.

*Lettre de M. le Chevalier de Tincourt à Madame la Marquise de *** sur les Tableaux et Dessins du Cabinet du Roi.* Paris, 1751.

Lettre sur les tableaux tirés du cabinet du roi et exposés au Luxembourg depuis le 24 octobre 1750. 1751.

Locquin, Jean. *La peinture d'histoire en France de 1747 à 1785.* Paris, 1912.

McClellan, Andrew. "The Politics and Aesthetics of Display: Museums in Paris, 1750–1800." *Art History* 7 (1984), 438–64.

_____. "D'Angiviller's Great Men and the Politics of the Parlements." *Art History,* 13 (1990), 175–92.

_____. "Nationalism and the Origins of the Museum in France." In *The Formation of National Collections of Art and Archaeology,* G. Wright, ed., *Studies in the History of Art* (forthcoming).

McKee, George. "The Publication of Bonaparte's Louvre." *Gazette des Beaux-Arts,* CIV (November 1984), 165–72.

Marot, D. "Recherches sur les origines de la transposition de la peinture en France." *Annales de l'Est* (1950), 241–83.

Martin, G. *Avis à la nation.* Paris, 1793.

Mathieu, Jean-B.-C. *Rapport . . . fait au nom du Comité d'instruction publique. . . .* Paris, 1793.

Mazière de Monville, Abbé S.-P. *La Vie de Pierre Mignard.* Paris, 1730.

Mechel, Chrétien de. *Catalogue des tableaux de la Galerie Impériale et Royale de Vienne.* Basel, 1784.

Meijers, Debora J. *Kunst als natuur: De Hapsburgse schilderijengalerij in Wenen omstreeks 1780.* Amsterdam, 1991.

Mellon, Stanley. "Alexandre Lenoir: The Museum versus the Revolution." *Proceedings of the Consortium on Revolutionary Europe,* IX (1979), 75–88.

Mercier, Sebastien. *Le Nouveau Paris.* 6 vols., Paris [1797].

Milizia, Francesco. *De l'Art de voir dans les beaux-arts.* Paris, an VI.

Montaiglon, Anatole de, and Jules Guiffrey. *Correspondance des Directeurs de l'Académie de France à Rome avec les Surintendants des Bâtiments, 1666–1804.* 17 vols., Paris, 1887–1908.

Muntz, Eugène. "Les annexations de collections d'art ou de bibliothèques et leur rôle dans les relations internationales principalement dans la Révolution française." *Revue d'histoire diplomatique,* 8 (1894), 481–97; 9 (1895), 375–93; 10 (1896), 481–508.

Musée Central des Arts. Pièces relatives à l'administration de cet établissement, imprimées par ordre du Directoire exécutif. Paris, an VI.

Nemeitz, Joachim C. *Séjour de Paris.* 2 vols., Leiden, 1727.

Notice des plusieurs précieux tableaux, recueillis à Venise, Florence, Turin et Foligno. Paris, 1800.

Notice des principaux tableaux recueillis dans la Lombardie. Paris, an VI.

Notice des principaux tableaux recueillis en Italie. Paris, an VII.

Notice des tableaux des écoles française et flamande. Paris, an VII.

Notice des tableaux des écoles française et flamande . . . et des tableaux des écoles de Lombardie et Bologne. Paris, an IX.

Notice des tableaux des écoles primitives de l'Italie, de l'Allemagne. . . . Paris, 1814.

Notice des tableaux des trois écoles, choisis dans la collection du Muséum des arts, rassemblés au Sallon d'exposition, pendant les travaux de la Gallerie. Paris, an IV.

Olivier, Louis. *"Curieux," Amateurs, and Connoisseurs: Laymen and the Fine Arts in the Ancien Régime.* Ph.D. dissertation, The Johns Hopkins University, 1976.

Ozouf, Mona. *La fête révolutionnaire 1789–1799.* Paris, 1976.

Perrault, Charles. *Parallèle des anciens et des modernes en ce qui regarde les arts et les sciences.* Paris, 1688.

Picault, J.-M. *Observations . . . sur les tableaux de la République.* Paris, 1793.

Pigage, Nicolas de. *La Galerie Electorale de Dusseldorf.* Basel, 1778.

Piles, Roger de. *Conversations sur la connoissance de la peinture.* Paris, 1677.

_____. *Abrégé de la vie des peintres.* Paris, 1699.

_____. *Cours de peinture par principes.* Paris, 1708.

Pomian, Krzystof. *Collectionneurs, amateurs, curieux. Paris, Venise: XVIe–XVIIIe siècle.* Paris, 1987.

Pommier, Edouard. "Idéologie et musée à l'époque révolutionnaire." In *Les Images de la Révolution française,* M. Vovelle, ed., Paris, 1988, 57–78.

_____. *Le problème du musée à la veille de la Révolution.* Cahiers du Musée Girodet, Montargis, 1989.

_____. *Quatremère de Quincy, Lettres à Miranda sur le déplacement des monuments de l'art de l'Italie.* Paris, 1989.

_____. "Winckelmann et la vision de l'Antiquité classique dans la France des Lumières et de la Révolution." *Revue de l'art,* 83 (1989), 9–20.

_____. *L'art de la liberté. Doctrines et débats de la Révolution française.* Paris, 1991.

_____. *Jean-Baptiste-Pierre Lebrun, Réflexions sur le Muséum national.* Paris, 1992.

Potts, Alex. "Political Attitudes and the Rise of Historicism in Art Theory." *Art History,* 1 (1978), 191–213.

_____. *Winckelmann's Interpretation of the History of Ancient Art in Its Eighteenth-Century Context.* Ph.D. dissertation, University of London, 1978.

_____. "Greek Sculpture and Roman Copies I: Anton Raphael Mengs and the Eighteenth Century." *Journal of the Warburg and Courtauld Institutes,* 43 (1980), 150–73.

_____. "Winckelmann's Construction of History." *Art History*, 5 (1982), 377–407.

Poulot, Dominique. "Alexandre Lenoir et les musées des monuments français." In *Les Lieux de mémoire*, P. Nora, ed., vol. II, Paris, 1986, 497–531.

_____. "Musées et société dans l'Europe moderne." *Mélanges de l'Ecole française de Rome*, XLVIII (1986), 991–1096.

_____. "Un regard britannique sur l'héritage de la civilisation: le témoinage des récits de visites de musées au XVIIIème siècle." *Enlightenment — Revue des études dix-huitièmistes*, 1 (1988), 11–52.

_____. "Le Louvre imaginaire: Essai sur le statut du musée en France, des Lumières à la République." *Historical Reflections/Réflexions historiques*, 17 (1991), 171–204.

_____. "Le public, l'état et l'artiste. Essai sur la politique du musée en France des Lumières à la Révolution." *EUI Working Paper in History HEC No. 92/13*, Florence, 1992.

Procès-verbal des monuments, de la marche, et des discours de la fête consacrée à l'inauguration de la Constitution de la République française, le 10 août 1793. Paris, 1793.

Puttfarken, Thomas. *Roger de Piles' Theory of Art*. New Haven, CT, 1985.

Quatremère de Quincy, Antoine-C. *Lettres sur le préjudice qu'occasionneraient aux arts et à la science le déplacement des monuments de l'art de l'Italie. . . .* Paris, an IV.

_____. *Considérations morales sur la destination des ouvrages de l'art*. Paris, 1815.

Rabaut Saint-Etienne, Jean-P. *Rapport . . . sur l'établissement d'un Muséum national d'antiques*. Paris, an III.

"Rapport sur la restauration du tableau de Raphael." *Mémoires de l'Institut. Littérature et Beaux-Arts*, Vol. V, an XII.

Réau, Louis. "Le jardin Elysée du Musée des monuments français." *Beaux-arts* (January 1924), 1ff.

Reboul. *Essai sur les moeurs du tems*. Paris, 1768.

Rémy, Abbé Joseph-H. *Eloge de Michel de l'Hôpital*. Paris, 1777.

Renouard, A.-A., et al. *Observations de quelques patriotes sur la nécessité de conserver les monumens de la littérature et des arts*. Paris, an II.

Réville, J.-B., and Lavallée. *Vues pittoresques et perspectives des salles du Musée des monuments français*. Paris, 1816.

Romme, Gilbert. *Rapport . . . sur la suppression de la place de directeur de l'Académie de France à Rome*. Paris, 1792.

Rosenberg, Martin. "Raphael's *Transfiguration* and Napoleon's Cultural Politics." *Eighteenth-Century Studies*, 19 (Winter 1985–6), 180–205.

Rosenblum, Robert. *Transformations in Late Eighteenth Century Art*. Princeton, NJ, 1967.

Rucker, F. *Les Origines de la conservation des monuments historiques en France (1790–1830)*. Paris, 1913.

Sahut, Marie-C. *Le Louvre de Hubert Robert*. Réunion des musées nationaux, Paris, 1979.

Saunier, Charles. *Les Conquêtes artistiques de la Révolution et de l'Empire*. Paris, 1902.

Schlegel, Friedrich von. *The Aesthetic and Miscellaneous Works of F. von Schlegel*. E. Millington, trans., London, 1849.

Schneider, Rémy. "Un ennemi du Musée des monuments français." *Gazette des Beaux-Arts* (1909), 353–70.

Silvestre de Sacy, J. *Le comte d'Angiviller, dernier directeur général des Bâtiments du Roi*. Paris, 1953.

Stanton, Domna C. *The Aristocrat as Art*. New York, 1980.

Stein, Henri. *Le peintre G.-F. Doyen et l'origine du musée des monuments français*. Paris, 1888.

Stuffmann, M. "Les Tableaux de la collection de Pierre Crozat." *Gazette des Beaux-Arts*, XXII (1968), 1–144.

Tate, Robert S. "Petit de Bachaumont: His Circle and the *Mémoires Secrets*." *Studies on Voltaire and the Eighteenth Century*, LXV (1968).

Testelin, Henri. *Sentimens des plus habiles peintres sur la pratique de la peinture et sculpture, mis en tables de preceptes*. Paris, 1680.

Teysèddre, Bernard. *Roger de Piles et les débats sur le coloris au siècle de Louis XIV*. Paris, 1957.

Thouroude, S. "Le couvent des Petits-Augustins." *l'Information d'histoire de l'art*, 4 (1964), 161–77.

Tuetey, Alexandre, and Jean Guiffrey. *La Com-*

mission de Museum et la création du Musée du Louvre, 1792–1793. Paris, 1910.

Tuetey, Louis. Procès-verbaux de la Commission de Monuments. 2 vols., Paris 1901–2.

_____. Procès-verbaux de la Commission temporaire des Arts. 2 vols., Paris, 1912–18.

Van Nimmen, Jane. Responses to Raphael's Paintings at the Louvre, 1798–1848. Ph.D. dissertation, University of Maryland, 1986.

Vanuxem, J. Ecole du Louvre. Positions des thèses soutenus par les anciens élèves de l'école du Louvre de 1911 à 1944. Paris, 1956.

_____. "Aperçus sur quelques tableaux représentant le Musée des monuments français." BSHAF (1971), 141–51.

Varon, Casimir. Rapport fait au nom des commissaires envoyés dans le département de Seine & Oise. Paris, 1794.

Vyverberg, Henry. Historical Pessimism in the French Enlightenment. Cambridge, MA, 1959.

Watelet, C.-H., and P.-C. Levesque. Dictionnaire des arts de peinture, sculpture et gravure. 5 vols., Paris, 1792.

PHOTOGRAPHIC CREDITS

All references are to figure numbers.

A.C.L., Brussels: 43
Alinari/Art Resource, New York: 50, 51, 52
American Philosophical Society, Philadelphia: 54, 55, 56
Archives Nationales, Paris: 25, 27, 57, 80
Author: 2, 3, 4, 7, 8, 9, 14, 15, 16, 18, 19, 46, 62, 63, 64, 65, 66, 67, 68, 69, 70, 71, 72, 73, 74, 75, 76, 77, 78, 79, 81, 82
Bibliothèque d'art et d'archéologie, Paris: 1
Bibliothèque Nationale, Paris: 17, 36, 40, 59
British Library: 20
Courtauld Institute of Art, London: 23, 45
Photothèque des Musées de la Ville de Paris: 34, 60, 61
Réunion des Musées Nationaux, Paris: 6, 10, 11, 12, 13, 21, 22, 24, 28, 29, 30, 31, 32, 33, 35, 37, 38, 39, 41, 42, 44, 47, 48, 49, 53, 58, 83, 84

INDEX

Index

Index

Maupeou, Chancellor René-Nicolas de,
 83–9
Mazière de Monville, Abbé Simon, 70; *Vie
 de Pierre Mignard*, 231
 n135, 255 n54
Mechel, Chrétien de, 4, 79–80
Meister, Jacques-Henri, 8
Mengs, Anton Raphael, 70, 73, 153
Mercier, Louis-Sébastien, 87, 166–7, 169
Mérimée, Jean-François-Léonor, 108
Michelangelo Buonarroti, 31, 41, 101, 106,
 146, 201; *Slaves*, 156
Miger, Simon-Charles, 99
Mignard, Pierre, 45, 47, 70, 127, 238 n89
Mique, Richard, 57, 59, 91
Moitte, Jean-Guillaume, 187
Molé, Matthieu, 89
Moline, Pierre-Louis, 97
Monge, Gaspard, 117
Montesquieu, Charles-Louis de Secondat,
 Baron de la Brède et de, 86
Montpetit, Arnauld-Vincent de, 238 n98
Montucla, Jean-Etienne, 72, 233 n13
Moreau le Jeune, Jean-Michel, 161–2
Murillo, Bartholomé Esteban, 62, 63
Museé de Cluny, Paris, 197
Museé de l'Histoire Naturelle, Paris, 122
Museé du Luxembourg, Paris, 200
Musée spécial de l'école française, Versailles,
 130–1, 169, 200, 203–4, 253 n24
Museum Commission: and Alexandre
 Lenoir, 161–3; criticism of, 103–8, 113;
 organization of the Louvre, 93, 94–5,
 99, 101, 125
Museum of French Monuments, Paris:
 arrangement and decoration of, 155,
 162, 169–71, 178–84, 187–8, 192–3,
 264 n102, n103, 104; catalogues to,
 162, 163–4, 165, 170, 191–2, 265
 n119; objections to, 169, 194–7; as a
 pantheon, 179–80; pedagogic purpose
 of, 167; political purpose of, 167–9,
 189–91, 190–1, 192–4, 266 n124; pro-
 motion of French Renaissance art,
 156–7, 181–2, 187–90, 265 n106; rela-
 tionship with other Paris museums,
 130, 169; restitution from, 194–7, 266
 n133; restoration at, 162, 184–8, 196,

264 n100; and Thermidorian reaction,
 165–7, 194

National Assembly, Paris, 91, 92–3, 100
National Convention, Paris: and arts policy,
 101–5, 113, 115, 130, 149, 158, 165;
 and public festivals, 94, 96–7
natural history, classification of, 3–4, 80–1,
 242 n129
Notre-Dame, Paris, 74, 156, 170, 194

Onsenbray, L.-L. Pajot d', 24–5, 51
Orléans, Charles de, *tomb of*, 184
Orléans Collection, Paris, 36, 38, 67, 152
Orléans, Philippe, Duc d', 19, 38
Orry, Philibert, 16

Pahin de la Blancherie, F.-C.-C., 73–4
Paillet, Alexandre-Joseph, 64–7, 152
Pajou, Augustin, 57, 90, 125, 188
Palais Royal, Paris, 19, 38, 57, 101
Palazzo dei Conservatori, Rome, 149
Palissy, Bernard, 182
Palma Vecchio, 28, 47, 130
Parlements, 83–90, 221 n31
Parma, Don Ferdinand, Duke of, 116–7
Parmigianino, 28, 47, 62
Pasquier, Pierre, 93
Passavant, Johann, 200
Passeri, Giovanni Battista, 134
Pei, I.M., 124
Perrault, Charles, 22, 44, 47
Perrault, Claude, 57
Perugino, Pietro, 120, 136–7, 141, 142, 144,
 145, 153
Petit de Bachaumont, Louis: as artistic
 adviser, 4, 22, 41, 79, 219 n16, 230
 n114; *Essai sur la peinture*, 8, 22, 47–8,
 224 n54; and La Font de Saint-Yenne,
 20, 21–2, 24, 221 n31; and Lenormand
 de Tournehem, 20–1, 219 n18; origins
 of the Luxembourg Gallery, 15–16, 18;
 preservation of artistic treasures, 18–19,
 21, 26, 219 n18, 220 n26, 264 n105
Peyre, Antoine-Marie, 178, 179, 180, 182,
 264 n102

Index

Richelieu, Armand du Plessis, Cardinal de, 157, 159, 169; *tomb of*, 187, 191
Rigaud, Hyacinthe, 47, 127
Robert, Hubert, 64, 125; *Views of the Louvre*, 54, 57, 58, 71, 75, 81
Robespierre, Maximilien-Marie-Isidore, 114, 122, 125, 158
Roland, Jean-Marie, 91, 93, 94, 103, 105, 107, 161, 163
Romanelli, Giovanni Francesco, 151
Romano, Giulio, 129, 144
Romme, Gilbert, 100
Rousseau, Jean-Jacques, 181
Rubens, Peter Paul, 4, 33, 41, 62, 196; *Adoration of the Magi*, 66; *Crucifixion*, 115; *Descent From the Cross*, 111, 115; *Erection of the Cross*, 115; *Marie de Medici Cycle*, 14, 24, 68, 109, 127, 156, 200, 204

Sacchi, Andrea; *Vision of Saint Romuald*, 119
Saint-Aubin, Gabriel de, 74
Saint-Denis, royal abbey of, 156, 158, 159, 163, 179, 180, 183, 197
Saint-Germaine, Claude-Louis, Comte de, 53
Saint-Hubert, Auguste-Cheval de, 126, 150–1, 152, 259 n114
Saint-Merri, Paris, 59
Sainte-Chapelle, Paris, 183
Salon (Salon carré), Louvre: exhibitions of confiscated art, 115, 127, 131–2, 133, 134–7; exhibitions of contemporary art, 10, 13, 18, 19, 21, 28, 44, 49, 54, 74, 76–7, 81, 90, 222 n35; renovation of, 57, 60, 235 n52
Santerre, Jean-Baptiste, 45, 127
Sarrazin, Jacques, 179, 191, 202
Sarto, Andrea del: *Charity*, 27–8, 133
Sauvage, Pieter-Joseph, 67
Schidone, Bartolomeo, 62
Schlegel, Friedrich von, 202
Sebastiano del Piombo, 130
Shee, Martin Archer, 198
Sirani, Elisabetta, 119
Slodtz, Michel-Ange: *Languet de Gergy Monument*, 186, 192

Société populaire et républicaine des arts, Paris, 102, 111
Soufflot, Jacques-Germain, 44, 52, 53–4, 56, 57, 58
Spada, Leonello: *Joseph and Potiphar*, 144; *Return of the Prodigal Son*, 144
Sully, Maximilien de Béthune, Duc de, 179
Suvée, Joseph-Benoît, 125

Talleyrand, Charles-Maurice de, 133
Teniers, David, 111
Terray, Abbé Joseph-Marie, 52
Thiers, Baron de, 226 n72, 229 n94
Thomas, Antoine-Léonard, 87
Thouin, André, 114, 117, 118, 121, 123
Tiarini, Alessandro: *Rinaldo and Armida*, 144
Tibaldi, Pelegrino, 129
Tinet, Jacques-Pierre, 118
Tintoretto, 162
Titian, 31, 32, 63; *Christ Crowned with Thorns*, 144, 200
Titon du Tillet, Evrard, 82
Traverse, Charles-François de la, 63
Troy, Jean-François de, 25, 45, 231 n132
Tuileries Palace, Paris, 28, 91, 93; *Ambassadors' Gallery*, 15, 32, 34, 36, 41
Turgot, Anne-Robert-Jacques, 52

Vallière, Louise de la, 127, 203–4
vandalism, Revolutionary, 156, 157–8, 165–7, 180, 184–6, 247 n60
Van Loo, Carle, 17, 44, 67, 103
Vanni, Francesco, 62
Varon, Casimir, 104, 113, 114, 125, 126, 155–6, 164
Vasari, Giorgio, 147; *Lives of the Artists*, 31, 134, 192, 201, 230 n117; on Raphael, 135, 141, 145; theory of history, 145–6, 181, 268 n7
Vatican Pinacoteca, 201
Vaudreuil, Comte de, 62
Velázquez, Diego de, 63
Velde, Adriaen van de, 111
Venus de Medici, 149, 153